Sean Connery

Robert Sellers is the author of *Sigourney
Weaver*, *Harrison Ford* and *Tom Cruise*,
also published by Hale. His hobbies include
the cinema, music and travelling. He lives in
North London.

Publication: 31-08-00
Format: Metric Royal 8vo
Text Paper: Rosemount Vol 20
80 gsm 1270 x 960 mm
Jacket printer: W.Q.P. 32s sewn
Illustrations
4 x 8 pp sewn
Illustration printer: W Q P

SEAN CONNERY

A Celebration

ROBERT SELLERS

ROBERT HALE · LONDON

© Robert Sellers 1999
First published in Great Britain 1999
First paperback edition 2000

ISBN 0 7090 6791 7

Robert Hale Limited
Clerkenwell House
Clerkenwell Green
London EC1R 0HT

2 4 6 8 10 9 7 5 3 1

Typeset in 10/12 Garamond by
Derek Doyle & Associates, Mold, Flintshire.
Printed in Great Britain by
St Edmundsbury Press Limited, Bury St Edmunds, Suffolk
and bound by
WBC Book Manufacturers Limited, Bridgend

Contents

Illustrations

Credits

Vince Leisure Wear: 1. The Movie Store Collection: 2–4, 7–10, 13–15, 18–19, 20–30, 33, 35, 38–40, 42–44. BFI Stills: 34, 36. *Movie Star News*: 41.

All other illustrations are from the author's collection.

Chronology

1930: Born Thomas Connery in Edinburgh.

1938: Starts first job as a milk boy.

1943: Leaves school with no qualifications.

1947: Joins the Royal Navy, but is medically discharged.

1953: Represents Scotland in the Mr Universe contest, which leads to a chorus line part in *South Pacific*.

1957: Film début in *No Road Back* and career breakthrough performance in BBC play *Requiem for a Heavyweight*.

1962: Achieves international stardom as James Bond. Marries actress Diane Cilento.

1964: Works with Alfred Hitchcock on *Marnie*.

1965: 'Bondmania' peaks, with Connery named the world's most popular star.

1967: Retires from the role of 007.

1970: Establishes the Scottish International Educational Trust.

1971: Returns as James Bond for world-record fee.

1973: Divorces Diane Cilento.

1975: Marries French artist Micheline Roquebrune, moves to Spain and becomes a tax exile. Release of *The Man Who Would Be King*.

1983: Back as Bond in *Never Say Never Again* after a twelve-year absence.

1986: Release of *The Name of the Rose*.

1987: Wins long-overdue Oscar for *The Untouchables*.

1989: Becomes cinematic father of Indiana Jones and Dustin Hoffman. Voted 'the sexiest man alive'.

1991: Appears in a television broadcast on behalf of the Scottish National Party. Receives the Freedom of Edinburgh.

1992: Co-presents smash-hit play *Art* on the London stage. Scores big with the MTV generation in blockbuster *The Rock*.

1998: Labour government controversially snubs Connery for a knighthood, but he receives the British film industry's highest accolade – the BAFTA Fellowship.

1 The Early Years

Fountainbridge

The streets in which Sean Connery grew up were a far cry from the tourist image of Edinburgh. You'd be hard pressed to find a postcard with Fountainbridge's wretched, depressing face on it. An industrial district, discreetly tucked away towards the south-west of the city, not too far from the Castle's gothic battlements, Fountainbridge was a mess of grim factories and manufacturing plants.

The locals called the place 'Auld Reekie' and never was anywhere more aptly named. All day the brewery, rubber mill and sweet factory spewed out their individual stenches into the air, producing a quite unique atmosphere. Little wonder the cream of Edinburgh society rarely if ever ventured into Fountainbridge, sometimes even thinking twice before hiring domestic staff from the district. But despite the area's deprivation, no family there was a stranger, everyone knew everyone else (and everyone else's business) and were always ready to pitch in and help a neighbour. In spite of the poverty there was little crime, and doors could be left safely unlocked – though probably because there wasn't anything worth stealing inside.

Doubtless there were worse-off people in poorer slums elsewhere, but Fountainbridge wasn't the greatest environment to raise a family, and Connery isn't one to start romanticizing the old days. It could be violent sometimes, but a legitimate kind of violence: if some brother's sister got pregnant he'd go round to sort the fellow out. Not like now, when pensioners are mugged for the sake of a few pounds. Connery lays much of the blame for today's ills on drugs. In 1997 he witnessed first-hand the effects drug abuse was having on his home town. His typically forthright views on how to deal with the problem included bringing in the military to clean up drug-dealing trouble spots in major cities. 'A few years ago I opened a hospice in Edinburgh. None of them got Aids through sex – they got it through sharing needles.' Despairing of the near-total breakdown of communities, so vibrant in Fountainbridge when he was young, he continues to give generously to local charities to fight the menace of drugs. 'One of

9

the problems is high unemployment. People have a lot of energy and nowhere to go with it. Not a chance of a job.'

Fountainbridge was also known as 'tenement land'. Each street was almost identical to the next, rows of tall ugly buildings blackened with the grime of factory smoke. Soon after marrying in 1928 Joe and Effie Connery moved into a rented flat consisting of one bedroom and a combined living-room/kitchen, which stood above a gent's outfitters and a baker's. They were one of twelve families sharing the same tenement block. There was just one cold water tap in the flat, no hot water, no bathroom; indeed in the whole street there wasn't a single bath. 'I still get a charge out of a bath,' Connery told Vanity Fair in 1993. 'When I go to the Grosvenor House Hotel I always lie in the bath – a real bath. The bath is something special. There was only one bath in the whole of our street and that belonged to the brewery.' Privacy was in short supply too; one was forced to eat, wash and dress in the kitchen area. And the walls of the flat were distressingly thin: arguments between neighbours, the cries of infants, nocturnal moaning and aged lungs coughing up years of hard graft were often too audible for comfort. Is it any wonder that for Sean Connery, growing up in that poky space, the pursuit of privacy became an obsession in later life?

As a struggling actor in the mid to late 1950s Connery returned home as often as money permitted. He always found it reassuringly the same: the washing drying out before the coal fire in the living room, the tin bath hanging on the wall outside. He also enjoyed meeting up with old friends, most of whom were still bemused over the big man's decision to carve out a career as an actor. 'Why go buggering about in the theatre?'

When Connery was in Edinburgh for the Scottish premier of *Dr No* he bumped into the father of an old drinking pal, contentedly puffing away on a clay pipe. 'Hello, Tam,' he said, referring to Connery's bygone nickname. 'Have ye been away?' – an innocent comment guaranteed to bring anyone back down to earth with a thud. Several former school and work mates waited outside the theatre that evening to catch a glimpse of Connery's grand return. As he emerged from his car one of them yelled, 'Hey Tam, are you coming for a drink afterwards?' Connery recognized the voice and smiled. 'Hey boys, of course! I'll see you after the show.' All drinks were on Sean that night. He had changed little, it was as if he'd never been away. On these visits to Edinburgh Connery avoided posh hotels, choosing to stay at home where his mum cooked his favourite meals for him. During the day he'd maybe visit old haunts like Portobello pool where he'd been a lifeguard, while evenings were spent with old pals down the pub; then they'd head back to his place with a crate of beer for a rowdy sing-song.

When Connery married Diane Cilento things changed dramatically, and these pilgrimages to his beloved Edinburgh became less frequent. Maybe as fame took over his life, he was just finding he had less and less in common with the people from his past. 'When I go to Scotland it's a very emotional

time for me, because the amount of people that I know dwindles each year as I get older.' So said Connery in 1992. 'When I left Scotland I lost contact with most people because I was just never back enough.'

In 1978 Connery took his second wife Micheline, along with his son Jason, to see his childhood house before the bulldozers moved in. Effie was there too, keen for one last look. 'I wanted them to see it. But it really was a dump. A terrible place. No hot water. Four flats with just two toilets. Gas mantles on the landings. What was interesting was their reaction.' Micheline called it a hovel; 'mother, of course, thought it was quite nice.' For Jason, who described the experience as 'interesting', it was really the first occasion he'd been made so vividly aware of the actual circumstances in which his father had grown up. He now remembered with embarrassment how he'd complain as a child about how much his feet stuck out of his bed. Connery had replied that his first bed had been a chest of drawers.

In honour of his birthplace, Connery has named his production company Fountainbridge Films, which in February 1998 closed a multiyear first look deal with entertainment giants Sony Pictures for movies Connery may wish to produce or star in.

Parents

There are two tattoos on Sean Connery's right forearm, a legacy of his navy days, symbolizing the two great loves of his life. One reads 'Scotland Forever'; the other, 'Mum and Dad'.

One morning Effie Connery answered the door to a tall Indian gentleman with a turban selling oriental silks. Waved away with polite firmness, the tradesman promised to tell her fortune if she made a small purchase. Suitably intrigued, Effie held out her palm. 'You have two fine, healthy boys,' he declared. Effie rolled her eyes, not impressed. Then he said something utterly startling. 'One day, one of your sons will be famous – very famous.' Effie paused for a brief moment before tutting, 'That'll be the day' and closed the door, returning to her chores.

Joe Connery took no stick from anybody. A giant of a man, he was also a tireless worker – a trait inherited from his own father who hailed from County Wexford and came to Scotland at the end of the nineteenth century finding work as a bookie's runner. Joe's lack of decent schooling had left him, like so many of his class, fit for little else save manual labour. In December 1928, after a brief courtship, he married Euphemia Maclean, a pretty twenty-year-old Edinburgh lass with few ambitions other than raising a family to be proud of. They moved into Fountainbridge where Joe found work at the nearby rubber mill, the area's largest employer, turning out wellington boots and tyres for £2 a week.

By the time he was nine Tommy (as Sean was then called) had begun to

see less and less of his father, who now worked at the Rolls-Royce plant in Glasgow and came home only on weekends. Even then Joe would spend little time with his son, apparently oblivious to his needs or how he was faring at school. He must have felt that bringing in the family money was where his parental duties stopped. It was how he'd been raised and he saw nothing wrong in it, but it did leave Tommy struggling to win any kind of acknowledgement from his father. Joe rarely sat down with him to check over school grades or listen to what he'd been up to that day. As a result his self-confidence took a battering.

Euphemia, or Effie as she was affectionately known, worked for a time as a charlady, then an office cleaner. Immensely proud, she always kept the flat looking presentable; dust was anathema to her. She was thrifty too – pennies weren't frittered away on luxuries, only on the bare essentials. The weekly diet consisted largely of bread and potatoes, Irish stew or Scotch broth, milk, of which Tommy was a prodigious drinker, porridge, and bread and butter pudding. Any leftovers went into a hotpot on the stove.

Effie doted on Tommy. He was a dutiful son, always pitching in to help with the housework, though in truth he'd little choice in the matter. On those days Effie worked it was Tommy who'd shop for groceries or bend down to wash the front stairs of the tenement. This was a job he despised but he revered his mother too much ever to make a fuss.

When Joe and Effie heard their son tell them he wanted to become an actor their reaction was one of surprise rather than shock. They'd raised him to be self-reliant, to make his own choices and stand by them, so whatever career he chose was fine by them. They were both supportive and relaxed about Tommy being able to take care of himself, and they basically just let him get on with it. Connery neither sought nor received any advice or guidance from either parent. 'I had to make it on my own or not at all. And I would not have preferred it otherwise.'

But it was only natural that Effie would worry for her son when he made the move down to London. Sometimes her fears were well founded. She, along with most of the family, were once kept in the dark about an illness which confined him to bed for three weeks. Over the course of the next few years both parents followed their son's career with keen interest, never missing any of his television plays or early movie appearances. Admittedly the intricacies of plot and artistic merit preoccupied Effie less than how healthy her Tommy looked on screen, or whether he was eating his greens or not.

When Connery hit stardom as James Bond reporters would descend on the flat to interview Joe and Effie, remarking on the kitchen walls adorned with publicity pictures of their famous son. 'We never thought he'd end up a film star,' Effie told *Photoplay* magazine in 1964, quickly adding that fame hadn't gone to his head. 'He comes in that door every time with his usual "Hello mum" and film star or no – he's just the same laddie he always was, daft as the devil. Nothing could change our Tommy.' Effie recalled the time

he once brought the stars of *South Pacific* over for supper. 'Shows he's not ashamed of his home, doesn't it.' He told his mum that it wasn't the house but the welcome that mattered. 'He's not swell-headed. A wee bit better spoken maybe, but he has to be.'

But according to brother Neil Effie did have trouble coming to terms with the sheer magnitude of Connery's Bond fame, barely able to comprehend that this person making news around the world was really her son. She was never less than proud of his achievements, but also shy and rather perplexed by it all. Sometimes on trips to the hairdresser's she'd book under her maiden name of Maclean instead of Connery.

Once a firmly established star Connery tried coaxing his parents to join him in London. But they'd have none of it, preferring to stay among people they knew. 'We've lived here so many years now, so what's the point of moving?' reasoned Effie. Joe, who was still in full-time employment, was equally blunt. 'I'm not the sort that would like to sit around and let a son take care of him.' Then when Connery offered to buy his mum an expensive fur coat she balked at the idea. 'I'd look silly in it in front of all my neigh-bours, showing off like that.' Instead he got them the latest new-fangled fridge, a huge thing which barely fitted into their cramped flat. It remained there looking faintly ridiculous, proof of a son desperate for his parents to share in the luxurious life he could now afford.

Having already set up a trust fund for his parents, in 1966 Connery managed finally to persuade his father to take early retirement. The old man certainly deserved it, having scarcely missed a day's work in his life. He also enticed them to move into a new home in a desirable Edinburgh suburb not too far from their old friends, but then only because the brewery had begun demolishing nearby properties. This and a few holidays were the only concessions Joe and Effie ever made to their son's success and wealth.

Joe took to retirement like the proverbial duck to water. The leisurely pace suited him, and on rainy days he'd simply not bother getting out of bed at all. So when it was confirmed in 1972 that he had cancer it came as a bolt from the blue. He was only sixty-nine and had been healthy and fit all his life. But the X-rays Sean and Neil saw confirmed it; their father's body was riddled with cancer, there was no hope, and all they could do was ensure that his final days were as comfortable as possible.

Within weeks he was dead. On the fateful night Sean was reminded of a Masai tribe saying: 'You're not a man until your father dies.' If so, he regarded it as too high a price to pay. Returning to Scotland Connery was faced with all the administration and technical details a death throws up, of which he had no experience. 'You had to register the death and get a minis-ter and organize the burial and so on, and no one had ever, ever told me what to do.'

His father's death had a devastating effect on Connery, more so than he perhaps had thought possible. It forced a wholesale reassessment of his own

life and career, and a painful dredging-up of the past. He lamented the fact they'd shared so little time together – Joe seemed always to be working or busy – and now it was too late. However, what remained was an intense pride for a man who remained loyal to his mother and who, during the Great Depression and lengthening dole queues of the 1930s never shirked his duty in finding employment so as to provide for his young family.

With Joe gone, Connery now treated Effie with even more deference and tenderness. Micheline Connery credits Effie as the source of her husband's strong will and inner discipline. She'd been the glue that held the family together when poverty threatened to destroy them. An artist, Micheline had long wanted to make a portrait of her and got the chance during a visit Effie made to the couple's Marbella home. The finished canvas was not to Effie's taste, but Sean thought his wife had captured her likeness and character perfectly. 'She was a very strong lady,' said Micheline, 'very reserved and very private. I'm convinced she was very proud of Sean, but she would never say, that was not her way.'

In 1982 Effie suffered a stroke and fell into a lingering illness. Rushing to her bedside Connery was shocked by her frail condition. Naively, like all sons, he had thought his mother invincible, that she'd always be there for him. He tried persuading her to live with him in Spain, but she refused. So he resorted to shuttling between the two countries whenever he could, while arranging for the best medical treatment. Friends note that during this difficult period of his life, if it hadn't been for Micheline and the children Connery might have succumbed to the darkest of emotional depressions.

Effie was seventy-seven when she died at Edinburgh's Royal Infirmary in April 1985. A grief-stricken Connery flew from America to attend the funeral. The two brothers, wearing full Highland dress, stood together silently at the graveside where their mother was laid to rest beside their father. Among the floral tributes was a wreath of pink orchids with 'MUM' picked out in red carnations and the simple message: 'From Sean and Neil.'

At the family service, held in the city's Mortonhall crematorium, it was Sean who comforted weeping relatives. As head of the family he also took it upon himself to thank each of the mourners in turn for attending. Then outside in the pouring rain he moved along the line of limousines, arranging everyone's transport. Only after the procession moved off did he finally allow any emotion to show. Looking down upon the many wreaths laid at the graveside, he brushed the tears from his cheeks as he began to remember.

Growing Up

'I was a tough little kid. I didn't have any money. I didn't have an education. All I had was broad shoulders and a broader chip on both of them.'

On 25 August 1930, a few minutes after 6 p.m, at Edinburgh's Royal

Maternity Hospital Effie Connery gave birth to a son. He was christened Thomas (later to become Sean) and weighed in at 10½ pounds. It wasn't the done thing for fathers to be present at the birth in those days, indeed to be anywhere near the hospital. That was fine with Joe Connery, who celebrated the arrival of his first-born down the local pub.

Legend has it that baby Connery's first cot was the long bottom drawer of a wardrobe which lay at the foot of his parents' bed. His bath was a tin tub in front of the fire, filled with water heated up from a kettle on the stove. Even such basics were too good for Joe, who often just dowsed the child, when he was still small enough to fit, under the cold water tap in the sink, much to Effie's consternation. 'A little cold water never hurt anyone,' he reasoned. When it came time to teaching young Tommy to swim Joe saw nothing wrong in throwing the kid into the water to see how he fared on his own. By the age of five Tommy had given up the shallow end altogether – that was for toddlers or girls – and always made for the deep end. 'I'm not scared,' he told his dad, who proudly watched him splash and gasp his way across.

Young Tommy Connery was a rough kid, wild even, someone you'd like on your side in a brawl. Physically strong and imposing for his age, he was by nature reserved, a loner almost, who never went looking for trouble; Tommy was more likely to quell any trouble than start it. Like most kids in the area he grew up fast; life's training ground was the street, where the toughest fared best. By the time he was nine he'd smoked his first cigarette. His mum caught him. 'Don't let your father find out,' she warned, 'because if he does he'll beat you so hard he'll break your bottom.' More healthy pastimes included games like marbles, hide-and-seek, tag and conkers. Sometimes he and his mates would challenge opposing gangs to a football or cricket match, or in fine weather jump on their bikes and ride into the countryside to fish and swim in cooling rivers. Another lark was staying in the park until after closing time, then take it in turns to vault the railings.

Tommy especially loved sneaking a ride on his uncle's cart or fishing with his younger brother Neil on the Union Canal, using Effie's discarded stockings and a jam jar. Further upstream was another favourite haunt, an old boatyard whose owner paid Tommy to retrieve boats customers had dumped up-river to avoid paying the hire fee. If he was really lucky he'd get to watch two brutes from the brewery knock seven bells out of each other by the canal's edge, a popular venue for the settling of scores.

Such carefree pleasures made for a memorable childhood, one Connery looks back on with fondness, despite the poverty, which at the time he was quite oblivious to. Then it was the only life he knew; doing without was the norm. At an award's dinner in Edinburgh one of the speakers was an old schoolfriend, Craigie Veitch. 'Looking back on it now, Sean,' he said, with a twinkle in his eyes, 'I think it's fair to say that we were disadvantaged. We grew up in an area of social deprivation. But in those days, of course, we

didn't have social workers to tell us that. Consequently we were as happy as pigs in shit.'

Michael Caine, who suffered a similarly deprived childhood, was still in short trousers when his mother got a job as a cook in a manor house. He saw for himself how the other half lived, having previously been unaware that there was such a thing as another half. 'I'm going to live exactly like this' is what he decided there and then. Connery had a similar eye-opening experience. In 1940, because of fears that German bombs might land on the odd school room (in the event Edinburgh suffered no wartime air raids), children were sent into the community to be taught in people's houses – an invasion in its own right. In some of the rather grand homes in which he was dumped the young Connery was made to feel distinctly out of place. 'A lot of people didn't want certain kids in their houses, and I was one of them.' It reminded him of the time he was invited to a birthday party, where his friend's mother turned him away at the door. 'You're the boy who delivers our papers. Get away with you!' For probably the first time in his life Connery understood what privilege meant, and it stank of injustice. Like Caine, he has grown up a fierce critic of the British class system.

Brief escape from the drabness of reality and monotony of school came on Saturday mornings at the local flea-pit cinema, where Tommy and brother Neil lapped up the latest instalment of *Flash Gordon* or the odd cartoon, usually Popeye or Mickey Mouse; the *Dead End Kids* were popular too. Tommy's all-time favourites were the western serials, *Roy Rogers* and *Hopalong Cassidy*, though he always sided with the Indians, as they seemed to have more fun, riding bareback and living wild. It's been suggested that Connery found in these serials his only available blueprint for a different sort of life beyond the boundaries of Fountainbridge. One abiding memory is of the time Roy Rogers appeared in person at Edinburgh's Empire Theatre as part of a national tour. His beloved Trigger stayed just round the corner from Tommy at the local dairy stables.

To save up for these cinema trips the enterprising Tommy collected and then sold empty jam jars and beer bottles or helped elderly women carry their laundry home from the wash-house. Sometimes he'd badger his mum to rummage through her wardrobe for any old rags to sell. When he was nine Tommy started work, delivering milk in the morning and, after school, doing a stint as a butcher's assistant at the local meat market. Most kids had little odd jobs, it was either that or doing without pocket money. It was also a way to help out at home, for every penny earned went towards the housekeeping. Effie always kept a little by, however, depositing it in a Post Offic account in Tommy's name.

Respite from the maddening confinement of city life came in the school summer holidays, when Tommy and Neil stayed with Effie's parents at their retirement cottage in the countryside near Dunfermline. Here the air was free from the stench of factory waste. Here they roamed wild and free among

the fields and woods, fished for tadpoles and newts in ponds or rode on the back of a benign Clydesdale horse. For two city kids the contrast between grimy cobbled streets and these lush green acres made them appreciate, maybe for the first time, that there was another world beyond their limited horizon. Who could blame Tommy for always wanting to stay behind with his grandparents at the end of the holidays.

Every morning they'd wash in the cold water, courtesy of an outside spring, before traipsing down to the local farm to fetch milk for breakfast. Both watched mesmerized as it was brought out still warm and once tried to milk a cow themselves by tugging on its tail as if it were a water pump. They also carried back eggs and loved watching their grandfather pierce a hole in the shell to suck out the liquid. It was a taste the two brothers soon acquired, and even in adulthood Connery would often indulge in swallowing them whole.

For treats their grandmother baked them hot scones over an open fire and filled their bellies with meals of lamb's hearts and haggis. Truly they were idyllic days which lived long in the memory. Years later Neil escorted both grandparents to a screening of *Dr No* in Edinburgh and remembers his grandmother being shocked by Sean's amorous on-screen antics. Whenever a photograph of him appeared in a magazine clasping some glamorous starlet, she'd mutter, 'It's not right. And him a married man.' Connery held his grandfather in great affection. As late as 1963 he was speaking with pride of this '86-year-old who drinks a bottle of Scotch a day'.

One eventful winter when the hills around Edinburgh were carpeted in snow Tommy built his own sledge, painted it black and called it 'The Coffin'. Prophetic indeed, for it almost became his transportation from this world to the next. Having carted the sledge off to the Meadows, one of the city's most picturesque parks, he selected the steepest slope to hurtle down. During one run he collided with the roots of a tree. While the sledge came to a sudden stop, Tommy didn't, and kept on going until he landed head first into the thick trunk of an oak.

He managed to scramble the half mile back home with the sledge on his back only to get an earful from his mum for being late for tea. Then Effie sensed something was wrong. Despite the fact his skull was throbbing madly Tommy shrugged off her concerns – he felt fine he said. As he went to wash his hands in the sink his mother noticed the back of his head was soaked in blood, streams of it pouring down his neck. Her hysterical shouts for help were heard by neighbours, who called for an ambulance.

The gash required thirty-two stitches and Tommy spent five days in hospital. Worse, he had to share a ward with four coughing pensioners, one of whom died right next to him during the night. The old man's death rattle rooted the boy to his bed in terror. Coming face to face with mortality early in life Tommy wasn't going to be frightened of much again. As if to prove the point, within days of being back on his feet, he was up at the Meadows again, hurtling down the slopes on his hastily repaired 'Coffin'.

Even today Connery delights in such tales of his puckish, innocent child-hood. 'Sean has almost total recall,' director John Boorman told *Time Out* in August 1987,

and his stories are replete with convincingly vivid details – names, names of streets, a description of the wallpaper of a posh house glimpsed through the half-opened door on his paper round 40 and more years ago. He evokes the harsh childhood with astonishment and delight and with the same amused curiosity with which he confronts the world today.

Schooldays

Connery's first school was Tollcross Primary, an Edwardian building erected on the site of a slaughterhouse. School and Tommy were not a match made in heaven. He often got into trouble, though he was more mischievous than plain bad, and he took his punishment with few grumbles. Rarely did he assert himself in the classroom. 'I was not enthusiastic enough, that was a mistake. But I've made up for it since.' Usually to be found at the front of the class among other 'undesirables', where the teacher could keep a watch-ful eye, Tommy found that few subjects commanded his attention. He was even barred from singing lessons for being tone deaf.

The one subject young Connery did excel at was mental arithmetic, a skill most likely inherited from his father and grandfather both of whom had been bookie's runners for a time. He had a healthy appetite for reading. By age six he'd reached a commendable standard, although his preferred literary diet was comics, loving nothing better than catching up on the latest strips in *Dandy* or *Beano*. Sadly, as he took on his milk round and other casual jobs he no longer found the time for books, even comics, and his reading suffered as a consequence.

Tommy's secondary education followed the same dismal path as his primary school one. He attended Darroch, which specialized largely in tech-nical skills such as metalwork, woodwork and science – preparation for a life of manual labour, just like everyone's fathers. 'When it came to the choice of French or metalwork, we took metalwork. Who did we know in France?' It was one of those traditional schools where discipline was strict and meted out mercilessly. One teacher used his Chambers Dictionary to wallop errant pupils. And it was a football school, which suited Tommy down to the ground; he turned his nose up at the rugby-playing swots over at the local grammer school.

Tommy was now twelve and as hard as nails when he wanted to be. One bloody playground brawl needed the combined efforts of the janitor and two teachers to break up. He could be a handful in class too, and was renowned for pranks, like the time he and a friend let loose two white mice on the table

of their Geography teacher. Certainly academia was passing Tommy by but he didn't seem to care a jot. Sometimes he didn't even bother to turn up. 'By 1940 nobody was going to school. Nobody was keeping a register, so there was no checking. We just dodged it.' Not until adulthood did Connery begin to bemoan the fact that he hadn't worked harder at school – though he always took pleasure in informing people how he'd climbed the ladder to success using his own sweat and without having had a formal education.

As his fourteenth birthday approached Tommy decided he'd had enough of school, and the feeling was probably mutual. It was better to be out in the workplace earning money than sat behind a desk listening to a lot of old waffle he didn't think was worth knowing. Connery left Darroch without a single qualification. 'I never remembered anybody making school sufficiently stimulating or interesting to make me want to stay,' he told *Empire* in June 1992. 'I couldn't wait to go to work.'

Milkman Connery

Aged nine Tommy Connery took it upon himself to get a job in order to help out his mum with the family finances. Walking home from school one day he popped into the local Co-operative dairy and talked his way into becoming a milk delivery boy. It meant getting up at five in the morning, whatever the weather. 'If you got wet you had to sit with your wet clothes on in the school. You daren't tell the teacher.'

Young Tommy enjoyed these early morning excursions. It wasn't the job he loved but being around the horses that pulled the milk wagons. Even before working at the dairy he had often stopped by the stables, where the men usually let him help groom and feed the horses. 'He was horse daft in those days,' Effie told the Scottish *Sunday Express*. 'Always taking my dusters to rub down the milk horse. And he loved driving the cart.' Funnily enough, one of the places on his round was Fettes College, where the fictional James Bond was expelled from.

Once out of school the dairy offered him a full-time post paying something like £2 a week. Jobs were easy to come by then, what with so many men away at war, especially for a strapping lad like Tommy. So it was out of bed again at dawn, and with a stomach full of porridge he would clock in before the carts left at 5.30 a.m. He was obliged to join the local union, though he had no political allegiances, and before graduating to his own cart he had to help out first on some of the other rounds. The first man whose tutelage he came under was nine years his senior – Alex Kitson, later to head the Transport and General Workers Union until his retirement in 1986.

Who knows if the young Connery expected to finish his days on the milk round – he was never one for thinking too far ahead. Certainly a position at the Co-op would have given him job security and the independence he

craved. Connery recalls that in his youth he had 'no sense of the future' and was content enough to be working hard and popular with his colleagues. He was well liked by his customers too, whom he'd help out with little odd jobs for the reward of cups of tea, sometimes even breakfast. And if there'd been a really decent flick on at the picture house he enjoyed acting out the plot for them; it was like having Barry Norman in your kitchen.

When his round finished he'd pop home for a quick bite to eat before going out again, this time delivering newspapers on foot, covering two to three miles for a 5 shilling wage. The days were tough, and made bearable only because of the love he felt for the horse in his charge, christened Titch as it was the smallest in the stable. Tommy was devoted to the animal, visiting the stables most evenings to feed and groom him, and using his mother's polish to shine up the brass on its harness. Once when Titch was struck down with colic Tommy stayed all night, comforting the animal and feeding it with his own concoctions of turnip, oats and hay.

One of Tommy's proudest early moments was when Titch was entered in the annual Best Horse and Cart competition at the stables. Against a field of forty he won a rosette and Tommy his own 'highly commended' certificate. It was the first time anything he'd done had been recognized and he ran all the way home to tell his parents the good news.

Another event involving Titch was probably best forgotten. Out on the round one day the horse's harness broke and Tommy panicked, leaving the animal and a fully loaded cart in the middle of a busy thoroughfare to run back to the stables for help. Such shortcomings were probably overlooked because of the enthusiasm he showed for the job and his devotion to Titch. 'It's as well he made it as an actor,' teased his old boss years later, 'because he'd no' have made it as a milkman.'

Adolescence

'I left school at thirteen and I've been working my backside off ever since.'

By the age of fourteen Connery cut an imposing figure with his strong gypsy-like features and thick mop of black hair. Not for nothing was he known locally as 'Big Tam'. He was hyperactive, the outdoors type. 'When you live in a tenement you find that most of your life is spent in the street, not in the house.' The fact was he'd simply become too big and clumsy for the place; turning the glass doorknob of his parents' bedroom one day he crushed it in his hand.

A good deal of his time was spent with the Sea Cadets, who met every Tuesday evening in a dusty old church hall. For an annual fee of 25 shillings youngsters learnt the basics of seamanship, signals, tying knots and so on. He was also taught boxing at a local gymnasium by a professional coach. Here Connery's athletic prowess did not go unnoticed. It seemed whatever

activity he channelled his reckless energy into, be it football, swimming or boxing, he usually excelled. As Connery entered his late teens such evenings were replaced by tours of local pubs or billiard halls. He was a fair player, as his father had been, and in those smoky rooms he'd chat with colleagues about the presures of work or engage in conversation with girls above the din of clunking balls.

As a rule Connery kept pretty much to himself. To his small clique of friends he was easy-going and fun company, to others his inherent shyness was often interpreted as aloofness. But he had a forceful personality even then, and was prone to speaking his mind – to hell with the consequences. With his commanding stature Connery also had little cause to act the hard man in order to command respect, but when pushed could more than capably hold his own. Once he crossed swords with the Valdors, a vicious Edinburgh gang who usually armed themselves with razor blades and bicycle chains. Playing billiards one night Tommy spied one of them hovering uncomfortably close to his jacket.

'OK,' Connery said, 'put it back.'

'Put what back?'

'Put back whatever you took out of my pocket.' The thug feigned ignorance so Connery reached out and grabbed him by the collar. 'I said put it back.'

'I tell you I haven't got anything.'

Though the thug revealed his hands to be empty Connery was under no illusions as to what he'd been up to. 'Well, get away from my jacket. Go on – get going.' For a moment the brute and a few of his lackeys stood their ground. Connery repeated his warning, more foricbly this time and they crept off.

Next evening Connery was at the Palais ballroom when he noticed six of the Valdor gang walking purposefully in his direction. They cornered him on the balcony and moved in, drawing Tommy closer to the edge and the 15-foot drop to the main dance floor below. Now he made his move. Grabbing one of the hoodlums by the neck and hurling him to the ground, he then floored two of the others. They left Tommy alone after that, treating him with respect whenever their paths crossed in the street.

The worst part of being poor and a teenager was that life was completely governed by economics. 'You didn't leave the light on when you didn't need it because it cost money. You had to count up tram fares. You couldn't have a bath when you felt like it; there was the price of a plunge at the public baths to think of.' With no hot water in the flat the only alternative was a visit to the municipal baths where you could either take a sixpenny dip or a shilling one, the difference being that you got to pour in the water as opposed to the attendant's giving you just four inches. But there is little bitterness in Connery about the past. He prefers to look back on the hardship and the doing without as an enriching experience.

As a teenager Connery remembers not having much of a sense of the future, no grasp of what he wanted to achieve, other than wanting to make something of his life. 'I wanted to have pride in it, feel the joy of it. There was far too little joy about.' It's part of his make-up; even as an actor he rarely plans ahead. 'I'm eternally concerned with the present.' Friends testify that whatever the future had in store for Tommy they knew it wouldn't be in Scotland. They somehow always sensed he'd leave one day, that his restless energy would drive him out. His first aim was to finish school as soon as possible and head off to war. When hostilities ended, he looked for any means to get out of Scotland. Eventually he found a way.

Seafaring Sean

'I got the romantic notion that I'd like to sail round the world. It wasn't romantic at all. I never rose above Able Seaman.'

For Connery, approaching his seventeenth birthday, the prospect of a life beyond the poverty of Fountainbridge gained a golden hue. Bored with the grinding routine Connery like so many of his contemporaries, saw the Navy as his ticket out. Maybe those evenings at the Sea Cadets had instilled in him a thirst for nautical adventure. So one day he hopped on a tram to the South Queensferry naval base and signed on for seven years' active service, with five more in the reserves. Effie was deeply shocked, while Joe resigned himself to the idea, even if he was peeved his son hadn't talked to him first before taking such a bold step. In the end both parents decided not to stand in his way.

He had visions of sailing to glamorous ports around the world, the blossoming of a whole new life, one that offered something more than delivering milk. In the end he never got further than freezing Portsmouth. Still, not bad for a boy who'd never set foot out of Scotland before. First, however, was the less-than-thrilling prospect of months of training. Then he was transferred to HMS *Formidable*, where he spent most of his time scrubbing decks, polishing brasswork and lending a hand in the kitchens; his goulash was a favourite among his shipmates. His brawn also came in handy on the ship's boxing team. 'I learned to box men twice my age. It wasn't exactly a bundle of laughs. When you box in the services, all they want is blood; it was usually my blood they got.'

Banking on the Navy to provide him with security, he instead found himself seething with frustration – which, in turn led to a duodenal ulcer that saw him being discharged at the age of nineteen. Almost from the word go he was plagued by stomach pains. Reluctant to seek medical advice Connery eventually ended up in hospital for two months. Ulcers ran in the family – Joe suffered from them as, later, would brother Neil. Connery reckoned that the ulcers developed from the dawning realization that naval life was falling

far short of his dreams – this combined with anxiety that he didn't have the tools for the job. Doctors disagreed, blaming all the milk he had drunk while working on the cart.

A career in the services would probably never have suited Connery anyway. His staunch individialism went against the grain of the strict discipline required. Having made his own way in life for years, he was now being forced to conform and take orders from people he knew to be stupider than him. 'Discipline was something I didn't need in my life. I'd had enough of it.' Anger also welled up from the injustice of his class, having to start at the bottom rung, with little chance of climbing much higher. His time in the Navy then was mostly wet, grey and dull, epitomized by a visit to an American ship, on which he heard an announcement reminding the crew to collect their sweet ration. 'I thought, candy issue? Christ, you don't get anything like that in the British navy.' The only clues to Connery's ever having been a sailor are two tattoes – as synonymous with naval life as vomiting over the stern in a gale – on his right forearm: SCOTLAND FOREVER inside a bleeding knife-pierced heart motif and MUM AND DAD scrolled in a bird's mouth.

Connery returned home to Edinburgh with head bowed, his first attempt to better himself having ended in abject failure. Not even a weekly disability pension of 6 shillings and ninepence eased the acute embarrassment he felt about his medical discharge. It haunted him for years. When the government finally offered him a lump sum of £90 he couldn't resist it and finally bought the motorbike he'd always wanted – the one he'd later be forced to sell as an out-of-work actor.

Odd-Jobs

Following his discharge from the Navy Connery drifted through a succession of dead-end jobs. He had no clear ambition beyond getting his pay packet at the end of the week to feed an increasingly active social life. There was no job he wouldn't do, be it delivering coal, bricklaying and cement-mixing, working in a steel mill or digging ditches. Having inherited his father's work ethic, he was never afraid of hard graft and long hours – overtime meant more money in his pocket, which went a long way to securing a future of sorts. Connery also got work as a part-time bouncer at a dance hall, where the mere sight of his broad shoulders did enough to quell most troublemakers.

Although financially well-off in Fountainbridge terms, his dismal prospects made him moody and fearful of becoming enslaved, as his father and now his friends had done. Effie was quick to sense how restless her son was and urged him to find a trade and settle down. 'Give me room,' he implored. 'I'm going to keep on going from job to job until I find the one I

really like. Then I'll stick to it.'

Just as he was contemplating a move overseas, perhaps to Canada, the British Legion, with whom he'd automatically registered as a disabled ex-serviceman, offered him a scholarship to learn a trade, a training course on which he could learn to become a tailor, a barber, an upholsterer or a plumber. Connery decided to try his hand at french polishing and subsequently found employment with a well-respected cabinet works. It proved to be the only job from which he was ever sacked. 'It was a bit of a shock. Until then I usually left a job as soon as I got fed up or had £50 in the bank.'

Next he tried his luck as a coffin polisher, but his heart was never in the work, sweating over something that ultimately ended up six feet under. But he never forgot the exerience, and once over dinner with colleagues years later he held the table enthralled with the proper way to polish a coffin. His boss was a real character too. Hearing a potential customer was on the point of no return he'd race round to measure them up with his practised eye as they lay weakly in their death bed. 'Then he'd come back and get us to make the coffin. Sometimes they cheated him and lived. We used to do coffins in mahogany and it was supposed to be oak – so we bleached it. But I suppose whoever was inside wasn't too aware.' Funnily enough, Bond co-producer Albert R. Broccoli also worked for a while at an undertaker's, which explains the presence of so many 'funereal' jokes in the 007 movies. Connery is chased by a death-dealing hearse in *Dr No*, and in *Diamonds Are Forever* is famously locked inside a coffin as it's about to be consumed by flames.

Some summers Connery worked as a lifeguard at Portobello open-air swimming pool, a popular meeting-place among the youth of Edinburgh. The unheated pool, one of the largest in Britain, was fed with salt water from the sea and boasted impressive artificial waves, though it was ugly, being sited close to a giant gas works. Connery swiftly made friends with some of the pool regulars, including a gang of giggling lasses who worked as usherettes at the Regal cinema and who nicknamed him 'the Hulk'.

On duty once at Portobello Tommy heard the cries of a swimmer in distress. 'Help! Save me!' Tommy tore off his sweater and was ready to dive in to do his duty when he saw the hapless swimmer was his brother Neil, fooling around. 'Drown!' he mumbled, walking off in a huff.

Fed up with the variable hours and poor pay at the pool, Connery landed a position in the ear-pounding machine room of the *Edinburgh Evening News*. It turned out to be the last regular job of his life. He mostly carried out menial tasks like sweeping the floor or melting down lead to fill the plates. 'It was considered one of the best jobs going. You actually had your own wash basin and locker.' But still, it was less than stimulating. To keep himself amused Connery sometimes carried out the days chores using just his left hand.

Body Beautiful

It was while working as a french polisher that young Tommy became interested in body-building, spurred on by a friend who'd already gained experience as a weightlifter. Standing at an impressive 6 foot 2 inches, if a little scrawny-looking, Connery had always been the athletic type. 'During World War Two, when the bombs began falling on Scotland, my parents made plans to evacuate me to Australia. If I had gone, I might have led an entirely different life – I'd probably be a tennis player.' He enrolled at the nearby Dunedin Amateur Weightlifting Club, which met three evenings a week at an old air-raid shelter that stank of liniment and body odour. 'It was not so much to be fitter but to look good for girls,' he later admitted.

Body-building was still very much a minority sport, and Connery was one of a small clique of enthusiasts who took it very seriously. That included the correct intake of food – lots of red meat, chicken, fruit and eggs galore. Connery also invested in a tracksuit for his regular jog, chest expanders and dumbbells for use at home. It wasn't long before his physique improved; back-breaking manual jobs like road digger and steel bender also helped build up the muscles.

Weightlifting brought with it some unexpected benefits. One was an introduction to the great Ray ('Duke') Ellington, whose orchestra was in Edinburgh playing one of the big dance halls. Both would work out backstage with the weights that Ellington, a former army physical training instructor, never travelled without. For Connery the band leader was probably the first celebrity he ever came into personal contact with, let alone strike up a friendship with.

That splendid new physique also landed him a job, at six shillings an hour, posing semi-nude for students at the Edinburgh College of Art. To the great amusement of his friends young Tommy was forced to shave off his hairy chest. 'It's murder staying in one pose all that time,' he'd complain to brother Neil. 'And the girls always want to sketch me up close. It's embarrassing.'

Just like the outside world, there was also a rigid class system operating in the art room; it simply wasn't done for models to fraternize with the students. Connery was lucky to make the sole friend he did, Richard Demarco, later an important art dealer in the city. Demarco remembers that even then Connery had an exotic look about him and possessed a natural grace: 'He was too, too beautiful for words. A virtual Adonis.' Another draughtsman, Martin MacKeown, wrote years later that he'd felt almost sorry 'for the well-built young man with a dead-end job and no future, while I was busy working to become a great artist'.

In-between posing at art school Connery worked as a photographic model for a men's mail-order catalogue firm. He'd shoot down to their Manchester studios on his motorbike to pose in their tight briefs and swim-

ming trunks, returning exhausted to Edinburgh the same day. Pictures of Connery also turned up in assorted body-building magazines. As late as 1957 he was still modelling menswear, just like Roger Moore, another budding Bond, who famously posed in wool sweaters advertisements. One, advertisement featuring Connery sporting faded blue denim jeans and a striped shirt appeared in the May issue of *Films and Filming*. Not many years later he returned, this time as its cover star.

Suitably muscular Connery was persuaded to try his luck at the 1953 Mr Universe competition, held at London's Scala Theatre. He travelled down with one of his weightlifting colleagues and took digs in Chelsea. But the contest proved disappointing. Dressed in snazzy white briefs Connery could manage only third spot in the tall man's class, winning a bronze medallion. 'I looked like Ronnie Corbett next to the fella that won. The Americans were mountainous. Their arms were like my legs.'

The Dunedin club had stressed the value of health and strength, and Connery ran, swam, and still played football. The Yanks and London body-builders, by contrast seemed bent solely on acquiring inches and bulk. Some of them wouldn't even run for a bus because they might shed some of that precious tissue. Just to be a hulking specimen would have been anathema to Connery; not to play the sports he loved – where would the fun be in that? His body-building days had ended in disillusionment.

For a while he persevered with his fitness regime, and acting chums remember his bedsit decked out like a mini gym – those chest expanders and dumbbells now used to burn off the frustrations of being an out-of-work actor. Then in later years he confessed to doing little specifically to keep fit. The physical and mental exertion of making movies was enough to keep him in good shape, though he continued to swim, play golf, of course, and a little tennis. 'I have a skipping rope and I might do a session with that,' Connery revealed to the *Sunday Times* in August 1996. 'I tried high-speed walking once. I did it for about three weeks. But the amount of effort I put in didn't seem to be justified by the results. I mean, I didn't feel that sensationally much better. I thought, Christ, after all that fucking effort not a hair grew. Nothing.'

At a distinguished London awards ceremony in Connery's honour Michael Caine typically made light of his old friend's weightlifting past. 'I think it's such a shame, Sean, that you didn't keep up the body-building. Because now you'd have a great career as Arnold Schwarzenegger's father instead of Harrison Ford's.'

2 Dress Rehearsal

First Theatrical Job

In the winter of 1951 Connery acquired his first taste of theatrical life – not as an actor but as a stage-hand, helping out during the busy Christmas season at the local King's Theatre. A colleague worked there part-time, so one evening Connery tagged along, fancying the extra income, and got a job as a general backstage dogsbody. While feeling an odd affinity with the colourful people who inhabited the theatre, it was perhaps the first time he'd ever set foot inside such an establishment, and the notion of becoming an actor himself never once entered his head.

The following autumn he spotted an advertisement in Edinburgh's *Evening News*: male extras were required to look regal around Anna Neagle, that great British star of the thirties and forties whose homage to Queen Victoria, *Sixty Glorious Years*, was booked at the Empire Theatre after a hit run in London. For a kid raised on soccer, comics and Saturday morning shoot-em-ups, the cultured atmosphere of the theatre held a curious fascination, maybe because it was so alien to him. Standing about in crowd scenes, doing nothing basically, was most agreeable, certainly less back-breaking than digging roads. 'I stood around on that stage for five weeks dressed as a guards officer. I only got the job because they wanted someone tall.'

South Pacific

Asked in 1995 by the *Mail on Sunday* to choose the most significant event of his career Connery surprised many by ignoring landing the Bond role, though he admitted that was vital. Instead he plumped for winning a place in the chorus line of *South Pacific* way back in the mid fifties. 'All it meant to me was a chance to tour Britain, get twice as much money as I'd earned before and only work for a couple of hours a night. I had a motorbike to go from town to town and I became hooked on acting. It altered the course of my life.'

Connery was in London attending the Mr Universe contest when he heard they were holding auditions for *South Pacific*, soon to leave its record-breaking run at Drury Lane to tour the nation. Recalling how much he'd

enjoyed his time as an extra in *Sixty Glorious Years*, Connery decided to have a crack. 'I knew there and then that I didn't want to go back to my job in Edinburgh.'

Undaunted by his lack of experience Connery worked for two days, cramming in singing lessons and dredging up a few steps from his dance hall days. He'd been on stage only a few seconds when nerves got the better of him and his script pages fluttered to the floor. Furious, he stormed off only to be hastily recalled by a voice from the darkened stalls. Lying that he could tap like Astaire and croon like Crosby and that he was a regular face around the theatres of Scotland, Connery launched into a sailor's shanty, managed a few handsprings and to his astonishment, was hired. His physique probably won him the job, and his real-life naval past helped too. Director Joshua Logan had been on the look-out for hefty lads to sing 'There Is Nothing Like a Dame' with a degree more conviction than the average male West End chorus line.

'What's the wage?' Connery asked, as bold as brass.

'That doesn't concern me,' the producer snapped.

'Well, it concerns me.'

It was £12 a week, on a par with a skilled tradesman back home and more than his father had ever earned. And it was just for working nights. Days were free to do with as he liked – it was money for jam. The Fountainbridge locals took the news with mild bemusement – Tommy going into showbusiness, fancy that! As for his work colleagues at the *Evening News* print room, all were of the opinion he'd be home soon, tail between his legs, asking for his old post back. But not this time.

It was an adventure at first. The whole idea of travelling around Britain was what appealed to him – nomadic leanings that he perhaps inherited from his father's family, which had tinker blood in it. 'I didn't seriously consider myself as an actor. It all seemed like a giggle.' Soon the adrenalin rush of being on stage, the applause and attention, became addictive. The crowds of women who flocked to the show, not so much for the tunes but to ogle at the bicep-bulging chorus line and queue up outside the stage door, helped too. An acting career presented Connery with a direction and a purpose after a succession of dead-end jobs. And like the Navy, it was an escape route out of a bleak existence at home. 'It wasn't until I decided to become an actor that I really began to do something with my life.'

A new boy uncertain of himself in foreign surroundings, Connery was appproached by no one for the first few weeks of the show until fellow cast member Millicent Martin plucked up enough courage to break the ice. 'I'll never forget that. It all came out later. The queer looks I was getting were because the cast couldn't fathom my Scots accent. They thought I was Polish. They couldn't understand a word I said.'

For the next year he criss-crossed Britain with a show that became one of the most successful touring productions ever staged. 'I don't think I was any good in the beginning, but when you sing in the chorus there are always

plenty of others to put the blame on.' By sheer hard graft Connery learned the trade, picking up the tips as he went along from watching his fellow professionals. The only thing that really irritated him was having to share a dressing room with a frightfully old thespian, who preened himself in front of the mirror. Finally glad to see the back of him, Connery feared the worst when his replacement arrived wearing a fur coat and clutching a teddy bear. It was Victor Spinetti, whose eyes immediately focused on a certain area of the Scotsman's reclining naked torso. 'A pigeon sitting on two eggs,' Connery excused. 'Not a pigeon,' Spinetti responded, 'but an eagle!' It was the beginning of a long and dear friendship that grew over the long nights Connery stayed up with Spinetti helping him to learn his lines.

A momentous event occurred midway through the tour: Thomas Connery became Sean Connery, a name most probably inspired by the hit movie of the time – *Shane*. It was a shift in name which neatly coincided with the new life he was creating for himself – a clean slate on which to write a golden future. To his mates back home though, he'd always be Big Tam. Even his mother had trouble adapting to it, always preferring to call her son Tommy.

Through sheer enthusiasm and effort Connery won the chance to under-study two roles (his wages rose by £2), until finally his diligence was rewarded when he took over the part of Lieutenant Buzz Adams, who'd been played on the London stage by Larry Hagman, the future JR in televi-sion's *Dallas*. Asked if he was nervous about speaking on stage for the first time Connery replied: 'Oh no, what for?' When the show hit Edinburgh Connery's parents occupied the best seats in the house and were as proud as their son to see his name included for the first time in the programme. Brother Neil later recalled how he'd never seen him so happy before.

The curtain came down on *South Pacific* at the Gaiety Theatre, Dublin, after eighteen exhausting but exhilarating months on the road. Determined to forge ahead in his chosen profession, Connery moved to London and underwent an inevitable bout of unemployment.

An Actor's Life

Robert Henderson ranks among the most significant men in the life of Sean Connery, on a par with Bond Producers Albert R. Broccoli and Harry Saltzman, and Hollywood agent Michael Ovitz, for it was Henderson who fanned the flames of desire within him to become an actor. Cast together in *South Pacific* Henderson showed Connery the ropes, acting as a mentor of sorts, and was the first to recognize the potential lurking beneath that rough Scottish exterior. But most importantly it was Henderson who encouraged him to stick at it, no matter how many times he was rejected. 'Robert Henderson takes a lot of the credit for putting me where I am today,'

Connery has acknowledged. 'And I'll bet there's a long list of people who'd like to wring his neck.'

Henderson was an American actor/director some twenty-five years Connery's senior. During *South Pacific*'s nine-week run at the Opera House in Manchester both men shared digs. Walking home after a performance one night they got chatting about acting and plays. When the name of Ibsen came up, Connery confessed to knowing nothing about the dramatist, so Henderson advised that he read the plays *The Wild Duck* and *Hedda Gabler*. Expecting to hear no more about it – 'most young men are keen to be stars but they're also dead lazy' – Connery surprised him by coming back for more. Henderson therefore decided to concoct a list of ten important works of which any would-be actor ought to have a working knowledge. They included Tolstoy's *War and Peace*, Proust's *The Remembrance of Things Past*, James Joyce's *Ulysses* and *Finnegans Wake*, Stendhal's *The Charterhouse of Parma* and Thomas Wolfe's *Look Homeward, Angel*. Shakespeare, Shaw and Wilde, were also obligatory.

It was a hell of a list, especially for someone who'd left school with no qualifications, but Connery diligently worked his way through it, usually with a dictionary at arm's reach. He also started frequenting libraries. As a kid he'd been keen on reading but lost interest during the war when his schooling was disrupted. 'I was like a mole, digging my way through the world's literature.' It was a programme of self-education that made up for the one society had failed to give him. Just as he had expanded his muscles with dumbbells, so Connery set about expanding his mind with the weighty tomes recommended by Henderson. 'When I got into it I realized how much I enjoyed it. It was like a whole new world for me. It was terrific for my ego and confidence to be able to converse, like overcoming a major hurdle.'

Henderson quickly identified Connery's gruff accent as a major handicap and told him to work on his diction. None the less he remained adamant that here was a potentially unique acting personality, someone who looked like a truck driver but could talk like Dostoevsky. 'Speak one thing, look another.' It was a philosophy on which Connery subsequently based his entire career. Partly because of the way he looked, Connery was always going to be cast in movies as tough and brutish heroes; the trick was to make sure that beneath each character there was a layer of vulnerability and emotion.

Connery next borrowed money from cast members to invest in a large Grundig tape recorder and set about reciting classical roles so he could play it back and listen for any errors. 'The only audience was myself.' It was a do-it-yourself course in acting that also included catching as many matinée shows as time and money allowed and visiting local courtrooms to observe the way people behaved under stress. Unlike most of his contemporaries, Connery never spent so much as an afternoon in drama school and more than once has spoken out against the people such institutions churn out. He's dismissive of the 'poetry voice' and standard house-style adopted by drama

pupils, believing the poetry inherent in the language should be allowed to speak for itself. When his son decided to become an actor Connery advised him to bypass drama school and instead go out to learn his craft in repertory theatres. Connery's working-class success stands as a monumental two-fingers to the RADAs of this world.

A crisis emerged when Connery was offered the chance to become a professional footballer for Manchester United. Sorely tempted, he looked to Henderson for guidance. 'If you're thinking of being a football player it's pretty late' was the advice. Henderson was right: a top-class player could be over the hill by the time he was thirty and Connery was already twenty-three. Acting offered him something a bit longer-lasting, if just as precarious. 'So I decided there and then to become an actor. It turned out to be one of my more intelligent moves.' And possibly a life-saving one. Had Connery accepted the offer he may very well have ended up a victim of the Manchester United Munich air disaster of 1958. Henderson was now adamant that with hard graft and the regulation good luck Connery could make it as an actor. Not so *South Pacific*'s producer Jerome White, who exploded with rage when he heard what Henderson had done. 'Are you mad? This boy will never make it as an actor. As a footballer he could have earned himself some fame and a decent living for a few years. He'll never do that in this business.'

When fame did arrive Henderson was quick to halt the carping of his protégé's detractors.

> People said how lucky he was to get Bond – lucky my foot! He started off with a Scot's accent that was so thick it was like a foreign language. He cured himself of that, but think of the study that took! He worked and sweated blood. It's the old thing in the theatre. Everybody gets their chance and the thing is to be ready – like Sean was.

He was also modest enough to disclaim any credit for 'discovering' Connery. The talent was already there; all he did was drag it out and inspire an interest in further study. It had been Connery's 'divine curiosity' that initially captured Henderson's special interest and distinguished him from the other wannabes. Would anyone else besides Henderson have had the foresight to notice? 'He was the first person in my life I'd had genuine guidance from,' admits Connery, 'a sense of direction.'

Connery on the Stage

When *South Pacific* closed in 1954 Connery moved to London and lived in various bedsits, usually with other struggling actors. When his savings expired Connery was forced to sell his beloved motorbike, replacing it with

a second-hand bicycle that now propelled him from audition to audition. He went for anything that was on offer – walk-on parts, extra work, roles in repertory theatre – but this was his 'too period' as Connery described it. 'I was too tall or too big, too Scottish or too Irish, too young or too old.'

Among movies he missed out on during these pioneer acting days were *High Tide at Noon*, a tepid melodrama that the wise men at Rank deemed him too dark for, and *Boy On a Dolphin*, which would have seen Sean cast opposite Sophia Loren. 'I'm big enough to stand up to her,' he boasted. 'She needs a real man.' No wonder journalists of the time found him cocky and brash. Some colleagues described him as having an almighty chip on his shoulder, though this may have been a mark of his inherent shyness. A lot of people were also put off by his brusque manner and tendency to criticize others, but then, as now, Connery was a man with few airs and graces; in other words, he told it straight.

In-between acting work Connery signed on at the dole, receiving £6 a week. 'I used to go to Westminster labour exchange, which was so full of out-of-work actors that it was called the actor's exchange. I'd get my money, then go home and wait for the phone to ring.' At one point he was unemployed for seven months, but never once considered packing it in. To survive he took little odd jobs and cooked big pots of Irish stew, his mother's speciality, which was kept on the stove day and night and lasted a week. 'So when I came in at night I could always take some and heat it up. It wasn't very good, but it was cheap and plentiful.'

It was Connery's old *South Pacific* ally Robert Henderson who rescued Connery, offering him the non-speaking role of court usher in his production of Agatha Christie's *Witness for the Prosecution* at the Q Theatre in November 1955. To compensate for his lack of dialogue Connery put to flamboyant use the traditional swirling robes of the legal profession. His mannerisms proved so captivating – drawing audience attention away from the main players – that the costume had to be removed.

At this small London repertory theatre Connery performed in a conveyor-belt run of plays including Jean Anouilh's *Point of Departure* and Dolph Norman's *A Witch in Time*. It was terrific experience, even though he wasn't required to do very much. Sadly the Q Theatre closed in February 1956 for lack of funds, and a valuable breeding ground that churned out young actors for the West End was lost forever. The likes of Vivien Leigh, Peggy Ashcroft, Flora Robson, Joan Collins and a certain Roger Moore had all trod the boards at Q early in their careers.

It was while working at Q that Connery first bumped into Ian Bannen, who was to become a close friend and screen co-star. 'My memory of Sean then is of a towering, huge fellow with hair everywhere, huge eyebrows like a squirrel's tail,' Bannen reminisced years after. 'I felt I wouldn't have liked to meet him down some alley.'

Though disheartened at the closure of Q his short stay there heralded a real

turnabout in his fortunes. A director at the Oxford Playhouse had seen one of his performances and invited him to play Pentheus, the tyrant Greek King in a production of Euripides' *The Bacchae*. It is interesting to note that even at this stage directors saw in Connery someone who could easily fill the role of a historical figure, roles that would loom large in his film career. The critics, however, disagreed. *Theatre World* thought he 'lacked regality' and *Plays and Players* said: 'Connery's Pentheus was too much on the surface and his American inflections were often irritating.' Later in the year he appeared as Mat Burke in Eugene O'Neill's *Anna Christie* opposite Jill Bennett. This time the critics were kinder, especially *Plays and Players*. 'Mr Connery happily seized upon Mat's Irish braggadocio and also illuminated the man's alternating savagery and tenderness with unfailing conviction.' The *Oxford Times* thought him simply 'magnificent'. He also appeared at the Lyric Theatre, Hammersmith, in *The Good Sailor*, a dramatization of Herman Melville's novel *Billy Budd*.

From the word go Connery was an avid learner, studiously observing the techniques and tricks of his fellow performers, and never afraid to ask the toughest questions. Not much got in the way of his goal for self-improvement and betterment as an actor. Moreover, he was a demon for work. 'It was almost unsafe to mention a play to him,' one director recalled. 'If he didn't know it he'd go straight out and buy it.' What he lacked in training and craft Connery certainly made up for in sheer stage presence and enthusiasm. But there were many who didn't think he had what it took. Early in 1959 playwright John Osborne held auditions for his musical *The World of Paul Slickey*. The lead required a fine singing voice and a strong sexual presence. 'I made a monumental misjudgement by dismissing Sean Connery, who turned up one morning looking like my prejudiced idea of a Rank contract actor.' So Osborne wrote in his autobiography. 'It was a lamentable touch of Royal Court snobbery.' At another audition, this time for the Old Vic, Connery was informed, 'You don't fit into the composition here. Take elocution lessons.' Years later, as a star, with working-class roots still intact, Connery vehemently answered Bond's critics by saying, 'Quality isn't to be found only in the Old Vic.' Some memories still hadn't healed.

What compensated Connery for the occasional setback at auditions was a great social life. Acting colleagues frequented the same pubs and restaurants; it was like an exclusive club and Connery was happy to be a member. Le Grande, a café in Soho, was an early meeting place; hard-up actors could sit and gossip all day for the price of a cup of coffee. Connery often dropped in before his evening stint in *South Pacific*. But the London Mecca for actors was the Buckstone Club, a cellar located behind the Haymarket Theatre. Run by Gerald Campion, television's Billy Bunter, the club served cheap food, but more importantly, drinks after hours. Here up-and-coming stars such as Terence Stamp and Peter O'Toole rubbed shoulders with more established types like Peter Finch and Kenneth Tynan. Connery felt very much at home in this male-dominated environment.

In October 1959 Connery returned to Edinburgh in a touring production of *The Sea Shell* with veteran performer Sybil Thorndike. Reviews were mixed, though *The Scotsman* wrote, 'Mr Connery throughout gives a fine performance.' In November 1960 Connery again appeared at the Oxford Playhouse, this time in Luigi Pirandello's *Naked*, an angst-ridden play about a woman's desire to commit suicide, alongside future wife Diane Cilento. *The Times* noted that he made an 'unforgettable impression'.

In late 1961 Connery's muscular physique was exploited to good effect in Jean Giraudoux's *Judith*, a work inspired by the Bible and translated from the French by Christopher Fry. Playing the Roman conqueror Holofernes, Connery was required to appear in little more than a loincloth. Negative reviews cut short its West End run at Her Majesty's Theatre, but not before future Bond director Terence Young had witnessed Connery's impressive natural presence. 'He was so good,' said Young, 'he acted the play itself off the stage.' Robert Henderson also attended. 'It was rather a bad production and Sean did very little in it. But he appeared in practically nothing, and with that magnificent body. And out of that came Bond.'

After *From Russia with Love* Connery made a conscious decision to quit stage work. True to his word he's never appeared in a theatre since. All that shouting hurt his throat, he told friends; he'd rather concentrate on making good movies. Wages were another factor – the money for theatre work was just not comparable to what he could earn in the cinema.

In 1994, however, he might have made a dramatic return to the stage if the rumours had been true that Broadway bosses wanted him to take over from Richard Chamberlain as Henry Higgins in a revival of *My Fair Lady*. Alas, nothing transpired.

Connery on the Box

Connery's early forays in television consisted of the obligatory walk-on parts. He cropped up as a young hoodlum in *Dixon of Dock Green* and an Italian porter, with an accent that must be heard to be believed, in *The Jack Benny Show*. In another BBC production, *The Condemned*, for producer Alvin Rakoff, he was so full of ideas that his role was beefed up. In a battle sequence filmed at Dover Castle Connery got to play both the soldier lobbing a grenade and the poor bandit on the receiving end. When the two strands of film were edited together audiences never twigged it was the same actor.

Requiem for a Heavyweight March 1957, BBC

Requiem for a Heavyweight was Connery's first big break. Though it didn't bring stardom it certainly put him on the right road. The script, written by Rod Serling, told the cautionary tale of fallen boxer Mountain McClintock,

a one-time contender for world champion who falls into the clutches of a
seedy manager. Jack Palance starred in the original American production and
was due in London for the BBC version when his Hollywood agent
cancelled just days before the start of rehearsals. Thrown into panic producer
Alvin Rakoff searched desperately for a replacement – even former boxer
Freddie Mills was in contention.

Then Rakoff's wife Jacqueline Hill suggested Connery. Rakoff had used
the eager young Scot several times as an extra, but the part of McClintock
required someone with real stature. 'Sean!' he answered. 'What do you
mean? He can't speak without that brogue and he mumbles everything.'
Jacqueline, cast as the 'love interest', disagreed. 'The ladies would like it if
you cast him,' she said, remembering how female audiences swooned at the
Oxford Playhouse when she appeared there on stage with him.

An enthusiastic, dependable, hard-working background player, nothing
more – that pretty much summed up how Connery was viewed by the indus-
try back then. So could he sustain a performance lasting well over an hour?
Going with a gut instinct Rakoff tested Connery and gave him the part, one
that few other working actors were in fact physically suited for. It was a huge
gamble that could have had disastrous consequences. Connery himself
couldn't believe his good fortune and was forever beholden to Rakoff.

During rehearsals, Connery required a great deal of direction; colleagues
noted his stiffness and need to relax and loosen up. Rakoff found Connery's
acting a touch on the rough side, but hoped his inexperience might
contribute to the character's punch-drunk innocence. Both men often
rehearsed alone together in a bid to ease his nerves and soften the accent. By
the end Rakoff emerged impressed by Connery's eagerness to learn.

Drawing on his boxing experience from the Navy Connery gave a formi-
dable performance for such a callow television actor – earthy, powerful and
full of emotion. It was all the more impressive given the programme went out
live, a daunting set-up even for a hardened professional. Connery later
confessed to loving the thrill of live television. 'It was extremely exciting.
Live TV was crazy.' Sadly the BBC who paid Connery a mere £25 saw fit not
to preserve this production for posterity, wiping it from their archives. In
doing so they denied Connery fans the chance to witness his first ever lead-
ing role, and the first screen meeting of Britain's two biggest ever movie stars.
The play closes on the pitiful image of a disillusioned McClintock, looking
on as his manager shows off his new protégé, a young Michael Caine.

Reviews were justifiably triumphal. Dismissive of the play itself, the
Listener thought: 'The dramatist ought to go down on his knees to Sean
Connery.' *The Times* highlighted his 'shambling and inarticulate charm' but
considered him largely miscast. Best of all was the *London Sunday Pictorial*,
which picked out Connery for future success: 'Physically Sean has the pleas-
ant strength of a Marlon Brando type.' Not bad, considering the BBC drama
bigwigs who watched final rehearsals feared the worst. 'We both sort of

expected it,' Rakoff recalled years later about the press reaction. 'It was a very showy part and he was good enough in it to get noticed.' Robert Henderson, his colleague and mentor from *South Pacific*, was impressed too. 'He was sensational in it. It was a performance that absolutely burst the television camera open. He looked like a prizefighter, and he had this magnetism.'

In Edinburgh the Connery clan crouched around a newly purchased television set on that Sunday evening, 31 March, to watch their boy. Afterwards Effie was overcome with emotion. 'By heavens, that was smashing,' declared Joe. Big Tam had done just fine.

Anna Christie August 1957, ITV

Eugene O'Neill's Pulitzer Prize-winning play concerns a lowly prostitute who falls in love with a young sailor. In this television production, Connery reprised the role he had played to such great acclaim at the Oxford Playhouse the year before – Mat Burke. His leading lady this time was one Diane Cilento, making her dramatic debut on British television.

Nobody gave much thought to the programme which immediately followed *Anne Christie*, a documentary on the making of *Hell Drivers*. In fact it was Connery's second movie and summed up the gulf between the dumb parts he landed in movies and those he got on television. Until he was cast as James Bond Connery's skill and talents as an actor were only properly explored on television or on the stage. In those media he was given roles of real potency as opposed to the one-dimensional 'heavies' film producers were so keen on him playing.

Women in Love September 1958, ITV

This two-hour drama spectacular opened ITV's new season and celebrated the station's third anniversary. An omnibus of six playlets set in different European countries and featuring 'typical' beauties from each nation, the whole affair was presided over by the king of smooth George Sanders.

Connery appears in the third segment, entitled 'The Return', which tells of the strange link between a persecuted young Jewish concert pianist and a tough Nazi war criminal.

The Square Ring June 1959, ITV

Connery played another boxer, the crooked Rick Martell, in this stark play which posed the question whether the sport of boxing is a noble art or mere barbarism. The action takes place in a dressing room, as six boxers await their turn to enter the ring. Connery received second billing in a strong male cast that included George Baker and a young Alan Bates.

The Crucible November 1959, ITV

Arthur Miller's classic dramatic retelling of the infamous Salem witchcraft trials of the 1690s, the playwright's metaphor for the McCarthy witch hunts that gripped America in the early 1950s. Connery scores as John Proctor, a role played by Daniel Day-Lewis in the 1996 cinema version, who chooses to be hanged rather than sign a false confession to devil worship. *The Times* thought Connery was 'powerfully virile' and 'carried off the acting honours'.

Colombe January 1960, BBC

Part of the BBC's Twentieth-century Theatre season was this version of the Jean Anouilh comedy, starring Dorothy Tutin and the great French actress Françoise Rosay making her British television drama debut. Set backstage in a theatre in turn-of-the-century Paris, *Colombe* featured Connery as Julien, a handsome suitor seeking the hand of the beautiful, innocent young flower-girl Colombe.

An Age of Kings April-November 1960, BBC

The BBC's epic serialization of Shakespeare's history plays, in 15 one-hour instalments, was shown live on alternate Thursday evenings. It was a madly ambitious and mammoth undertaking, with a large cast to match. It was Shakespeare for the masses, according to Connery in the *Radio Times*. 'The most gratifying thing about the series has been the warm response to Shakespeare by people who would not normally go five yards to see one of his plays.'

Courageously cast as Hotspur opposite Robert Hardy's Prince Hal, Connery graced the first four episodes, which derived from Henry IV. His energetic performance – part rough-and-ready charm, part steely composure – was welcome relief from stock BBC Shakespeare performance, all proper vowels and posturing. With great booming voice, clipped beard and moustache, thick eyebrows and dark sleek hair, Connery commanded the viewer's attention. With his bulky frame and outsize personality, it was inevitable that he'd make an impression on the small screen.

Hardy, once understudy to Richard Burton at Stratford, saw in Connery a charisma and capacity to succeed. He also detected striking similarities with Burton; both men shared a strong nationalism and stubbornly refused to ditch their accents. 'Just to be with him one knew Sean had great presence. I never had any doubt he was going places.'

Without the Grail September 1960, BBC

In this BBC drama Connery plays the Bond-like Innes Corrie, an agent assigned to investigate a crazed Michael Hordern, who is running his tea

plantation in Assam like a feudal kingdom. Joseph Conrad meets Ian Fleming! The part didn't amount to very much, although Connery received a crash course in the rudiments of Mah Jong, courtesy of Chinese co-star Jacqui Chan.

The play is a real curio, which baffled most who watched it. But Connery again earned decent notices.

Riders to the Sea September 1960, BBC

Set in Ireland, this one-act play by J.M. Synge cast Connery opposite *grande dame* of the stage Sybil Thorndike. She plays Maurya, an ancient Irish peasant woman who had struggled all her life to bring up her sons.

The Pet October 1960, ITV

This dramatization of actor Robert Shaw's first novel, *The Hiding Place*, starred Shaw himself and Connery as two British airmen shot down over Germany during the war, who are then held captive by a local citizen.

During the scene where they have to bail out of a studio-bound plane, Shaw fixed Connery's straps so that when he jumped out they became entangled, leaving the panic-stricken actor dangling helplessly in mid-air. 'It was embarrassing, so I told him to come down and deal with me ... He wouldn't. But after we got that straightened, we became good friends.' It was the beginning of a long and competitive relationship between the two men.

Adventure Story June 1961, BBC

In Connery's biggest television role of all he played Alexander the Great who conquered a vast empire and died aged thirty-three, master of the world. This earnest adaptation of Terence Rattigan's West End play saw Connery, in a curly blonde wig, launch himself into the role with verve. Conscious of the corrosive quality of power yet unable to resist its charm Connery's Alexander grew from young adventurer to embittered tyrant, a compelling transition that drew striking praise from *The Times*: 'Certain inflections and swift deliberations of gesture at times made one feel that the part had found the young Olivier it needs.' This was heady praise, totally justifying the choice of Connery as that week's *Radio Times* cover star.

Anna Karenina November 1961, BBC

Rudolph Cartier, the director of *Adventure Story*, a pioneer of early television drama, best remembered now for his productions of *Quatermass* and *1984*, was so impressed by Connery that he cast him opposite the classical actress Claire Bloom in this prestigious adaptation of Tolstoy's romantic tragedy. The story concerns a woman, trapped in a loveless marriage, who falls for a dashing army officer.

Appearing polished and cultured, with just the right sort of aristocratic swagger, Connery played Anna's lover Count Vronsky with a subtle intelligence. His performance was proof of how much he had learned as an actor. His earthy flamboyance contrasted sharply with Bloom's rather detached, cerebral performance. In the opinion of *The Times* his was a 'headstrong, passionate Vronsky'.

Much of the spotlight and critical plaudits passed to Miss Bloom, a recognized star who was making her first British television appearance in four years. However, within days of the broadcast Connery had been chosen to play a certain British secret agent. Save for a glorious one-off, he was never to grace the television drama arena again.

MacNeil February 1969, ITV

This was the first in a trilogy of Alun Owen plays that turned into a major television event. It all came about when Richard Attenborough badgered TV mogul Lew Grade into making a show that might raise funds for charity. Grade agreed to find three actors willing to give their services for free. They would also have to be big names in America so that the programme could be sold oveseas too. Connery headlined the first play, cast as a disgruntled and lecherous master carpenter with a twenty-year-old daughter. Michael Caine starred in the second play, and Paul Scofield the third and last. Laurence Olivier introduced each instalment.

Connery's first telvision role since 1961 was heralded by a cover feature on the week's *TV Times*. 'After BB Comes TV' ran the headline, eluding to his recent escapades in the movie *Shalako* with Brigitte Bardot. He told the magazine's reporter that he was using his television appearance as a weapon against the Bond image, stressing the need for roles which taxed him as an actor, roles that brought him critical plaudits rather than uncritical fan worship.

To date, *MacNeil* is Connery's last television acting role and it looks like remaining so, because he subscribes to the view that one's prestige in the cinema tends to drop if you do television. This was amply demonstrated in April 1998, when Connery revealed he'd been asked to guest star in the US sitcom *Friends* playing Courteney Cox's boyfriend. He turned it down, despite his agent's enthusiasm. 'I don't feel that I've worked for so long in films to take a bit-role in a sitcom,' he said. 'But I suppose in the end you can never say never.'

Contract Player

Anyone with any brains in the business watching Connery's television acting debut in *Requiem for a Heavyweight* couldn't have failed to notice

someone who may have been a little rough round the edges, but possessed undeniable presence. Sure enough Connery's agent was flooded with enquiries. Rank showed interest, as did Hollywood in the form of Twentieth-Century Fox, both of which dangled contracts lesser actors would have killed for. But Connery, showing remarkable restraint, would not be rushed, calmly taking his time before making – the wrong decision. 'I went round to every company – canny Scot that I am – to see which one would offer the best deal. I plumped for Fox.' It was a seven-year contract that paid £120 a week. Connery celebrated by purchasing a mews flat in North London and the first of a succession of cars, albeit second-hand ones. Asked later why he'd traded in one particular model for another he joked, 'The ashtrays were full.'

Connery hoped Fox would use its considerable clout to turn him into a star, but instead he found himself being put up for roles in films he felt totally unsuited for. 'I used to live in a basement and eat spaghetti and nothing else for weeks because that's all I could afford. And if necessary I'll go back to that.' Signing for Fox taught Connery a valuable lesson: what it felt like to be owned. 'Suddenly you cease to be a person. You have become a thing in a certain financial bracket. They buy you, they put you into this bracket, and from there on in you're considered not on the strength of your ability, but on your price.'

After giving up casting him in any of their own movies, Fox got their money back by loaning out Connery to make lousy films at other studios, some of which he likened to 'a man walking through a swamp in a bad dream'. Then it was back home to twiddle his thumbs while drawing his salary. This inevitably led to pangs of guilt. Here he was earning ten times more than his dad just sitting with his feet up waiting for the telephone to ring. Whenever an opportunity did arise to do something worthy and exciting like a play at Oxford, he'd have to apply for permission. 'But it was like dealing with the Inland Revenue people. By the time you got the answer the play had been on long ago.'

While he was filming in Hollywood Fox invited Connery to enrol in their charm school. He told them to get lost, refusing to play by their rules, or anybody's. 'If you compromise your independence for any reason, there's not much use living. If you compromise it for something as fleeting as money you are already dead.' During his stay Connery was also offered roles in numerous US television series, including the lead in *Maverick* and a role in *Wyatt Earp*. He turned them all down. 'They might have earned me a fortune, but they'd have finished me as an actor.' Connery had no desire to be stuck in the rut of playing the same role week in, week out.

The pain of being an unused contract player eventually became too much to bear. Financially he was doing well, but creatively it was suffocation. Despite his growing reputation as a dramatic actor on television and stage, Fox didn't seem to be pulling their weight in finding him good work.

Relations worsened and by mutual consent his contract was terminated. *The Longest Day* was the only time Fox employed Connery in one of their own productions, and that was just a cameo. Months later Sean was a star thanks to *Dr No*, and executives over at Fox must have been kicking themselves.

Early Movies

No Road Back (1956)

Connery always craved film stardom; not for him a distinguished career in the theatre. Alas, his film debut was an inauspicious start, as they so often are. *No Road Back* was the sort of forgettable B movie in which British studios excelled during the fifties. Rope in some dodgy American has-been – or, in Skip Homeier's case, never-was-been – to sell the film abroad and surround him with native no-hopers. Throw in a diamond robbery, a murder and a romance and you're left with a crime drama that probably didn't even look good on paper. The budget was so low that one's admission price probably covered the entire production costs.

Connery played Spike, a 7-foot-tall moron and lackey to low-life crook Rudge (played by Alfie Bass). Cast because of his brawny physical appearance, rather than his acting prowess, Sean dutifully turned up for work at Pinewood studios in the summer of 1956 only to be suckered into a rotten prank perpetrated by Bass and Canadian actor Paul Carpenter, who was playing the chief heavy. As green as spinach on his first film, Connery was persuaded to confront the director Montgomery Tully about some of the feeble dialogue he had to speak and the lame-brained concept of his character stuttering like an idiot all the time. This he did, only to discover that Tully had co-written the script and stuttered himself. 'He was very nice about it,' Connery recalled. 'Can't think why.' It wasn't all bad: Connery's success with women, whom he managed to lure back to the dressing room he shared with Bass, more than compensated for the dubious artistic nature of the project.

No Road Back was released in February 1957 and quickly sank without trace. The slogan 'Underworld queen ... entangled in a web of crime', enticed no one to part with their money. But that wasn't quite the end. During the height of Bondmania in 1965 some enterprising producer released *No Road Back* in Europe, promoting it as a glamorous spy film. The poster, with breathtaking audacity, depicted Connery in Bondian pose, surrounded by a bevy of indecently clad ladies and with his name in epic letters above the title. Just in case even the slowest patron didn't get it, an 007 was emblazoned afterwards. The name of the film's original star, poor old Skip, was nowhere to be seen. Crowds flocked to the picture, but storms of protest followed when the cruel deception was uncovered.

Hell Drivers (1957)

A hard-hitting exposé of the cut and thrust world of ... road haulage. Though hardly a subject to get the pulse racing, this is actually one of Connery's best pre-Bond movies. He plays one of a motley crew of lorry drivers hauling ballast at breakneck speed over dangerous roads. He doesn't do very much, except look tough and scowl occasionally, but in a dancehall scene he demonstrates some nifty footwork with the young Jill Ireland. A definite plus was that he got to act alongside real stars like Herbert Lom and Stanley Baker, soon to become a dear friend and golfing partner. Baker actually predates Connery as perhaps Britain's first actor with a working-class accent to become a star.

The supporting cast is remarkable, made up as it was of embryonic sixties cult heroes. There was Patrick McGoohan (*The Prisoner*), Sidney James (the Carry-Ons), David McCallum (*The Man from UNCLE*) and William Hartnell (*Dr Who*). 'It was what we then called a star-studded cast,' Lom recounted at a function honouring Connery years later. 'And of course Connery's name was never mentioned anywhere. I saw the picture advertised the other day, I think for a re-run on television, and it said – "*Hell Drivers* starring Sean Connery, full stop." That is a compliment and fame indeed.'

The film was effectively directed by Cy Endfield, later to give Michael Caine his big break in *Zulu*. Endfield was a member of the Magic Circle and would regale everyone with tricks during lulls in filming. 'He used to throw all the cards in the air and be left holding four aces,' Connery recalled. Eminently watchable and quaintly old-fashioned, in the end *Hell Drivers* strains credulity by having us believe these drunken louts who drive like deranged Mr Magoos wouldn't all have been locked up years earlier. 'This extraordinary film may interest future historians for its description of road haulage and masculine social behaviour in the mid-20th century.' *Monthly Film Bulletin* had a point.

Time Lock (1957)

Connery's smallest ever film role finds him so far down the cast list you'll strain your neck looking for him. He is billed as 'second welder' in this moderately tense tale of a young boy trapped in a bank vault. The production team of Gerald Thomas and Peter Rogers, who were two years away from initiating the Carry On phenomenon, cast Connery simply because he looked like a labourer. Your average thespian probably didn't know which end to hold an acetylene torch, whereas Connery had experience of manual work and looked it, big and brawny with a face seemingly chiselled from marble. 'He was a very arresting personality,' Gerald Thomas later recalled. 'You wouldn't walk past him in an identity parade.'

Both producers appreciated the professionalism and hard graft Connery

brought to the job, though not enough to trust him with any dialogue of note. This was probably just as well given his largely unintelligible accent. They admired how he paid attention to what was happening around him on the set, watching the other actors and hoping to pick up tips. But they had no sense that here was the new Olivier or the next Brando; indeed they declined to use him on their next movie with John Mills when his name cropped up again. Connery received the princely sum of £100 for four days' work on *Time Lock*, and very glad of it he was too. Years later they'd sometimes bump into each other at Pinewood, home of the Carry Ons and 007. Connery never forgot the veteran producers and enjoyed reminiscing about their time spent working together.

Action of the Tiger (1957)

Spain was the location for this risible adventure yarn. Rainstorms, hard frost and a Suez-related fuel shortage conspired to scupper production. Again Connery was cast largely because of his tough-looking exterior. This time he played Mike, a slovenly, unshaven ship's mate whose main contribution to the action is molesting starlet Martine Carol. Upon eyeing Sean's bulging torso, she apparently remarked: 'Am I supposed to run away from that?'

Impressed by his romantic charm Carol, though short on talent herself, was astute enough to realize the potential of Connery, and told director Terence Young he should have been playing the lead instead of the tepid Van Johnson. 'This man has star quality.' It was an opinion few others shared; the film industry had seen fit to categorize him as a brainless beefcake, nothing more. When aspiring director Michael Winner wanted Connery in a film his producer refused: 'He's just a B-picture actor. You can't use him!' Here was the man destined to become Britain's greatest film star and, strangely hardly anyone saw it coming.

Connery was naively convinced that *Action of the Tiger* had all the makings of a hit; gritty action, a half decent premise about a troubleshooter helping a beautiful woman free her brother from Communists in Albania – all handsomely shot in colourful Cinemascope. MGM was hopeful too, holding a lavish world premiere at the Empire Leicester Square with specially invited real-life adventurers, a tame tiger and celebrity guests including a fresh-faced Roger Moore. It's raw! It's rough! It's romantic!' screeched the posters. 'It's rubbish!' returned the critics in unison.

With the benefit of hindsight Connery dismissed this would-be epic as 'pretty rotten'. It really is tedious in the extreme, let me confirm.

Another Time, Another Place (1958)

In September 1957 the big movie break arrived when Lana Turner personally selected Connery out of a hatful of hopefuls to be her new leading man. It

was a great opportunity: screen time opposite a true Hollywood legend (if a little faded by this time) and his first chance of wide exposure in America. Credit must go to Miss Turner, the first high-profile artist to recognize and seize upon Connery's star potential. Two years earlier she'd starred with another 007-to-be Roger Moore, in *Diane*, a choice piece of MGM historical codswallop.

Set in Blitz-torn London this turgid melodrama sees Connery as dashing BBC war correspondent Mark Trevor, who has an affair with a visiting American (Turner) before being killed in a plane crash. He was gone after just twenty minutes, resurfacing only as a framed picture on a piano. Part of his research entailed listening to old wartime broadcasts. These the director had played to the cast before shooting in the vain hope of creating some atmosphere. 'One of the most passionate of all love stories,' bragged the poster. Not even close.

This was potentially a star-making film for Connery, who was given a special 'and introducing' credit. But all this tear-jerker produced from audiences were tears of frustration at having paid good money to see such bilge. Unhappy with the final result Connery blamed a poor script that was being rewritten as they went along. 'It wasn't very good,' he later admitted, wishing for the chance to burn the negative. 'It was nothing to do with Miss Turner. She was first class. One's intuitive senses were saying that the director was an idiot. I'd no influence or authority at the time, so my protests went unheeded. But at least I learned from it.'

Having, till then, always been cast as the heavy, looking unshaven and shabbily dressed, alongside Turner Connery wore smart suits and was groomed to match matinée idol expectations. He acquits himself well, and his love scenes with Miss Turner produce minor sparks, which no doubt fuelled speculation that they were off-screen lovers. One should not overlook the scale of his achievements: here was a young Scot from the back streets of Edinburgh, not long an actor, holding his own against a Hollywood goddess who ate studs for breakfast.

Another Time, Another Place opened to a critical roasting and public apathy. 'Made in England ... evidently as a part of the current Go-Home-Yank plan' – *New York Times*. In his 'breakthrough' film Connery was rubbished by the papers. 'Connery, in his first big part, gives the impression that he is reading his lines from a none-too-helpful prompt book' – *Daily Herald*. Derek Monsey in the *Sunday Express* referred to him as 'a newcomer to films who will not, I guess, grow old in the industry'.

Darby O'Gill and the Little People (1959)

Sean Connery, Walt Disney and an army of dancing leprechauns combine to provide an enchanting fairy-tale that esteemed American critic Leonard Maltin calls, 'one of the best fantasies ever put on film'.

Inspired by a personal trip to Ireland in 1947 this project was very close to Disney's heart. The story follows the rascally Darby O'Gill (wonderfully played by Albert Sharpe), who catches the King of the Little People and is granted three wishes. A screening of *Another Time, Another Place* and an audition secured Connery's place among a distinguished group of Irish acting talent, some heralding from the famous Abbey Theatre. While hardly a Dublin man, Connery was deemed Celtic enough to fool most Yanks. He couldn't believe his luck: his debut Hollywood movie and his first trip over to America. 'I didn't realize that on the plane all the food and drink was free. It took me for ages to order something.'

In Los Angeles Connery took a room at the Bel Air motel. From there he was within walking disitance of Disney's Burbank studio, where a picture postcard Irish village had been recreated. He soon rented a nifty sports car with the intention of living it up, often joining his fellow actors in the myriad profusion of local bars. But he was never less than the consummate professional, always turning up for work on time and raring to go. The man in charge was director Robert Stevenson, who Connery discovered to be a direct descendant of Robert Louis Stevenson, and the man later responsible for movies entire generations have grown up with – *Mary Poppins, The Love Bug* and *Bedknobs and Broomsticks*.

On 24 June 1959 *Darby O'Gill and the Little People* was unveiled at the Theatre Royal, Dublin – it was the first time ever a Disney world premiere had taken place outside of America. Connery attended, as did Uncle Walt. The movie went on to be a deserved hit, Connery's first qualified success, and today is regarded as something of a minor classic, in part because of its terrific special effects. Even the critics had nice things to say. 'Comparative newcomer, rugged Sean Connery makes a distinct impression . . . combining toughness, charm and Irish Blarney' – *Variety*. As humble caretaker Michael McBride, who falls in love with Darby's headstrong daughter, Connery makes a dashing romantic lead fusing strength and innocence. Hints of the character's dark sexual power crept past the Disney censor.

Connery bursts into song for the first time since those chorus days, though Stevenson did consider dubbing him. A single of 'Pretty Irish Girl' was released on the Top Rank label in April 1959 but failed to dent the British charts. Connery the pop star failed to materialize, and Tommy Steele and Cliff Richard could again breathe easily. The recording was a disaster. Connery stood on one pedestal while co-star Janet Munro occupied the other. Intimidated perhaps by the huge orchestra, when the band struck up he suddenly twigged it was his turn to sing, only nothing came out. 'So after a few stops and starts they realized that I had absolutely no experience of it.' Worse, the Disney people suddenly announced they wanted a B-side and presented a song sheet entitled 'The Bally McQuilty Band', which both had to learn and sing on the spot. Janet left the studio and returned minutes later with a bottle of vodka. After numerous hefty swigs they were ready to go.

'Absolute nightmare,' Connery recalled years later, the memory still vivid. 'An absolute nightmare.'

Darby O'Gill and the Little People is a truly magical film full of whimsy, leprechauns and inoffensive stereotypes, plus the odd scary moment. I defy any child not to shudder at the sight of the screaming banshee or the death coach with its headless horseman – images from the dark side of Disney.

Tarzan's Greatest Adventure (1959)

A cut above most of the post-Weissmuller Tarzan movies, this latest instalment of the loinclothed hero, here played by the hefty Gordon Scott, was filmed largely on location in Kenya. Real tribesmen were employed as extras, and many of them quickly adopted Western ways by staging a strike. In for a free holiday was Connery as O'Bannion, one of a gang of cut-throats out to find a diamond mine. Hardly overawed by such material, he accepted partly because it afforded the chance of working with Anthony Quayle, cast against type as a psychotic killer. Holding the megaphone was London-born John Guillermin, who later served up such blockbusters as *The Towering Inferno* and the remake of *King Kong*.

Paramount didn't hold out much hope for the film, releasing it in some cities in America in July 1959 as part of a double bill with a Jerry Lewis comedy. And while the press was largely dismissive, this was no formulaic Ape Man flick, but a thrilling adventure story in its own right. The clichés of yesteryear were refreshingly absent. Jane is nowhere in sight, and even Cheetah is reduced to a mere walk-on part – though the traditional fight with the plastic alligator remains thankfully intact. The plot may be thin, but gutsy action and solid ensemble playing lend the production terrific zest. The *Los Angeles Times* hailed it 'a unique adult tale. I would single it out for its impact, even brilliance as cinema making.'

As for Connery, his role is woefully undemanding, requiring him to look brainless and tough in equal measure, mere arrow fodder for Tarzan's bow. A bigger challenge would have been a crack at playing Tarzan himself, and in 1961 Connery was apparently being lined up to replace Gordon Scott. In August 1994 Scott himself spoke admiringly of Connery to the magazine *Classic Images*. 'Sean was a great guy with a great sense of humour. He has a lasting quality and does everything well. He is still the best Bond I've seen. He took a real chance when he gave it up, but the guy knew exactly what his plans were. I admire him.'

The Frightened City (1961)

This low-budget gangland potboiler may have been seen by some as a backward step after pitching for Disney and Tarzan, but it's actually rather good and Connery's biggest role at that time. Filming got under way in December

1960 at Shepperton Studios and on location around Soho, with a former Flying Squad detective acting as technical adviser. Billed above Connery was Herbert Lom, predictably cast as the Mr Big figure, and a pious John Gregson.

Intended as a tough exposé of West End racketeering *The Frightened City* opened in September 1961 to poor takings. Its bold attempt to transfer the American gangster milieu to a London setting was clearly lost on most. Now, of course, it all seems terribly dated, with its smoky jazz clubs and cardboard sets. Connery, however, was really beginning to move up the gears, turning the part of Irish hoodlum Paddy Damion from the loyal, slow-witted animal of the script into a showreel performance, as he seeks revenge on the gang leader who murdered a friend. The cool menace oozing from him in the final showdown with the villains, and the flirtation with torpedo-bosomed Yvonne Romain, foreshadow the way he would play James Bond. There are times where he already looks like the super spy in waiting – the facial expressions, body language and the inflections of his speech, already seem to be in place. This role more than any other was Connery's dress rehearsal for 007, the rough-hewn actor of a few years back had gone forever.

Trivia note: re-released in 1965 to exploit Connery's rise to fame, *The Frightened City* enjoyed an increase in box-office business of up to 300 per cent in some European countries.

On the Fiddle (1961)

This probably ranks as Connery's most amusing pre-fame movie, a quintes-sentially English comedy, set during World War Two, and chronicling the exploits of a pair of spivs who will do anything to avoid active service but end up unlikely heroes. Connery brings charm and an awkward grace to the slow-witted Pedlar Pascoe, effectively playing straight man to the wise-cracking Alfred Lynch. They're an inspired double act, backed up by cameos from established British comedy stars like Stanley Holloway, Cecil Parker, Wilfred Hyde White, John Le Mesurier, plus a young Barbara Windsor.

No one was surprised, however, when *On the Fiddle* tripped at the first hurdle. In America it received only a limited release, opening proper in 1964 as *Operation Snafu* (later retitled *Operation Warhead*). The advertising campaign predictably traded on Connery's 007 image. Lines like 'From boudoir to battlefield . . . It's Sean Connery . . . mixing dames and danger as only he can' hyped this dotty old farce into some sort of sex-crazed action adventure. Few were stupid enough to fall for it.

Amiable enough, *On the Fiddle* was still small fry, although Connery did receive top billing for the first time. Prior to its release in October 1961 some journalists queried whether stardom would forever elude Connery, having earlier so confidently predicted it. He must have been wondering the same thing, for not so many years before he was being touted as 'the British

Brando'. As one female scribe for *Woman* magazine perceptively wrote at the time: 'It is a real mystery to me why no film company has built Sean into a great international star. He reminded me of Clark Gable. He has the same rare mixture of handsome virility, sweetness and warmth.' But the wheel of destiny was turning in his favour. 'I remember Sean was very worried at the time about whether or not he should accept an offer to play some spy hero called Bond,' recollected Alfred Lynch in 1969. 'I told him to turn it down. He's forgiven me – I think.'

The Longest Day (1962)

An 'event' picture from the very top drawer, *The Longest Day*, Darrel F. Zanuck's mammoth reconstruction of the D-Day invasion, is the Mount Rushmore of war movies. As the critic of the *Sunday Express* noted: 'It's so realistic a stalls seat feels like a foxhole.'

Opening to near-unprecedented ballyhoo, premieres galore seized global attention: first in Paris, where the film's title was set in lights on the Eiffel Tower, then New York, and finally a Royal gala in London. The public flocked to see the cavalcade of stars on view – John Wayne and Robert Mitchum representing Uncle Sam; Richard Burton and Kenneth More batting for Blighty – turning it into the most successful monochrome movie of all time.

Connery is seen only briefly as bumbling Private Flanagan, speaking in a dense Celtic brogue that no one south of Glasgow had much hope of understanding. He formed part of another comedy double act, this time with Norman Rossington, and both are a joy to watch as they crack gags while dodging bullets on the Normandy beaches. 'We did ad lib a bit,' Rossington informed me. 'Sean always likes putting things in, adding bits and pieces to a script. The scene where he jumps off the landing craft into the sea, he ad libbed there, but I think they cut a lot out. Sean is a very good comedian, very funny on film when he's allowed to be.'

Watching from the sidelines was Richard Todd, who later wrote in his autobiography, 'Towards the end of my stay in France, a new arrival joined us: Sean Connery. Not yet world famous, he was a nice chap who seemed rather shy and kept very much to himself.'

This performance contrasted sharply with the one Connery was giving just a few hundred yards up the West End, because by the time *The Longest Day* hit London screens so had a certain British movie called *Dr No*.

3 Bond . . . James Bond

Bond . . . James Bond

'Arguably the most significant fictional character of the post-war years.'
National Film Theatre

Winning the Role

Who would play the part of James Bond became the male equivalent of the search for Scarlett O'Hara. In auditions producers Albert R. Broccoli and Harry Saltzman scrutinized some 200 hopefuls in their search for an unknown whom audiences could automatically accept as Bond; limited funds had scuppered hopes of using a star name. That both producers were American undoubtedly affected the final choice: neither wanted some cultivated theatre actor – alert to the international market, they needed their Bond to be less Ian Fleming's old Etonian and more brawling street-fighter. Hence Broccoli's belief that Connery's virile, aggressive masculinity was crucial, arguing against the role being played by 'some mincing poof'. Their view was shared by 007 screenwriter Richard Maibaum. 'Sean was nothing like Fleming's concept of Bond,' he told *Starlog* in 1983. 'But the very fact that Sean was a rough, tough Scottish soccer player made him unlike the kind of English actors that Americans don't like. Sean was not the Cambridge/Whitehall type – he was a down-to-earth guy. The fact that we attributed to him such a high-style epicure was part of the joke.'

It was very much a combination of events that led to Connery securing the decade's most coveted role. A *Daily Express* readers' survey to find a suitable face to play Bond had Connery well placed, while editor Peter Hunt, putting the finishing touches to *On the Fiddle*, sent a couple of reels over to Saltzman to illustrate Connery's powerful screen presence. In Los Angeles Broccoli watched *Darby O'Gill and the Little People*, and what impressed him most was the way his wife Dana reacted – she commented that this Sean Connery was one 'very sexy guy'. So a meeting was arranged at the producer's London office in South Audley Street.

Terence Young, who'd been slated to direct Bond's screen debut, telephoned

Connery and urged him to wear a suit for the interview and not his usual street gear. The actor turned up wearing baggy, unpressed trousers, a nasty brown shirt minus a tie, a lumber jacket and suede shoes. 'I never saw anyone come more deliberately to antagonize people,' said Young. Throughout the meeting Connery behaved with bloody-minded arrogance, laying down his own terms and thumping the table hard with his fist whenever he wanted to emphasize a point. It was all an audacious act, for Connery didn't want to leave the impression of a starving actor desperate for work. And it paid off. 'I think that's what impressed us,' recalled Broccoli, 'the fact that he'd got balls.'

Next, the thorny question of a screen test was broached. Connery shook his head. 'Sorry, but I'm not making tests. I'm well past that. Take it or leave it, but no test.' Broccoli and Saltzman rose to their feet to thank him for coming and said they'd be in touch. Then they rushed to the window to watch Connery leave the building and walk down the street. It was the way he moved that clinched it: for a big man he was light on his feet, like a cat. As Broccoli later put it, 'The difference with this guy is the difference between a still photograph and film. When he starts to move, he comes alive.' They'd found their Bond. Barring falling under a double-decker bus Connery was it from that moment. 'We'd never seen a surer guy,' said Saltzman. 'Or a more arrogant son of a bitch!' added Broccoli.

'I think they always knew from day one that Sean Connery was going to be Bond,' associate producer Stanley Sopel told 007 fanzine *Bondage* in 1981. 'We did go through the motions of screen-testing some hopefuls. Had a genius come out of that testing, Sean probably wouldn't have gotten the part, but he was it from the beginning.'

Backers United Artists were less convinced. Refusing to test, Connery was tricked into undergoing a few filmed auditions with prospective leading ladies. This footage was sent to the States and the studio response was blunt. 'See if you can do better.' To their credit Broccoli and Saltzman stood by their man, intending to go ahead with Sean or not at all.

On 3 November 1961 it was announced that Connery had signed a multi-picture deal binding him to Bond until 1967, with provision to do one non-007 film per year. In today's climate of $20 million deals, it's striking to note that Connery was paid just £6,000 for his first Bond movie.

Colleagues found it all terribly amusing that Connery had landed the role of James Bond. 'It was a bit of a joke around town that I was chosen. The character is not really me at all.' There is also evidence to suggest that Connery didn't rate winning the Bond role as much of a career break-through. One afternoon strolling around Harrods he bumped into Joan Collins and Anthony Newley. 'Congratulations,' said Newley. 'You'll be great and I'm sure the film's going to be wonderful.'

'Oh, it'll be just another job,' Sean shrugged, 'then I'll be waiting for the phone to ring again as usual.'

Critic Barry Norman also remembers a train journey he shared with

Connery, while travelling up to report on the filming of *The Longest Day*. Every compartment was packed with actors and technicians, so Norman and Connery were forced to sit on the floor of a third-class carriage. Just to make conversation Norman asked what the actor was doing next. 'I'm playing James Bond,' Connery answered, and then rather defensively he added, 'Well, it's a job.' The rest, as they say, is history. 'I've travelled third class many times since then, but I doubt if he has,' says Norman. 'He probably bought the train.'

Broccoli and Saltzman took a giant leap of faith casting Connery, a man who was everything Bond was not. Die-hard Fleming fans must have raised an eyebrow at the thought of a Scotsman playing their very English hero, but the people that really mattered were audiences around the world. Unaware of the literary 007, they got swept up by Connery's portrayal, and to them this man was James Bond. No other actor could have pulled it off quite so brilliantly or has ever looked better in a tuxedo.

They Turned Bond Down

Ian Fleming's own personal choice to play his creation was David Niven. Other candidates (seemingly anyone with an equity card and good teeth) included Richard Burton, Michael Redgrave, Trevor Howard, Peter Finch and even James Stewart. Both Cary Grant and James Mason – who would have made a smashing Bond villain – voiced an interest but would only commit to one film and not a series. From the new generation of actors there was Richard Johnson (later the 007 up-dated Bulldog Drummond), the soon-to-be Sainted Roger Moore, then classed as not 'macho' enough for the part, and Patrick McGoohan, who turned down the offer three times on moral grounds and never regretted it.

According to James Spada's biography of 1950s heart-throb Peter Lawford, Broccoli offered the London-born actor the Bond role in 1958 when the producer was first toying with bringing Bond to the screen. Lawford, famous more for his associations with President John F. Kennedy and Frank Sinatra than his acting, would actually have made a decent Bond; he was familiar to American audiences and combined David Niven-like English charm with a mild toughness. But the prospect of playing a spy didn't appeal. It was a missed opportunity that remained one of Lawford's deepest regrets. Ironically, Lawford was among the cavalcade of stars in *The Longest Day*, the movie Connery made before embarking upon his 007 career.

Ian Fleming

After casting Connery as Bond the producers' next hurdle was convincing Ian Fleming that they'd found his dashing spy hero in the guise of a former

Scottish milkman. On hearing the news Fleming wrote to a friend: 'Saltzman thinks he has found an absolute corker, a 30 year old Shakespearean actor, ex-navy boxing champion, and even, he says, intelligent.' A meeting between Fleming and Connery was arranged at the author's cramped business office near Pall Mall. They talked and in the end, Connery guessed, Fleming regarded him as a compromise choice. Saltzman, however, knew Fleming was far from sold on the idea. 'I was looking for Commander James Bond, not an overgrown stunt man,' was one derisory comment.

Fleming feared that working-class Connery didn't have the social graces to play Bond, but his mind was swayed by a female companion over lunch one day at the Savoy. At Fleming's table was Connery and long-time friend Ivar Bryce, who'd brought along his cousin Janet, recently married to the Marquess of Milford Haven. After lunch she pronounced Connery as having 'it' and that seemed good enough for Fleming.

Any other misgivings vanished when Fleming saw the finished cut of *Dr No*. 'This chap Sean Connery is damn good,' he boasted to *Photoplay* in November 1962. 'When I first met him I thought he was a bit on the large side and rugged. But he looks and moves very well. I think he makes a very good Bond.' As a debt of gratitude Fleming, in the later novels, bestowed Scottish ancestry upon Bond. It's also clear that some of the characteristics of Connery's film persona influenced his literary counterpart. 'Sean is not exactly what I envisaged,' Fleming once revealed, 'but he would be if I wrote the books over again.' But Fleming wasn't the only Bond author to pay Connery literary homage. There's a neat in-joke in John Gardner's 007 novel *Scorpius* (1988). An airborne Bond watches the in-flight movie – *The Untouchables* – despite already having seen it because 'a favourite actor of his played a Chicago cop'.

Over the next two years Fleming grew particularly fond of Connery, and the feeling was reciprocated with genuine warmth. 'Ian was a very interesting man, he had such curiosity and his knowledge was so wide. Terrible snob, but he went to Eton and I think that explains quite a bit of that side of him. But a terrific companion.' Connery remembers telling the author that if his stories were to succeed in cinema form, they needed to have a lot more humour and fantasy. 'Fleming was a bit taken aback at first, but he agreed.' Asked once why he thought Bond caught on with the public in such a big way, Connery replied, 'I think it was because of Fleming's imagination. He was a great journalist. He knew the particularities of things. He made it real. That's always been my approach, too. It's fantasy, but you try to make it real.'

Fleming lived just long enough to enjoy the early success of the Bond films, but never witnessed his creation's rise to the status of world icon. He died of a heart attack on 12 August 1964, just weeks before the release of *Goldfinger*. He was only fifty-six. Connery learned of Fleming's death while playing golf with Rex Harrison in Rome. In a tribute to his memory, an extra

eighteen holes were played, with Connery employing the Penfold hearts ball used in the famous golf sequence in *Goldfinger*. 'It seemed appropriate,' he said. 'I think Ian would have liked that.'

Broccoli and Saltzman

In spring 1961 two London-based American producers struck up a partnership destined to become the most successful in entertainment history. Albert R. Broccoli and Harry Saltzman shared a dream of bringing James Bond to the screen, but no one in Hollywood wanted to know. Finally on 20 June 1961, just days before their option on the Fleming novels expired, a deal was struck with United Artists.

Broccoli and Saltzman complemented one another perfectly, Michael Caine saw their partnership as being that of good cop, bad cop. 'Cubby gives you the cigarette and Harry knocks it out of your mouth.' Broccoli was the more laid-back of the two, though still capable of volcanic moments of rage; his bag was the Bond babes. Saltzman was the gadgets man. Temperamental and mercurial, he spouted ideas like a geyser; most were unusable but out of the dross the odd gem would emerge. It was Saltzman's idea, for example, to start each 007 movie with a mini-adventure before the credits.

Prior to Bond, Saltzman had been the more successful of the two. With director Tony Richardson and playwright John Osborne he'd founded Woodfall Films, specializing in gritty kitchen-sink dramas like *Saturday Night, Sunday Morning* and *The Entertainer*. As for Broccoli, he'd been an agent before forming Warwick Films, whose most notable success was *The Cockleshell Heroes*. When Saltzman left Woodfall he spoke with John Osborne about his future plans. 'I've bought the Bond books,' he said, barely able to restrain his excitement. 'Who do you think I've got as Bond?'

Osborne scarcely knew of Fleming's work, but played along. 'I don't know. James Mason?'

Saltzman's blood pressure began to rise. 'Hell, no.'

'David Niven?'

'For Christ's sake,' screamed Harry, before pausing for effect. 'Sean Connery.'

'Harry, he's a bloody Scotsman!' Osborne argued. 'He can hardly read!'

Connery's relationship with Broccoli and *bête noire* Saltzman began to sour around the time of *Goldfinger*. The main bone of contention was money. Connery felt that his cut of the profits was paltry compared to what the producers were taking in, and that his part in the global success of Bond went largely unappreciated. He even joked that both men would have played Bond themselves if they could have, in order to save money. It was only when he returned to play Bond in *Diamonds Are Forever* that Connery felt he got the kind of fee he'd always deserved. 'I was in conflict with them from the beginning. Even they had

to divorce, because they would be sitting opposite each other at the table think-ing: "That asshole's got my other $30 million".'

By the time *You Only Live Twice* came out, the relationship had irre-trievably broken down. Connery was no longer on speaking terms with Saltzman and according to Bond lore wouldn't come on the set if Harry was around. 'If they'd had any sense of fairness, they could have made me a part-ner,' Connery lamented. 'It would have been beneficial for all.' Had a partnership been struck, Connery speculated years later, maybe the three of them would now be running United Artists. As it was they parted acrimo-niously. 'I wouldn't piss on them if they were on fire.' Connery hit out and Broccoli counter-attacked, accusing the actor of sour grapes. Such was the depth of bad blood between them that when Connery heard Broccoli had suffered a massive stroke leaving him paralysed down one side of his body, his reported response was: 'Fucking good. I hope he's paralysed down the other side tomorrow.' In spite of hostilities Broccoli and Saltzman did try luring back Connery one last time for *Live and Let Die*. Called at home out of the blue with the offer of a very fat cheque, Connery must have enjoyed telling both producers to get lost.

In 1985 Connery mounted one of the biggest-ever court claims for lost profits: $225 million in total against United Artists and Broccoli, now sole Bond heir. Saltzman sold up in 1975 and was later to die almost forgotten in 1994. The feeling that he'd never been paid enough for his contribution to the series had been gnawing away at him for years and this was a once-and-for-all battle to secure a retrospective slice of the Bond pie, which by the mid eight-ies had topped $1.5 billion. 'All I ever did to Sean Connery was to make him an international star and a very, very wealthy man' was Broccoli's understand-able view. To which Connery replied: 'How much has *he* got? How much was he worth before the Bond movies? And how do you spell G-R-E-E-D?'

Amusingly, throughout the lawsuit Connery remained on speaking terms with Broccoli; it was cheaper, he pointed out to Cubby, to talk directly than speak through lawyers. After months of legal wrangling the claim was even-tually settled out of court. Its terms were never disclosed, and though both parties naturally claimed victory it was clear Connery never got the settle-ment he felt was warranted.

Stricken by the illness which eventually was to kill him, Broccoli received a call from Connery wishing him well. The producer took some comfort from this reconciliation of sorts. Connery also renewed communication with Saltzman before his death. 'But it doesn't really change the past,' the actor confessed. 'You can't re-write the script.'

At Broccoli's memorial service in November 1996, held at London's Odeon Leicester Square, scene of many Bond premieres, stars and friends gathered to celebrate the life of arguably the greatest producer of all time. Roger Moore, Timothy Dalton and Pierce Brosnan attended; Connery was conspicuous by his absence.

Playing Bond

'One needs the constitution of a rugby player to get through those weeks of swimming, slugging and necking.' – Connery on the perils of making *Thunderball*.

There was nothing much in Fleming's English public school Bond that connected with Connery, but in the words of director John Boorman, 'he took the character by the throat and shook some sense into it. It was the disparity between the man and the role that made it so compelling.' Here was a working-class Scot playing an upper-class product of the English establishment; what made Bond so appealing worldwide was that Connery was able to imbue the character with a classy classlessness. His robust portrayal was the antithesis of Fleming's rather unappealing snob, whom audiences surely would have found unpalatable. 'I probably wouldn't like Bond if I met him on the street,' Connery once said. 'I'm referring to the way he was conceived in the novels.'

What Connery brought to 007 was sheer animal sexuality and a raw masculine power. As Bond editor Peter Hunt described it: 'Sean really was a very sexy man. There are very few film stars who had that sort of quality . . . they virtually could walk into a room and fuck anybody.' As suave and sophisticated as Connery could be as Bond, there was always a hint of the brute lurking beneath the tuxedo. Audiences believed that here was a man who would kill without hesitation. 'There is in Sean a sense of cruelty that suits the part admirably,' according to Terence Young. It was the Bond role which first revealed Connery's rare gift of being able to excite women while simultaneously holding the attention of the male audience.

He also brought a great deal of physicality to the role, particularly in the fight scenes. A hefty figure, Connery looked formidable on screen, the embodiment of Broccoli's edict that Bond be a ballsy, two-fisted spy. 'Sean had great animal magnetism and danger to him,' said Barbara Broccoli, 'and of course the wit, the sardonic, caustic wit.' In 1996 Connery revealed the secret to playing Bond. 'The person who plays Bond has to be dangerous. If there isn't a sense of threat, you can't be cool.' He also once revealed that in his discussions with Ian Fleming both agreed Bond was a complete sensualist – 'senses highly tuned, awake to everything, quite amoral. I particularly like him because he thrives on conflict'.

Connery's impact on the role was such that future actors not only had to tussle with the myth of the character, but also the image of Connery himself. Honor Blackman once confessed to me that she lost interest in the Bond movies after Connery left. 'Sean was so special and so right in the part.' All this is incredible when you think that prior to playing Bond Connery had only read one Fleming novel – *Live and Let Die*. Even today, if someone does an impersonation of James Bond it's always with a Scottish accent. 'Sean is remembered as Bond because he imposed a new kind of virility,' believes

Adolfo Celi, *Thunderball*'s baddie, 'a new style of courting women, a new style of action.' His performance had just the right mix of humour, cruelty and sexual power. It was a cinematic landmark that influenced countless future screen tough guys. As Steven Spielberg put it, 'Sean made a contribution to all movie heroes with Bond.'

Typecast as Bond

'I don't think any role changes a man quite so much as Bond. It's a cross, a privilege, a joke, a challenge and as bloody intrusive as a nightmare.'
Though pleasantly surprised to be offered the Bond role, Connery had severe doubts. It was a great chance, his first leading role, but suppose the film flopped? It might finish off his career before he'd had a chance to get started; conversely if it was a hit, he was going to be saddled with a long-running series. 'Contracts choke you and I wanted to be free.' Following much deliberation with his wife and agent, Connery signed.

Naively, Connery believed there was no real chance of becoming typecast in the role; otherwise, as he told friends, he'd never have accepted the job. Perhaps he felt safe in the knowledge that he was the complete antithesis of 007: he lived in Acton not Monte Carlo; made do with a second-hand Jaguar, not a sleek Aston Martin; and was more your meat-and-potatoes man than a *bon viveur*. He also intended to make diversely different movies in between his Bond work. 'That's why I have no worries about being typed as Bond,' he said in 1963. It was wishful thinking.

Connery may have created Bond, but in another sense the character really created him, turning a relatively unknown actor into a superstar. To millions worldwide Connery instantly became their vision of what and who James Bond was, an indelible image that took him two decades to shake off. It angered him that media people in particular ignored his earlier stage and television credentials. 'The image that the press put out was that I just fell into this tuxedo and started mixing vodka martinis.' For years among profit-conscious Hollywood producers Connery was still largely identified with Bond. 'But since *The Untouchables* and other things he's done,' says Larry Gordon, former president of Twentieth-Century Fox, 'I think that's long gone. I haven't seen a bad film that he's done.'

For a time even audiences refused to accept him in other roles, which Connery came to find 'intolerably restricting'. Films like *The Hill* counted for zero against Bond. 'No film you could do, no matter how good it was, could compete with the new Bond.' Whatever he did, the spectre of 007 seemed to follow him. In October 1967 magistrates in Hendon, North London, fined the actor £15 for speeding. The officer making the complaint was one – wait for it – Sergeant James Bond.

Fears grew that the Bond character was so popular that Connery was in

danger of losing his own identity as an actor. People even expected him to act like Bond in everyday life. *Variety*, in its review of *From Russia with Love*, was among the first to pick up on this. 'Connery's only problem now is to avoid being identified entirely with Bond, whom he has created so well.' As the films' popularity grew, typecasting became the bane of his life. Invited to a society party in Nassau during the making of *Thunderball*, one of the guests asked him, 'With all this success as Bond, do you think you'll ever be able to do anything else?' Connery didn't offer any answer, he just turned away.

'The 007 thing was great for Sean,' Diane Cilento told the *People* newspaper in 1969. 'Hell, we've made a packet out of it. But, oh, it was so boring for Sean. You have to be pretty strong-willed to hold onto your own identity against a character like 007. Once you get a screen image it's a murderous thing to keep out of your private life.'

This hatred of typecasting was perhaps a by-product of being repeatedly cast in the same kind of roles as a young actor, and his years of stagnation as a contract player with Twentieth-Century Fox. At one early audition a casting director asked: 'And what type of actor are you, Mr Connery?' He stormed out.

One positive thing to have come out of the whole wretched typecasting experience is that since leaving Bond Connery has tackled probably as wide a range of characters as any other actor. His post-Bond policy was to strive for salaries he thought his talent and dedication merited and for parts that would stretch and challenge him as an actor. This led to some pretty off-the-wall choices, not all of which clicked with the public. Industry analysts worried that his pursuit of roles the diametric opposite of Bond could irreparably damage his box-office standing. 'Sean could be bigger than Clark Gable ever was if he switched to romantic he-man roles,' chipped in old boss Harry Saltzman. 'But poor Sean is trying to be so un-Bond like that he doesn't know what parts to take anymore.' Tongues started wagging that Connery was a bankable star only when he was behind the wheel of his trusty DB5. Ironically, after a series of dreary 'noble' films like *The Molly Maguires* and *The Offence*, in which he probably took himself too seriously in the hope audiences and critics would do likewise, Connery began to untie the Bond noose only with dramatic crowd-pleasing movies like *The Wind and the Lion* that came later. Bond made him a star, but perversely it also delayed recognition of his acting abilities.

Bondmania

On the release of *Goldfinger* Bondmania hit with the force of a nuclear strike and Connery began receiving the kind of adulation usually reserved for pop stars. According to *Photoplay* magazine in 1965 he received some 1,500 fan letters a week. 'I had no idea of that scale of reverence,' Connery explained

to the *Observer* in 1998. 'It was around the same time as the Beatles. The difference of course was that there were four of them to kick it around and blame each other.' The Beatles connection is more than coincidental – both became British institutions that dominated the entertainment business throughout the sixties and beyond. Fascinatingly, both emerged on the scene within twenty-four hours of each other. The Beatles debut single *Love Me Do* was released on 5 October 1962, and the following day *Dr No* premiered in London. How's that for destiny?

In a televison interview Terence Young spoke lucidly about the effect Bond fame had upon Connery. 'Any human being must have enjoyed the astonishing success and impact he had. By the time he made *Dr No* he was known pretty well all over the world, by the time he made three or four of them, there's no question he was the biggest individual star in the movies. I think he enjoyed it up to a point, until he found that it was a damn nuisance.'

The pinnacle of Bondmania was perhaps the Paris opening of *Goldfinger*. Connery attended and was persuaded to drive the famous Aston Martin along the Champs-Elysées, escorted by six gold-clad starlets on scooters. Thousands lined the streets cheering and waving at an increasingly apprehensive Connery, who hadn't anticipated such a turn-out. It was overwhelming. Suddenly a lone figure vaulted the barricades and dived through the car's open window, landing unceremoniously in Connery's lap. Next morning every French newspaper carried the story. Finally arriving at the theatre, Connery stepped from the vehicle to be mobbed by fans and reporters alike as if he were some holy relic on legs. It took two hulking bodyguards to forcibly push the actor inside. The incident shook Connery to the core.

Another extraordinary incident occurred during the filming of *Thunderball* in the Bahamas. Young fans, mostly American students on their summer break, followed the crew everywhere. On one occasion some 200 were treading water round a speedboat, moored at sea, on which Connery was filming. 'Speak to us,' one shouted. 'You're our leader and we're your people.' Connery told them to get lost in no uncertain terms.

And of course there were the women ... females literally threw themselves at him. In interviews, his then wife Diane Cilento laughed off those who became commonly known as Bond groupies. 'It's very tedious. You get stupid birds who really expect Sean to slap 'em round the face and throw them across the nearest sofa à la Bond.'

Connery wasn't even safe at his London home. Crowds would gather outside and peep into the front windows. If he set foot outside he risked being pestered by autograph hunters. 'We have a marvellous house in Acton in a wonderful situation – a cul-de-sac right by the park,' he told Alan Whicker. 'But there are some real headcases around. They just come up and sit on top of their cars, or knock at the door and say it would be marvellous if they could come in and have tea, or take some photographs or stand on

your wall. There's only one way to solve it and that's not to be there.'

It's amazing, really, that Connery got through the enormous pressure of being Bond and arrived on the other side intact and sane. 'Before Bond I'd been around a long time. If I'd been twenty-five and unknown, Bond might have ruined me.' That was pretty much the fate of his successor, George Lazenby.

Connery in Japan

What made *You Only Live Twice* Connery's least agreeable Bond experience was the incessant fan worship and press harassment he faced on location in Japan. Had he not already decided to retire, surely this 'madness', as he described it, would have been the final straw.

By the time he and Diane Cilento arrived in Tokyo on 27 July 1966 Connery was already rattled by having been mobbed in Bangkok and Manila while travelling. Roped into giving a press conference in his hotel, which was attended by hundreds of journalists, Connery arrived in an open-necked shirt, minus his socks and toupee – a far cry from the suave secret agent. Here he was besieged with inane questions concerning subjects totally unconnected with Bond, like his views on swinging London and Carnaby Street.

The lobby of the Tokyo Hilton was usually brimming with paparazzi, while on the streets shooting proved a nightmare. Japan was in the grip of Bond fever, and fans and pressmen swarmed like plagues of killer bees when- ever the film crew set up shop. The intrusion became absurd. Even when Connery went to the bathroom they poked cameras over the door. 'They've followed me into the ruddy toilet,' he complained to *Photoplay* magazine. 'Coming at me like a firing squad. I've never known it like this before. I knew Bond was popular – but this has been incredible.'

After Connery's close encounter with a lens in his toilet all photographers were banned from the set. To make sure this order was carried out the producers hired twelve security guards. 'So the first morning we lined up these security men as Sean's car arrived, six on each side,' Lewis Gilbert recalled. 'Sean got out of the car and suddenly twelve guards whipped out twelve cameras and all started shooting him. Well, that was the end of the security guards.'

Gilbert decided it would make for a great shot to have Connery walking down Ginza, Tokyo's busiest shopping thoroughfare. Gilbert set up his camera in a shop across the street and planned for Connery to emerge quickly from a car and reel off enough film before anyone noticed. 'I called action and Sean got out, got onto the pavement and disappeared; he disap- peared into a mob of people. He had to come rushing back into the car. It was impossible.'

Even the simple act of going out for a meal in Tokyo turned into a Bond-like operation. Everyone would take the service lift to the underground garage, where two cars were waiting, one being used as a decoy. They were then pursued through the streets by carloads of photographers. Finally at the restaurant journalists posing as customers were rooted out and ejected. 'Sean had a terrible time out there,' Desmond Llewelyn confirms, 'but it never affected his work at all. Sean is a complete professional and he would never let that affect his work.'

Things scarcely improved when the crew headed south to Ibusuki, on the far tip of the island of Kyushu. Fans were drawn to even this desolate spot, and despite police checkpoints thousands of them managed to break through. One enterprising local tourist office began organizing a Bond bus tour. After a few days, control was regained and the film-makers were left in peace.

The weather, insufferaby hot and humid, now became the enemy. Connery suffered his usual bout of dehydration. 'I was slowing down without realizing it. They had to pump a pint of saline into me.' With not much to do in the evenings Connery mostly played table tennis with his wife or with Broccoli. For a nation so crazy about golf, it was odd that there was not a single course for miles.

Hating Bond

'I've always hated that damn James Bond. I'd like to kill him.'
In the heady days of the mid sixties Connery was the world's foremost celebrity. But such fame had a price: life came to resemble a freak show for this most solitary and secretive of men. It became almost impossible for him to walk the streets without people calling out, 'Look, there's James Bond.' It drove him nuts. Michael Caine remembers that at the 1965 Cannes Film Festival Connery turned up to publicize The Hill, but was so engulfed by fans and the press that he literally couldn't visit the hotel dining-room for a meal and ended up leaving later the same day.

There had been early warning signs. In 1963 Connery flew into New York accompanied by Terence Young. The waiting scrum of fans at the airport was so great that security, fearing a riot, hustled the pair through a side entrance. One elderly lady broke ranks to ask for an autograph. 'Sean, sign the bloody thing,' urged Young. But the woman took one look at the signature and ranted, 'No! I wanted James Bond.' Heaven knows how Connery remained composed. Young later recalled,'This was the first time this had ever happened to Sean. He kind of crumbled. It suddenly occurred to him that he was no longer a human being, he was a symbol.'

Sure Connery derived great satisfaction from the early success of the Bonds. 'For now I'm reasonably content with what I'm doing,' he told the

Saturday Evening Post. 'After all, I can kill any SOB in the world and get away with it.' But as the franchise grew the burden became intolerable; soon he began referring to the character as his personal Frankenstein monster. 'If you were Sean's friend in those days,' recalls Michael Caine, 'then you didn't mention the subject of Bond. Never.' As an industry insider quipped at the time, 'On the subject of James Bond, Sean's considered the best three-second interview in the business.'

A major thorn in his side was the Bond merchandising boom – toys, clothes and so on. There was around $60 million worth of products on sale in America alone to tie in with *Thunderball*'s release, but Connery's percentage was nominal. It maddened him to see products on sale bearing his image that were making a fortune for the producers, and he began to see himself less as an actor than a 'money-making machine'. As Bond, Connery could have made a fortune plugging alcohol, cars or cigarettes, but to his credit, he's avoided such crass financial gain, on the whole. The only product he endorsed during his tenure as James Bond was Jim Beam bourbon in 1967. More recently he appeared in Japanese commercials for whisky.

Another major gripe was that as 007 got bigger, it became increasingly difficult to plan other projects, because the films were taking longer and longer to make. Huge chunks were being taken out of his life that he felt could be better spent playing more artistically rewarding parts.

Despite this, Connery never once forgot that it was Bond he had to thank for his wealth and star status. 'I admit he's done more for me probably than any character has done for an actor in history.' As critic Dilys Powell summed up, 'Before *Dr No*, one never really thought much about Sean Connery. But after that it established him, it gave him the kind of confidence and self-assurance which any actor needs.' Certainly over the years his attitude has mellowed. Now he looks back on those days more fondly, believing that the early films have 'withstood the test of time'. He even made his entrance on the David Letterman chat show in October 1993 wearing a jet pack (*à la Thunderball*) and escorted by two Bondian hostesses.

Back in the sixties he could sometimes make fun of his 007 image, notably on the occasion he, along with Bruce Forsyth, Dickie Henderson and singer Ronnie Carroll, arrived one night at the Albert Hall for a heavyweight title fight only to discover it was being held over at Wembley. Hailing a cab the entertainers piled inside. Looking in his rear-view mirror the cabby half-recognized Forsyth's face and started scrambling around for his name, an ego-deflating experience for any star. After the third attempt Forsyth said, through clenched teeth, 'I'm Bruce Forsyth.' The cabby, who had yet to see the rest of the gang, wasn't convinced. 'If you're Bruce Forsyth,' he said, 'I'm James Bond.' Connery then tapped him on the shoulder and said, 'No, I'm James Bond.'

On at least two occasions Bond has come to Connery's rescue. On a European promotional tour for *The Offence*, a West Berlin television crew

came up with the idea of filming Connery crossing the Berlin wall at Checkpoint Charlie. Then without warning the actor's driver was hustled away and questioned by East German police. Kept waiting, an impatient Connery finally stormed into the room blaring, 'What the bloody hell's going on here?' From the back of the room emerged a stern-looking Russian major dressed in full uniform. Taking one look at Connery he threw up his hands in horror and surprise. 'No! No! Mr Bond!' Within seconds the driver's passport was returned and everyone could leave. But Connery, the hero of the hour wasn't impressed. 'Bond! Mr Bond they called me.'

Another time, filming *The Man Who Would Be King* in Morocco, Connery was driving alone one night, dressed in jeans and a T-shirt, when he was stopped by the local police. Lacking any ID and on the verge of being arrested, Connery looked both officers in the eye and said: 'Oh, oh *seven*!' It took a few seconds for the words to sink in, but their faces changed to a picture of euphoric recognition. Crisis over.

Casino Royale (1967)

Sean Connery wasn't the screen's original James Bond; that honour goes to Barry Nelson, who played 007 as an American CIA agent in a television dramatization of Fleming's first Bond novel, broadcast live on CBS television in October 1954. Woefully stilted and utterly forgettable, despite the inspired casting of Peter Lorre as the villainous Le Chiffre, most of it looks like the out-takes from an Ed Wood movie. Nelson wasn't too surprised, or unhappy, that the film-makers passed him over for the movie job. 'Connery undoubtedly played a major part in creating the image of Bond that everybody could accept.'

There was also the infamous *Casino Royale*, the novel of which had been sold off separately, so wasn't part of the package purchased by Broccoli and Saltzman. At first rogue producer Charles K. Feldman planned a serious thriller and begged Connery to make the movie once his current Bond contract ran out. Connery quoted his price – one million dollars. Feldman refused.

So the movie entrepreneur decided to go for broke and turn *Casino Royale* into the biggest and most expensive comedy in history. The finished product is a lavish and wretched mess which tries to spoof something that was already on the verge of self-parody. But it is perversely enjoyable and boasts one of the all-time great casts. David Niven and Peter Sellers both play 007, Ursula Andress returns as a Bond girl and Orson Welles is the villain; plus there's a young Woody Allen, as Bond's twisted nephew Jimmy, in a manic performance that predates his early seventies screen persona. There's also a gamut of guest stars – Deborah Kerr, William Holden, John Huston, George Raft, Ronnie Corbett and Peter O'Toole.

Today *Casino Royale* is remembered chiefly as one of the box office turkeys of the decade. Connery bumped into Feldman one evening in London, knowing full well his pet project had gone grossly over budget and he was up to his neck in trouble. The actor couldn't help but ask, 'How did it go, Charlie.'

'I tell you what, Sean,' he answered. 'I wish I'd paid you the million. It would have been a whole lot cheaper.'

The Bond Movies

Dr No (1962)

It was just another movie, and a cheap one at that ($900,000). No one had any inkling they were working on anything special. 'There were times,' Connery confessed, 'when Terence and I were on location and both thinking, "What on earth have we here? Will anyone want to watch?" ' But together with the Beatles, 007 represented the most important entertainment breakthrough since Elvis. Revolutionary in their way, the Bond series changed the way action movies were made, proving that Britain could make films as well as Hollywood and that it had the best technicians and crews in the world.

The cinematic James Bond was born in a telephone kiosk in Kingston airport on 16 January 1962. Bond, suspicious of his chauffeur, telephones a government contact to have him checked out. Connery played this, his first ever scene as James Bond, with just the right hint of cool menace. For the remainder of the shoot he was as dedicated as anyone, doing everything that was required of him and more. 'I think he really said, "This is my chance. I've made a lot of unsuccessful pictures and this is the chance for me," ' recalled Young. 'After we'd been working together for a week I just knew that it was going to click, because he was really interested, he was really trying.'

'Bloody good' was Connery's opinion of the finished film, scenting a hit. 'So I just sat tight and waited.' But like everyone else he never anticipated the huge success or longevity of 007. Backers United Artists were less positive, especially about the film's chances in America, where they guessed a story about an English spy had about as much chance of survival as an ice cube in the Sahara. After a test preview, executives filed out in silence; only one of them spoke. 'Well, the only thing good about the picture is that we can only lose a million dollars.'

The world premiere of *Dr No* was held on 6 October 1962 at the London Pavilion. Connery attended along with numerous socialites, like Paul Getty and Ian Fleming himself. The author said afterwards, 'Those who've read the book are likely to be disappointed, but those who haven't will find it a

wonderful movie.' Critical reaction was mixed. The Vatican condemned it as 'a dangerous mixture of violence, vulgarity, sadism and sex', thus virtually assuring its success. High-brow critics were pompously dismissive. *Films and Filming* called it a 'monstrously overblown sex fantasy of nightmarish proportions'. It was the sex and violence, tame by today's standards, which really got up their noses. The *Daily Express* even reprimanded Bond for not behaving like a proper hero, accusing his methods of being indistinguishable from those of the villains. The *Evening Standard* classed it as 'sadism for the family'. But noted critic Dilys Powell astutely saw *Dr No* for what it was: 'All good and, I am glad to say, not quite clean fun.'

Connery's notices, too, were a mixed bag. The snobbish *Spectator* ridiculed him as being nothing more than a superannuated Rank starlet. The *News of the World* felt he fitted Fleming's hero 'like a Savile Row suit'. Back home in Edinburgh, an old school friend caught the film at his local Odeon. 'That's it,' he said coming out, 'Tommy's made it for life.' Indeed the public lapped it up, turning *Dr No* into the year's second most popular film in Britain. 'We broke every record known,' Saltzman trumpeted to *Weekly Variety* in 1987 about the London opening. 'We held the house record for years. They never saw such business, and the most surprised was United Artists. To them it was a B picture. They hated it. They said, "Hammer makes the same kind of pictures for one-third the price." '

Terence Young puts *Dr No*'s success down to opening at exactly the right time when a particular mood was beginning to envelop Britain – it was the birth of the swinging sixties. 'I think people were getting tired of the realistic school, the kitchen sinks and all those abortions.' Watched today, *Dr No* looks quaintly old-fashioned with its tale of a mad scientist on an island interfering with America's space programme; it's hard to appreciate just the kind of impact it must have had on pre-permissive society audiences.

By the New Year *Dr No* was one of United Artists' biggest ever international hits, but still they dithered over an American release. As one executive said, 'I can't show a picture with a limey truck driver playing the lead.' Finally it opened in May 1963 to positive reviews and healthy business. *Variety*'s verdict summed up the US response: '*Dr No* is a high-powered melodrama . . . a perfect picture of its kind. Bond played by Sean Connery, is handsome, charming, muscular and amusing. Mickey Spillane with class.'

Years later Connery remembers returning to his hotel in Los Angeles after a night on the tiles with Michael Caine and Richard Burton to find *Dr No* playing on the television. He decided to stay up and watch it, only to fall asleep halfway through.

From Russia With Love (1963)

From Russia with Love, like fine wine, just gets better with age. It is the connoiseur's favourite Bond, and Connery himself rates it as the best

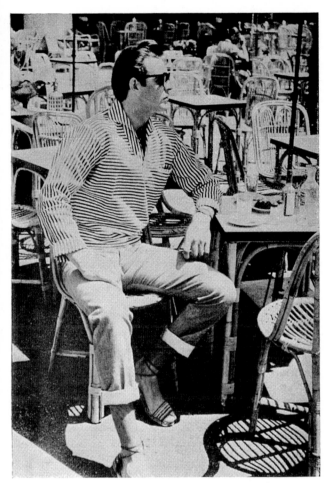

We all have to start somewhere. Connery models clothes as an out-of-work actor in a magazine advertisement

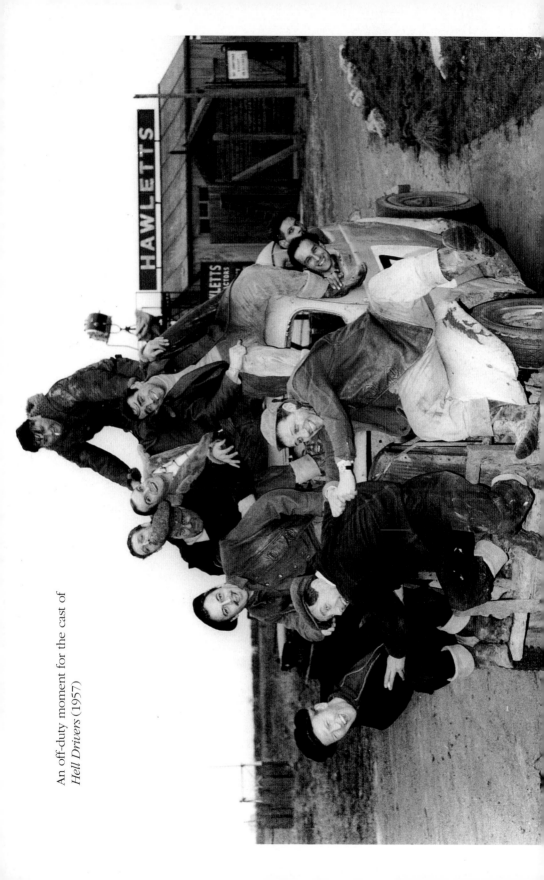

An off-duty moment for the cast of *Hell Drivers* (1957)

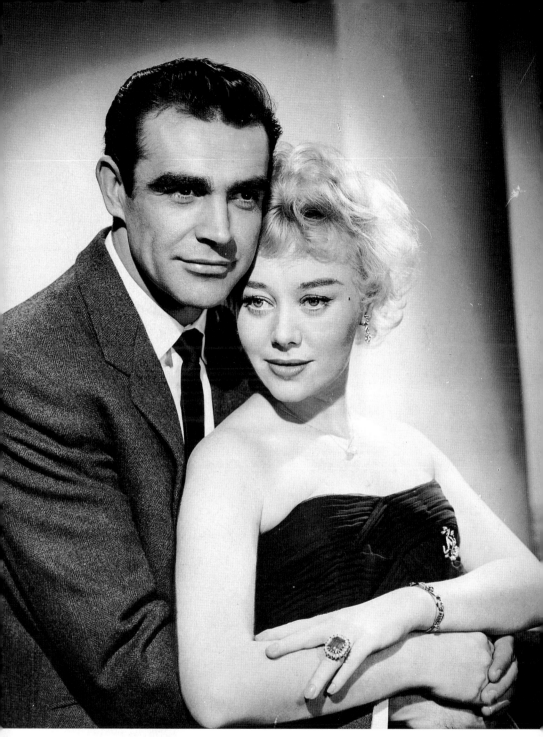

Trying hard to be a Rank matinée idol and failing. With Glynis Johns in tear-jerker *Another Time, Another Place* (1958)

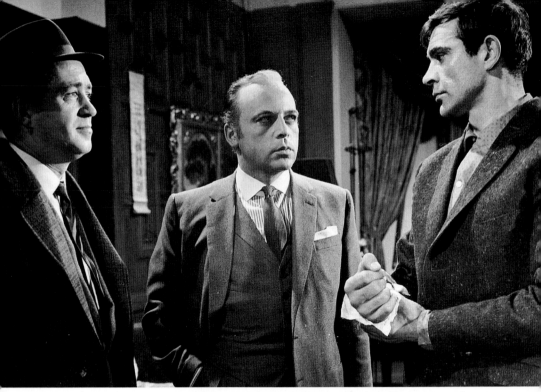

Bond in embryonic form. The cool menace and dark sex appeal – it's all there in *The Frightened City* (1961)

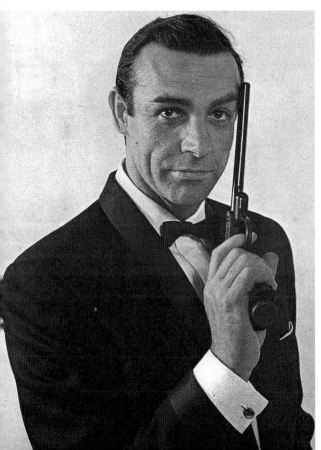

Born to be Bond. Connery strikes the 1960s' most iconic pose in *Dr No* (1962)

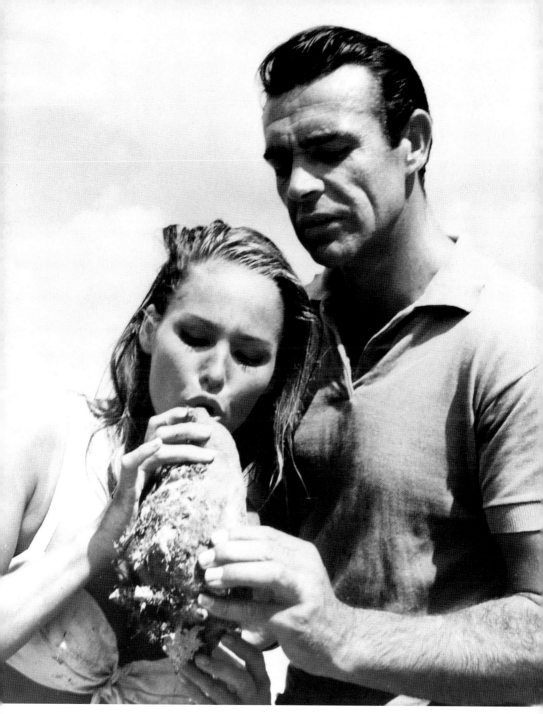

Fancy a blow? Mucking about with Ursula Andress on location in the
Caribbean for *Dr No* (1962)

Hurtling into danger aboard the Orient Express with Daniela Bianchi
in *From Russia With Love* (1963)

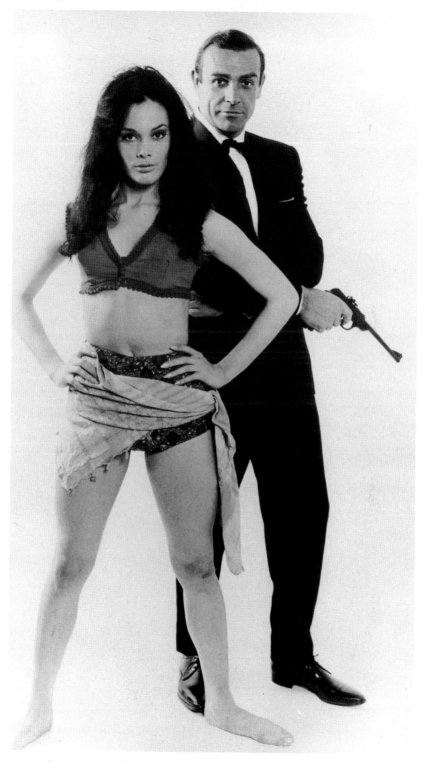

A tuxedo, a gun and a scantily clad woman – the ingredients that turned Bond into a global phenomenon in *From Russia With Love* (1963)

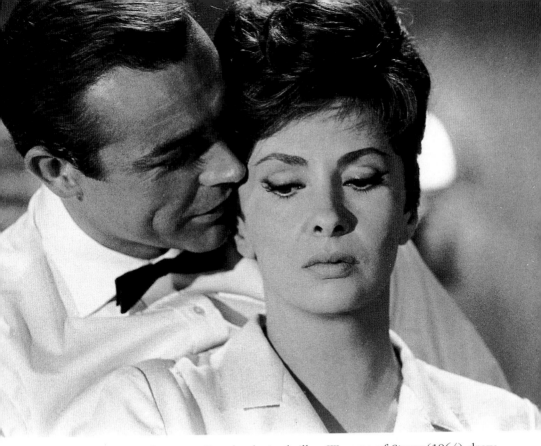

Connery's first post-Bond role in thriller *Woman of Straw* (1964) drew
heavily upon his superspy playboy image

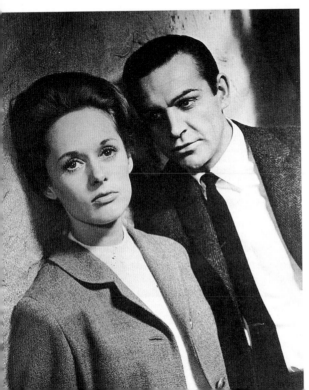

Hitchcock's psychological thriller
Marnie (1964) was shot down
upon release but has re-surfaced
as a minor cult classic

because the plot is more credible than the later ones. 'As the films got bigger, they became more involved with hardware than people.' Yet the film was an unexpected follow-up in that it deviated from the science fiction approach that worked so well in *Dr No*, opting instead for sinister realism and *Third Man*-style intrigue. As such this most 'cold war' of Bond movies remains out of kilter with the rest of the series. The fact that President John F. Kennedy had recently revealed it to be among his favourite ten novels might have tipped the balance in its favour.

To compensate for the lack of 'fantasy' we are given Fleming at his story-telling best. SPECTRE hatch a plot to kill Bond, who is sent to Istanbul to help a beautiful spy defect with a Soviet decoding machine. Moreover, we get to enjoy some of cinema's most hideously eccentric villains – namely Rosa Klebb, she of the poison-tipped shoes, and Red Grant, the psychopathic assassin unforgettably played by Robert Shaw, whose dust-up with Bond aboard the Orient Express must rank among the greatest two-man scraps in cinema history. Connery and Shaw bravely handled much of the stunt work themselves. Never have we feared for Bond's life so much as at this moment, the tension is white knuckle stuff. And there's Vladek Sheybal as Kronsteen, SPECTRE's chess-playing master planner. At first Sheybal turned the part down, dismissing the script as 'rubbish'. Then he got a call from Connery, who blasted down the line: 'You complete idiot! How dare you turn down this part! It was I who suggested you to the producers! You are going to play this part' – before slamming down the receiver. Taking a deep breath, Vladek phoned his agent and signed up.

With a budget double that of *Dr No* and a £1,000 Savile Row wardrobe for Connery, filming began at Pinewood in April 1963. Slightly overweight at the time, Connery was filming the scene when Bond, naked but for a towel, discovers his leading lady waiting for him in his bed. Terence Young suggested: 'Go in and hold your breath and we'll try it again.' To which Connery responded, 'Now I know how Tarzan feels.'

Another time Connery, hoping to add a dash of realism to a fight scene, smeared his jacket with dirt and left it overnight, only to find in the morning that a well-meaning wardrobe mistress had cleaned and ironed it.

Less than two months after completion *From Russia With Love* premiered in London on 10 October. The gala affair drew huge crowds, who watched Connery arrive with his wife and parents, totally overawed by the occasion and the frantic attention their little Tommy was commanding.

Critical reaction was good, though the prudes were amazed it had been granted an A (PG) certificate. 'If Odeon cinemas really think the new Bond is nice clean fun for all the family, then Britain has some pretty kinky families, or soon will have,' preached *Films and Filming*. 'The new James Bond film like its predecessor is an expensive penny dreadful, enjoyably absurd, calculatingly sadistic' – *Sunday Express*. 'Incredible twaddle it may be, but I for one find such twaddle irrestible' – *Daily Mail*. 'The nonsense is all very

amiable and tongue in cheek and will no doubt make a fortune for is devisers.' So declared *The Times*, in what proved to be the understatement of the year. Theatre records tumbled as the movie became the biggest box-office attraction British cinemas had ever known. Bond fan clubs started sprouting up nationwide, the most elite being the 007 Society at Oxford Univesity, whose president visited Pinewood Studios to inform Connery that his members heartily approved of his portrayal of their hero.

The homegrown success of *From Russia with Love* was nothing to what was achieved abroad. 'Cannot miss,' announced *Variety*. 'It's a preposterous, skilful slab of hard-hitting, sexy hokum.' After receiving its US premiere at the Astor in New York on 8 April 1964, it went on to become the most successful ever British film at the American box office, scoring a mighty $24 million gross.

Slicker and more technically accomplished than *Dr No*, *From Russia with Love* also broke new ground: it introduced the pre-credit sequence; John Barry made his debut as composer; and Bond's lethal attaché case started the trend for ever more outrageous gadgetry. Connery's performance is also a revelation; ironing out the rough edges visible in *Dr No* he achieves a predatory coolness that after thirty years has lost none of its power to impress.

Goldfinger (1964)

One of the stylish Bonds, combining the chic fantasy of *Dr No* with the pacy tension of *From Russia with Love*, *Goldfinger* perfected the Bond formula.

But trouble was brewing. By 1964 Connery was already tiring of the Bond role and the attendant fan worship, though he never allowed personal problems to corrupt the working atmosphere on the set. 'Sean was never less than totally professional,' Burt Kwouk, cast as a Chinese Red Army villain, once told me. 'On the factory floor he had a job to do which he simply got on and did. He's one of the great cinema actors, one of the all-time heroic stars.'

To ease Connery's pain a new pay structure was introduced, £50,000 plus a 5 per cent cut of the profits. Having just returned from filming with Alfred Hitchcock in Hollywood, Connery had grown appreciably in stature and confidence, and his performance in *Goldfinger* was the most accomplished yet. A wonderful exhibition of cosmopolitan cool and casual send-up, he simply glides effortlessly through each frame – you hardly notice he's acting. Audiences lapped up his new sexually brutish escapades, apparently unfazed by the film's celebration of a hedonistic, amoral and violent lifestyle.

Designer Ken Adam nearly steals the show. His wonderfully stylized set of Fort Knox, where master-fiend Goldfinger plans to detonate a nuclear bomb, is a veritable cathedral of gold and a production triumph. But *Goldfinger* is a film crammed with genre-busting highlights. There's Oddjob, played by wrestler Harold Sakata, who in delivering a karate chop behind

Bond's neck as he squats at the fridge almost laid Connery out cold. 'He wasn't quite used to the cinema technique of taking it to the wire and then stopping,' revealed Connery. We also have the Aston Martin, Pussy Galore and the gold-plated Shirley Eaton. 'Sean was a dream, so kind and courteous and, of course, so terribly handsome,' Eaton told the *Mail On Sunday* in 1995. 'Many of my girlfriends were desperately jealous because I got to kiss him.' Eaton also once revealed to me that Connery stuck around the set to watch the filming of her gold-painted body. 'He was fascinated with the whole process.'

The Bond team really hit the jackpot with *Goldfinger*. 'It's the year's best piece of escapist hokum,' according to the *News of the World*, and the *New York Daily News* thought it 'The best and the wildest.' Perhaps the *Observer* summed it up most ably: 'We may look back 20 years from now and realize this was the brassy, swinging, ungallant taste that the 60s left on the tongue.' A summer blockbuster in Britain, *Goldfinger*, when it opened in the United States in time for Christmas, became the fastest-grossing film yet produced, making an awesome $51 million – not bad for an outlay of $2.9 million. *Playboy* hailed James Bond as the hero of the age and Connery the man of the decade. Even the Queen Mother sidled up to Connery at a function to tell him *Goldfinger* was one of her favourite movies.

There was only one problem: how do you follow that? The producers opted for bigger budgets, bigger explosions, bigger boobs, bigger everything. Bond screenwriter Tom Mankiewicz believes the introduction of the Aston Martin sealed Bond's future. 'I think the minute Sean pressed the button on the ejector seat and the audience roared, the series turned around.' As the films grew in popularity, so did the pressure and expectation increase to outdo the last one for action and spectacle. Connery, meanwhile, was weary of the obsession with gadgetry, but resigned to the fact it was what the public wanted.

One summer, when Connery's granddaughter was staying with him in Marbella, she asked if they could watch a Bond movie. Putting on a tape of *Goldfinger* he sat back to watch it with her. 'It was interesting. I'd only seen it once before when they were putting it together and I liked it better this time. There was a certain elegance, a certain assurance to it. Of course, I also saw things that could have been improved.' Back in the sixties Connery rarely caught any of his 007 movies at the cinema. 'It was always pandemonium.'

Thunderball (1965)

When the time came for Bond number four there was one slight problem: somebody else – Kevin McClory – owned the film rights to the original Fleming story and was setting up a rival movie. Richard Burton was reportedly interested in playing Bond. 'I think he must be out of his mind,' said

Connery. 'It would be like putting his head on a chopping board. Whatever he did couldn't make the films more successful than they are.' Deep down McClory really wanted Connery, and the only way to get him was to join forces with Broccoli and Saltzman, providing afterwards he agreed to relinquish all rights to the *Thunderball* property for a period of ten years.

Shooting got underway behind closed doors in February 1965 at the historic château D'Arnet near Paris, where Bond escapes superman-style from pursuing goons in a jet pack (on loan from the US army) during the blistering opening sequence. Production next moved to the Bahamas, when our James begins his search for two nuclear bombs stolen by perennial baddies SPECTRE. Nassau was certainly the place to be in 1965, just prior to the Bond circus hitting town The Beatles had been busy shooting *Help* on the island.

Bond's love interest this time was a former Miss France, Claudine Auger, who beat off stiff opposition from Raquel Welch and Faye Dunaway. She was thrilled to be working with the 007 star. 'Connery is the modern hero of the world – a fine actor, strong, cruel, hard, but capable of great tenderness – a real man. We have nothing like him in France.' On location they hit it off wonderfully. 'He was just like a brother to me.'

All round it was a fun picture to make, if strenuous. Terence Young, back behind the camera, liked to create an atmosphere of sophistication on the set, and though most of the whopping $5.5m budget is up there on-screen, mostly in the guise of hi-tech underwater craft and a luxury yacht that turns into a speedy hydrofoil, an awful lot of it also went down the necks of the cast – champagne ran like tap water.

Both Connery and Young later voiced dissatisfaction with the film. Young believed that the predominance of underwater sequences slowed down the action, while Connery felt they'd reached the limit as far as spectacle and gimmicks were concerned and hoped that next time the emphasis would be more on characterization. Critics agreed, regarding Bond's future as being little more than a showroom dummy. Connery was also convinced Bond could last no more than five or six pictures.

Yet the public's thirst for 007, far from waning, hit its zenith during the Christmas and New Year release of *Thunderball*. In terms of 'bums on seats' its performance has never been equalled by any other Bond epic, some cinemas in America having to stay open twenty-four hours a day to cope with demand. In London, meanwhile, there was not one but two premieres, though one notable star was absent: Connery, who preferred staying at home. Fans had to make do with huge photographs of their idol, which were torn off the cinema hordings. The final US box-office gross of $63 million puts *Thunderball* right up there with *Gone with the Wind* and *Star Wars* as one of the all-time movie hits.

Critical reaction was good. 'Cunning, heartless, extravagant, shamelessly mid-60s', *The Times* called it. The *New York Times* placed it in their ten best

of the year list alongside more revered works like *The Pawnbroker* and *Kwaidan*. Connery himself graced the cover of *Life* magazine, *Esquire* and the *Saturday Evening Post* and made his debut in America's star poll at number one beating Elvis and John Wayne. There was also a television special, *The Incredible World of James Bond*, which proved a ratings winner in the United States. Connery – to no avail – was offered a huge wad of cash to act as host of the programme, which was being sponsored by Pepsi. Hollywood legend Joan Crawford, herself a Pepsi director, even phoned Connery personally in an effort to change his mind. 'I told her she was wasting her time, there was nothing to talk about.'

Connery really is at his super-cool best in *Thunderball*, prowling around each scene like a sexual predator, safe in the knowledge that the opposition didn't stand a cat in hell's chance. It's one of the most knowing and self-assured performances of the decade. The script, arguably the wittiest of the series, allowed him ample room to demonstrate his now utter mastery of the throwaway line.

You Only Live Twice (1967)

Before a frame was shot on the new Bond, Connery had already decided to throw in the towel. 'I'm finished,' he announced. 'Bond's been good to me but I've done my bit. I'm out.' He was turning his back on the biggest entertaiment franchise in history and didn't give a damn; so fed up had Connery become it was probably the easiest decision he ever made. There was simply no challenge left in playing the same character *ad infinitum*. Watching the movie, you can tell his heart just isn't in it; he's like a worker waiting for clocking-off time. Most critics agreed. 'Bond, you are getting to be a bore,' the *Sun*. 'The Bond formula has now been run into the ground and only requires a headstone,' chipped in the *Evening Standard*, whose critic wasn't bothered about Connery's threat to quit. 'I'm sure Ken Adam could now run up a robot Bond to replace him.'

Broadcaster Alan Whicker, watching filming from the periphery with a documentary crew, noted how Connery seemed to have 'abandoned his fierce professional concentration' and was almost indifferent to the film's progress. 'At Pinewood I noticed he retreated to his dressing room whenever possible . . . to practice putting.' Having said that, Connery even on autopilot, delivers the goods, and the film itself is hugely enjoyable. Director Lewis Gilbert assured me that he had had no problems with Connery during filming and that he remained professional throughout.

The space age plot of *You Only Live Twice*, which has SPECTRE hijacking Soviet and US rockets in a bid to start a global war, was the first radical step away from the Fleming origins. With a script courtesy of Roald Dahl, who at first found the idea of writing a Bond screenplay 'exceptionally distasteful', the emphasis was on hardware: *You Only Live Twice* is simply

awash with gadgets and gizmos. Connery himself wondered just where the series could possibly go from here. 'Apart from into space or something, which is a whole different ball game.' I wonder what he thought of *Moonraker* – not a lot, I suspect. The film's highlight is the breathtaking volcano set, baddie Blofeld's latest headquarters, which for style and sheer audacity has never been equalled. Built on the backlot of Pinewood for a million dollars, the equivalent of the entire budget of *Dr No*, it amply demonstrated how far Bond had travelled in five years.

The world premiere of *You Only Live Twice* on 12 June was memorable for two of its guests: Connery, making his first London Bond premiere appearance since 1963, replete with a thick Mexican-style moustache; and the Queen, who upon meeting the actor asked sincerely, 'Is this really your last James Bond film?' To which Connery dutifully replied, 'I'm afraid so, ma'am.'

In America, where the film enjoyed a four-theatre premiere in New York, takings were lower than *Thunderball*, but grand enough to make it the second-highest money maker of 1967 after *The Dirty Dozen*.

Diamonds Are Forever (1971)

Off-duty and dressed in a blue T-shirt, Sean Connery – 'looking middle-aged, more like beer and television than diamonds and dames,' as one critic saw it – saunters past a queue of people waiting to see a Dean Martin cabaret in one of the plush Las Vegas hotels. Nobody notices him. He then goes over to play on some slot machines; still no one pays the slightest attention. The next day, dressed in his white tuxedo and ready for shooting, looking every inch like 007, Connery turns everybody's head.

After the comparative box office failure of *On Her Majesty's Secret Service*, Broccoli and Saltzman were desperate to regain Connery's services, at any price, or witness the Bond franchise go down the pan. Not on speaking terms with the star, they gave the mission to colleague Stanley Sopel. Over drinks at London's Dorchester Hotel Connery laughed off the idea of returning.

The man who finally lured Connery back was David Picker, head of United Artists. With production on the latest Bond looming he personally took charge of the situation and got Connery on board. 'They dangled the right carrot in front of him,' says Sopel, 'and Sean bit it.' Just in case, Broccoli had already hired American actor John Gavin to play Bond; he was eventually paid off. Even Burt Reynolds was under consideration. Flattered by the offer Reynolds passed. 'I'm a big fan of Connery,' he said, 'and I knew one thing, I'm the best Burt Reynolds there is, I don't want to be the next best Sean Connery. I could never do Bond better than he did.'

Connery came back for one reason – money! He swallowed his pride and made a killing: $1.2 million, which he donated to charity, and a 10 per cent

slice of the profits. The package also included a promise by United Artists to back two films of his choosing, which he could either direct or star in. The deal was an actor's dream and earned Connery a place in the *Guinness Book of Records*; no star had been offered such riches before. One of Connery's pet hates about the Bond movies was that they always took too long to shoot, so he weaved in a personal clause stating that if production overran its allotted eighteen-week schedule he'd be paid $145,000 for each additional week. Needless to say, *Diamonds Are Forever* finished bang on time. 'It can be done, you see, if there's money at stake,' Connery pointed out.

Happy to be making the movie as a glorious one-off, almost an act of exorcism, Connery was determined to have a ball. And it's evident in the performance; that old sparkle, largely absent in *You Only Live Twice*, is back again. Journalists picked up on Connery's buoyant mood, as well as the fact that he was no longer the spring chicken of his *Dr No* days. His waistline was thicker, he was fuller in the face and his toupee came replete with realistic grey streaks. But returning after four years, he felt fresh and revived and threw himself into the part, performing many of his own stunts. He even enjoyed himself on location in Las Vegas, spending his spare time on the golf course, where he was ferried to and from the Bond set by helicopter. He also caught some of the big-name shows – and even chanced his arm in the gambling halls, throwing the odd die or tugging at a one-arm bandit. 'There are no clocks,' he reported. 'On my first week on the film I only got seven hours sleep. Time means nothing in this town. It's madness.' He even liked the finished product, despite a plot that baffled many with the combination of diamond smuggling, Blofeld doppelgängers and a laser-firing satellite.

Prior to release, critics speculated whether a seventies audience would buy the Bond formula as readily as they did in the sixties. Connery was in no doubt that the public's appetite for escapism 007-style would always remain and he was proven right. *Diamonds Are Forever* stormed box offices during Christmas 1971, and its performance in America would not be bettered by any other Bond until 1995's *GoldenEye*. Audiences roared their approval when Connery delivered his immortal 'My name is Bond . . . James Bond' line. Critics raved too. 'Connery proves yet again that he is irreplaceable as Bond,' cheered *Monthly Film Bulletin*. The *New York Times* agreed. 'Great absurd fun (and Connery's return) is enough to make one weep with gratitude.'

The Connery/Bond chemistry had worked again, ensuring the long-term survival of the 007 series. Indeed, the light-hearted tone of *Diamonds Are Forever* paved the way for the Roger Moore era. Connery agreed with director Guy Hamilton that after the solemn *On Her Majsty's Secret Service*, the new Bond needed to be punchier and more humourous. Conscious of the inevitable drift towards all-out comedy Connery played the whole thing for laughs, sending up his own Bond image with great aplomb.

Offered the world to return one more time, Connery was delighted to

refuse. As one studio executive commented, 'Well, you've got to admire the bastard.'

The Warhead Files

Nineteen seventy-five was the year of the McClory resurrection. The Irish producer, having promised to relinquish all rights to the *Thunderball* property for a decade, knew that the time was now up. He lost little time in forging ahead with a rival Bond project co-scripted by author Len Deighton, creator of Harry Palmer, the kitchen sinks answer to 007.

Kevin McClory knew Connery didn't fancy playing 007 again, but hoped he might get involved in a creative capacity. Who else on the planet knew more about the character of James Bond? Surprisingly Connery agreed to McClory's request; when he heard of Deighton's involvement his enthusiasm was fired. The three men worked as a team in Ireland and Marbella over the course of four months. What emerged was a screenplay, entitled *James Bond of the Secret Service*, which made headlines around the world. 'It was a tremendous experience working with Sean,' McClory told 007 fanzine *Bondage* in 1979, 'because he did not contribute just throwaway lines, he also got involved in the construction of the plot, and he's a very good story teller. He writes visually. He made enormous contributions, and we all got on very well.'

It was a stroke of genius on McClory's part to rope in Connery. Not only was it good for business, adding *kudos* to his project, but as McClory must have hoped, Connery found a growing affection for the character he had so resolutely spurned years before. As work on the script blossomed, it wasn't long before Connery announced his intention of returning. McClory likened his decision to a 'prestige-fit' Muhammad Ali challenging the present world champion.

James Bond of the Secret Service was slated to go before cameras in 1977 on locations as far afield as Nassau, New York and Japan, with the backing of Paramount. 'If you can visualize *Star Wars* underwater, you'll get some idea of our story,' trumpeted McClory. Snippets of plot included SPECTRE being responsible for lost aircraft over the Bermuda Triangle, audacious schemes to infiltrate Wall Street and to melt the Antartic ice cap.

Then nothing, save writs, legal battles, suits and countersuits between McClory and Broccoli, which kept lawyers in lobster thermidor for years. Connery, perhaps naively, was under the impression that the project was litigation-free, and when he saw packs of lawyers descending, decided to head for the hills. 'The legal factors were harder to go through than to make the film. I said, "That's enough!" And I walked away from it.'

But rumours of Connery's return to Bond persisted; for the next five years it was a case of 'will he or won't he?' The McClory/Deighton/Connery

script had since changed into *Warhead*, a much snappier title, and names like Richard Attenborough, Bond veterans Peter Hunt and Terence Young, even Connery himself were talked up as possible directors. As for casting, Orson Welles was allegedly being slated as Blofeld, with Trevor Howard as M.

Warhead became one of the great 'if onlys' of cinema; the court battles dragged on for so long that the project had appeared to have died on the vine of litigation. Until a miraculous rebirth.

Never Say Never Again (1983)

It was Connery's wife Micheline who prompted her husband's comeback. 'Why not play the role?' she badgered him. 'After all these years it might be interesting.' The more he mulled it over the more enthusiastic he became. Micheline also coined the ironic title, which Connery hoped would pre-empt 'all the bullshit that will be written about my coming back'.

Having fought so hard to escape the Bond image why, people were asking, was Connery so willing to return? Was it purely the $3 million fee, or sweet revenge against old boss Broccoli, who fought all the way to get the film banned? Maybe it was just a bid to boost a career that had recently suffered a succession of flops. Whatever the reason, Connery certainly had a twinge of curiosity about playing the old chap again.

The man responsible for Connery's comeback was producer and former entertainment lawyer Jack Schwartzman, who bought Kevin McClory's oft-postponed *Waterhead* project, acquired independent finance and commissioned a new script, which went through ten rewrites and still stank. Sitcom masters Dick Clement and Ian La Frenais of *Porridge* and *Likely Lads* fame, were personally brought on board by Connery to add a little more British-style humour; they did much the same job years later on *The Rock*. Much to Connery's public chagrin both writers were denied a screen credit.

Schwartzman hoped to open his movie in direct competition with the official Bond *Octopussy*, leading to press speculation of a growing feud between Connery and Roger Moore. 'The press has concocted the story that it's war between the two Bonds,' said Connery. 'It makes good reading, sure, but it's untrue and unfair.' Both actors remained on friendly terms throughout. And though most magazine polls conducted around the time placed Connery ahead of Moore in popularity, he privately cared little for the honour.

With success or failure resting almost solely on his shoulders Connery claimed control over virtually every facet of pre-production. One key decision Connery made was to insist that the characters not be eclipsed by gadgets, and the cast he assembled is the film's true saving grace. Klaus Maria Brandauer, whom Connery rated as one of the best actors in Europe, plays the ever so slightly deranged Largo. Kim Basinger, then practically unknown, and Barbara Carrera, whose extravagant performance as a sexually warped

murderess almost steals the show, form the above-average female support. Connery was also behind casting black actor Bernie Casey as Bond's CIA buddy Felix Leiter.

Never Say Never Again was a glamorously global shoot. The $34 million movie kicked off in September 1982 at locations around the South of France, including the famous casino in Monte Carlo. Then it was off to the Bahamas, where Connery showed considerable courage diving to a sunken vessel on which his co-stars were a school of six-foot Tiger sharks.

Alas, filming wasn't the joy Connery hoped it might be. In Schwartzman he felt the film was encumbered with a producer that was 'totally incompetent, a real ass. In the middle of everything he moved to the Bahamas with an unlisted number. It was like working in a toilet. I should have killed him.' So instead of basking in his return as Bond, Connery ended up getting embroiled in every decision. 'There was so much ineptitude and dissension that the film could have disintegrated. The assistant director and myself really produced that picture.' He even occasionally took personal charge of scenes from director Irvin Kershner. 'Well, I'd done six Bonds and this was his first,' Connery excused. The whole experience left him drained and disillusioned. He even contemplated writing a book about the whole wretched mess but didn't fancy dredging up such bad memories again. Instead he spurned all offers of work, including an absolute fortune to play Bond again, to take a long and deserved sabbatical, the longest of his career, and didn't make another film for three years.

The anticipated box-office showdown between the two Bond camps never materialized. *Octopussy* was given a clear run at the summer box office, leaving *Never Say Never Again* to debut Stateside in October, where it was greeted almost like the coming of the new Messiah by reviewers. Noted critic Roger Ebert hailed this comeback as: 'One of those small showbusiness miracles that never happen. There was never a Beatles reunion. But here, by god, is Sean Connery as Sir James Bond.' The *San Francisco Chronicle* believed the movie fell 'only a desperate hair short of being the best Bond movie in recorded history'. But in 1983's battle of the Bonds, despite grossing over $100 million worldwide, *Never Say Never Again* lost out to *Octopussy*; that must have rankled with Connery.

The premiere in London was a real sixties throwback with guests as diverse as Ringo Starr and Harold Wilson, while this response from *Starburst* magazine was typical of the critical reaction. 'A definite hark back to the halcyon days of the Fleming series . . . superb entertainment.' But *Never Say Never Again* is anything but a return to the glory days; all too often it resembles some clapped-out television spy movie. It just doesn't feel like a Bond movie and isn't in the same league as the film it purports to be remaking – *Thunderball*. Kershner admitted approaching the project as if there had never been another 007 movie, and maybe that was the problem.

Connery's performance more than compensates for the film's titanic

flaws. He's a joy to watch, an 007 for the bureaucratic eighties; plucked from semi-retirement once again to save the world, he's the last hero in a society run by computers and technocrats. At the film's close we leave the real James Bond enjoying his retirement in paradise with Kim Basinger.

Incredibly, in 1997 rumours circulated of yet another *Thunderball* remake, with Connery returning as Bond. This time Dean Devlin and Roland Emmerich, the producer/director team behind *Independence Day* and *Godzilla* had the backing of entertainment giants Sony, who hoped to start their own rival 007 series. The inevitable result was yet more court cases and the legal locking of horns.

That Connery was almost in his seventies didn't seem to deter anyone. 'Sean Connery has been approached and he is very interested,' a studio source hinted to the press. 'It is a question of money – they have the money and they will get him.' Many in Hollywood welcomed the news. 'I don't care how old Connery is,' said esteemed writer Robert Towne. 'I'll guarantee you'll have a hit if you cast him again.' Others were not so charitable. US chat show host Jay Leno joked that the new Connery Bond movie would be titled 'Octo-prostate'.

By October 1998 rumours of Connery's return were mounting, despite the best efforts of MGM/UA, the official Bond franchise holders, to halt Sony attempting to make their own 007 movie. One newspaper reported that *Doomsday 2000*, as the picture would be called, was due to start filming in January 1999 in Britain, Australia and the Bahamas, with Lois Maxwell having already signed to reprise her role as Miss Moneypenny. Wisely Connery declined to comment on the gossip that linked him yet again to a return to Bondage. He could just have said: 'Never say never again.'

The Bond Stars

Ursula Andress

She is the epitome of the Bond woman, the original and the best. She's also Connery's personal favourite and they've remained close friends ever since. He never fails to visit her whenever he's in Rome, where she now lives. 'What I like about Sean,' Andress has said, 'is that he's still the same down-to-earth person he was when he was unknown.'

It was her vital statistics that won Andress the role of Honey; Broccoli practically flipped when he saw a photo of her wearing a wet T-shirt. But she didn't want to do *Dr No*; it was her husband, the actor John Derek, who talked her into accepting the offer. Even after finishing the film she was hardly anticipating it to be a hit. 'I've just been in Jamaica enjoying the sun,' she told an actress friend, 'doing this crappy thriller with Sean Connery. It was ghastly. Absolute crap.'

Connery was as knocked out by Andress as Broccoli had been, comparing her beauty favorably with another pin-up of his, Ava Gardner. Not for nothing was Andress once described as 'the most awesome piece of natural Swiss architecture since the Alps'. Connery even tried persuading the producers to give Andress a cameo role in *From Russia with Love*, but without success, much to the actress's disappointment. Never mind, she had to content herself with being one of the great sex symbols of the sixties, her cold, classical beauty exploited in films like *She* and *The Blue Max*. Though her subsequent films failed to fulfil her promise.

Bob Simmons

One of the all-time great stuntmen, Bob Simmons was Connery's action double on the Bond films. That's Simmons and not Connery who performs the opening gun-barrel walk in the first three Bond movies and whose shoulder the tarantula crawls over in *Dr No*. Together they worked closely to make sure the fight scenes were as good as they could be, toiling in the studio sometimes until ten o'clock at night. 'We'd stay there on the set with just the house lights on, when everybody else had gone – just the nightwatchman was there,' remembered Simmons. 'Sean was so keen, so good.'

Simmons also handled the stunts and horse riding on Connery's first Bond breakaway movie *Shalako*. Arriving on location two weeks early for riding lessons under Simmons's tutelage, Connery applied himself with customary dedication and became a competent horseman – a skill that came in handy in later historical epics like *Robin and Marian*.

Lois Maxwell

The screen's one and only Miss Moneypenny first met Connery in Cubby Broccoli's office. 'He had that wonderful atmosphere of menace. But he was still a poor young actor in rumpled corduroys who looked like he lived in a bedsit.'

In 1964, during a party thrown by the Bond producers to launch *Goldfinger*, Lois Maxwell detected a personality shift: Connery was now very much his own man. She watched perplexed as he guzzled down caviar using a large serving spoon. 'Sean you mustn't eat from that.'

Connery didn't see the problem. 'I can have caviar whenever I want now,' he answered back.

'I think he was serious,' said Maxwell. 'I don't think he was drunk. I've never seen Sean drunk.'

Filming *Goldfinger* Maxwell complained to a journalist that all Bond ever gave her was a passing peck on the cheek. Connery overheard and on the next take grabbed the actress and gave her a huge kiss full on the lips. The action was printed and later given to Maxwell as a birthday gift.

In 1967, along with other Bond regulars like Bernard Lee, Maxwell appeared in *Operation Kid Brother*, the infamous Italian Bond rip-off starring Connery's younger brother Neil. When Sean found out he hit the roof, feeling it was tantamount to betrayal, despite Maxwell's protestations that it paid better than all her Bond appearances put together. The next time they met was on *Diamonds Are Forever* and Connery offered to give her a lift home one day after shooting. During the journey he passed on how his brother had told him what a good sport she'd been on that movie, looking out for him, always on hand with advice, and he took the opportunity to thank her. 'He's a wonderful man. Really, a darling. I liked him very much and he had a nice off-beat sense of humour.' Maxwell ended up feeling let down when Connery failed to cast her as Moneypenny in his Bond comeback *Never Say Never Again*.

Once asked the eternal question, Sean or Roger Moore? by the *Mail on Sunday*, Maxwell replied. 'There is a hint of danger in Sean that isn't in Roger. If I had my chance, I would like to be married to Roger and have Sean as a lover.'

Desmond Llewelyn

A highlight of every Bond movie is gadget master Q's usually tetchy encounter with 007. Here was a true case of art imitating life, for when these scenes were shot Connery, in character, never listened to poor old Desmond Llewelyn trotting out his dialogue, and would instead fiddle endlessly with the props. Q's immortal line, 'Pay attention 007', was born out of Llewelyn's frustration with the actor. 'That line wasn't originally in the script. I said it in *Goldfinger* because Sean was putting me off.'

In interviews Llewelyn never allows himself to be drawn on naming his favourite Bond actor, wriggling out of it by arguing that each one brought different qualities to the role. 'Connery probably had the most sex appeal and he was undoubtedly the best fighter of them all.' He never hesitates, however, in naming *From Russia with Love* as his favourite of the series. 'I just think it was an extaordinarily good film. I think Sean was at his best. I think it's a classic. It just has everything in it.'

George Lazenby

As *On Her Majesty's Secret Service* neared production Broccoli and Saltzman still hoped to change Connery's mind about quitting the Bond scene, but their efforts were in vain. Connery wouldn't budge even for a million dollars. In the end they chose a complete unknown for his replacement, a male model from Australia called George Lazenby. Very much in the Connery mould, Lazenby, on hearing about the Bond auditions, bought a suit from Connery's tailor and cheekily procured a Bond style haircut at

Broccoli's very own barber's before gatecrashing the producer's office. Like Connery before him it was Lazenby's nerve that landed him the job.

Prior to shooting Lazenby was subjected to probably the worst thing the producers could have done – sticking him in a screening room for days on end, watching old Bond movies *ad nauseam* until he literally fell asleep. Despite such intimidation Lazenby did a laudable job as 007, handling the action scenes particularly deftly. 'I felt he had a fair crack at it' was Connery's view. 'But it was wrong to expect someone with so little experience to cope with the part.' Ultimately his greenness did show. 'Sean should have done *On Her Majesty's Secret Service*,' Lazenby himself confessed in 1978. 'It would have been beautiful.' Desmond Llewelyn agrees. 'The real tragedy is that Sean didn't do it. It would have been the greatest Bond film of them all.'

Ostracized by the industry after his Bond flop, Lazenby tried his luck in Hong Kong appearing in several low-grade Kung-fu movies. When work dried up Lazenby forged a new career as a property developer and became a millionaire.

Roger Moore

When Moore signed to play Bond in *Live and Let Die* he met with director Guy Hamilton over a lunch of oysters and martinis at a fancy Mayfair eatery. Here Moore confessed that when reading the script all he could hear was Connery's voice saying: 'The name is Bond, James Bond.' He was even rehearsing his lines with a put-on Scottish accent. 'Look, Sean was Sean and you are you,' Guy reassured him, 'and that is how it's going to be.'

Moore also lunched with his young son Geoffrey before jetting off to start filming. Sitting in the packed restaurant Geoffrey, preoccupied as most children are about whether their dad is bigger and stronger than other people's dads, asked, 'Can you beat anybody up in here.'

Looking around, Moore reckoned his fellow diners to be a weedy lot, so replied, 'Sure, I could beat up anybody here.'

Then the questioning got a little tougher. 'Supposing James Bond came in.'

Swelling with pride Moore replied, 'Well actually, I'm going to be James Bond.'

'I know that,' Geoffrey sighed impatiently, 'but I mean the real James Bond, Sean Connery.'

Asked for his thoughts on Moore's debut Connery, who actually predicted that the former *Saint* star would be his successor, answered: 'It was a trifle lightweight, but I thought Roger was very good and very funny. He is an old friend of mine and I wish him great success.' As the series progressed Connery saw a clear pattern emerging: increasingly it seemed as though all the stunts were dreamed up first then the story was built up

around them. 'I tried for a more realistic, credible film within the realms of possibility.' Even *For Your Eyes Only*, which Connery agreed at least attempted to revert back to the old style, was spoilt by too much flippant humour.

In 1983 rumours circulated that Mel Gibson had been offered the Bond role. 'As a replacement Mel would be ideal,' Connery said. 'Then Roger could play Q and I could play M.'

At Connery's BAFTA Tribute award ceremony in 1990 Moore was on hand to pay a typically light-hearted tribute. 'For me it was an honour, Sean, to fill your shoes, and if you've got any other old ones lying around I'd be very grateful.'

Timothy Dalton

Dalton is seen by many die-hard fans as the one who came closest to playing Bond as he was originally written. His casting was welcomed by Connery, too, who saw him as a tremendous actor with a real chance of asserting his personality in the face of proliferating hardware. Dalton was happy to pay homage to his precursor. 'I thought Connery was superb, completely believable, very masculine. He originated it and he *was* it.' Dalton was actually a possible Bond candidate as far back as 1970. 'I was very flattered, but I think anybody would have been off their head to have taken over from Connery.'

Ultimately though, Connery felt Dalton didn't quite get a handle on the role. 'Timothy played it too seriously in the wrong way.' He also criticized the way both Dalton Bond movies were handled; in his view they were too politically correct, 'not quite dirty enough'.

Around the time of *Licence to Kill*, Dalton's second and last Bond appearance, Connery was inevitably being asked whether he'd ever consider playing Bond's father, having just scored such a hit as Indiana Jones' dad. His reply was typical: 'Well, why not? If the part is well written. But it would cost them. It would definitely cost them.'

Pierce Brosnan

Connery welcomed the casting of Brosnan, as he had Timothy Dalton. He even offered some advice to the new makers, suggesting they inject more humour in the stories, something he felt the Dalton Bonds lacked. 'And I suggested that they get Quentin Tarantino and get an original script by him. That would have a different slant.' Rumours also linked Connery with a possible role as the villain in Brosnan's 007 debut *GoldenEye*. 'I don't know how that started,' Brosnan said to *Sci-fi Universe* in 1996, 'but it would be great if he did. Maybe if I prove myself then he just might do it.'

Brosnan doesn't hide his complete awe of Connery, both as a man and an

actor. 'He created such a cinematic icon and in the 60s there was no one that stood on the screen like him. I think he was the best Bond. He's the man. The first I ever saw. To get up there with Connery, that's the goal.' Since the phenomenal success of his first two Bond outings Brosnan has become one of the decade's biggest stars.

The Bond Directors

Terence Young

With the possible exception of first wife Diane Cilento, no one had more influence over Connery in his early Bond days than Terence Young. In the words of Bond editor Peter Hunt, 'Terence was the water that made Sean grow.'

After Bryan Forbes and Guy Hamilton said no to *Dr No*, it was journey-man director Terence Young who stepped into the breach. 'So they've decided on you to fuck up my work!' was Ian Fleming's classic response to the news. Actually, Young and Fleming were cast very much from the same mould: both were real-life Bond characters, well-educated men of a certain class who knew how to order the best wines. As Fleming created the literary Bond in his own image, so Young set about creating the screen Bond after his own, making him cooler than a dry martini in a breeze.

Much of Young's cosmopolitan lifestyle rubbed off on Connery. 'When I first met Sean,' Young told the *Los Angeles Herald Examiner* in 1980, 'he was a wild Scotsman. We groomed him for Bond. In those days Connery called us Sir.' Sent to Young's personal shirtmaker and tailor (Savile Row, of course), Connery was made to wear the new clothes everywhere to get their feel, even sleep in them – 'because Sean's idea of a good evening out would be to go off in a lumber jacket.' His hair and eyebrows were also trimmed. It was a feat Henry Higgins would have been proud of. Connery was a man who preferred pints to champagne, and egg and chips to *foie gras*. And in the early days, his table manners were questionable. Filming the dining scene in Dr No's lair, Young kept having to insist: 'Sean, you've got to eat with your mouth closed.'

The reply was perfectly reasonable. 'Well, I can't breathe if I do that.'

Fortunately the two men shared much the same sense of humour. Young admits that as much as 90 per cent of the humour in the films was knocked up by Connery and himself.

Young first encountered Connery in 1957, on the set of *Action of the Tiger*, and likened his raw potential to that of a young Kirk Douglas. 'He was a rough diamond. But already he had a sort of crude animal force.' At the close of the filming, Connery eagerly approached Young asking: 'Sir, am I going to be a success in this?' Aware the film had about as much chance of

being a hit as a Blackpool donkey had of winning the Grand National, Young was blunt in his answer: 'No, but keep on swimming. Just keep at it and I'll make it up to you.' No truer words were ever spoken. While unimpressed by Connery's performance in *Action of the Tiger*, though admittedly he was not much used, like most Young was struck by the sheer sex appeal of the man. 'He had this strange thing already back then, a sexual quality.' This Young later brilliantly exploited in the Bond films.

In the beginning Young was Connery's champion when the critics whined that Bond was all he was good for. After *Dr No* he became convinced that Connery was the one British actor since Laurence Olivier with a chance of international fame. Just two years later he was forced to alter his view; now he felt Connery could become the biggest star since Clark Gable. 'But he doesn't give a damn for the ancillary aspects of being a star. It's not that he's ungrateful, it's just that he's too concerned with personal integrity. A hell of a lot of people don't like Sean because of this.'

Young pleaded with Broccoli and Saltzman to turn Connery into a partner. 'Make it Cubby, Harry and Sean,' he told them. 'Sean will stay with you because he's a Scotsman. He likes the sound of gold coins clinking together. He likes the lovely soft rustle of paper. He'll stay with you if he's a partner, but not if you use him as a hired employee.'

Thunderball was Young's third and final Bond movie, but he always maintained a wish to return one last time, if it was to direct the final ever 007 epic. It was never to be. In 1994 he died of a heart attack, aged seventy-nine, his place in cinema history assured.

Guy Hamilton

Assuming the director's chair after Terence Young on *Goldfinger* was Guy Hamilton, who like his predecessor was another journeyman film-maker. He'd been churning out stiff upper-lip British adventure yarns for some years of which *The Colditz Story* is his pinnacle. Hamilton remembers catching some of Connery's early stage and film work but had to admit to never particularly rating him. 'I didn't think he'd too much going for him. But by *Dr No* he was proving his salt.'

'Connery is an enormous pleasure to work with,' Hamilton said in 1972. 'He's getting better and better as an actor and is also a good light comedian. I think of him as another Rex Harrison.' Hamilton rates Connery as 'one of the great underrated light comedians' and bemoans the fact he never played more comedy.

With *Goldfinger*, Hamilton was responsible for what many 007 fans judge to be Connery's finest performance in the Bond role. 'Sean was much more accomplished than in *Dr No*,' Hamilton once told me. 'There's a big difference in the performances. He was becoming more assured in front of the camera; his personality was breaking through.'

Lewis Gilbert

For the fifth Bond movie the producers hired Lewis Gilbert, a much respected director who'd recently scored a hit with *Alfie*, starring Michael Caine. Gilbert first ran into Connery in 1957, when Diane Cilento, whom Gilbert was then directing in *The Admirable Crichton*, brought him to dinner one evening. Gilbert recalls being impressed by his looks and physique, but not for a second reckoned he had much of a future in films.

On the set of *You Only Live Twice* Connery often talked with Gilbert about how disgruntled he'd become in the role and his decision to quit as Bond 'But I was against him leaving,' Gilbert revealed to me, 'and I used to say, "Sean, you are taking a risk, because in a sense you are typecast now. You're in an incredible situation here, because when you're Bond you can do what the greatest actors in the world can't do. If you say to United Artists, 'Yes, I'll do the next Bond film, but I want to play Oedipus Rex, or I want to do Hamlet,' they'd say, 'OK, Sean, here's the money.' " But his mind was made up.'

'What is interesting about Sean is that he's never really lost his looks,' Gilbert continued, recalling a time he visited the main administration building of Paramount Studios. Suddenly there was a mad commotion, with secretaries and female workers rushing out of offices and running down the main corridor. Gilbert caught one of them and asked what was going on. 'Sean Connery's coming! Sean Connery's coming!' she shrieked. 'Now, Paramount Studios are very much used to all these big stars walking down that corridor, and you never see a girl move out of an office. It says something for Sean.'

Irvin Kershner

Looking for a director to take the helm for his comeback *Never Say Never Again*, after first choice Richard Donner declined, Connery chose Irvin Kershner. He had just scored big with *The Empire Srikes Back* and the two men had collaborated years before on *A Fine Madness*. But Kershner needed a lot of persuading. 'Why don't you do it?' Connery pleaded. 'This is gonna be my last Bond ... The last one! C'mon, let's do it. We'll have some fun, we'll go to Paris and the Bahamas, what the hell!'

Kershner caved in and soon wished he hadn't. 'It wasn't fun,' he confessed to *Starburst* in 1990. 'We had to shoot in five countries and I was hopping around on planes. It was monstrous.' So bad was his experience Kershner didn't direct again until 1990 with *Robocop 2* before semi-retiring from the business.

4 The Movies

Woman of Straw (1964)

Connery's first movie after making his mark as James Bond was this wannabe Hitchcock thriller, which he signed up to without a detailed script reading. Perhaps he was won over by director Basil Dearden's reputation and the chance to work alongside his favourite actor, the wondrously dotty Ralph Richardson. 'Wonderful character,' Connery remarked after bumping into him at Pinewood's canteen in 1981. 'He still drives a motorbike to work. At his age! Can you imagine.'

The role on offer intrigued him too, that of Anthony Richmond, a cold, calculating playboy out to murder his rich uncle then pin the blame on the old goat's ultra-glamorous nurse, played by Gina Lollobrigida. Prior to 1998's *The Avengers*, Richmond represented the sole true villain Connery had played as a star. It was certainly a bold first step in what soon became a running battle with the public to accept him as characters other than James Bond.

When *Woman of Straw* opened in April 1964, critics were divided on his performance: some thought he should stick to the Bond image, while others believed he'd escaped the spy's straitjacket admirably. In the 'for' camp were *Films and Filming*: 'Connery's range is perceptibly widened after the limiting Bond role.' Against was the *Daily Herald*: 'Connery, wooden as an old oak beam, looks as if he were desperately wishing himself somewhere else.' And the *Daily Mail*: 'If this is the best Mr Connery can do when he is not playing 007, the sooner he gets back to Bondage the better.' *Variety* agreed: 'Connery wanders around with the air of a man who can't wait to get back to being Bond.' Which couldn't have been further from the truth.

Woman of Straw, then, wasn't the best of starts on the road to a career beyond Bond. Though stylishly made – 'a neatly contrived suspense drama' according to *Time* – and featuring imposing sets from Bond designer Ken Adam, it creaks under an excess of melodrama. 'A brilliant example of how to dress up dross so that it gleams like mink,' wrote critic Alexander Walker.

Up against Europe's fieriest actress in Lollobrigida, Connery more than holds his own, ably matching the then greater celebrity as he'd done previously with Lana Turner. But he always seemed resigned to its eventual fate, even though it achieved a modicum of success on the international circuit. 'I wasn't all that thrilled with *Woman of Straw*, although the problems were

my own. I'd been working nonstop since goodness knows how long and trying to suggest rewrites while making another film *From Russia With Love*. It was an experience, but I won't make that mistake again. When it was shot down I wasn't entirely surprised.'

Marnie (1964)

A little over a year after *Dr No* and relative obscurity, Connery suddenly found himself working with Alfred Hitchcock, arguably cinema's greatest director. Both Frank Sinatra and Cary Grant had been considered for the role he eventually filled, that of a Philadelphia businessman who blackmails a female thief into marriage.

The making of *Marnie* is shrouded in dark tales of Hitchcock's obsession for its star Tippi Hedren, whose career he nurtured and whole life he tried to control. The part was originally conceived as Grace Kelly's Hollywood comeback, but when her subjects in Monaco vented displeasure at their serene Royal Highness playing a frigid kleptomaniac she was forced to back out, much to Hitchcock's disappointment. Instead Hedren, who'd already been almost pecked to death in *The Birds*, was cast and delivers a devastatingly haunted performance.

Hitch's obsession for Hedren led inevitably to tragedy. Well into production he committed the cardinal sin of propositioning his star in her trailer and when rebuffed turned overnight from sponsor to enemy, promising to wreck Hedren's fledgling career. He even refused to address her personally, giving his directions through assistants. Hitchcock's threats came true – can you name a film Hedren made after *Marnie*? – but at least she later had the satisfaction of watching her daughter Melanie Griffith rise to international fame. She also adored working with Connery. Years later she fondly recalled their lingering screen kiss. 'Unfortunately the camera was a foot and a half away, as well as the entire motion picture crew.'

Connery maintains he knew nothing of the off-camera problems, or maybe simply chose not to get involved. Questioned over Hitchcock's penchant for blonde starlets he did drolly reply that surely it was preferable to fancying blond men. In Hollywood he kept his by now customary low profile, preferring to drive himself to the lot rather than be ferried about in a studio limo, and he declined a suite at the plush Château Marmont in favour of the modest motel he used during his Disney days. With Bondmania beginning to grip America Connery was enthusiastically received and became the focus of favourable press coverage. His professionalism also endeared itself to *Marnie*'s crew of seasoned veterans, who all chipped in to present him with an inscribed gold watch as a souvenir. Connery was extremely touched by the gesture and has kept it to this day.

Voicing satisfaction with the movie Connery awaited its American open-

ing in June 1964. Alas reviews weren't encouraging: too long and pondering, the critics complained; was Hitch finally losing his touch? 'A clear miss, the master's most disappointing work in years,' pronounced the *New York Times*. 'It creaks,' admitted the *Evening Standard*, 'but the cruelty fascinated.' *The Times*, however, called *Marnie* 'over two hours of very glossy entertainment' and thought Connery 'escapes quite effectively from the James Bond stereotype'. *Marnie* was Connery's first 'real' dramatic role and the first glimpse of the accomplished actor he would become.

Taking just $3 million at the US box office *Marnie* was labelled a flop, but the passage of time has established it as one of Hitchcock's more fascinating misfires. 'The film buffs at UCLA are constantly dissecting *Marnie* to see how it was done,' Connery revealed in the eighties; directors of the calibre of Coppola and George Lucas 'were all caught by the movie'. Some atrocious back-projection and lamentably obvious backdrops – aberrations some theorists testify were deliberate reversions to an expressionistic style – have contributed to its cult repute. What's more likely is that Hitchcock, aggrieved by the Hedren débâcle, simply didn't give a damn by the end and rushed all the technical details.

Marnie ties with *Frenzy* as Hitchcock's best work after *Psycho*, a return to psychological suspense and subtle terror after the shock-horror tactics for which he's perhaps more renowned. A clear failure, but one more engrossing than most directors' successes.

The Hill (1965)

It's rather ironic that Connery's arguably best movie is one he at first turned down. Anxious to try something more artistically 'worthy' after his third Bond opus, Connery mulled over the offer again while in Rome to visit Diane Cilento, who was shooting *The Agony and the Ecstasy*. This time he accepted and collected a healthy £150,000, more than the rest of the cast were getting put together. Not so enticing were two weeks of training at an army camp, marching for hours on end under the shrill orders of a real-life sergeant. Connery was so exhausted some evenings he'd fall into bed the moment he arrived home.

The Hill is based on author Ray Rigby's own experience as a prisoner in a British North African detention camp during the war. Connery plays sergeant-major Joe Roberts, court-martialled for punching a superior officer's lights out, one of five new prisoners exposed to numerous maltreatments. Worst of all, he is forced to scale a man-made hill of sand in full kit under the blazing sun. When the punishment proves too much for one of the men (played by Connery's *On the Fiddle* sparring partner Alfred Lynch), Roberts takes it upon himself to accuse his captors of murder.

A replica of the stockade was built from scratch in Gabo de Gata, a desert

wasteland near Almeria in south Spain. There shooting began in September 1964 in temperatures that soared to 115 degrees. The crew suffered a gruelling five-week schedule, ten hours a day, six days a week. Dysentery was rife, and while fitter than most Connery finally succumbed and was out of action for two days. 'Spanish tummy and the heat combined to lay me out.'

Duty-bound to treat Rigby's material with respect, director Sidney Lumet intended to make a realistic film and not a piece of glossy melodrama. It's why he shot in black and white, commissioned no music score and insisted the actors climb the hill themselves with no help from doubles; the strain clearly shows on their faces. In America subtitles were needed to help those few people who went to see it decipher the strong accents and profuse slang. MGM actually wanted to dub the entire soundtrack, a move blocked by producer Kenneth Hyman.

The Hill premiered at the Cannes Film Festival, where it jointly won best screenplay. It also succeeded in ruffling the feathers of the staid British film establishment, which complained about its prejudiced view of military life being detrimental to Britain's image abroad. But *The Hill* found favour with cult director Sam Peckinpah, who approached Kenneth Hyman during the festival, a meeting which led to their later collaboration on *The Wild Bunch*.

Despite excellent reviews *The Hill* failed to find an audience. *The Sunday Express* hailed it as a 'psychological masterpiece', and the *Daily Worker* agreed: 'a bold, agonizing and proudly human cinema experience'. 'A more powerful film has not come out of a British studio for many a year' concurred the *Daily Telegraph*. Connery was also mentioned in dispatches, his talents now beginning to be fully recognized. 'Connery gives one of the most disturbingly effective performances of the year. It is a masterful portrayal of a caged and anguished animal,' said the *Daily Express*. 'Connery reminds us what a really splendid actor he is when he is allowed to escape from his stereotyped James Bond image,' added the *Sunday Express*. Connery's performance as Joe Roberts remains the most naturalistic he's ever given, so radically different from anything he had previously attempted. Bond director Terence Young, who dubbed the movie 'James Bond in a glasshouse', declared Connery's acting here to be amongst the finest he had ever witnessed. 'It was Spencer Tracy stuff. Remarkably good acting.'

Disappointed with the film's lack of commercial success, Connery nevertheless had found the work the most stimulating of his career to date. He also hoped it might alter the perception of producers, who saw him only in a tuxedo at the roulette table or behind the wheel of an Aston Martin. 'Anyone who still thinks Sean can't act is in for one hell of a surprise,' championed Lumet. Alas, while *The Hill* itself received six British film award nominations, including Best Picture, Connery's performance was criminally overlooked.

This is an unglamorous, brave work that comes close to classic status, with an all-male cast producing some of the finest ensemble acting ever seen in a British film. Ian Hendry, who played a sadistic drill sergeant, told the *Sunday People* in 1980. 'The action was so realistic that every night when we got back to the hotel after shooting, it took the other actors half an hour to remember we had only been acting before they would speak to me.' Surprisingly there is little actual on-screen violence; the brutality works more subtly, by destroying the men from within, through the use of fear and intimidation. And like most prison movies the convicts are portrayed in heroic light; it is the wardens who are the real criminals.

A Fine Madness (1966)

Following the artistic success of *The Hill* Connery continued his policy of tackling diverse roles in the quirky comedy *A Fine Madness* – but this time with less favourable results. He starred as Bohemian poet Samson Shillitoe, whose obsession to complete an epic poem leads to psychological and romantic problems. He probably agreed to take on the role for no better reason than that it was light years away from Bond. It was also Hollywood-based, with location work in New York, so within commuting distance of Cilento, who was then filming the western *Hombre* in Arizona with Paul Newman. It was a case of real wife-swapping, as Newman's partner Joanne Woodward was starring opposite Connery. They make a fiery team, going for each other like two pitbulls in a barrel. Every Friday night both couples, joined by cast members of *A Fine Madness*, would meet in the screening room of the Beverly Hills Hotel to watch their favourite movies. It was an informal film club, with Newman supplying beer and home-made popcorn.

Connery's other leading lady was Jean Seberg. In one racy scene the pair frolic in a hospital ripple bath, a sequence that merited a double-page spread in *Playboy*. Seberg was opposed to performing naked, though in the end reluctantly agreed to wear flesh-coloured panties to cover any embarrassment. Connery, who often relaxed in his dressing room without a stitch on, wondered what all the fuss was about. Desperate for the scene to work, Connery ordered up bottles of champagne, and while the crew set up the shot gradually got Seberg tipsy. When 'Action' was called he ripped off his clothes, jumped in and pulled in Seberg with him. The champagne continued to flow and by the end of the afternoon Seberg had totally stripped and was loving every minute.

A Fine Madness opened in America in May 1966. Though the film was a financial disappointment Connery still judged it to have been a worthwhile enterprise, pointing out some glowing New York notices. 'Give it an A for effort and a B for impudence and originality. It flounders but it gleams,' said the *New York Times*. He was less pleased with the lack of enthusiasm in

Britain. 'If he wants to continue to be accepted as a serious actor, I suggest that he keeps out of comedy from now on,' advised Leonard Mosley of the *Daily Express*. The general consensus was that he was badly miscast. Others were less harsh, such as *Films and Filming*: 'The lead is enthusiastically performed by Connery ... who attacks the part with eloquence. In one scene, imitating a man regressed to infantile idiocy, he is hilarious.' The *Financial Times* was also full of praise: 'Connery is an actor who often surprises with new turns of talent. As Samson he achieves something very rare in screen or stage impersonations of poets: you can feel that this bum actually could write a poem if he tried.' Connery displays a neat gift for comedy in *A Fine Madness*, a side to his acting that's been sadly overlooked in favour of his more familiar tough-guy image. He clearly revelled in the anarchic freedom offered by the role and dominates the screen, lending direction to an otherwise rudderless film. But while the public largely accepted him in *The Hill* they were unprepared for this ranting and raving beatnik. They stayed away in droves, patiently waiting for the next Bond opus. Years later Connery was philosophical about its failure. 'That didn't make a penny, of course. It was a highly unsuccessful film, as quite a few of the others I've done, too.'

Director Irvin Kershner was under no illusions as to why it misfired, complaining that once principal photography closed he was thrown off the lot by Jack Warner, who commissioned a new music score and had the film cut to his own taste. 'What was shown bore little resemblance to what I'd intended,' Kershner argued. 'The film's a mess. I can't watch it even today.'

Shalako (1968)

As children Connery and brother Neil loved Saturday-morning picture shows, sitting in their local fleapit goggle-eyed at the adventures of Flash Gordon, as later generations would be to the exploits of 007. Sean's favourite serials were always westerns and for his first post-Bond project his dream of playing a cowboy became reality.

Originally planned as a low-budgeter with Henry Fonda and Senta Berger, veteran director Edward Dymtryk instead saw Connery as his ideal frontier scout hero, who rescues a party of visiting European aristocrats from marauding Apaches, including a heavily mascara'd Brigitte Bardot. For Dymtryk, Connery was one of the few contemporary stars who reminded him of the Hollywood greats. And indeed the hefty budget of £2 million was raised from various independent sources on the strength of Connery's name. But with the filming due to begin on location in Mexico, a proposed labour strike prompted a quick rethink and operations moved instead to Almeria in Spain, home of Clint Eastwood's 'Dollar' movies.

Hailed as Britain's first western (and the last one too!), *Shalako* opened in

America in October 1968 to a deserved critical mauling. 'To the Apache Shalako means bringer of rain, in movie parlance it merely means stupefier of audience' – *Time*. 'Almost everything about *Shalako* is embarrassingly bad. So bad that one is staggered by the uniform and unrelieved awfulness' – *International Herald Tribune*. At least *Variety* liked it – 'a robust western adventure' – making one wonder whether its critic was watching something almost entirely different. Bardot cleverly shirked all responsibility for the disaster: '*Shalako* is Sean Connery's picture. He carried the whole weight of it on his shoulders.'

Despite severe reservations about the film's quality Connery remained faithful, partly because of his large financial stake in any profits. He attended the London opening in December along with Bardot and Royal guests Princess Margaret and Lord Snowdon. Days later, fulfilling a promise made to him, promoters put on a special mini-premier of Shalako in Glasgow, which the actor attended with family and friends.

Arguably the sixties' top two sex symbols, Connery and Bardot really deserved better than this. *Shalako* is duller than a tin of grey paint, squandering a top-notch cast that also includes Stephen Boyd, Jack Hawkins, Honor Blackman and Sean's golfing chum Eric Sykes. At one point during filming Bardot threatened to quit, perhaps after having seen the rough cut. Connery escaped the débâcle unscathed and remains, without question, the most credible British actor ever to wear spurs. Having ignored sniggers from his detractors when first accepting the role, Connery went on to receive some of his best ever notices. 'A convincing portrayal, quite able to take its place beside the memorable western heroes of Gary Cooper and James Stewart' – *Sunday Telegraph*. 'The best western lead since the discovery of Steve McQueen' – *Observer*. But even as a cowboy Connery couldn't quite escape 007's shadow – 'Bond in buckskin' was the headline of the *News of the World* review.

Asked later why he never made another western, Connery replied that quite simply no one ever asked him again.

The Molly Maguires (1969)

Out of Bondage Connery's career was heading for recession. Though desperate to prove he could survive beyond the silk-lined prison walls of 007, the two movies he chose to close the decade with were colossal disasters.

The Molly Maguires is Connery's most overtly political film, tackling a slice of American history few people even knew about. It is the true story of a secret organization of Irish immigrant miners, who used violence in their struggle for better pay and conditions in the Pennsylvania coal mines of the 1870s. Director Martin Ritt, himself a victim of injustice (he was

blacklisted during the McCarthy era), saw them as nothing less than the indirect forerunners of the free trade unions.

Approached to star during a visit to the set of *Hombre*, where Ritt was directing Diane Cilento, Connery immediately grasped the importance of the project. There were obvious parallels with the Civil Rights Movement and other minority factions in the turbulent late sixties. And the role of Jack Kehoe, the gang's leader, his meatiest since *The Hill*, was another tough, uncompromising character to contrast with the Martini-sipping spy audiences knew, loved and missed. 'We caught Sean at a good time,' said screenwriter Walter Bernstein. 'He was sick and tired of the Bond pictures and wanted to do something more serious.'

An honourable and well crafted film, *The Molly Maguires* is ultimately a dull watch. Ritt lays on the bleakness with a shovel. When Paramount refused him permission to shoot in black and white Ritt dowsed the locations, some of which were the actual sites where these events occurred, in thousands of gallons of black spray paint. When trees came into bloom gangs were hired to pick them bare – all in an effort to convey the grim reality of the miner's existence. 'This film had to be done on location, in a genuine atmosphere,' said Ritt. 'Not only for the physical look of the film, but also for the actors.'

But the depressing tone surely preyed on Connery, who was reportedly moody on set and also suffered dehydration and exhaustion in the high temperatures. He did lend a hand with the odd interview, though questions about Bond, as would be the case for years to come, were taboo. Quizzed about his slipping box-office appeal and second billing to Richard Harris, Connery replied: 'They're paying me a million dollars for this picture. For that kind of money they can put a mule ahead of me.' Both stars gave passionate, committed performances, particularly Harris as the detective hired to infiltrate the Maguires, identify its leaders and bring them to trial.

Shelved for over a year *The Molly Maguires* finally saw daylight Stateside in January 1970. 'Well-mounted but sluggish drama' was *Variety*'s verdict, which pretty much summed up the critical response. 'A failure, yet it's an impressive failure. It's too sombre and portentous for the rather dubious story it carries,' wrote the *New Yorker*. The public didn't bother either, staying away *en masse* and embarrassing Paramount, which had gambled a whopping $11 million on it. Connery reasoned that it would have been cheaper to make the film in Scotland or Wales, where old mines were still in existence and didn't have to be built almost from scratch. 'It went on its ass,' admitted Ritt who feared he may never work in Hollywood again.

In a 1974 *Films and Filming* interview Connery was philosophical about its failure, certain that its leaden mood had alienated audiences. 'It was well-intentioned and a good film. But it never caught fire. One reason was the fear that humour might intrude, whereas in actual fact it can enhance a situation.

The piece had a very political slant. When the first cut was ready and I saw it with Marty, I told him I thought he'd missed it.' Ritt took Connery's advice to heart, injecting more humour into his subsequent films, but he still maintained that *The Molly Maguires* was one of his finest achievements.

At least Connery came away with a decent crop of personal notices. It must have gladdened him to note that he was now starting to receive high praise whatever the artistic merit of the picture he was in, a state of affairs that has never changed. *Time* then rated him as 'one of the screen's most underrated stars, an actor of tightly controlled power and technical accomplishment.' And the *Sun* thought he'd 'never, ever acted so well. Connery proves himself better than the reputation he deserved but never got in *The Hill*.'

The Red Tent (1969)

One of Connery's more obscure pictures, this mega-budget adventure saga recalled the true events of a doomed airship expedition to the Arctic led by General Nobile in 1928. Cast as Norwegian explorer Roald Amundsen, the man who beat Robert Falcon Scott to the South Pole, Connery was involved in the picture for a mere three weeks. For this he secured equal billing with poor Peter Finch, who as Nobile had been slaving away on the project for over a year. Still, Connery was attracted to the subject matter and impressed by how director Mikhail Kalatozov was striving for total historical accuracy. He also felt it worthwhile attaching himself to this Italian/Russian co-production, as it was the first time the Soviet Union had collaborated with any other country on a film.

Released in America in August 1971 *The Red Tent* went on to become a catastrophic flop, returning a feeble 900,000 box-office dollars to offset the $10 million budget. 'To have taken a situation with such potential and to have made it as dull as Kalatozov has must have taken great ingenuity,' observed the *New York Times* tartly. With reviews like that, little wonder the film joined *The Molly Maguires* on the all-time list of cinematic clangers.

A revered success in Russia and Italy where it ran a sapping four hours, *The Red Tent* remained unseen in Britain until June 1972. 'This is one of the most beautiful and moving action pictures ever made,' raved *Films and Filming*. 'Visually, this is the most impressive film since *Doctor Zhivago*.' This was unwarranted high praise for a noble film that was plodding and ponderous in execution; only stunning photography and a haunting score from the great composer Ennio Morricone saved the day.

Wrinkled and wearing a silvery wig courtesy of make-up, Connery lends a dignified grace to the international proceedings. The critics were impressed by what was little more than an extended cameo. *Variety* thought his portrayal of a man almost twenty years his senior 'very convincing', while

Films and Filming rated it 'excellent, an intelligently drawn character study which represents his best work on screen since *The Hill*'.

The Anderson Tapes (1971)

With a string of duds to his name, Connery found that his reputation and status as a box-office attraction was in doubt by the start of the seventies. *The Anderson Tapes*, a slick caper movie shot by Sidney Lumet in a breathless six weeks during the summer of 1970 in New York on a tight budget, changed all that and returned him, albeit temporarily, to America's list of top-ten stars.

Connery plays Duke Anderson, a safe cracker fresh from a long jail term, who plans to 'rob the guts' out of a luxury apartment block with the help of some fellow cons. The film's original ending, in which the gang makes a clean getaway from the police, was changed by Columbia to a dramatic shoot-out where they're either killed or captured – this so as not to jeopardize its sale to American television, in which stricter moral codes prevailed. The studio's intrusion actually benefited the movie, for once, as the new climax featuring a seven-car pile up was, in the words of *Variety*, 'breathtaking stuff'.

Pre-Watergate and a full three years before Francis Ford Coppola tackled the same subject in his critically acclaimed *The Conversation*, *The Anderson Tapes* served as a biting indictment of wiretapping, bugging and other means of photographic surveillance in our daily lives. While planning his caper, Duke is scrutinized by hidden cameras and microphones wherever he goes. The irony is that the authorities aren't interested in his activities, only the people he's associating with – like the mafia – and the crime is allowed to proceed unchallenged.

While shooting *Diamonds are Forever* in Las Vegas Connery took the unusual step of organizing a private screening of his new movie, inviting the stars and chorus lines from all the big shows. Their enthusiastic response confirmed to Connery that he was on to a winner and, indeed, *The Anderson Tapes* opened in America in June 1971 to encouraging reviews with the *New York Times* praising Connery's 'laconic, attractive, beautifully subdued' performance. More importantly, the movie pulled in more audiences than any of his previous non-Bond outings.

It was also critically well received in Britain. 'A highly professional, taut, well-written, splendidly acted thriller' (*Observer*); 'Connery looks a more substantial actor with every film he makes' (*Sunday Telegraph*); 'Connery gives his best rough-diamond performance since *The Hill*' (*Evening News*). Even so *The Anderson Tapes* had a lame run in British cinemas, probably because it was released so close to Connery's swansong as 007. Punters had the choice of seeing him as either a balding, common crook or Ian Fleming's dashing hero. No contest.

The Offence (1972)

A crucial part of the bait which lured Connery back to Bond was United Artists' promise to finance any two films of his choice to the tune of $1 million each. Setting up his own production company, Tantallon Films, Connery hired John Hopkins to do a screen adaptation of his own play *The Story of Yours*, which had enjoyed a critical success at London's Royal Court Theatre in 1968.

Hailing the script as the best he'd ever read, Connery hired Sidney Lumet to direct what turned out to be one of the most viscerally disturbing British pictures of its era. The movie is an unflinching examination of a policeman so infected by the urban horrors he's witnessed after twenty years on the force that he cracks up and beats a suspected child molester to death. As you've probably guessed, it's no fun to watch, coming over as *Z-Cars* meets Irvine Welsh. And coming so soon after the global success of his Bond return, Connery bravely risked losing his box-office status by starring in such a downbeat and frankly unappealing film. Few stars of his stature would even have contemplated such a gamble. But again, the need to distance himself from Bond and to challenge himself artistically outweighed all other considerations. Professionally it was a triumph; as Detective Sergeant Johnson, Connery's compelling and detailed portrait of a man's anguish and self-destruction ranks among his finest achievements. The *New Statesman*'s verdict that he'd given 'the performance of his life' was typical of the press reaction. Bruce Williamson, *Playboy*'s film critic, admitted later that had the movie been properly pushed in the United States Connery would almost certainly have garnered an Oscar nomination. John Huston rated the film's last quarter, in which Johnson comes apart at the seams before our eyes, as some of the best cinema he'd ever seen.

Behind the scenes Connery was kept busy working ten-hour days in cramped sets at Twickenham studios, his main concern being to complete the film within the scheduled twenty-eight days and under budget. Refusing even a token fee, Connery claimed only living expenses. It was a gruelling experience, but personally as satisfying as anything he'd done; he particularly relished the chance to work opposite actors of the calibre of Ian Bannen, Trevor Howard and Vivien Merchant. Married to playwright Harold Pinter, Merchant knew Connery only as 007 and scarcely looked forward to the prospect of appearing with him. 'It was a heady experience,' she confessed later. 'But what a presence!'

Determined that *The Offence* should reach as wide an audience as possible Connery embarked upon a rare promotional tour. But it soon became clear that United Artists weren't prepared to back him up, particularly in America, where the film sank without trace. 'Despite good acting, audiences will want to avoid *The Offence*,' prophesied *Time*. The film played just seven days in New York. 'I don't think UA spent $3,000 advertising it,' moaned Lumet.

'They had no faith in the picture.' Such was Lumet's fury that he never again spoke to the head of UA in New York, David Picker, who'd been the best man at his wedding. *The Offence* took ten years finally to break even. But then let's face it, the movie hardly had 'hit' written all over it.

Alas, the second United Artists-backed film never materialized. John Hopkins did write a screenplay, *The Devil Drives*, based on the life of explorer Sir Richard Burton, but its epic scope, with locations in India and Turkey, would have swamped the meagre $1 million budget. Shame, as Sidney Lumet was scheduled to direct.

Connery also spoke with Germaine Greer, who'd written a piece about the decimation of Australia's Aboriginal population. But nothing came of that either. 'I feel the Aboriginals have been there thousands of years before us and seemed to have survived – so let them get on with it!' was the Connery view.

Zardoz (1974)

Connery's never been much of a science fiction fan; films like *Star Wars* leave him cold; but twenty pages into John Boorman's script of *Zardoz*, he was seized by its profound originality. Here was a sci-fi piece that dealt with the future of the human species, as opposed to ray guns and whizzing rockets. Within days of speaking with Boorman he'd flown to Ireland to join the director on location.

Zardoz surely ranks as the craziest movie of Connery's career, a gloriously pretentious, visually stunning fantasy fable in which he plays Zed, a 23rd-century superhuman who brings havoc to the tranquil but sterile world of a race of immortals who secretly yearn for death. Borrowing liberally from such diverse sources as Tolkien, the Arthurian legend and *The Wizard of Oz*, Boorman's basic theme seems to be: the trouble with eternity is that it goes on for too long!

Hampered by a budget too small to fully realize the director's vision, filming was an uphill struggle. 'We had so little money that the extras in the background were Irish guys with red painted legs instead of boots, and their Y-fronts dyed red,' recalled Connery. For the sake of his art he endured such indignities as being covered in a mixture of cement dust and earth, which hardened quickly and tore out tufts of chest hair when removed; being buried beneath a pile of grain with only a flimsy tube for air; and almost suffocating inside a plastic bubble. But he revelled in it, the bizarre role of Zed clearly suiting his intrepid approach to acting. Few stars of his calibre would have been prepared to run amok around the Irish countryside in a costume that resembled a giant red nappy. At one point he even dressed up as a bride in a full white gown – not very flattering. But there were compensations, as most of his scenes seem to involve grappling with young actresses

in various degrees of undress – including co-star Charlotte Rampling, part of whose promotional duties for *Zardoz* involved posing nude for *Playboy*.

Zardoz opened in America in January 1974. 'Beyond 1984, Beyond 2001,' preached the billboards. Another ran: 'I have seen the future and it doesn't work.' Nor did the film according to critics. 'A glittering, cultured trash pile ... gloriously fatuous,' pronounced the *New Yorker*. Another gave the movie joint honours with *The Man Who Fell to Earth* as the most tortuous sci-fi cinema experience of the seventies. The *Sun*, in its own inimitable style, referred to Boorman's work as 'a pretentious load of old bananas'. And *Rolling Stone* sympathized with Connery for begetting 'one of the truly thankless roles in recent films'. Even Connery's wife hates this movie, which, though a major flop at cinemas, has grown, inevitably, into a cult favourite today. 'I was coming out of an underground car park in Marbella,' Connery related to *Time Out* in 1987, 'and cracked my head on the barrier. And the poor guy on the gate recognizes me and thinks I'm going to sue him. But we got talking and he has a video of *Zardoz* which he and his friends watch every day. They think it's the bible. And the starter at my golf club sees things in it that Boorman and I never saw.' So if you've never seen it, be prepared to either love it or loathe it.

Ransom (1974)

After the dazzling originality of *Zardoz*, mediocrity again reigned supreme in *Ransom*, a run-of-the-mill hostage thriller set in Norway. Connery was ideally cast as Colonel Nils Tahlvik, a no-nonsense airport security chief, pitting his wits against a group of terrorists that has hijacked an airliner and is demanding the release of political prisoners. 'It was not an easy role for him,' producer Peter Rawley believed, 'but one which suited his personality perfectly.'

Filming began in January 1974 amid sub-zero temperatures and heavy fog. The Norwegian pilots' union was none too pleased about a hijack movie being made at Oslo Airport and threatened strike action. Connery was quickly on the defensive, making clear that the film was not out to glorify terrorism. '*Ransom* deals with how to prevent a hijack, not perform one.' If anything, it was for taking a stand against international lawlessness in the face of increasing governmental capitulation. Norway was only being used so that the Arctic conditions, captured wonderfully by Sven Nykvist's camera, would add to the dramatic effect of the story. But that brought its own problems, when the snows melted prematurely and thousands of tons of salt mix had to be carted in.

At a low ebb professionally and personally at the time, Connery wasn't at his happiest during filming, and alas, it's all too visible in a rather tetchy, moody performance. 'Throughout the whole affair Connery looked old,

tired and browned out,' wrote the *Sun*. For starters, there was an inhospitable lack of golf courses, and he couldn't even ski because of insurance regulations; he had to make do with the odd game of indoor tennis with co-star Ian McShane. Nor did the meagre budget stretch to decent catering. An aggrieved Connery raised the issue in his traditionally forthright manner. Either the food improved or he walked. Guess what, the grub improved, overnight. That's power.

'Connery Won't Pay,' blasted the billboards for *Ransom*. Unfortunately neither did the public and the film perished miserably when released in Britain in February 1975. Opening as *The Terrorists* in America, it perched at the bottom half of a double bill – the only time a film with Connery as its star has suffered such indignity. Reviews were less than flattering. 'Weak and flabby on almost every level,' blasted the *Guardian*. 'Shoddily made,' agreed the *Financial Times*. Felix Barker of the *Evening News* was spot-on when he wrote: 'Connery always gives the impression of quiet strength. But I always have the feeling that the screen roles don't extend him as they could. Since Bond only *The Offence* has given him a chance to get inside an interesting character. It is a pity, for when we meet I am aware of a thoughtful actor wanting to break out of the mould of the conventional he-man.'

Other critics despaired that someone who a decade ago was the world's number-one film star was now reduced to appearing in low-key movies no one wanted to see. 'Connery certainly deserves better than this,' argued the *Sunday Express*. One really wonders what drew him to such underwhelming material, directed in pedestrian fashion by Casper Wrede.

Murder on the Orient Express (1974)

In March 1974 Connery joined an all-star cast for this stylish adaptation of Agatha Christie's classic mystery novel. Filming at Elstree studios was under the capable control of old friend Sidney Lumet. It was their fourth collaboration, and from the beginning Lumet was desperate to snare the big man, to the point of pestering Connery's agent with hourly phone calls. Lumet made it clear that his involvement in the project was contingent on Sean signing up. Connery's involvement also turned out to be the key to casting Albert Finney, who gives a virtuoso performance as Belgian sleuth Hercule Poirot. 'It was a question of persuading these two leviathans that if the other was in it, it must be a good film,' according to producer Richard Goodwin. 'They were pivotal to each other.'

The role on offer was no great shakes – a stuffy army officer just back from India, one of a dozen suspects in the murder of a ruthless businessman aboard the famous train snowbound in the Balkan Hills. Connery's look of grey toupee and monstrous moustache was partly inspired by a real-life acquaintance he'd known during his Navy days.

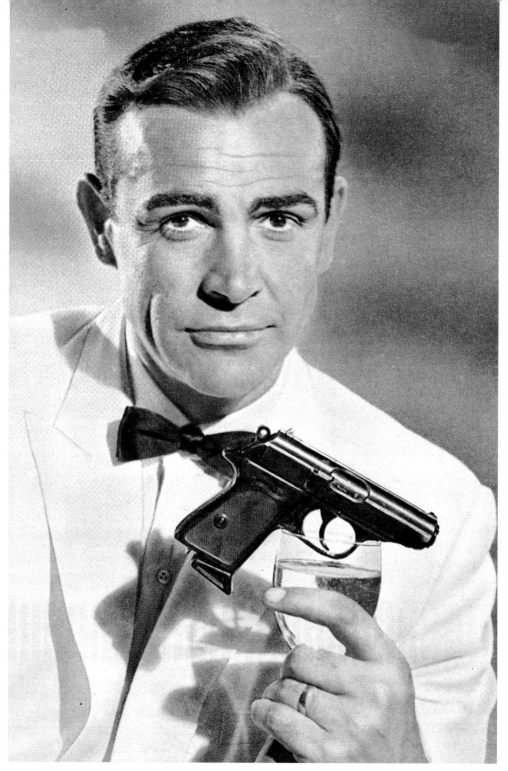

The epitome of cool. A publicity portrait for *Goldfinger* (1964), probably the most widely seen of any Bond movie

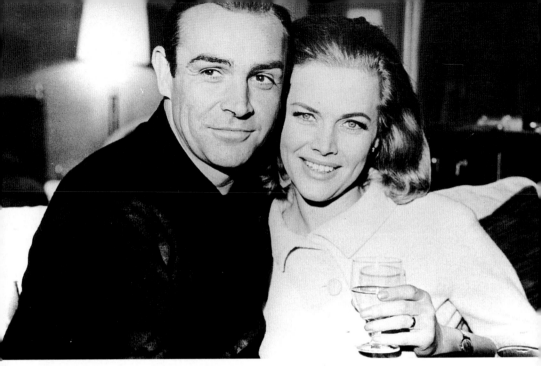

Connery and Honor Blackman, as Pussy Galore, meet the press before cameras roll on *Goldfinger* (1964)

As busted Sergeant Major Joe Roberts in *The Hill* (1965), Sidney Lumet's harrowing examination of glasshouse politics during World War Two

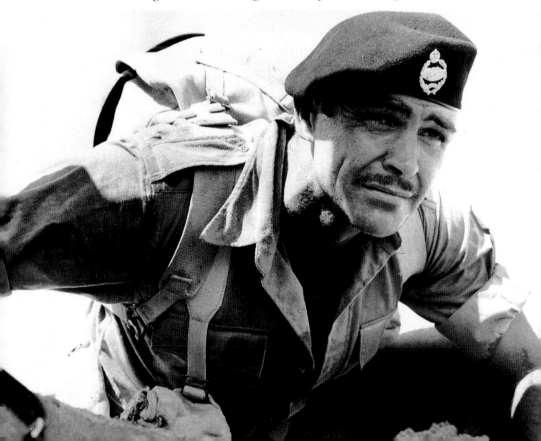

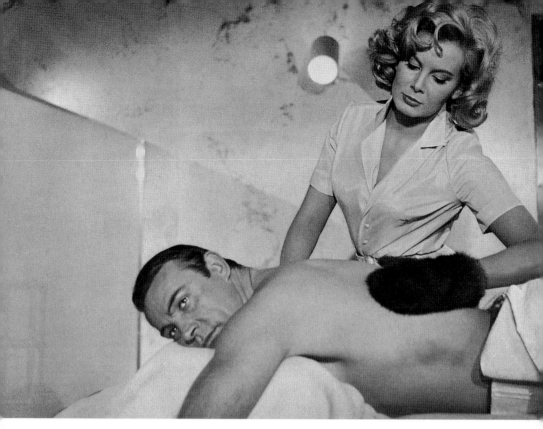

The perks of the job – being given a massage by Molly Peters in *Thunderball* (1965)

By 1965 Bond had literally become superman, taking to the skies in a rocket suit. A classic moment from *Thunderball*

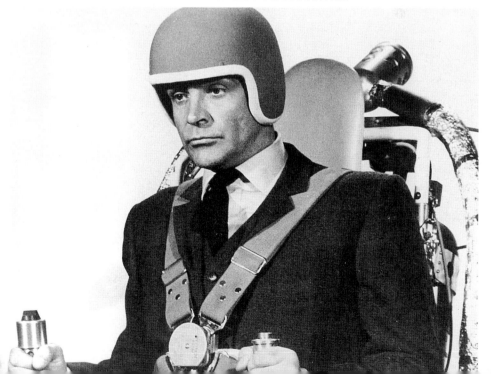

The pressure of Bondage eventually took its toll and Connery called it quits
after *You Only Live Twice* (1967)

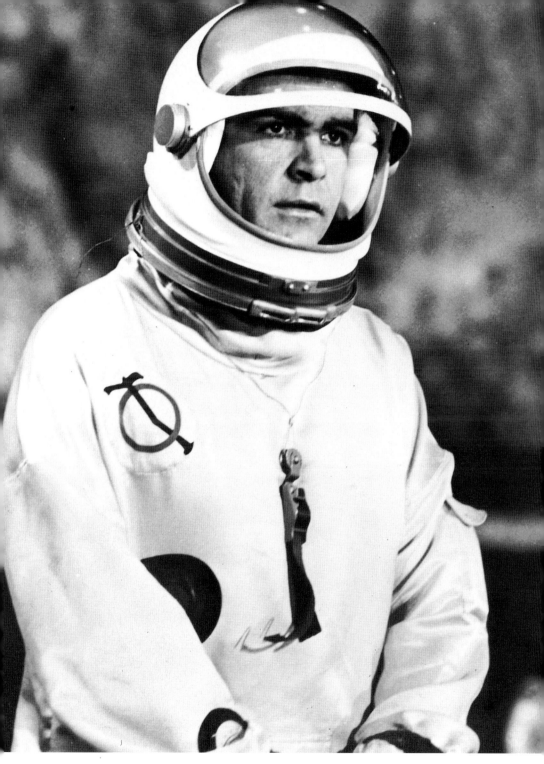
Scotland's first astronaut. As Bond in *You Only Live Twice* (1967)

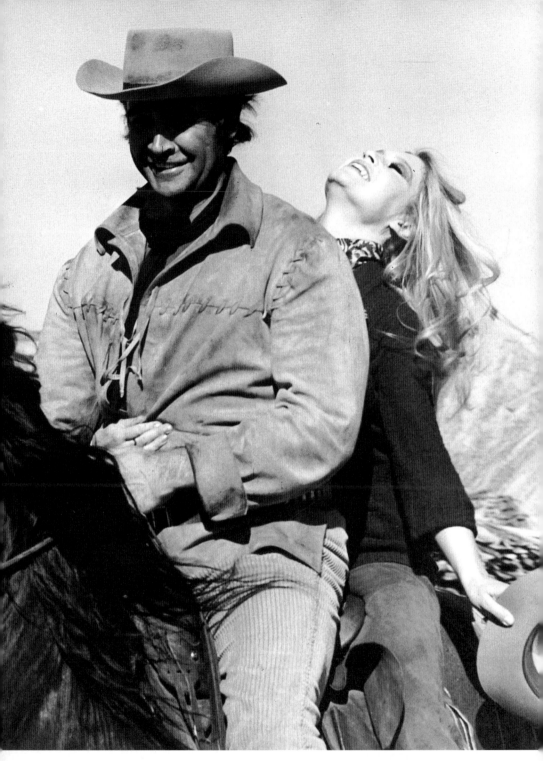

The 1960s' biggest sex symbols Connery and Brigitte Bardot fail to set the screen alight in western *Shalako* (1968)

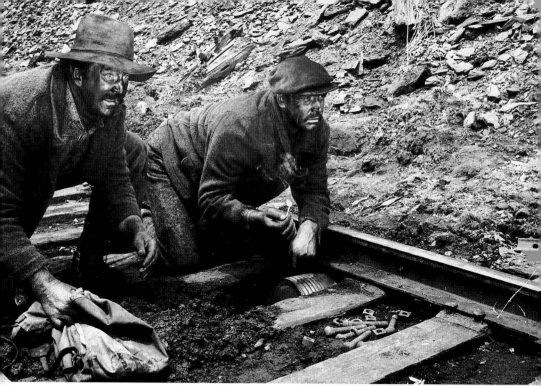

Connery's most politically overt film
statement, *The Molly Maguires* (1969),
focused on down-trodden miners in
1870s' America

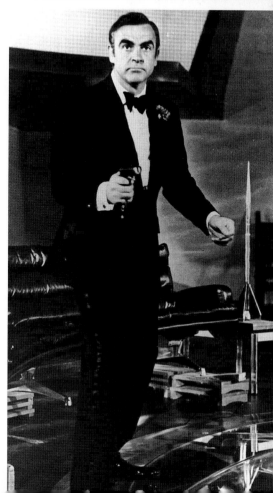

After turning his back on Bond
Connery returned for a world record
fee in *Diamonds Are Forever* (1971)

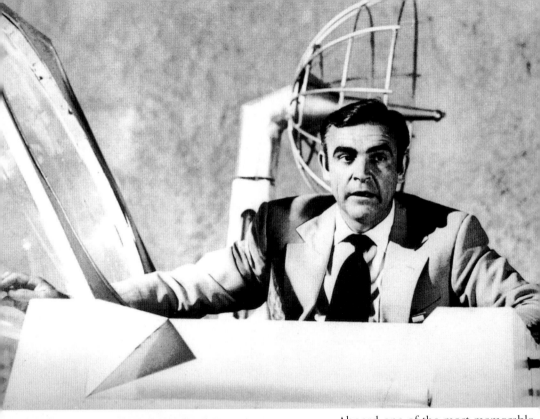

Aboard one of the most memorable
Bond vehicles, the Moon Buggy
from *Diamonds Are Forever* (1971)

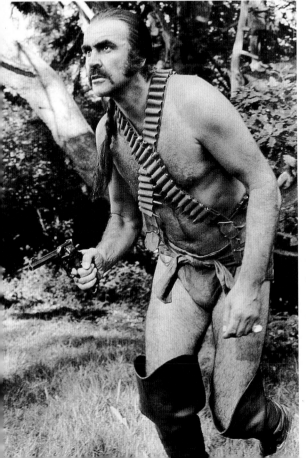

What other star could get away with
wearing a man-size red nappy? As
Zed in John Boorman's allegorical
fantasy *Zardoz* (1974)

The idea to use an all-star cast was Lumet's. 'They were chosen for one simple reason,' explained the director. 'The story takes place on a train, which is a rather limited visual experience, so something better keep you bloody interested.' It's an almighty line-up, mixing screen giants like Lauren Bacall, Ingrid Bergman, Anthony Perkins and Richard Widmark with theatrical luminaries such as John Gielgud, Vanessa Redgrave and Wendy Hiller. No wonder the film was dubbed the 'Who's Who of the Whodunit'. More amazing is the fact that the entire picture cost just £1.5 million, a budget that today would barely cover Arnold Schwarzenegger's laundry bill.

At the first cast rehearsal Lumet had trouble hearing the actors; everyone seemed to be murdering their dialogue, speaking so quietly they were almost inaudible. Finally he figured out what was happening. The movie stars were in awe of the theatre actors, who in turn were in awe of the movie stars. 'A classic case of stage fright,' reported Lumet.

A global smash when released prior to Christmas, earning $19 million in America, *Murder on the Orient Express* spawned a wholesale revival of period whodunits and Poirot follow-ups. None, however, quite matched the class of the original. 'A splendidly frivolous gift wrapped in glittering silver foil and tied with a big satin bow,' as *Screen International* put it. Its unexpected success in New York moved one critic to remark that not since the days of Korda had he seen an all-British production fare so well. In London the movie was the subject of a royal premiere in the presence of the Queen. Connery could not attend, but the 84-year-old Agatha Christie was there and stole most of the limelight, happy for once at the cinematic treatment of her work.

The Wind and the Lion (1975)

A cleverly woven fusion of fact and fiction, this film combines romance and heroism. When John Milius read a true account of the kidnapping in the early 1900s of an American citizen by an Arab pirate, he thought it would make a great subject for a movie. Connery agreed. From the first reading, Milius' script fired his imagination: with its desert battles and political brinkmanship, it had terrific scope, and he loved the idea of pitting El Raisuli, the pirate, against President Roosevelt.

The choice of Connery to play Raisuli was an audacious and inspired piece of casting by Milius, who refused to go down the tired Omar Sharif route. 'Connery is a terrific actor,' he said, 'and looks very much like an Arab and, in fact, he looks not unlike the Ayatollah.' Some critics judged him totally miscast – 'it's the mad Sheikh of Aberdeen', derided the *Observer*. Others were quicker on the up-take. 'Connery scores one of his major screen impressions' (*Variety*). 'A performance to rank among his best' (*Sunday*

Telegraph). 'In a bravura performance, Connery captures the fierce nobility of the desert warrior to perfection' (*Sunday Express*). A role that could have been offensively stereotyped is made totally believable by Connery who lends the brigand Olympic-size charm. It was his most important career move since *The Hill* and a godsend after wasting his talent on low-grade rubbish like *Ransom*.

Shot over the summer of 1974 on locations in Madrid, Seville and Almeria, the film echoes the epic style of a David Lean movie. In Almeria one needn't dig too far among the local sand dunes to unearth cartridges spent on *Lawrence of Arabia*. Moreover, Milius didn't let mere historical fact get in the way of a rattling good yarn. The kidnapped American was in reality a balding pensioner, so who better to play him than the glamorous Candice Bergen? And who cares if the incident was resolved peacefully (Raisuli agreed to release his captor unharmed)? Milius instead chose to send in the Marines for a climatic shoot-out.

The mood on set was genial and productive. Alarm bells sounded during filming of the opening kidnapping sequence, when a stuntman fell off a high roof. Crew members rushed to his aid, fearful of serious injury, only to be amazed to see him get up and immediately resume work. Inevitably, though, as production dragged over schedule the often slow pace started to rile. On one occasion, having been on call for four days in a row without working and all suited up in his chieftain gear under a torrid sun, Connery stormed through a crowd of extras climbed into his car and sped back to his hotel in a cloud of dust.

The world premier of *The Wind and the Lion* took place at the Radio City Music Hall in New York in May 1975. Box office was moderate, but critical reaction favourable. Wrote *Time*, 'Connery, who has become a superb film actor, makes a dashing, funny Raisuli. It has been a long time since Hollywood has produced an adventure as sumptuous or a fantasy as rich.' British critics treated it more sceptically, some complaining that its theme of American imperialism in the Middle East was all but swamped beneath the spectacle.

A sweeping historical epic in the old Hollywood tradition, *The Wind and the Lion* remains one of Connery's favourite movies. Although it runs out of steam in places, the action set pieces are dazzling. 'I remember at the height of the Iranian crisis,' Milius recalls; 'it was on peak time television and they said that is what happened years ago, but then we had a president with guts!'

The Man Who Would Be King (1975)

For twenty-five years John Huston dreamt of making a film of Rudyard Kipling's tale of colonial derring-do. 'I think it's one of the greatest adventure stories ever written.' Humphrey Bogart and Clark Gable were cast

originally, later making way for Richard Burton and Peter O'Toole. In 1973 the unmade script saw new light as the perfect vehicle for Paul Newman and Robert Redford, a sort of *Butch Cassidy and the Sundance Kid* set in Shangri-la. Newman was enthusiastic, but thought both leads really ought to be played by two Brits. 'For Christ's sake, John,' he said. 'Get Connery and Caine!' It was an inspired on-the-spot piece of casting.

Both stars were sent scripts and within a week were on board. Connery (cast in the Gable role of Daniel Dravot) loved the story of two ex-army rogues who journey to Kafiristan, a far-flung Indian province, in a bid to set themselves up as kings. It had fantasy, an epic scale and wonderfully drawn characters.

The $8 million production kicked off in January 1975 with Morocco doubling for the Indian subcontinent. Extras were cast from the local population, including a group of Berber tribesmen who'd ridden down from the Atlas mountains. None could speak English yet by the end of the shooting were so used to modern living, staying in hotels and watching television that they refused to return to their harsh life in the foothills and had to be sent back by the army.

Along with the intolerable heat, illness was another location worry; Caine suffered his usual bout of stomach upset. And then there were the animals, camels in particular. Caine managed to arrive at the stables first to procure an animal of sound mind, leaving Sean with psycho-camel. Preparing for take one, Caine had a severe attack of the trots and ran off in search of the toilet . . . leaving Connery to deftly switch beasts. Caine was none the wiser on his return, then when he clambered aboard he suddenly thought: this bloody camel is pulling a bit! Connery almost got his come-uppance on a horse, when a wire rigged between his legs to aid a stunt fall wasn't set properly and when it was pulled – 'Well, he nearly lost his balls,' reported the unit doctor. 'He walked off the set and went back to the hotel. It was so close, and he knew it.'

Like *The Wind and the Lion*, Huston's film brought back old-fashioned adventure to cinemas, arousing memories of *Gunga Din* and its ilk. A substantial hit, making a decent $11 million in America, critics were won over too, with *New York* magazine claiming it as Huston's finest work for decades. But it was Connery's performance that pulled in the best notices. Revered film critic Pauline Kael wrote, 'With the glorious exception of Marlon Brando and Laurence Olivier, there's no screen actor I'd rather watch than Sean Connery. His vitality may make him the most richly masculine of all English speaking actors.' The *Daily Mail* agreed. 'Connery continues to be amazing. With every film he grows in stature, discarding all the vestiges of James Bond, to become a truly fine character actor.' Critic Alexander Walker perhaps summed up the film's appeal best. 'Sean Connery and Michael Caine are, saving Roger Moore, the only two names who came out of the 60s, made an impact on the international scene, and have never

needed or wanted to return to the stage. *The Man Who Would Be King* is the perfect demonstration of their strengths – character roles that are also star vehicles.'

Apart from the Bonds, *The Man Who Would Be King* stands as arguably Connery's most enduringly popular film and one of the few genuine classics he's ever made. It's a firm favourite with him, and with Caine who calls it the one picture people will always remember him for. Connery particularly enjoyed working with Huston and a top-notch cast that also included Christopher Plummer and Saeed Jaffrey. 'I stayed at the same hotel as Sean, Jaffrey told me. 'He was a bit of a recluse there, we never met socially for drinks or dinner. I was closer to Michael. But Sean was very respectable, very sweet. "Have you seen the rushes?" he'd say to me. "You come across very well in the film." '

It's memorable for another reason too – Connery's one and only nude scene. Minutes before Daniel's coronation he stands, with his back to us, in his full glory as he awaits the royal robes. Connery didn't make a great fuss about the scene, such as demanding the set be cleared; he just got on with it.

The Man Who Would Be King was resurrected in 1997, when a brand-new print of the movie closed that year's Edinburgh Film Festival.

Robin and Marian (1976)

The heroic exertions of his historical double-bill had exhausted Connery. He was thus looking forward to a family holiday, when an offer arrived that was too good to refuse – the chance to play Robin Hood in a revisionist take on the popular legend. Gone was the pantomime figure clad in green tights, as personified by Errol Flynn, to be replaced by a tarnished hero on his last legs, just back from the Crusades and eager to rekindle his love affair with Maid Marian, now the abbess of a priory. Connery was fascinated – 'I love roles that take the idea of the hero and re-examine it' – and the icing on the cake was his co-star Audrey Hepburn, lured back to movies after an eight-year hiatus. Not to forget a supporting cast as distinguished as any film in recent memory – Robert Shaw, Nicol Williamson, Denholm Elliott, Ian Holm and Richard Harris.

For tax reasons, and unpredictability of the English weather, *Robin and Marian* was shot during the summer of 1974 in the Basque region of north-ern Spain, then enduring record heatwaves. Birds dropped out of the sky with sunstroke, while most of the cast experienced a variety of stomach complaints. In the interest of economy all the accoutrements of Hollywood, personal secretaries, limos and so on, were jettisoned by director Richard Lester. Better for the money to be up there on the screen than frittered away on the foibles of his stars. He pushed ahead at breakneck speed, using multi-ple camera set-ups and running as few takes as possible. 'I never remember

doing more than two takes on anything,' Hepburn recalled. 'Lester didn't pussyfoot around.' And that was the way Connery liked it, just so long as the work never suffered.

Robin and Marian opened worldwide in March 1976 to critical acclaim. Connery was singled out by *Films Illustrated* as 'probably the most improved British actor of the decade'. Pauline Kael in the *New Yorker* called him 'the most natural looking heroic figure. He seems unrestrained, naked, a true hero. He's animal-man at its best.' *Time* described the film as 'sentimental, flawed and quite wonderful'. The *Village Voice* thought it 'one of the most affecting moviegoing experiences of recent years', while *New York Magazine* said 'perfection is unattainable but this film comes close'. Of course, there was the odd party pooper who derided Lester's picture for robbing beloved characters of all their magic. 'Disappointing and embarrassing,' was *Variety*'s wrong-headed verdict.

With Columbia promoting it as a romance – 'Love is the Greatest Adventure of All,' read the poster – little wonder *Robin and Marian* flopped. Filmgoers were expecting a jolly medieval romp in the mould of Lester's earlier Musketeer movies; instead they got a sad old man in a dress and a double suicide. Perhaps they would have been better off keeping the original title – *The Death of Robin Hood* – changed under pressure from the backers. Connery blamed its failure on American audiences' aversion to their heroes being over the hill or in any state of deterioration. 'Also we never anticipated the resistance from the Catholics. They protested about Marian being a nun and helping me to die and then committing suicide.'

Naturally studio executives came up with their own excuses. 'Richard Harris would have been a better Robin,' one said, 'because it's a very romantic part and Sean is a very down-to-earth person.' Lester originally envisaged Connery as Little John with Albert Finney as his Robin, before deciding that Connery's self-deprecating sense of humour suited Robin more. 'It's hard for an actor to do two things,' the director revealed in a BBC documentary about Connery. 'One is to make a fool of himself and not be frightened by it, and that normally comes with age and experience. But also to be able to play an innocent man, to be a genuine fool and to do that with grace. And Sean seems to have that gift naturally.'

The trilogy of historical adventures that began with *The Wind and the Lion* and culminated with *Robin and Marian* represents the artistic peak of Connery's career. It established him as a mature leading man who was approaching middle age with strength and dignity. No longer was everything he did assessed in comparison with 007. Such was the impact of the three characters he played – El Raisuli, Danny and Robin Hood – that Connery unwittingly cast himself as cinema's champion of lost causes, a portrayer of men made heroic by their refusal to be beaten by adversity. *Time* magazine was later to describe him as: 'Perhaps the one genuine romantic hero in the movies now.'

The Next Man (1976)

Like Michael Caine, Connery is prone to choosing the odd dog of a movie
and in that context *The Next Man* qualifies as a Crufts winner. This sloppy
political thriller had 'disaster' written all over it, though luckily for Connery
it bombed so badly that few people actually saw it. It should have been so
much better: a sizeable $4 million dollar budget, a capable director in
Richard C. Sarafian, locations as globe-trotting as any Bond – London, New
York, Nassau, Morocco, Nice and Munich – and Cornelia Sharpe as a beau-
tiful assassin, who seduces her victims before killing them.

Anticipating the Middle East peace talks of the nineties, Connery took on
the role of a Saudi Arabian minister who shocks a United Nations confer-
ence by proposing a peace deal between Arabs and Israelis. He thus becomes
a prime candidate for assassination. He probably chose the part in reaction
to his recent slew of period dramas. He also felt the film was trying to say
something important politically, while still offering a fair quota of action to
keep his regular fans happy.

The film courted some mild controversy when one of New York's leading
female columnists suggested Sharpe won the part because she happened to be
the producer's girlfriend. Connery leapt to his co-star's defence and phoned
the journalist threatening to shove her opinion down her throat. 'She was
speechless,' he recalled later. 'She was entitled to say what she liked about
Cornelia's performance. But not to comment on why the girl got the part.'
Such gallantry won him the staunch admiration of Sharpe. 'He's a true
professional and a wonderful person. He has helped me to feel confident
every step of the way. When he walks into a room, he commands attention.
He would even if he weren't a movie star. He's the greatest thing since Coca-
Cola.'

Released in November 1976, *The Next Man* swiftly nose-dived. The reac-
tion of the *New York Times* was typical. 'Made by people whose talent for
filmmaking and knowledge of international affairs would both fit comfort-
ably into the left nostril of a small bee.' *Variety* dubbed it 'a slick travesty'.
Connery was his usual effective self, but the whole enterprise was distinctly
lacklustre. It was hard to believe that its producer Martin Bregman had been
responsible for *Serpico* and *Dog Day Afternoon*. Bregman had nothing but
praise for his star, however. 'He's a marvellous actor who has style and a huge
presence on screen, a bigger-than-life glamour.'

Facing another failure head-on, Connery made his excuses. 'Basically, it
was a good idea that went off half-cocked because we didn't have a good
script. We tried to salvage it through editing, but that can never be done.' So
bad was *The Next Man* that for the first time ever a Connery film wasn't
given a British theatrical release. Fans had to wait until its television premiere
in January 1982 to discover what a crock it was.

A Bridge Too Far (1977)

Connery had the distinction of appearing in two of the biggest ever war movie epics – *The Longest Day* and *A Bridge Too Far*. The latter was a monstrously overblown but admirable exercise in carnage and gore from director Richard Attenborough, which with a $25 million budget was then one of the most expensive films ever made. The movie chronicled the Allies' botched military campaign at Arnhem, Operation Market Garden; Montgomery's bold gamble to end the war in a single co-ordinated thrust succeeded only in littering Dutch fields with the corpses of brave soldiers. *A Bridge Too Far* boasts one of the all-time jaw-dropping casts. Flying the Union Jack were Dirk Bogarde, Michael Caine, Connery, Edward Fox, Anthony Hopkins and Laurence Olivier. The Americans were represented by James Caan, Elliot Gould, Gene Hackman, Ryan O'Neal and Robert Redford. The token Euros were Hardy Kruger, Maximilian Schell and Liv Ullmann, who replaced first-choice Audrey Hepburn. As a child, Hepburn had witnessed the horrors of Arnhem at first hand and couldn't stomach them a second time.

Connery felt much the same as Miss Hepburn, turning the film down twice. He wanted no part in recreating an appalling episode of the war, having read Cornelius Ryan's vivid book on the subject and come away truly disturbed by it. After long discussions with Attenborough, desperate to bag the star, Connery finally relented. He came to realize that the new generation of cinema-goers, raised on *Jaws* and *Star Wars*, had forgotten or were plain ignorant of what happened in the war and needed to be reminded again about why it was fought and the sacrifices that were made. While in Hollywood Connery and Attenborough ran into an indignant Michael Caine: 'Everybody else is in this fucking film except me!' After this, the quickest audition in cinema history, Attenborough gave him a part.

Connery was always the first choice to play Major-General Roy Urquhart, the formidable Scottish commander of the British First Airborne Division, simply because no other actor could have done him justice. Urquhart himself acted as technical adviser on the film, but confessed to never having heard of Connery. 'But my wife and daughter had just seen a film of his – I think it was *The King and I*. They told me – "He'll do." ' The General obviously knew more about capturing bridges than cinema.

The logistics of putting *A Bridge Too Far* on to the screen were brain-numbing. With its mammoth cast and crew, plus thousands of extras, parachute drops, tanks and a myriad of explosions, the film turned Attenborough into a kind of general, waging his own private military campaign. After shooting he was so exhausted that he slept for four days, waking up only to eat.

In June 1977 *A Bridge Too Far* opened in the United States and Britain to

mixed reviews and decent profits. 'Epic films about WW2 will be measured from now on against *A Bridge Too Far*,' announced *Playboy*. 'A cinematic triumph,' heralded the *Daily Express*. 'One finds oneself angered and harrowed by a film that can make something like A Night of a Thousand Stars at the London Palladium of such an unforgettable military tragedy,' said the *New Yorker*.

Though Connery gives a commendable and believable performance (Attenborough contests that it ranks amongst his finest work), yet again he was ignored when the awards were handed out. It was strange, too, that *A Bridge Too Far*, along with *Murder on the Orient Express*, films in which Connery was merely one of a galaxy of stars, should end up his two biggest hits of the decade.

It was a massive gamble making so expensive a film in which the good guys end up losing. Previously war blockbusters like *The Longest Day* had celebrated patriotic victories, not inglorious failures. Both films also serve as cast-studies for the stereotyping of British and American servicemen in cinema. US marines are all square-jawed hunks who chew gum; and, because it's Hollywood money, they get to win the war single-handed. The British army, meanwhile, consists solely of tea swilling, stiff-upper-lip eccentrics or excruciating cockney caricatures.

Both productions made intelligent use of their all-star casts. The famous faces not only helped sell the films round the world, but also enabled audiences to identify quickly with each person on screen. This technique eliminated the need for lengthy character exposition, allowing more time for that primary requisite of war films: shooting Germans.

The First Great Train Robbery (1978)

This delightful costumed caper is among Connery's most underrated movies, a real undiscovered gem. Michael Crichton, of *Jurassic Park* fame, directed, from his own 1975 novel, which was loosely based on an actual incident. Connery plays gentleman thief Edward Pierce, who plans to rob a train carrying a large gold shipment intended for payment of troops fighting the Crimean War in 1855.

Approached to star by Crichton and Dino de Laurentiis, Connery turned them down – twice. First hurdle was the script. 'It was pretty awful. It was very heavy and obvious. One was aware of the fact that it was a period piece, in the worst sense.' Connery found the original novel much better and supported Crichton during the subsequent rewrites. The star was particularly concerned that the Victorian dialogue should not alienate a modern audience. Luckily, Crichton himself always wanted his film to have a contemporary feel. 'My dream,' he said, 'was that the historical world was going to be lovingly recreated, and then I was going to shoot *The French*

Connection inside it.' The second hurdle was that old Connery chestnut – money. The film was due to be shot at Pinewood, but Crichton obligingly relocated to Ireland, where Connery's tax status would not be compromised.

Watching the film, one is left in little doubt that everyone concerned must have had a whale of a time making it, and the period whimsy is infectious. The only sour note came from a controversial scene that recreated the hugely popular Victorian pastime of baiting, in which dogs were set loose on rats, usually in a pit. The RSPCA complained that a terrier killed or maimed several rats during filming and ordered the offending footage be deleted. The film company incurred a token fine.

'Never have so few taken so much from so many' ran the poster on the film's release in Christmas 1978. *The First Great Train Robbery* stirred up little interest, however, despite critical nods for the masterly recreation of Victorian London. Most approved of the rampant sense of fun, underpinned by a deliciously dark line in cruelty, with scenes of murder and public hanging, bawdy language and innuendo. Connery gives a wonderfully relaxed, witty performance, as do his co-stars Donald Sutherland as a master screwsman and Lesley-Anne Down as Pierce's loose mistress. It's a shame they never engineered a sequel, for Connery and Sutherland make a smashing double-act.

But in Britain the film failed to make an impact, and in America it fared even worse, grossing barely $5 million. Connery was livid. Blaming half-hearted studio promotion, he confronted United Artists' top brass for an explanation, only to be told that the picture 'had no legs', meaning it was destined for an early grave. Connery left aggrieved – 'I never got an entirely satisfactory answer.' You'd think the studio owed him at least that, after all the money they made from his portrayal of James Bond.

Trivia note: *The First Great Train Robbery* is dedicated to the memory of Geoffrey Unsworth, the great cinematographer, who worked on a total of five Connery movies. He died two months before it opened.

Meteor (1979)

With a script as bad as the budget was big – $17 million, more than it cost to make *Star Wars* – this unnecessary addition to the disaster movie cycle was directed by veteran Ronald Neame. The story is huge – you can't get much bigger than the destruction of the earth – and the harbinger of doom is a five-mile-wide meteor. Connery, as the no-nonsense Dr Paul Bradley, hopes to deflect it with the help of a joint East/West nuclear strike. Such a premise, based on the schoolboy science fantasy that a meteor may one day hit our planet, was enough to hook Connery, whose name still added lustre to a film's marketing appeal, despite some recent flops. 'Get Connery,' urged the

backers. 'He's a hero. We need a hero type and he's a star round the world.'

Even so, the original script by Edmund (*The Day The Earth Stood Still*) North had to be practically rewritten by Neame and Stanley Mann before Connery agreed to join the all-star line-up of Natalie Wood, Karl Malden, Brian Keith and Henry Fonda. Supporting player Joseph Campanella was particularly impressed by Connery: 'He's a logical successor to the Gables and Bogarts.' Natalie Wood also took the role primarily for the chance of working with Connery. Neame complained one day on set that Wood was wearing too much make-up. 'Tell him I'd be happy to wear less make-up,' she announced. 'But only if Sean will work without his toupee.'

Meteor all but took over MGM's Culver City studios. The sets were vast, including a recreation of the UN Security Council chamber and a replica of a subway station which used enough construction material to build a ten-storey office block. For the scene where a stray meteor splinter hits Manhattan, causing the Hudson River to spill into Bradley's subterranean headquarters, the actors had to endure ten days of physical hell as thousands of gallons of slimy cold sludge was pumped over them. 'It looks like chocolate pudding, but it tastes like shit,' offered Connery, who called the set the most frightening he'd ever worked on. 'We have a fine line safety factor,' one technician ominously put it. 'We're trying to supply as much mud as possible without actually killing Sean Connery.' The actor's suggestion that the scene be played with the cast on their knees in a mere two feet of mud was unsportingly rejected.

Still, Connery was happy to be back working in Los Angeles again, *Meteor* being his first Hollywood-based movie for almost a decade. The place served as an energy booster for him. He even enrolled in a martial arts class run by Steven Seagal, who later singled out Connery as having influenced his own approach to acting. A more permanent stay was ruled out, however, for Los Angeles was 'only a good place to be if you're working'. Connery, who usually stayed at director John Schlesinger's house during his trips over, did eventually buy some property there, when his Hollywood career hit the big time in the eighties.

Meteor took over two years finally to make it on to the screen, but by then the disaster genre had long since peaked. No one gave a damn anymore, and despite a brief publicity tour by Connery and a mammoth advertising blitz *Meteor* returned a Scrooge-like $6 million at the US box office, earning it a hallowed place among cinema's mega-flops.

The special effects were anything but, the models looking as if they'd been loaned out by Airfix. Connery was less than pleased, knowing full well that their supreme tackiness reflected badly on him as an artist. 'They were diabolical,' he ranted. 'Shit flying across the screen instead of meteors.'

Hitting British screens in time for Christmas, *Meteor* was dismissed as brainless holiday fodder. 'Not so much a disaster movie as a disaster' (*New Statesman*); '*Meteor* would lose to a firework display on a very rainy night'

(*Guardian*); 'See it on peril of death by boredom' (*Time Out*); 'There are moments that make Godzilla look like a masterpiece' (*Boxoffice*). And those were the nice ones.

Hailed as the disaster movie to end all disaster movies, *Meteor* certainly did that, crippling an entire genre. Not until the late nineties, with *Twister, Dante's Peak* and the *Meteor*-inspired *Deep Impact* and *Armageddon,* was it successfully resurrected. Like friend Michael Caine, who fended off thousands of bees in *The Swarm,* Connery, acting purely on auto-pilot was lucky to walk away from this unholy mess unscathed.

Cuba (1979)

Richard Lester had long envisaged a romantic thriller set against the backdrop of Fidel Castro's takeover of Cuba, a recent world event as yet unexploited by Hollywood. After their artistically rewarding partnership on *Robin and Marian,* Lester was eager to work again with Connery, cast here as a brash British mercenary hired to train Batista's army in anti-terrorist tactics.

Problems arose, however, when the script, written expressly with Connery in mind, never looked like being ready in time for the September 1978 deadline, when weather conditions in southern Spain, doubling for Cuba, were ideal. Seeking to document the moment when one corrupt regime was replaced by an equally dubious one, Lester feared that he might trivialize his subject. Filming eventually got underway in November. 'I postponed it twice as the script wasn't ready,' Connery told *Starburst* magazine in 1981. 'I didn't think the script was ever ready, so it became a case of patchwork. In my opinion Lester hadn't done his homework.' Remaining loyal, and convinced the theme was a fascinating one, Connery helped Lester with some of the rewrites. Nothing new there. 'I've had a hand in writing or rewriting virtually every film I've done.'

The ten-week shoot was so plagued with mishaps that Lester must have wondered whether it was jinxed. The big battle climax between rebel government troops was forcibly scaled down when army bases were placed on alert after the assassination of a local General by Basque separatists. As a result, promised equipment and men were withdrawn. Next a train integral to the action blew its boiler; then a B26 plane, which in the script was to have swooped low and decapitated Martin Balsam's character with its propeller, crashed before adequate film of it could be taken and they had to make do with test footage. It was not a happy ship and Connery concealed from Lester grave misgivings when he first saw a finished cut of the movie.

Opening in America during Christmas 1979, *Cuba* made few friends. 'If Fidel Castro ever catches *Cuba,* he will discover a ready-made subject for a three hour speech about capitalist waste' (*New Yorker*); 'A hollow, pointless,

non-drama' (*Variety*); 'Mr Connery, who has saved worse films than this, has his work cut out here' (*Sunday Telegraph*). After such a bashing, it's not surprising *Cuba* received only a limited release in Britain.

The *Cuba* débâcle rankled with Connery for years; a film of great potential had in his view been botched. 'I haven't made too many mistakes, but I made one with *Cuba*.' And it was to Lester that Connery directed his wrath, vowing never to work with him again; the pair have rarely spoken to each other since. Lester concedes that he made a mistake by shunting the revolution into second place behind Connery's love affair with Brooke Adams (a last-minute replacement for first choice Diana Ross), and in the actual casting of Connery. 'Audiences thought. "Oh, Sean Connery, that means it's a love story, or an adventure story, a post-Bond story." And the original story about Cuba itself disappears. I kept fighting myself about this and never got it right. It was a hopeless, total mess-up.'

Cuba is seriously flawed, fluctuating awkwardly between documentary realism and Hollywood romance, but it's a rewarding watch. Lester makes vivid use of local colour and there's a charismatic central performance from Connery. A handsomely mounted failure.

Time Bandits (1981)

One of Connery's most popular films, this wacky, highly imaginative fantasy written by Terry Gilliam and Michael Palin of Monty Python fame concerns a gang of time-travelling dwarves who team up with a ten-year-old schoolboy to go on a robbing spree through history, plundering the treasures of Napoleon, Robin Hood and King Agamemnon. In the script Agamemnon was supposed to pull off his helmet after defeating the minotaur to reveal himself as 'none other than Sean Connery. Or someone of equal, but cheaper stature. Our little joke, it was,' Gilliam remembers. 'Then Denis, the producer, said, "Well, let's find out if Connery wants to do it." We were stunned when he said yes!'

Tracked down to a golf course, Connery was intrigued by the idea. Days later Gilliam's backers, ex-Beatle George Harrison and Denis O'Brien of HandMade Films, called him up. They had a script but, 'the trouble is we only have $2½ million to make the picture.' In other words, he wasn't going to be paid much. 'Would you like to see it anyway?' 'When I thought of some of the assholes who get the money to make movies it seemed ridiculous,' so Connery gladly accepted, being something of a closet Python fan. Once Connery signed, the project rapidly picked up other stars like John Cleese and Ian Holm, with Ralph Richardson and David Warner playing God and the Devil respectively.

Suitably heroic and engaging as Agamemnon, the legendary King of Mycenae who led the Greeks against Troy, Connery participates all too

briefly. His scenes were shot in conditions of furnace-like heat in Morocco. Watch out, though, for a brief reappearance of Connery right at the end as a fireman. It was the actor's own idea, after Gilliam was forced to edit him out of the climactic battle between the forces of good and evil because of time and cost restrictions. Connery was available for only an hour, so a borrowed fire engine was towed into the parking lot of Lee International studios in Wembley, the actor clambered in and Gilliam shot it as quickly as he could.

The amazing success of *Time Bandits* surprised everyone, especially since America is such a well-known graveyard for British humour. A minor hit in the UK, the film was taken on by Avco Embassy, which secured US distribution rights, after others had turned it down. They gambled on an advertising campaign that cost more than the actual movie, in the hope of it appealing to both children and adults. They hit gold when Gilliam's oddball creation topped the charts for over a month in the lead-up to Christmas. It made $20 million, helped no doubt by a crop of excellent reviews. 'Deserved to be called a classic' (*Los Angeles Herald Examiner*); 'The Wizard of Oz of the eighties' (*US Magazine*). It was Connery's biggest hit for years – good news as he'd agreed to appear for no salary, accepting a percentage of the gross instead.

Outland (1981)

Connery was drawn to *Outland* in much the same way as he was *Zardoz*, because its concept of the future was woven into a dramatic story dealing with human conflicts and problems, rather than being a mere showcase for special effects. The appeal of movies like *Star Wars* is a complete mystery to him – 'In the end I get lost among all those laser beams and hurtling spaceships.' Not only was *Outland* the most exciting script to come his way for some time, 'but it was the first credible vision of the future I'd come across'.

Once aboard, his creative input was enormous; he participated in the set design, casting decisions and script meetings. 'I found him to be very challenging, genuinely intelligent when it came to the screenplay,' said writer and director Peter Hyams. 'Sean made wonderful suggestions about motivations, and was ready to relinquish screen time if another actor's part needed development.' Connery's main gripe with Hyams' script was that it was too black and white. Set on Io, Jupiter's volcanic moon, the film has Connery playing Federal Security officer O'Neil, who is pitted against Peter Boyle's crooked mine boss. The latter feeds his workers energy-giving drugs that turn them psychotic. Connery felt O'Neil handled the problems he faced too slickly; more inner doubt was required. Hyams was persuaded to relocate his $14 million production from Hollywood to Pinewood, which for Connery housed the finest technicians in the world. There was also a nostalgic reason, as he'd not made a complete picture in London since 1974.

With science fiction then very much in vogue, Connery expected *Outland* to make a packet, and he promoted it vigorously. Alas it was the very features Hyams avoided – hi-tech gizmos, laser guns and spaceships – that audiences seemed to want, and when *Outland* opened in America in 1981 it took only $10 million. Reviews were a mixed bag. 'A tight, intriguing old-fashioned drama that gives audiences a hero worth rooting for ... Connery delivers a stellar performance' (*Variety*). 'Connery and Boyle's dialogue is so banal you expect them to blush as actors, or the movie to suddenly reveal itself as deliberate parody. But *Outland* is no comedy. It's a travesty' (*Newsday*). 'Intelligent entertainment, certainly one of the best thrillers of the year' (*Sunday Telegraph*). 'Don't go. Give it a miss. Avoid it like the plague. The acting is bad, bad, bad' (*New Statesman*).

Certainly watchable, and technically proficient, *Outland* suffers irredeemably from its leaden, downbeat aura, not helped by its claustrophobic, future-Gothic look. Seen by many as a galactic reworking of *High Noon*, the western references are obvious: O'Neil is Gary Cooper's marshal standing alone against the bad guys; the mining complex resembles a western frontier town complete with swinging saloon doors; and the preferred weapon of the future seems to be the pump-action shotgun. Lawrence Gordon, producer of *Family Business*, told *GQ* magazine in 1989. 'If you were casting *High Noon* today, who could leave Grace Kelly behind and walk down the street like Cooper did? I think only Sean Connery could. He is the kind of guy you want by your side, even though you know he'll probably steal your girl.'

The Man with the Deadly Lens (1982)

Released in America under the title *Wrong Is Right* this movie is a real curio, part futuristic thriller, part political satire, part incomprehensible, if fascinating, mess. Blitzing its way, in hit-and-miss fashion, through a range of targets from arms dealing to satellite spying, the main butt of its poisoned humour is American television. In particular, it singles out a form of chequebook journalism, in which television stations outbid one another for exclusive rights to cover global disasters. Connery admired the topicality of the subject matter and the merciless send-up of political double-talk. He also looked forward to working with director Richard Brooks. 'Richard is someone I had known for years and never had a chance to work with. He's great – he's about 70 and still going like the clappers.'

Brooks had written the lead character expressly with Connery in mind. 'Sean is perfect in the role,' he told *Prevue* in July 1982. 'Not only is he a real pro, but he's got a good story mind. His attitude set an example for everyone. Sean extended himself totally – no task was too difficult.' Connery told Brooks, who was renowned for not showing actors the complete script, that it was pointless going any further until he'd read it. Eventually agreeing,

Brooks went further by inviting him to collaborate in cutting it from a cumbersome 280 pages to a more filmable length.

Connery plays Patrick Hale, a Bond-style television reporter – in his words a cross between Ernest Hemmingway and Barbara Walters – who gets embroiled in the search for two missing nuclear warheads. The marketing people certainly picked up on the 007 angle, presenting Connery in a very Bondian stance on the poster: he holds a video camera as if it were his trusty Walther PPK, and bikini-clad women lie fawning at his feet.

When released in the United States in April 1982 barely a soul bothered turning up. 'Miserably unfunny' wrote *Village Voice*. 'What a dog of a movie this is! Connery is totally wasted' – this from the *Boston Herald*. The *Hollywood Reporter* seemed alone in saying: 'I place it right up there with *Dr Strangelove* and *Network* both as entertainment and as admonition.' In Britain it was likewise slaughtered, closing after two weeks.

As Hale Connery is remarkably good, and as the film spirals out of control he remains its sole stabilizing influence. Every inch the superstar anchorman, his television technique and mannerisms are spot-on. The *New York Times*, however, rather strangely claimed this to be 'the first uncertain performance of an otherwise exemplary career'. There's a neat touch right at the close. With a promise from the US military not to raid an Arab base until after the commercial break, Connery parachutes into a war zone, camera at the ready, but not before whipping off his toupee. A classic gag, and a pity so few people saw it.

Five Days One Summer (1982)

In the early 1950s acclaimed director Fred Zinnemann, a keen mountaineer in his youth, stumbled on Kay Boyle's haunting short story about a doomed love affair played out among the splendour of the Swiss Alps. It ignited within him a desire to bring it to the screen one day. Eventually his plans bore fruit and Connery was cast as Douglas Meredith, a respected doctor on a climbing holiday with a woman half his age, who turns out to be his niece. But when she begins to reciprocate the advances of their handsome young guide, the relationship teeters on the brink of collapse. What Zinnemann found so compelling about the story was its climactic scene, in which the young woman awaits news that one of the two men she loves has been killed in an avalanche. Connery himself saw the film as 'a small story with an epic quality'.

The rather thin and plodding tale is enlivened by the most impressive mountaineering footage yet put on celluloid. Shot high up in the Alps, in some locations so isolated they could only be reached by helicopter, cast and crew were forced to endure extremes of temperature, below zero in the mornings, baking hot by mid-afternoon. If that wasn't bad enough, because of the story's 1930s setting all modern safety gear had to be dumped in favour of period equipment, heightening the risk factor.

Exposed to numerous perils Connery gamely declined the use of a stunt double. He'd done a little hill climbing as a teenager and underwent a two-week mountaineering course prior to filming so was feeling confident. Soon he was being suspended by ropes into a yawning crevasse 200 feet deep. 'There he was,' Zinnemann recalled, 'this marvellous man, this superstar worth millions, just hanging there.' All the director could do was hold his breath till it was over.

Later he cut a solitary path along a glacier, in which lethal crevasses lay hidden all around him. Markers used in rehearsals to indicate the safest route were removed during filming. 'It was the loneliest walk I've ever taken,' Connery admitted afterwards. Tragedy struck that same day when two tourists were killed in a nearby region. This incident prompted the actor to call the location work 'the most audacious I've ever been involved in. It was all very hairy.' He also regarded mountaineers as more than a little barmy – including Zinnemann, whose own idea of heaven was being stuck up the Matterhorn with no clue how to get down. 'All of them have had to climb down at some time with a broken arm or leg, or suffering from frostbite. It's not my idea of a good time.' So he stuck with golf, winning a local tournament on his second day in Switzerland.

Five Days One Summer flopped hugely in the States when it opened in October 1982, barely taking $1 million at the box office, not much to offset against a $15 million budget. Connery despaired at yet another of his movies failing to find an audience. 'I expected a better response. The picture was better than the reception it received.' At least he could take pride in some decent reviews. 'In an age of computerized movies, a triumph of compassionate cinematic craftsmanship,' judged the *Daily Mail*. 'One of Zinnemann's most mysterious and beautiful works ... one of the best films of the year,' applauded *Films and Filming*. Others were less charitable. 'It is ultimately as empty and inconsequential as an abandoned elevator shaft,' derided American Rex Reed. 'Feels more like Five Summers One Day,' scoffed *Variety*.

Old-fashioned in tone and perhaps too leisurely paced for modern audiences, Zinnemann has left us with a haunting if inconsequential mood piece. Even Connery is at his most low-key, but it was a performance that prompted this response from critic Alexander Walker: 'In the hands of Sean Connery, in the smile, the wrinkled eyes, the thoughtful brow – yes, even in the balding head of Sean Connery, the man has a visible seasoned sex appeal. What a wonderful actor he has aged into.'

Sword of the Valiant (1984)

The Green Knight, a magically extravagant warrior who challenges the knights of King Arthur's court to solve a riddle or forfeit their heads, ranks alongside Zed (from *Zardoz*) as Connery's most fantastical creation. With

his flowing green hair, bronze make-up and green eyeliner, effects which took an hour to apply each day, he comes across as a truly hissable pantomime villain.

Appearing on screen less than ten minutes Connery easily steals the acting honours, bringing zest and life to a dreary sword-and-sorcery epic. For just six days work he was paid $1 million on locations in northern France. Stephen Weeks, remaking his own 1972 take on this Arthurian legend, justified the fee by declaring Connery perfect casting and worth every penny. Weeks had spent half a year chasing the coveted Connery signature and found him a practical man with few of the trappings or airs of a typical star. This was in marked contrast to co-star Miles O'Keefe (famous as Bo Derek's Tarzan), here cast as Sir Gawain, who takes up the Green Knight's challenge. Despite giving a bland performance, he behaved like a prima donna throughout, his personal manager and agent forever in tow. There were no hangers-on cluttering up Connery's life and he was content to stay in the same hotel as the rest of the cast.

It was the sheer pageantry of the film, and its morality tale, that attracted Connery, a fan of all the Arthurian stories. 'The Green Knight is something new, it is a mystical character, the kind of role I have never played. I love to try as many different parts as possible.' This is perhaps the most positive legacy from his days as Bond, craving for variety in roles and to escape type casting. Few stars can boast such an eclectic range of movie characters as Connery, from medieval monk to Russian submarine commander, from Arab chief to beatnik poet.

Despite a solid cast of stalwarts including Trevor Howard and Peter Cushing, both looking as if they've been dragged to the location from their respective deathbeds, *Sword of the Valiant* found no willing UK distributor after flopping disastrously in America. It remained unseen in Britain until its video release in 1986. 'The film seems so amateur; almost grotesque enough to pass as a sub-standard offering from a struggling local amateur dramatics group,' wrote *Western Mail.* You have been warned.

Highlander (1986)

By the mid 1980s Connery's career again seem poised on the edge of uncertainty and possible oblivion. Despite remaining as popular as ever with the public, flop followed flop and exceptional roles in successful vehicles somehow eluded him. His 1983 Bond comeback was an easy, some would say cynical, way back into hitsville, but then after a two-year lay-off a series of outstanding film choices hurtled him back to the kind of superstardom he hadn't enjoyed since the sixties.

The grand resurrection of Connery's career started with *Highlander*, which bombed on its initial release, but later became a cult smash, spawning

three sequels and a television series. As with *Time Bandits* it was the element of fantasy and myth in the story that drew him to the project. His imagination was immediately captured by the audacious premise of a gang of immortals fighting each other down the centuries. That his scenes were to be film in Scotland was a mighty inducement too, as was the reported $1 million fee for what amounted to little more than a cameo appearance.

Because of the widespread locations, beauty spots like Ben Nevis and Glencoe, and because his time with the crew was limited, Connery often arrived by helicopter in grand Hollywood style. Usually engulfed by local children he was happy to sign autographs or pose for pictures. Secretly, though, he was worried that his seven days on the film wouldn't be enough to get all his material into the can. 'He was just as surprised as the rest of us when we actually finished on time,' said director Russell Mulcahy.

Cast as Ramirez, an amalgam of Obi-Wan Kenobi and Errol Flynn, Connery was required to brandish a blade convincingly in a number of sword duels. Mulcahy's request for some practice sessions was dismissed by Connery, who felt his fencing skills were polished enough. When Mulcahy insisted Connery's response was 'It'll cost you.' The price tag was $10,000. So off he went by helicopter up to the highlands, where Bond stuntman Bob Simmons was waiting. Upon landing he grabbed the nearest sword and wasted no time in thrashing it about in the air. 'One thousand,' he roared before making another swift thrust. 'Two thousand.' Next a parry. 'Three thousand.' And so on until he reached ten. He then calmly handed the sword back to Simmons, with doubtless a wry grin on his face, boarded the helicopter and ascended skyward. Not bad work if you can get it.

However, on the first day of the sword fight with Clancy Brown, playing the psycho villain, Sean was slightly injured. 'He went apeshit and started screaming,' Mulcahy told the *Face* in September 1986. 'So I said, "well, it's your fault. You refused to come in and do any bloody rehearsals with swords. What do you expect? You're going to get cut, aren't you?" ' After that, usually during lunch breaks, Connery would rehearse his sword moves behind his trailer. 'I think it was more pride than anything else, because the whole crew was there when the man fucked up.' On the whole Mulcahy never had a problem with his star. 'Though occasionally we would have what came to be known as our "Connery Meetings". He would group us all together and air his views on why so and so wasn't doing his job correctly. This was free advice – very expensive free advice.'

Highlander opened to a bemused American public in March 1986 and made barely $3 million, a figure that the latest Stallone flick could have mustered in a single weekend. Its failure proved puzzling, seeing how heavily geared it was to the mass youth market, with its violent comic-book action, special effects and rock soundtrack courtesy of Queen. Critics were scathing. 'Mulcahy can't seem to decide whether he's making a sci-fi, thriller, horror, music video or romance. End result is a mishmash,' said *Variety*. 'All

style and no content,' the *Daily Telegraph* chipped in. These are fair points: *Highlander* is trashy, flashy and noisy, moving quicker than a cheetah on roller-blades, but it also has a neat offbeat sense of humour that undercuts the ludicrousness of the script.

Other critics were open-mouthed that Connery could waste his time on such inane rubbish, as clearly he was the best thing in it. As the *New York Times* put it, 'For his brief time on screen, Mr Connery brings dash and style to the overblown proceedings.' Hollywood producers surely took note of just how effective Connery was in *Highlander*. Though on screen for barely minutes, he stole the movie from under the nose of its star Christopher Lambert. This rare knack of making even bad films look halfway decent turned Connery into just as hot a property as Tom Cruise or Arnold Schwarzenegger.

The Name of the Rose (1986)

Umberto Eco's multi-layered novel, enjoyable as either a rich account of monastic life or a metaphysical murder mystery, was a publishing sensation many believed would defy screen adaptation. French director Jean–Jacques Annaud thought otherwise and wanted either Roy Scheider or Michael Caine for his William of Baskerville, a sleuthing medieval Franciscan monk appointed to investigate a string of unholy murders at a remote monastery. 'But the day I had a meeting with Connery suddenly he was there. Sean has only to say maybe and he's beautiful.'

It was the sheer originality of the story which grabbed him, although the irony of the former James Bond playing a monk wasn't lost on critics. 'Celibacy is no great problem at my age,' he countered. One American critic wrote that Connery's performance almost made chastity appealing: 'You think that if *he*'s into it, there must be something to be said on its behalf.'

For three years Annaud toiled on what became a project of passion, sweating blood to raise the $18 million budget and finding suitable location sites, finally settling on monasteries in Stuttgart and Frankfurt. As for casting, Annaud wanted faces for his cast of monks that might have been borrowed from the canvases of Bruegel or Bosch, and *Variety* pondered why everyone had to look 'like Klaus Kinski in *Nosferatu*'. Annaud also hired a priest to maintain religious accuracy.

To achieve the desired naturalism, filming at each monastery, during the winter of 1985, was conducted without heat so that the actors' breath was visible. 'I'm wearing a monk's outfit, thermal underwear and space boots and my arse is still freezing,' grieved Connery. 'You could hang meat on this set.' Even worse were the rats used for the celebrated labyrinthine library sequence, hundreds of them. 'I was walking on a carpet of rats. I killed about 15 of them in my sandals and bare feet. I was sorry but there was nothing I

could do about it.' By the end Connery felt Annaud's quest for total realism was perhaps overdone, referring to the shoot as the most arduous of his career. Just as irksome, when operations moved to Rome's Cinecitta studios, was the lack of golf courses in the area.

Though he was usually allowed no more than three takes, Annaud got on well with Connery, observing aspects of the star he never anticipated. 'He's so entertaining at dinners that we made a tradition of them on the set. During the feasts he'd do magic tricks and sing Spanish songs, while I danced the flamenco.' It was a rare insight into this most private of individuals. 'Sean protects himself,' reflected Annaud. 'He's afraid of emotions, so when he opens the gate it's really something to see.'

In an age of mindless pap like *Top Gun*, a film as artistically brave and different as *The Name of the Rose* was always going to be a huge gamble – a fact borne out by its reception in America. Released in September 1986, and ludicrously marketed as some sort of Carry on up the Monastery, it was shamefully criticized and publicly ignored. 'Connery lends dignity, intelligence and his lovely voice to the proceedings. His performance and the labyrinths are about the only blessings to be found in this plodding misfire,' wrote *Variety*. 'Like a cheap horror film it exploits religion for morbid kicks,' thought the *New York* magazine.

Connery was furious, and adamant that Barry Diller, head of Twentieth-Century Fox, had cocked it up by releasing the movie too quickly. 'The producer told them to wait until it opened in Germany. We made more money there in three weeks than in the whole of the States.' Years later he was his usual forgiving self: 'We've buried the hatchet now,' Connery said of Diller. 'I've put it in his head.'

The real tragedy is that the film's failure in America almost certainly robbed Sean of an Oscar nomination for Best Actor. 'Connery's portrayal of a man ahead of his time should cultivate at the very least an Oscar nomination,' predicted the *Mail on Sunday*. Its critic pointed to other factors too. 'In America they have all been weaned on vitamins since the Revolution and they all look wonderful. Here's this film full of medieval monks who look hideous, like gargoyles, and I don't think they can take it.'

Thankfully common sense prevailed in Europe, where *The Name of the Rose* met with astonishing success. Winning an Italian 'Oscar' for Best Picture, it remained in the top ten for twenty weeks in Germany and finally grossed $100 million internationally, proving that a movie needn't make big bucks in America to qualify as a hit. A few critics did gripe that Annaud had trivialized his source material, diluting the book's metaphysical content in favour of gothic thrills. 'It is all a sorry example of what happens when movie-makers try to make an intellectual best-seller intelligible to the Rambo mob,' as the *Evening Standard* put it.

Missing out on an Oscar, Connery received compensation courtesy of BAFTA, which awarded him their Best Actor prize. He was also honoured

by the British Critics Circle. Never before had his peers paid him such homage, and it marked a turning point in his career. Far and away his best work for a decade, *The Name of the Rose* takes its rightful place alongside *The Hill* and *The Man Who Would Be King* as supreme examples of Connery the artist at the peak of his powers.

The Untouchables (1987)

Not many films boast such impressive credentials as *The Untouchables*: direction by the cultish Brian De Palma, a script by Pulitzer Prize-winning David Mamet, a sweeping score from Ennio Morricone, opulent costumes by Giorgio Armani and a top-notch cast, including Kevin Costner in a star-making role and Robert De Niro as Al Capone. What more could you want! How about an Oscar-winning performance from Sean Connery.

The buzz around Hollywood in 1987 was that this was going to be Connery's year. His fellow actors knew it and so did the critics, who fell over themselves to offer praise. 'Connery commands one's attention during every moment of his screen presence. He delivers one of his finest performances ever,' wrote *Variety*. Nominated by BAFTA for Best Supporting Actor, Connery went on to win a Golden Globe award and, finally, that long-over-due Oscar. Asked what led him to choose the role of Malone, the ageing Irish beat cop, Connery answered, 'Maybe I took it in kickback to playing a celibate monk.' Mamet's script, a fictionalized account of Federal officer Eliot Ness and his fight against Capone's bootleggers, was perhaps the stronger incentive. 'I see so few scripts of this calibre. Mamet has a great gift.'

And then there was De Palma, who'd earlier toyed with casting Connery instead of Michael Caine as the psychotic psychiatrist in *Dressed To Kill*. Although he found the director's films rather impersonal Connery had always admired his technical and visual flair, which is on overdrive here. De Palma's vision of prohibition-choked Chicago is an affectionate recreation of a fabled time in America's history; it is more akin to a western than the world of *The Godfather*, with Ness and his gang of incorruptibles coming across as latter-day cowboys.

Shooting began in August 1986 with Connery agreeing to take the cast under his wing to coax the very best out of them. 'I kept them very much on a wire by snide little remarks, digs at America, what have you.' If tensions exist between characters Connery believed it can sometimes help if they continue off-camera too. 'He was always so respectful towards me,' remembers Costner. 'But at the same time he was always taking little shots at us, keeping a little tension going.' Finishing a scene, he might look over at Costner and enquire: 'Is that the best it's going to get?' It was a profitable and friendly working atmosphere; the young actors would typically huddle round Connery to digest his feelings about the day's work. Some scenes were

even revised to take advantage of the rapport which developed between everyone.

Connery also made his by now customary contribution in the script department, notably the scene in which Malone makes Ness swear to a blood oath before agreeing to partner him in defeating Capone. The scene was originally set in a busy street; Connery's idea, given the biblical implications of the dialogue, was to move the whole exchange inside a church. Connery saw the film as very much about natural justice, an eye for an eye. 'There are times when the law's enough, and times when it isn't. Times when it falls over backwards to be fair and favours people like Capone.'

The original budget of $16 million soon spiralled to $24 million and the big action climax, a shoot-out aboard a train, was deemed too expensive. 'We're out of money,' the studio informed De Palma. 'Sorry: the moving trains, the helicopter shots, we can't do it.' So De Palma brilliantly improvised by staging the final gun fight on the giant marble staircase in Union Station, a homage to the Odessa steps sequence from Eisenstein's *Battleship Potemkin*. In the process he created one of the great movie set-pieces of the eighties.

Fortunately for Connery, who declined a large upfront fee for a stake in the profits, *The Untouchables* was a surprise mega-hit in America, grossing $76 million to become the fifth highest earner of the year. The New York opening was a star-packed affair: Connery arrived with De Niro and fellow guests Eddie Murphy, Sean Penn, Michael J. Fox and fan Christopher Reeve. Reviews were glowing. 'A masterpiece' (*Time*); 'Vulgar, violent, funny and sometimes breathtakingly beautiful and often bloody and outrageous' (*New York Times*).

Factually dubious it may be, but its power as cinema is undeniable; *The Untouchables* stands as the best post-*Godfather* gangster movie. Certainly it was Connery's most important film since *The Man Who Would Be King*, its success turning him into a bankable world star again for the first time since his heyday as James Bond. It's just a shame that he and De Niro never got to share a scene: what screen fireworks that could have produced! To the press Connery spoke admiringly of his co-star, approving of the way De Niro never pulled any punches when it came to portraying true villainy.

The Presidio (1988)

Why Connery got involved in this brain-dead, formulaic action dud is anyone's guess. Was it the chance to play a role Marlon Brando was originally slated for or the opportunity to team up again with *Outland* director Peter Hyams, a last-minute replacement for Tony Scott? Hyams tantalized audiences, promising hitherto unseen sides to Connery. These turned out to be a touchy/feely relationship with his daughter (played by Meg Ryan), a not quite convincing drunk scene in which he lays bare his soul and a genuinely

moving graveside farewell to a fallen comrade. If nothing else *The Presidio* was worth the prize of admission just to see the cinematic rarity offered by that final moment – Connery crying.

The $20 million production was shot on location around the San Francisco area with some scenes filmed on the Presidio itself, a military base close to the Golden Gate bridge. There Connery's Lieutenant-Colonel Alan Caldwell must unravel a plodding murder mystery linked to a diamond-smuggling ring. The biggest obstacle to getting to grips with his character was learning to march properly in formation. 'It was very difficult not to march like a British sailor. I was 16 when I went in and was quite conditioned by it.'

The Presidio was released in June 1988, and after an initial burst of misguided interest it lost momentum and died. Connery, performing his usual job of lending a film a sense of dignity it scarcely deserves, came out best. 'Connery at 58 evokes moral authority, physical strength and rugged maturity (*New York Post*); 'His qualities as an actor are so subtle and consummate that the smallest gesture is enough. He adds authority' (*Scotsman*); 'Connery negotiates the line between testy and tender with a gymnast's grace' (*USA Today*). Britain was fortunate in that it didn't get the movie for another six months, by which time critics had been sharpening their pencils. 'Begins at rock bottom and stays there. It looks like a straight off-the-shelf video. Wait until it is one before viewing' was the *Financial Time*'s damning verdict.

After the epic grandeur of *The Untouchables* most films would probably have looked insignificant by comparison, but *The Presidio* looks positively lifeless. De Palma's movie was proving a tough act to follow. Admittedly Hyams pulls off some great set-pieces, such as an opening white-knuckle car chase, a pursuit on foot across Chinatown and an amusing bar-room brawl in which Connery defeats a lager lout using just his thumb. Rehearsing this scene Connery always made sure his fellow performer was all right after each pratfall, even though the man in question, Rick Zumwalt, was built like a Sherman tank. Zumwalt admitted he came close a number of times to knocking out Connery, whose only reply was: 'Hey, put it right there, it's my job to move.'

Alas Hyams presents us with little else in between the action, including a wretched climactic shoot-out that looks like something dredged up from an abandoned episode of *Hart to Hart*. Actor and director are hard-pressed to hit *Outland* quality here, and even that, let's face it, was hardly *Citizen Kane*.

Indiana Jones and the Last Crusade (1989)

When Steven Spielberg and George Lucas collaborated on *Raiders of the Lost Ark* both agreed to make at least two more Indiana Jones adventures. But when numerous scripts for 'Indy 3' were rejected it looked like the

trilogy might never be completed, until the concept was born that finally brought it to life: give Indiana a father and so allow Spielberg the chance to weave in a meaningful emotional relationship amid all the action, which this time centres on Indiana's quest for the Holy Grail. The problem soon arose of who to cast.

It was Spielberg who came up with perhaps the casting coup of the decade – why not Sean Connery, the original James Bond and forerunner of modern action heroes like Indiana Jones. Concerned that Harrison Ford's presence would smother an actor of lesser stature, Spielberg figured Connery would give his star a run for his money. But would Connery wish to be associated with a film so evocative of the Bond series? Connery later picked up on the primary difference between 007 and Jones: 'Indiana deals with women shyly.' In *Raiders of the Lost Ark* he's flustered when a student writes 'Love You' on her eyelids. 'James Bond would have had all those young coeds for breakfast.' A note of caution came from George Lucas, who argued against using so powerful a personality as Connery; he was thinking more along the lines of senior British theatrical types. But Spielberg was adamant: it had to be Sean.

After reading the script Connery's initial reaction was to turn down the offer. As written, Jones senior resembled the Henry Fonda character in *On Golden Pond*, completely at odds with how he wanted to play him. Connery visualized Henry Jones as more of a Victorian eccentric, based loosely on Sir Richard Burton, the explorer who discovered the source of the Nile. He would be the sort of chap who'd be indifferent to his son growing up and think nothing of gallivanting around the globe for months on end. 'That's quite un-American,' Connery observed, 'and I think I shocked them in a way.' It's a measure of the respect with which he's held within the industry that the powerful duo of Spielberg and Lucas allowed him to get so much of his own way. 'Sean thought Professor Jones was too much like a doddering Yoda character,' said Ford. 'So he went to work and gave that character a charm and a wit and the energy that is all Sean.'

Indeed, Connery's impact was so great that he won promotion to page 50 in the script, having originally made his debut on page 70, and four new scenes were written for him. 'Sean was instrumental in all the rewrites,' Spielberg confirmed. 'And when he gets a good idea, which is about 20 times a day, he's such a child, his face lights up.'

The $36 million production kicked off in May 1988 on locations as diverse as Jordan, Germany, Venice and America. The atmosphere on set was jovial, and Connery couldn't remember a happier and more enjoyable film-making experience. 'There was a real buzz when Dad, Harrison and Steven were working out scenes,' revealed Jason Connery, a frequent visitor to the set. 'Dad had a great time on that movie.' And the evidence is there on-screen in a delightfully comic performance that was justly rewarded with Best Supporting Actor nominations at both BAFTA and the Golden Globes, and

Actor of the Year at the Variety Club of Great Britain. As in *The Untouchables*, Connery managed to steal the film from under the very nose of its star.

Financially surpassing all previous Connery movies (Paramount trumpeted the fact it made more money on its first weekend than any film in history – $45 million), *Indiana Jones and the Last Crusade* opened to glowing notices. 'This is a film of which Lucas, Spielberg and their collaborators long will be proud,' enthused *Variety*. 'In this imperfect world, you're not likely to see many man-made objects come this close to perfection' agreed *People* magazine. Beaten by *Batman* as the year's undisputed US box-office champ, 'Indy 3' actually went on to make more worldwide, an incredible $440 million.

In London Spielberg's movie enjoyed a well-publicized premiere attended by Prince Charles. But not Connery; his place was filled by son Jason. By and large British critics treated the film less reverentially than their American counterparts, believing that the formula had become too obvious. The flow of original ideas had all but dried up, they argued, and this latest instalment was saved only by the introduction of Connery. Others hailed it an instant classic. 'The grandest family entertainment likely to come our way this year' (*Observer*). 'Probably the best written and generally most accomplished of the series' (*The Times*).

For years rumours circulated of a possible Indiana Jones 4. Connery made it known how much he'd enjoy making another Indy movie, seeing the amount of fun he had on the last one. Now it seems highly likely that the Henry Jones character, as played by Connery, will appear in a proposed sequel planned for release some time in 2001.

Family Business (1989)

Having begot Indiana Jones, Connery next moved on to become the father of Dustin Hoffman, an actor a mere seven years his junior, and grandfather to Matthew Broderick in this not altogether successful blend of crime thriller, comedy and family drama.

Family Business reunited Connery for the fifth time with Sidney Lumet, who vowed not to make the picture unless Sean took the pivotal role of Jessie McMullen, an incorrigible old crook. 'Jessie needed to be an attractive role model to his grandson, and I really don't know of any other actor who could have played him with so much charm and charisma.' The challenge facing screenwriter Vincent Patrick, on whose novel the film is based, was turning this family of Bill Sykeses into likeable rogues. It was Connery, however, who wanted Jessie stripped of some of his more redeeming qualities, so as to make the character a lot rougher round the edges; then he admitted that for the role to have really worked someone like Burt Lancaster should have been

cast. 'I thought the grandfather was about as hard as they come – until I met Sean,' said Patrick who was awestruck by the reception Connery received from New Yorkers during location work. 'You suddenly realise he's the closest we now have to Clark Gable, an old time movie star,' he told *Time Out* in 1989. 'Everyone knows him and likes him, there's something very likeable about him on screen.'

During filming Matthew Broderick had a routine of impersonating Connery as Bond – when the big man wasn't around. 'Why doesn't Matthew do it for me?' Sean asked one day.

'I think he might be afraid to,' an assistant replied.

'Good,' said Connery. 'He should be!'

Despite this the younger actor was thrilled to be working alongside legends like Connery and Hoffman. 'You show respect to Sean, particularly,' he said. 'Sean just kind of lets you know he doesn't want some smart-ass kid in his face all the time.'

Family Business opened Stateside in December 1989 to poor reviews. 'There's no telling what drew these three to such trite material. It's like hiring the Rolling Stones and forcing them to sing Barry Manilow,' wrote *Rolling Stone*. Connery liked the film and was genuinely bemused by its poor showing at the box office, the humbling $12 million being a figure not much higher than the combined fees of its three stars. 'I would have assumed people would have gone to it just out of curiosity value. But it was a real flop. I don't know why.' Lumet was certain its failure lay in the fact audiences expected something more substantial considering the stellar cast, not a mere lightweight heist movie.

In Britain audiences were left unmoved, though Connery collected some decent notices. 'The reckless spirit of James Bond inhabits the senior citizens that Connery is playing these days,' wrote the *Mail on Sunday*, while television critic Barry Norman commented that 'like fine malt whisky Connery seems to get better as he gets older'.

The Hunt for Red October (1990)

Based on Tom Clancy's blockbuster novel, which Ronald Reagan called 'the perfect yarn', this expertly crafted techno-thriller proved Connery's biggest solo hit since his Bond days. Ironically he wasn't even first choice to play the lead character Marko Ramius, a maverick skipper of a new Soviet nuclear submarine planning to defect to the West. Only when Klaus Maria Brandauer dropped out was Connery rushed a script by producer Mace Neufeld. Neufeld was amazed when the star turned it down. Calling Connery at home the producer was informed his plot was now out of date because of the demise of the cold war.

'But Sean,' reasoned the producer, 'we explain that right up front.'

'No you don't.'

'Yes we do, on the first page.'

'What first page?' asked Connery.

It turned out he'd been faxed everything except the first page, which explained that the movie was set prior to *glasnost*. Had Neufeld not called, Connery would have ended up not making the movie. 'There's no problem,' insisted Connery when the missing page finally arrived. 'I'll be there in two weeks.' It was a wise career move and pocketed him his biggest pay cheque for years – $4 million.

Once aboard, his first act was to recruit John Milius to rewrite the part of Ramius, which he felt was too thinly drawn. Connery also felt there was too much similarity between the two nations depicted. He wanted the Russian crew of the *Red October* to be more disciplined, 'to run a more British-style naval operation in terms of attitude and bearing, to contrast with the laid-back Americans'. Connery was also responsible for Ramius' striking appearance, 'a sort of mixture of Stalin and Samuel Beckett, that kind of military brush of hair, the white beard. I think it works.' Dressed in a fetching dark uniform, Connery cuts an almost regal presence on deck, like some lost czar. It's a beautifully understated and dignified performance which drives the film on through occasional murky patches.

On set Connery wielded his usual authoritative influence. 'He brought discipline to the set and respect from other actors,' reported Neufeld. 'Nobody wanted to screw up in front of him.' Director John McTiernan, hot stuff in Hollywood after the success of *Die Hard*, was similarly impressed. 'The minute he stepped on the set, he became unapproachable. Everyone else around him involuntarily straightened up and stood a little straighter.'

Visitors during filming included a Russian ambassador, various Pentagon bigwigs and even Gorbachev's niece, who happily posed for pictures with Connery. The big mistake was inviting her along to see the rushes, which that day included the scene in which Ramius breaks the neck of a young KGB officer. 'I don't think she was too impressed with me,' Connery admitted later. 'I had to get somebody else to talk her out of going.'

Released in March 1990, *The Hunt for Red October* stunned industry analysts by becoming a global smash, raking in $120 million in America alone. A near universal thumbs-up from critics probably helped. 'Connery scores another career highlight as Ramius. A terrific adventure yarn' (*Variety*). 'Heart-thumping thriller. Connery, he's quite simply superb' (*Daily Express*). 'Connery dominates the movie like a Lithuanian colossus' (*Sunday Times*).

The Russia House (1990)

This film adaptation of John le Carré's international bestseller has the distinction of being the first major American movie made in the Soviet

Union. Initially, however, the $21 million project hinged on one thing alone – Connery's participation. 'The backers told us that we either got Sean or we could forget about the film,' said director Fred Schepisi. 'So I gave him the script, talked like hell and tried to convince him to do it. I laid down my terms, he laid down his.' A few days later Connery called Schepisi and said he wanted in. 'Boom, we were up and running. When you are looking for an actor who is big in both Europe and America, all roads lead to Sean.'

The offer was really too good to refuse, the chance to see first hand the effects of *glasnost* and *perestroika*. Connery liked Tom Stoppard's script, too, which cleverly simplified le Carré's plot. 'It was a terrific read as a script, as the novel was.' And the part of Barley Blair, a bluff, incorrigible jazz-loving publisher, was another typical Connery figure, an ordinary man given a purpose, in this case to smuggle top-secret documents out of Russia. He is then thrust into extraordinary events in which his actions become almost heroic. 'Like Barley I'm fond of jazz and I like the idea that this guy is in the toilet, he's washed up.' That is, until he meets his courier, the beautiful Katya (Michelle Pfeiffer), 'who helps connect him back, finally, to the world'.

The shooting schedule was tight to avoid Russia's killer winter weather and there was early friction between the foreign and local crews. The food was pretty bad too, so all meals had to be flown in from Britain. On set Connery was as busy as ever, watching over nearly every detail, often beating Schepisi to the video monitor to study footage just taken. Producer Paul Maslansky was impressed. 'He is much more than a brilliant actor, he is a brilliant technician too. He involves himself at every level, without being selfish or an egomaniac – like so many other big stars I could mention.'

The Russia House was MGM's big 1990 Christmas release, but despite the Connery/Pfeiffer combination and the lure of Connery's return to the spy game it failed to generate interest, notching up a pitiful $10 million at the US box office. This despite some decent notices. 'A marvellously literate, ravishingly good-looking adaptation' (*Newsweek*). 'As Barley Connery proves he is in a class of his own as a screen actor and produces the best performance of his career' (*Daily Express*). 'Connery is currently enjoying an Indian summer of stardom, and he invests this role with his usual wry charisma' (*Independent*).

Filmed amid the authentic hustle and bustle of Moscow life, *The Russia House* succeeds wonderfully in capturing a city in the throes of spiritual regeneration. With its run-down apartment buildings and stores without food, it was a Russia few in the West had ever seen before. This stunning footage, along with a lush score from Jerry Goldsmith, are the saving graces of an otherwise deadly dull affair that commits the cardinal sin of being a thriller that simply isn't thrilling.

Despite its obvious failings Connery counts *The Russia House* among his favourite movies. 'It meandered a bit in the third act, but I like the movie, I liked the story, I found it very moving.'

Robin Hood: Prince of Thieves (1991)

Kevin Costner's hugely enjoyable romp through Sherwood Forest was a worldwide box-office smash, despite a troubled production shoot and on-set acrimony between its star and director Kevin Reynolds. At Costner's personal request, Connery agreed to play a cameo role as Richard the Lionheart. His screen time amounts to little more than 30 seconds, and for the day's work that that entailed, he received $500,000. The inevitable press hullabaloo about his fee was quickly quelled when Connery made it known that all money would go to charity.

King Richard's grand entrance comes right at the close, during Robin and Marian's wedding. Costner had personally revised the scene to make full use of Connery's presence, having Richard and Azeem the Moor (played by Morgan Freeman) meet face to face. It was to be a tense moment. How would the men react to each other having until recently been fighting on opposite sides in the Crusades? Alas, because of time restrictions, this dramatic exchange was never shot.

During idle moments on the set Connery enjoyed chatting with Kevin Reynolds about his own escapades playing Robin Hood. 'We made *Robin and Marian* for $5 million in five weeks.'

'Five weeks!' In the present era of hyper-expensive movies taking eons to finish Reynolds could scarcely comprehend it.

'Yes,' Connery continued, 'and we did three days of reshoots. Poor Audrey, she hadn't made a movie in eight years, and we had a nine-page take. It was a good movie.'

Inevitably *Robin Hood: Prince of Thieves* became one of those movies on which critics love to pour scorn, but which the public lap up. Even Connery came in for some stick, courtesy of the *Evening Standard*'s Alexander Walker: 'The King of England appears as the surprise guest, dressed like a Crusader-gram, with one line to speak and a half million dollars in his saddle bag, no doubt thinking that this beats sacking Jerusalem any day.'

Highlander 2: The Quickening (1991)

Along with the rest of the planet, Connery wasn't expecting a *Highlander* sequel, but since its less-than-successful cinema release the sci-fi epic had acquired a massive cult following on video. Plans were therefore drawn up for the inevitable 'Further Adventures of . . .' And if you thought the first one was confusing, *Highlander 2* makes *Dune* seem as complex as *The Railway Children*. Connery returns as Ramirez, this time aiding Connor Macleod in his battle against an evil madman intent on taking over a polluted and dying earth.

Linking up again with Messrs Mulcahy and Lambert certainly appealed to Connery, provided the time could be found in his busy schedule. To satisfy their foreign distributors, *Highlander 2*'s producers promised that Connery would appear in at least a third of the movie, as opposed to his brief stint in the original. To maximize his ten days' location work in Argentina, Connery's screen time was further extended by the clever use of a double. Indeed, Connery's attachment to the project was deemed so vital to its success that the whole crew waited thirty weeks while he dithered over signing the contract. His much-hyped arrival on the set certainly sent jitters through the production team. Costume designer Deborah Everton was so nervous she kept referring to Connery as 'His Sean-ness'!

As usual Connery voiced dissatisfaction with the script. He liked the environmental issues it broached, the fact that in the future the Ozone layer is completely destroyed, rendering the earth almost inhabitable, but he didn't care for the way Ramirez had been developed. Having suffered decapitation in the first film Connery was concerned that his return be handled in the right way. For him, Ramirez was the light relief amid this new, dark, sub-Blade Runner world and he wanted his scenes sharpened up accordingly.

Highlander 2 received only a limited release in the United States and even fared badly in Europe. 'The biggest load of tosh I have seen in some time,' scoffed *Today*. 'A movie almost awesome in its badness. If there is a planet somewhere whose civilisation is based on the worst movies of all time, *Highlander 2* deserves a sacred place among their most treasured artefacts' was Roger Ebert's damning judgement. This was a deserved panning for a film which lacks the charm and flamboyance of its predecessor, instead going overboard on mindless action, gore and special effects.

Connery didn't lose any sleep over it, happy with his $3 million paycheque, which was upped a further $500,000 when a vital sequence was returned from the lab with a scratch on the negative and had to be reshot. Connery was among the first to notice the flaw, as he always checks the rushes. 'I can never understand people who don't go to rushes. There is no other medium where you are given such an advantage with the chance to reflect on what you are trying to accomplish.'

Medicine Man (1992)

Set in the rapidly depleting rain forests of Mexico, this $40 million eco-drama, the most high profile of a spate of green-issues movies that swamped Hollywood in the early nineties, was described by Connery as 'probably the worst experience of my life'. It was a personal disaster from start to finish, with a $3 million script by Tom (*Dead Poets Society*) Schulman that was full of clichés and stilted dialogue; Tom Stoppard did a script polish, but to no avail. And conditions were appalling. Most days, temperatures hit 115

degrees. 'When you combine that with 98 per cent humidity and swarms of mosquitos that eat you alive, you can imagine what it is like – hell,' groaned Connery, who required two litres of water daily to ward off dehydration. Asked who his co-stars were, he replied, 'Trees. Fucking trees.' The amenities weren't much to write home about either. 'The tennis court was like the beach at Dunkirk and you couldn't swim in the water.'

His complaints continued in the February 1992 issue of *Premiere*. 'You couldn't eat in town, you wouldn't want to. The noise of the insects and wildlife where I had this house was insanity, noises that were neanderthal, primordial, noises that I've never heard anywhere else.' At least he didn't fall prey to illness, thanks to prodigious quantities of vodka. Understandably in such conditions tempers were short. While most of the crew praised Sean's professionalism, one describing him as 'a prince', others questioned it, saying he moaned too much for a man making a million dollars a week. Producer Andrew G. Vajna sprang to his star's defence. 'At all times Connery displayed the highest calibre of ethics and conduct. In fact, he was responsible for keeping up the spirits of the crew.'

What attracted him to the project in the first place was the scientific background. As the rain forests vanish so do numerous unstudied plants that may prove pharmacologically valuable to mankind. 'I saw that it could have something significant to say without being Western Union.' As if to prove the point, when director John McTiernan was scouting for locations he visited the forest in Borneo where he'd made *Predator* five years before, only to discover it was no longer there.

It also gave Connery the chance to play out an *African Queen*-type scenario, for *Medicine Man* also aspires to be a romantic comedy. The action revolves around a pair of mismatched scientists who are searching for a cure to cancer in the jungle before developers move in. But Connery and co-star Lorraine Bracco fail to create any engaging sexual tension. At least Connery looks suitably grizzled; with a ponytail and academic specs he was in his element, said one critic, 'as a sod of almost heroic grumpiness'.

Madelaine Stowe auditioned for *Medicine Man*. The reading went well. 'Then Sean asked me to dance.' The actress told the *Calgary Sun* in January 1999, 'There was an important dance sequence in the film. I knew I was doomed because I absolutely have two left feet. I stomped all over his feet.' When they met again on the set of *Playing By Heart*, Stowe pretended it was for the first time. 'It didn't work. He remembered. He taught me to dance for this film. There's nothing that man can't do.'

The film was largely derided by critics on its release early in 1992. 'Throw in Sid James and cronies and you've got Carry On Up the Jungle Part 2,' joked the *Daily Mail*. 'A long and lazy movie, years away from the sort of urgency which the issue demands,' wrote the *Independent on Sunday*. Only a modest hit with the public, the film has its memorable moments – for example Connery in full Tarzan mode swinging from the treetops on pulleys

some 120 feet above the ground, without stunt double. Not for the first time he received better notices than the film itself. *Variety* thought he 'remains watchable, as always, but these are not two of his better hours'. The *New Yorker* noted: 'Connery provides the only hint of amusement with his seemingly effortless and virile charm.' The critic of the *Washington Post*, meanwhile went so far as to call him 'the greatest actor alive'.

Rising Sun (1993)

Based on Michael Crichton's bestseller, which emerged at the height of paranoia over Japanese investments in American business, *Rising Sun* rates among Connery's most controversial movies. Labelled as 'Japan-bashing', Asian groups across America held protest meetings and cinemas were picketed in New York and San Francisco. Though justly trounced by critics for its crude yellow peril-ism, actually the finished product emerged as little more than a lacklustre, if slick, thriller. Writer/director Philip Kaufman deliberately toned down the more contentious elements of Crichton's race-baiting novel, emphasizing instead its murder-mystery plot. This led to a parting of ways when Crichton abandoned the project, citing artistic differences.

Connery, who was also executive producer, tried not to get drawn into the argument. Racism was a theme of the film, he said, not its point of view; he was there because the story had everything he finds interesting in a movie – strong characters, a culture clash and a significant topic. Connery plays John Connor, a maverick LAPD special services liaison officer with a deep understanding of Japanese mores, who is called in to investigate the murder of an escort girl found strangled one floor above a party being hosted by a large Japanese corporation. It's a beautifully judged and charismatic performance littered with great Connery touches, like his one-upmanship of a party bouncer or his orders barked out in Scots-accented Japanese. Arguably, he's never looked better in a nineties film, cutting a very dashing figure in his silver wig and beard, and black suits personally tailored for him by Giorgio Armani. He also enjoyed being back in Los Angeles and got on well with a young and eclectic cast that included Harvey Keitel, Tia (*Wayne's World*) Carrere and Wesley Snipes. The latter remembers the warm reception he and Connery received when they filmed in an inner-city neighbourhood. 'Sean, from his Bond films, his popularity is so great, cats down there embraced us real quick. Like *that*.'

Rising Sun performed decently at the American box office when it opened in the summer of 1993, proving Sean was still a hot draw even in his sixties. But reviews were at best, negative: 'One of those big, shiny, expensive Hollywood thrillers that looks as if it has been made by a committee rather than a single filmmaker with a vision of his own' (*Guardian*); 'It's one of

those whodunits that disintegrates into a whocares' (*Julie Burchill*); 'Arguably the worst expensive Hollywood film of the year' (*Empire*).

A Good Man in Africa (1994)

A fine cast, including Diana Rigg and John Lithgow, are totally wasted in this witless comedy of manners adapted by William Boyd from his own novel set in a fictional post-colonial African state. Connery is perfectly cast in the supporting role of Dr Alex Murray, the eponymous 'good man in Africa' a brick wall of integrity who refuses to be corrupted by African political sleaze. The character is based on Boyd's own father.

It's hard to imagine what tempted Connery to this project, or for that matter director Bruce Beresford (who made the Oscar-winning *Driving Miss Daisy*). Maybe a free holiday to South Africa, where the movie was shot during a period of great political unrest, was too good an offer to pass up. Once there, though, Connery more than earned his fee. It was his suggestion to make Dr Murray more sardonic and witty in his dealings with the bumbling British diplomat (Colin Friels), and he gave Boyd the idea to turn the character into an obsessive golfer. That famous Connery golf swing, rarely seen before in movies, was starting to crop up with alarming regularity, in *Medicine Man*, then *Rising Sun*, and lastly here in a funny scene set on a lush golf course. It was as though Connery's movie career was getting in the way of his practice for the next pro-celebrity golf tournament.

Admittedly there are some amusing performances and a few good laughs to be had along the way. 'Show me a man who's perfectly content,' Connery says at one stage, 'and I'll show you a lobotomy scar.' The poster's tagline was also a hoot: 'Deep in the heart of Africa the British practice bizarre rituals. They call it diplomacy.' Mostly, though, the film is a dreadful mess. Once again Connery demonstrated his uneering knack for scenting out turkeys, as *A Good Man in Africa* bombed dismally and was roasted by the critics. 'I lost count of the number of repetitive jokes about the size of men's willies' (*Evening Standard*); 'Even Connery cannot save the proceedings from descending into trivial farce' (*Sunday Times*); 'By comparison, *Carry On Up the Khyber* is a satirical masterwork' (*Observer*).

Just Cause (1995)

This John Grisham/Thomas Harris style thriller has twists and turns aplenty, but not many thrills. Connery plays Harvard law professor Paul Armstrong, who because of his opposition to capital punishment is called in to help save the life of a young black man on death row for the brutal rape and murder of a young girl. It's a dark and at times unpalatable tale, shot on location in

the atmospheric Florida Everglades. Though it succeeds in its primary purpose of maintaining one's interest to the end, it is nevertheless flawed and utterly forgettable.

Connery, bearded and Panama-hatted, here deserts his usual beloved rogue to play a timid family man, ineffectual against the bully-boy cops he encounters during his investigation into the murder. For once he loses out in the acting stakes to Ed Harris, whose cameo as a Bible-thumbing serial killer gave new meaning to the phrase 'chewing the scenery'. Connery enjoyed making the movie and got on well with co-stars Laurence Fishburne and Kate Capshaw; but he left the biggest impression on bit-part actress Liz Torres, who spent just a week on the film. 'The first night I got to the set he called and said, "Hello, this is Sean." Sean! And fifteen minutes later he knocked on my door to go over our scene. I was floored. He would get up every time I walked into the room. When we had a break, he would gesture for me to pass first. I'm a big woman, but my size meant nothing to him. I was a lady.' When Liz wanted to pose for a picture with Connery, the star called for the stills photographer and later sent her the glossy, signed and framed. 'I was just a two-bit player,' gushed Torres; 'I was not prepared to fall in love.'

Just Cause opened in America in February 1995 to mediocre reviews and average takings. 'Without Connery this rather illogical and increasingly silly thriller would be pedestrian indeed' (*Guardian*); 'If you want to see it because you like watching a genial, fit, wisecracking old bald guy in action, then you'll like it whatever!' (*Mail on Sunday*); 'Arne Glimcher directs with all the subtlety of Michael Winner hailing a waiter' (*Daily Mail*).

First Knight (1995)

Looking for a follow-up to his surprise 1990 smash *Ghost*, writer/director Jerry Zucker settled for another retelling of the Arthurian legend. At $60 million it was a mammoth production featuring 800 extras, 200 horses and 300 suits of armour. A dusty open field on the backlot of Pinewood was converted into a glittering Camelot, derided by critics as looking like a medieval Disney theme park, and a heavyweight cast was assembled: Connery as King Arthur, Richard Gere as Lancelot and Julia Ormond as a headstrong Guinevere. The former Tie-Rack shopgirl relished her time as Sean's leading lady. 'Sean is so lovable and self-deprecating. I didn't expect him to be so entertaining,' she told *Time Out* in April 1996. 'As a kid he was my favourite Bond. Then you meet him and he has this very powerful presence. He's totally in command. But he's also very gentle.'

Casting King Arthur, Zucker, still best known as the man behind the classic *Airplane* and *Naked Gun* comedies, really had no option but to plump for the obvious. He declared that Connery has 'an instant kingly presence

that comes from being himself. When he said he'd play the part, I went running round the house and jumped up and down on the bed.' What appealed most to Connery was the way scriptwriter William (*Shadowlands*) Nicholson had simplified the legend by focusing on the age-old love triangle between Arthur, Guinevere and Lancelot. But by jettisoning the story's mystical elements (Merlin, the Holy Grail, excalibur and so on) *First Knight* often seems reduced to being a glossy medieval soap opera. But Zucker's intention was to make an entertaining romantic fantasy rather than a bleak historical diatribe. 'If you want to do Ingmar Bergman,' reasoned Zucker, 'what you end up with is a film where everybody is covered in shit and who wants that.' *First Knight* was expressly geared towards the multiplexes of middle America, not the purists.

It turned out to be a gruelling four-month shoot, and for once in an action movie Connery was happy to take a back seat; it was Gere who did all the leaping about and swordplay. 'I looked and thought: "Let him get on with it." I have done plenty of that in my time and it was nice to play the elder statesman for once.' And yet Sean remained as adroit a horseman as ever, even if the bones weren't up to galloping in rolling meadows and he needed the service of a small step-ladder to mount his steed. Photographers hoping to snap him doing so were discouraged.

Released in July 1995 *First Knight* was hardly the blockbuster the studio was hoping for, grossing just $37 million in the United States. Critics weren't impressed either. 'If you go in for chaps in armour hacking lumps out of each other you won't be disappointed' (*Independent on Sunday*); 'First Knight may look impressive on the surface, inside it is a mediocrity de luxe' (*The Times*); 'Connery's flinty, patrician Arthur dominates, a rock of ages cleft with ironic wisdom. Since this actor is now as godlike as anyone since Charlton Heston, he can represent any Edenic golden age the cinema throws at him' (*Financial Times*).

Dragonheart (1996)

Unquestionably the most bizarre role of Connery's career is Draco, a talking dragon brought to life courtesy of special-effects masters Industrial Light & Magic. When director Rob Cohen approached Connery to play the part of the last dragon on earth who strikes up an unlikely alliance with a knight played by Dennis Quaid, the actor was flattered, if a little nonplussed. He liked the script – 'It's fascinating and very humorous. I like stories, I'm not too old to listen' – but wanted to know more about the effects process, not wishing to lend his voice to something that children would laugh off the screen.

There was never any fear of that: Draco is a triumph of computer-generated design. Much of the budget went into his creation. 'He's the most

expensive star ever to be put on film. He cost more than Mel Gibson and Arnold Schwarzenegger put together,' bragged Cohen. Not only did he need to move his lips in sync with Connery's recorded dialogue, but his facial expressions and mannerisms had to be the same too. This was achieved by creating a reference library of Connery film clips. 'Sean has an incredible body of work,' Cohen observed,

> so I pulled clips from the beginning of his career to his most recent performances, categorizing every possible emotion. We broke down his emotional life on film and studied how he uses his eyes, and posture and body, then we applied them to Draco. For example, if we needed Draco to look angry, I could tell the animators, 'Go to the anger bin and you will see something Sean does in Russia House, suitable for Draco in this moment.'

Connery guessed they must have been sick of the sight of him by the end, but he found the whole process truly absorbing. 'One is not conscious of all your gestures until they've been put together like this.'

Critics were impressed. 'Dragonheart is Connery's movie. It's hard enough to steal a scene from Connery in the flesh, but absolutely impossible when the actor has grown 18 feet high and 43 feet long' (Washington Post). Others were less so. 'The initial impact of that smooth, over-familiar Scottish purr is anything but awe-inspiring; you keep expecting the dragon to start asking for Miss Moneypenny' (New Statesman).

Sadly, however eye-popping Draco is, it's a shame more time and effort didn't go into the script. Filmed on location in Slovakia with hordes of Pythonesque medieval extras, this is pretty lame stuff which was a modest box-office hit.

The Rock (1996)

Hollywood's dream team of Jerry Bruckheimer and Don Simpson, the producers behind such mega-hits as Top Gun and Crimson Tide, hit pay dirt again with The Rock, a sort of 'Die Hard on Alcatraz'. Connery plays John Mason, a former British intelligence agent who leads a combined assault on Alcatraz, in which a group of terrorists threaten to launch a missile attack on San Francisco.

The $75 million production was shot on the rock itself, which was shut down in 1963 because of crumbling foundations and which has since become a major tourist attraction. To further heighten realism authentic US Navy seals were hired to play the commandos. Connery wasn't best pleased with the inhospitable conditions on Alcatraz, but impressed by the quick and efficient production schedule. Again acting as executive producer he worked closely with director Michael Bay on fleshing out his character, which in the

original script came over as brutish and lacking in background detail. It was Connery's idea to introduce the idea that Mason had once worked for the British SAS. He also roped in writing pals Dick Clement and Ian La Frenais to sharpen up his dialogue, notable in the one-liner department. Rewrites became an ongoing feature of filming, and names like Aaron Sorkin and even Quentin Tarantino had a hand in the final script.

As the film neared completion Connery was informed one afternoon of the sudden death of Don Simpson. He'd been found that morning at his Bel Air home having suffered heart failure, brought on by a combination of drugs and sedatives. 'Having met him only once I was not completely surprised,' Connery later dryly observed. 'He did not look well.' *The Rock* is respectfully dedicated to Simpson's memory.

The world premiere of *The Rock* captured the media's attention by being held on Alcatraz itself. Connery and co-star Nicolas Cage dutifully turned up, but there was something rather perverse about guzzling champagne in a place where men had endured years of isolation and imprisonment. Critics either loved or loathed the picture. 'A first-rate, slam-bang action thriller with a lot of style,' enthused Roger Ebert. *Sight and Sound* begged to differ: 'Hollywood appears to have developed a new definition of the comedy thriller; not a thriller that's also funny, but one with a plot so stupid it can only be played for laughs.' But the public lapped up *The Rock*'s mixture of explosive action and tongue-in-cheek humour turning it into one of the year's biggest hits with a worldwide gross of $330 million – a figure proving that Connery's name could still pull in the crowds. He gives arguably his most charismatic performance of the nineties, and the witty barbs and exchanges between himself and Cage are worth the price of admission alone. There's also a rousing score from Hans Zimmer, one of many memorable soundtracks to have graced Connery films. It's worth pointing out here the wealth of musical talent that has worked on Connery movies – the likes of Bernard Herrmann, Henry Mancini, Ennio Morricone, Quincy Jones, Jerry Goldsmith, Maurice Jarre, James Horner, John Williams and, of course, John Barry. Quite a list.

The Avengers (1998)

This stylish, if soulless, big-screen version of the classic sixties television spy show was a monumental flop. Never has a film in recent memory suffered so harshly at the hands of the critics. 'A leaden, witless fiasco, lacking thrills, excitement or surprise,' boomed the *Daily Telegraph*. 'The movie is an idiocy-driven 90 minutes of torture dreamed up by people who have no new ideas of their own,' the *San Francisco Examiner* jeered. The *New York Post* dubbed it, 'A big fat gob of maximum crapulosity.' Indeed, one could write a book on how badly this film was received. Certainly Connery wasn't

amused, 'I had a bit of fun – until they put the film together.' He said a year after the event. 'And if ever there was a licence to kill, I would have used it to kill the director and the producer.'

This is a pity, because Connery actually had a good time on the set of *The Avengers*, surrounded as he was by a team of seasoned professionals, including costume designer Anthony Powell with whom he had worked forty years earlier, during his theatre days at Oxford. Connery agreed to play comic-book villain Sir August de Wynter in the first place only because of his long-standing friendship with producer Jerry Weintraub, who'd been battling for twelve years to get the project off the ground. At one point Mel Gibson was poised to don the famous bowler hat of John Steed, but this honour was ultimately passed to Ralph Fiennes, who actually makes a decent job of it. The casting of Fiennes and Uma Thurman as spy vamp Emma Peel were further inducements in capturing the all-important Connery signature. 'What with Ralph, a fabulous and formidable actor, and Uma, whose got all these costumes and legs up to her armpits, I think we have made a unique film.' So spoke Connery, in one of his less-than-prophetic moments.

It was a gruelling shoot, partly because the colossal $60 million production was spread over two studios – Pinewood and Shepperton. With a plot centring on the manipulation of the world's weather, a replica of Trafalgar Square, that covered over 10,000 square feet of studio space, had to be built and then shot amid an Arctic snowstorm. The sheer grandeur of the piece impressed Connery, who kept a low profile during his time in Britain, refusing interviews or calls for press pictures. One incident, however, did grab the headlines. Refusing the offer of a chauffeur-driven car home, Connery insisted on driving himself. One afternoon as he sped along the motorway the windscreen of his Range Rover was shattered by a brick thrown from a bridge. For a split second the actor believed he was under attack. 'The noise was so loud and the impact so great he thought it was a gun firing,' his brother Neil said afterwards. The next day Connery spent recuperating, 'deeply shocked' according to his wife, but unhurt. He was also very angry towards the vandals responsible. 'Of course he was not targeted,' Micheline told reporters outside their Belgravia home. 'It could have hit anyone. It is terrible that anyone could do anything like this, he could have been killed. It hit the glass just above his head.

Certainly not the disaster critics led the public to believe, *The Avengers* does stand as a woefully missed opportunity; it could and should have been much better. The final cut shows all-too-evident signs of pre-release tampering, and a good twenty minutes of the movie ended up on the cutting-floor. At least the makers did try to capture the show's quintessentially English feel and surreal style, which Connery revelled in playing. At one point he dons a giant teddy-bear outfit, and still manages to look cool. 'He has an extraordinary ability to carry off some very silly costumes,' Uma Thurman told *Cinefantastique* in August 1998. 'I think he can embody, or express, whatever he likes. He's such a massive personality and has so much energy and

Robert Hale

THE SCOTSMAN
Weekend
PR Planner No. 67B-2250
Daily — 80,900

REGION
12

19 FEB 2000

ROMEIKE
GROUP

Books in brief

Looking for Robbie, by Neil Norman
(Orion, £16.99) ★

WHEN is a tribute not a tribute? When it's
Neil Norman's Robbie Coltrane biography.
To get to know Coltrane isn't necessarily to
come to love him, but even so it is hard to
see what he's done to deserve a biography
which seems intent on burying his
reputation in bathetically hyperbolic praise.
To devote 80 pages — a third of the book —
to summarising in detail the action of
every episode of *Cracker* ever made is
merely to underline the comparative
insubstantiality of Coltrane's achievement
to date.

Michael Caine, by Michael Freedland
(Orion, £18.99) ★★

UNFORGETTABLE classic and downright
schlock: Michael Caine has done them both —
and with equal gusto. But while the quantity
of dross in his cinematic CV may make more
artistically-minded fans despair, it's arguably a
testimony to that very humility which makes

him the great p
imitated, but a
stars, Michael (
having lost his
actor, and as h
content to rest

In an age wh
increasingly au
themselves, it i
not ashamed te
unselfconsciou
with some care
sort of boilerpl
has given us.

Sean Connery
Sellers (Hale,

THAT Connery
turned down
much says it a
Scotland. Selle
credit, isn't af
man really has
touched. Whi

mer that he is. The most
y the most inimitable, of
is almost unique in never
of himself as a jobbing
ved in *Little Voice*, isn't
s laurels.
ne big stars have
d their own films around
ting to watch one who is
an artisan. But such an
nt needs to be uncovered
in some depth – not the
iography that Freedland

elebration, by Robert
★★★

uple of years ago
k-on part as God pretty
out his standing in
'celebration", to its
o question whether the
sed everything he's
husiastic Nationalists

may feel the politics is given short shrift,
others will feel he gets the old tax-exile's
commitment about right. Part personal
biography, part record of the work and part
anthology of anecdotes and quotes, this is
the perfect companion to contemporary
Sean Studies.

Sam Hanna Bell: A Biography, by Sean McMahon (Blackstaff, £17.99) ★★★

THE shores of Strangford Lough where, just
before his death in 1990, they filmed his
master novel, *December Bride*, was the
closest Sam Hanna Bell ever got to
Hollywood. For all the "Hardyesque"
fiction and folklore, Bell wasn't quite as
unworldly as he may have seemed, making
a successful career in regional radio and TV.
But Sean McMahon's decorous biography
recalls him as he surely would have
wanted, as an old-fashioned Ulsterman of
letters.

MICHAEL KERRIGAN

incredible charm that he could probably wear a black garbage bag and carry it off.'

Playing By Heart (1998)

After the mega-budget excesses of *The Rock* and *The Avengers* Connery returned to earth in this gentle, if slight, romantic comedy. Written and directed by Willard Carroll, the story focuses on eleven characters, each with a rich story of their own, but sharing a common quest to understand something about love.

Carrolls's screenplay attracted a top-drawer cast that included Gillian Anderson, Dennis Quaid and Ellen Burstyn, excited by the notion of an intricately woven ensemble drama. Connery was so taken by Carroll's incisive writing he agreed to a massive pay cut to star and lobbied other cast members to do likewise, all of which helped to keep costs down to a mere $14 million. In the film Connery is teamed with Gena Rowlands as Hannah and Paul, a successful middle-aged couple on the brink of a breakdown. 'Connery and Rowlands together is such a spectacular pairing that during their first reading together you'd have believed they had been married for forty years, although they've never even worked together,' said Carroll.

Shot entirely in Los Angeles in just forty-one days and utilizing twenty-seven different locations, it was the story's sense of romantic optimism that most appealed to Connery. 'I saw it was a feel-good film. I love its optimism.' So he was rather aggrieved when some reviewers deemed *Playing By Heart* too gooey in the romance department. 'How can a movie be *too* romantic? It shows that intimacy and romance don't end when you reach a certain age.' There was also the chance to work with Rowlands. 'It's delightful to have a leading lady who's not half my age for once!' Connery joked. Rowlands felt the recent trend of casting nubile actresses opposite the star wasn't Sean's strategy. 'It's the studios. Sean is a man without ego. He's sexy because he's allowed himself to age. Sean is sexy because he's so real. There's nothing plastic or phony about him and women love that in a man.'

The film's other female star, Gillian Anderson, was swept off her feet by Connery, as she described to *Movieline* in January 1999. 'There's an energy that Sean projects on-screen that is so radiant and sexual and intriguing and powerful. And if he were to walk in here right now and be hidden behind that partition, you'd still feel his energy. Men, women and children flock to him. My daughter went straight for him the day I brought her to the set.' Connery got on well with the entire cast. Actor Ryan Phillippe explained how Sean was, 'one of the few people who lives up to your expectations of a real star'. A month after filming Connery left a message on Phillippe's answerphone explaining how he'd enjoy working together again. 'Of course,

I've saved the tape and I've played the message for absolutely everyone I know.'

Connery was only on set for eight days and most of his scenes were filmed as if they were a stage play. 'Sean and Gena did a lot of rehearsing. So when the cameras rolled, it went very smoothly. We seldom needed more than two takes,' confirmed Carroll, conscious of Connery's reputation for disliking doing more than three takes. Still, the star's commitment to the film was unquestioning, happily attending the New York opening in January 1999. But sadly *Playing By Heart* was lost amid a rush of new releases and sank quickly, despite a clutch of decent notices. The *San Francisco Chronicle* called it – 'mushy yet funny and intelligent, beautifully executed. The ideal romantic comedy-drama for a winter afternoon'.

Entrapment (1999)

When *Entrapment* made the US number one spot in its opening weekend in April 1999, scoring $20 million, it was proof yet again of Connery's immense drawing power with the public. And this was in spite of a generally unhealthy press response. 'Another soulless, by the numbers attempt to resurrect a genre that made money for the studios in the past' – *New York Post*. 'A wildly expensive movie where wit, romance, elegance – everything – is sacrificed on the altar of gigantism, cliché and over-the-top action' – *Chicago Tribune*. On the plus side *TV Guide* recommended it as 'A star-driven, globe-trotting exercise in finely crafted absurdity.'

Connery plays master art thief Robert 'Mac' MacDougal who forms an unexpected alliance with tough insurance investigator Virginia 'Gin' Baker, a radiant Catherine Zeta-Jones. Both play an exotic game about power and money, with ever shifting rules and roles as together they set up a daring plan for a multi-billion dollar-heist tied to the dawn of a new millennium. When writer Ron Bass pitched the story to Connery and his partner at Fountainbridge Films Rhonda Tollefson, the actor recognized it as 'A good yarn with wit, and an intriguing romantic element that puts a real sting in the tale.'

Heavily involved in the development of the script and pre-production, Connery was also instrumental in casting Catherine Zeta-Jones, resisting studio pressure to go with a big name. *Entrapment* features another potentially implausible union between Connery and a younger actress, but Catherine was undaunted by the age difference, comparing their relationship to that of 'Katherine Hepburn and Spencer Tracy or Bogart and Bacall in some of their films'. Perhaps mindful of the gulf in ages Connery ultimately asked for the bulk of their sex scenes to be removed from the final print. 'I don't think it had anything to do with Sean's shyness or that he has a son older than me.' Catherine said. 'He's still such a sexy man and there was a

definite spark between our characters and he's a good kisser.' Ironically it was Connery who fell out with first choice director Antoine Faqua (*The Replacement Killers*) because he craved wall-to-wall action, while the actor wanted the script to emphasize the romance angle and to allow more room for characterization.

Faqua was replaced by Jon Amiel, whose most recent work includes *Copycat* and *Sommersby*. 'Sean was a joy to work with,' Amiel said afterwards. 'He knows exactly what is needed. He's well prepared, and at the same time his enthusiasm for film-making is undimmed. Watching him step in front of the camera is a revelation – the energy that seems to blaze from him makes it obvious why he's not just an actor or movie star; he is truly an icon.'

With a budget of $80 million and locations as diverse as London, Scotland, New York and Malaysia *Entrapment* boasts a series of Bond-like action set-pieces culminating with some breathtaking stunt work on the Petronas Twin Towers in Kuala Lumpur, the two highest buildings in the world. The makers wanted *Entrapment* to be a rollercoaster, house of mirrors and a tunnel of love all in one. Sadly it falls short of all three, but is an entertaining ride all the same.

5 Co-starring

Lana Turner

She was known as the 'Sweater Girl', a top pin-up during World War Two and MGM's most artfully manufactured glamour queen. Lana Turner's turbulent life – she was married no less than seven times – largely overshadowed her acting talent and by 1957 she was nearing her decline. But Turner still had co-star approval on her new movie *Another Time, Another Place* and liked what she saw in Connery's test.

Some reporters taunted Connery about the age difference – Turner was ten years his senior – but during filming a deep friendship developed. In her autobiography Turner fondly recalled how the inexperienced actor 'often missed his marks or forgot his key lines, to the annoyance of the director'. But how far their relationship went only Sean knows. Rumours at the time suggested the pair were lovers, and there was certainly a chemistry between them; friends, moreover, judged the Hollywood starlet to be exactly his type. Turner's daughter Cheryl, then fifteen, later wrote that her mother and Connery 'had a certain familiar air with each other'.

Connery himself chooses to remain tight-lipped about the alleged affair. He admits only to the odd night out on the town, sometimes picking Turner up on his battered motor scooter. 'She'd be all dressed up for the evening, but she'd hop on anyway. A good sport. I adored her.'

On his first trip to Hollywood in 1958 Connery attended the Academy Awards ceremony as Turner's guest; she'd been nominated for her performance in *Peyton Place*. Everyone was there – Newman, Astaire, Peck, Gable, Loren, Wayne, Cooper. Connery was starstruck and, as Cheryl Turner remembers, in complete awe of her mother. 'He looked like a gentle giant stuffed into his tuxedo – impish and soft-spoken.'

After the show there was a bash at some swanky hotel and Turner was holding court at her table. During a dance Connery whispered into the ear of his partner, 'Cheryl, love, look over there at your mum. That's what I call a star.'

Connery and Turner bumped into each other again at the 1981 Deauville Film Festival, where retrospective seasons of their work were being held.

They dined together and happily posed for pictures, but as for any revelation about their shared past – answer came there none.

Robert Shaw

It is ironic that the role which made Robert Shaw a star, Bond's blond adversary in *From Russia with Love*, was one he didn't want to play. 'I thought it was just rubbish.' It was his wife, actress Mary Ure, who finally persuaded him to accept.

Shaw had already worked with Connery in television a few years earlier, and in Istanbul the pair spent much of their free time in a gym learning the art of Turko-Grecian wrestling from two local champions. They were doubtless toning up in preparation for their dust-up on the *Orient Express*. 'If we had only had a few more days off we'd have come home the fittest actors in the British film industry,' Connery joked.

What characterized the two men most was a mean competitiveness at sport, any sport, be it swimming, squash or table-tennis. 'I hate good losers,' Shaw told the *Sunday Express* in 1966. 'I play to win and I like good adversaries. That's why I like playing with Sean. He plays to win, too. He hates losing.' Shaw loved to brag that he once whopped Connery at golf.

Shaw's untimely death in 1978 robbed the screen of one of its real characters. 'I think it was Spanish brandy that killed him,' Connery said in 1983. 'He was a great storyteller, though, great fun.'

Gina Lollobrigida

With a shrewd eye on the international market the makers of *Woman of Straw* cast Lollobrigida opposite Connery, a pairing the industry hyped as: 'the most intriguing teaming of the decade'. Lollobrigida, then one of Europe's biggest female stars, not only enjoyed script and director approval, but also that of her co-star. 'They wanted very badly Sean Connery,' she recalled years later. 'Sean who? I asked.' The actress was genuinely ignorant of Connery, having not then seem him as James Bond. She was even more perplexed when studio representatives flew to Rome to try to convince her. 'They didn't say to me that at the time he wasn't very well known, that he was a good actor, that he was very handsome. Nothing like that. They said to me: "He's a real man!" I was so astonished I accepted him immediately.'

Shortly before filming, *Photoplay* magazine asked Connery how he felt playing opposite 'La Lollo'. 'How is one supposed to feel?' he curtly responded, not playing the game. 'But there is only one Gina,' the hapless journalist reminded him – a statement that unfortunately proved all too accurate.

Connery soon grew weary of her penchant for arriving late on set and her annoying habit of dictating to Basil Dearden how her scenes ought to be handled. 'Either he is directing the picture,' said Connery, stepping in, 'or you are directing it. If it's you I may not be in it.' The atmosphere was often strained and made worse by a gossip-hungry press. By the end Connery was reportedly sick and tired of La Lollo'. 'The trouble with a lot of stars,' he said, 'is that they develop heads as big as their close-ups.'

Relations may have been tense, but one cannot ignore their effectiveness as a screen couple; sparks really do fly. During one scene Connery was obliged to roughen up Lollobrigida then slap her across the face, which he did a trifle too hard. He profusely apologized for the resulting swollen lip and all was forgotten. 'You only have to be an inch out in your calculations and I was. It was a fair old belt she got and she felt the blow, but she took it very well.' Many watching from the sidelines wondered just how much of an accident it really was.

Brigitte Bardot

By 1968 Bardot was *the* female star of the decade and being hotly pursued to star opposite George Lazenby, the new 007, in *On Her Majesty's Secret Service*. In the end she chose to make *Shalako* – a serious lapse of judgement. Producer Euan Lloyd phoned Connery in the middle of the night with the news that Bardot had signed. 'Bloody marvellous,' the actor said, before going back to sleep.

Connery and Bardot met for the first time in Deauville, France, during the film festival there. The encounter was captured by photographer Terry O'Neill.

> There was an instant chemistry. She was the most beautiful woman in the world at that time, and Sean has always had an animal sex appeal; it doesn't matter how old he is, he has the same effect on women. He's got the eyes, the mouth and, when he wants to use it, charm galore. I don't think they had an affair – they didn't need to; it was all there on film.

Bardot was the last to arrive at the Spanish location for *Shalako*, and did so with true razzmatazz, pulling up in a white Rolls-Royce with a cavalcade of paparazzi, personal attendants and hangers-on in tow. The lad from Fountainbridge wasn't impressed and walked off, mumbling something about a 'bloody circus'.

From day one *Shalako* courted massive press attention, everyone praying for the two stars to click. They were to be disappointed. Connery personally found Bardot rather aloof. 'She's all girl,' he told reporters, 'but if I must say so, all on the outside.' For the most part Connery kept very much to himself,

saying his lines, riding his horse and basically doing his job – then it was back to his rented villa and Cilento and the children.

Still, on paper at least, Connery and Bardot were a sensational screen pairing – 'In its way an historic meeting. Two of the great sex symbols of the age come to film,' ran one *Daily Mail* strapline. Publicists lost little time dreaming up gems like: '007 + BB = TNT'. More like: ZZZZ. Despite all the hype the expected on-screen fireworks were more of a damp squib. They don't even share the traditional love scene, only a rather gratuitous moonlit fumble.

Richard Harris

In the 1970 dreary if noble *The Molly Maguires* real sparks fly whenever Connery and Richard Harris are on screen. It makes one lament the fact they never made another movie together (Harris does crop up in *Robin and Marian* as a mad Richard the Lionheart, but all too briefly). Connery called working with the Irishman 'an experience'. Both were so sure of themselves as men and fellow professionals neither was frightened of approaching the other for advice. 'I think our co-star Samantha Eggar was amazed to see two actors of our calibre helping each other,' said Harris. 'Not trying to upstage each other.'

The pair became good friends; indeed, Harris counts Connery as one of his few showbiz pals. On the whole he doesn't have much time for actors, as he explained to the *Sunday Times* in November 1982. 'I don't like 'em. I find them fucking boring. Sean Connery is my only genuine friend, the only one I've ever asked to my house. I'd spend an evening with O'Toole, Roger Moore and maybe Richard Burton, but I can't be bothered with the rest of them.'

Candice Bergen

In a role originally earmarked for Faye Dunaway, director John Milius instead cast Candice Bergen as the spirited Eden Pedecaris. Though kidnapped by the exotic El Raisuli in the end she falls for his rakish charms.

Bergen largely agreed with those critics who found Connery as an Arab chieftain a quirky piece of casting. But she wrote fondly of him in her amusing autobiography:

Sean gave an effortless performance: strong and dashing, witty and wry. He had that same wryness in life – a laconic sense of humour, an easy sense of fun. But what struck me as most unusual in a star of his stature was his lack of vanity, his comfortable sense of assurance. There was an honesty and directness about Sean, a wholeness, a manliness that stardom has not eroded.

The film itself remains one of the actress's favourite: every day on set there were tribesmen on horseback, herds of camels or beautiful palaces to wonder at. It was the most romantic location of her life and Sean would forever be the great Raisuli – 'and the only Scots Berber'.

Michael Caine

The momentous first meeting between Connery and Caine occurred at an after-theatre party populated largely by out-of-work actors. Connery was still in the chorus line of *South Pacific* and Caine remembers being struck by him the moment he entered the room. Whereas all the other actors looked puny because they were living from hand to mouth, Connery was the very specimen of health and fitness – though like everybody else he didn't have two farthings to rub together. 'You could tell by his clothes and shoes.' Both got chatting. 'I was secretly grateful to find someone with a working-class accent and attitude,' Caine recalled later. 'And possibly he was more relaxed with me than he would have been with other types of actors in the room.'

They met again months later in an agent's waiting-room while auditioning for the same part in the 1957 movie *How to Murder a Rich Uncle*. Though Caine beat Connery to the role they soon became friends, drawn to one other partly because of the similarities in their background. Caine was raised in South London in a two-room flat, where he was bathed in a tin tub usually reserved for the laundry.

Caine knew from the word go that Connery had what it took. 'He had charisma. He looked great, had a great line in chat and, well, look at the way he was built.' But to succeed, Caine felt that British films needed to move with the times, be more American. The industry needed adventure movies featuring macho heroes. 'In the late fifties it was all about Bunty's having a party and everybody playing tennis and running in and out of French windows, which Sean didn't look like he could do.' Of course, 007 changed all that.

While Connery was filming *Shalako* in Almeria in 1968, Caine was over the next sand dune being soldiers in *Play Dirty*. During those weeks Caine didn't see much of Sean, who was either working or practising his driving shots. Caine was also busy pursuing Brigitte Bardot, only to discover that her taste ran to tanned Spanish youths, not lily-white middle-aged spectacle wearers. Caine did meet up with Connery for the odd dinner, where the subject of his thwarted courtship of Bardot was treated with great hilarity.

It wasn't until 1975 that Connery and Caine finally teamed up for a movie, but *The Man Who Would Be King* was well worth the wait and their scenes together are a joy to watch. The stars based their characters upon their own private relationship, even weaving their particular brand of humour into the script. 'Sean and Michael would rehearse between themselves and come

to me with a finished scene, presented on a silver platter,' John Huston wrote later. 'I had to do no direction whatever. There it was for me, each day a new gift. It was like watching a polished vaudeville act – everything on cue, and with perfect timing.'

In his wonderful autobiography *What's it All About?* Caine writes fondly of his time filming with Connery. 'I had rarely worked with any actor who was so unselfish and generous. I like to think our personal relationship and trust came through on screen and helped the picture.'

During the making of *The Man Who Would Be King* Connery and Caine stayed in a desolate town on the edge of the Sahara desert. At night there was nowhere to go except a small disco where men danced with other men, because womenfolk were barred from going out at night. Despite this Connery was desperate to check out the place. A jukebox stood in one corner and a makeshift bar in the other. This being a devout Muslim area, it was bereft of alcohol. Downing endless cokes while watching the surreal spectacle of all-male dancing, Sean finally sprang to his feet when an old rock 'n' roll number came on. Leaning over he asked Caine. 'Do you mind if I dance with your driver? Mine's too ugly.'

That neither star was nominated for an award is bewildering considering it was their audience-drawing power that ensured the film's success in the first place. And its enduring appeal owes much to their icon status. 'They are just great together,' Huston noted at the time. 'Extraordinary, they strike a chord that is unique in my entire experience.'

The fact that Connery and Caine haven't worked together since is a source of disappointment. For years they searched for a common project, but conflicting work schedules and inadequate scripts prevented further collaborations. Caine did have a small role in *A Bridge Too Far* but they never met on screen. Comedy writers Dick Clement and Ian La Frenais long expressed a desire to write something for them, while agent Dennis Selinger had a project for Connery, Caine and Roger Moore. They would have played sea captains in an old-fashioned adventure story entitled *All the Tea in China*. Connery was rumoured to have been nervous about the prospect of working with Moore, thinking it might be interpreted as a Bond gimmick. There was also talk of the three stars forming their own production company. Allegedly Moore's idea, the venture never took off.

The nearest Connery and Caine got to starring together in another movie was *Travelling Men*, a Scottish-based project directed by *The Long Good Friday*'s John MacKenzie. The plot concerned two men who despise each other, but are thrown together after becoming assassination targets. Connery looked forward to playing a hard-nosed Scot, but when MacKenzie dropped out the actor sensed a sinking ship and headed for the lifeboats.

Caine sums up his friend's appeal. 'The attractive thing about Sean is his complete lack of bullshit. He's absolutely straightforward. There's no two-facedness, which in this business is rather unusual.'

Audrey Hepburn

When Connery won the coveted American Cinematheque tribute award in 1992, there could have been no better hostess than Audrey Hepburn. 'Like every actress, for years it was my dream to work with Sean Connery,' she told a spellbound audience. 'Marvellous-looking, superb acting, versatile and wildly sexy. I got my wish. But I was cast as a nun. Nevertheless, once Robin was back from the crusades in all his splendour, the nun's veil just seemed to melt away.'

No longer the *ingénue* of her heyday, Hepburn was apprehensive about returning to the screen in *Robin and Marian* after almost a decade's absence. However, she was relieved to discover that Connery didn't give a damn about how old he looked. At forty-five he was only a year younger than Audrey, but looked a good deal more weather-beaten, with his balding scalp and shaggy beard. Both stars immediately warmed to each other and remained friends until Hepburn's untimely death.

One Sunday off during filming in northern Spain Connery took Hepburn into nearby Pamplona. The town is famed for its San Fermin festival, in which bulls are let loose in the streets among crowds of revellers. You might have thought that a person as fragile as Hepburn would have balked at anything to do with bullfighting. But it was just the running, in which the bulls normally come out on top.

In its review of *Robin and Marian* the *New York Post* singled out Connery and Hepburn as two stars who 'epitomize ideals of glamour and sophistication that have since passed out of our lives'.

Christian Slater

Only his second film, and just sixteen at the time, Christian Slater was incredulous when Jean–Jacques Annaud cast him in *The Name of the Rose*. 'There is no way I can play a medieval monk – no chance!' In the end it turned out to be one of the greatest experiences of his life.

Coming face to face with Connery was a little daunting. 'The only time I felt really thrown was when I met Sean Connery and the first thing I did was knock a glass of red wine over his trousers,' Slater told the *Sunday Times* magazine in December 1996. 'He's a real guy, funny, charming and polite. I wish I'd been old enough to appreciate hanging out with him. As it was, I walked around most of the time with my mouth open because I couldn't believe I was there.'

After a tentative start Connery and Slater developed a kinship not dissimilar to the one portrayed on-screen. When it came time for him to perform a difficult sex scene the young man turned to Connery for advice. 'It was just great that I had the master of love scenes there on the set. King love . . . James

Bond. What better man to ask how to do a love scene?'

Taking him to one side, Slater asked, 'You've done a lot of love scenes – how do you do this?'

'Just don't think about it,' went Connery's reply. 'Just go with it, breathe and do it.'

Kevin Costner

'When you're with Sean you learn pretty quickly what your own place in the galaxy is. And it pales,' Costner once told the *Sunday Times*. A good example occurred when the two actors, who had become friendly, were filming a street scene for *The Untouchables*. On the other side of a barrier erected by police to keep fans and onlookers at bay, Costner spied a beautiful blonde woman trying to attract his attention. When the director yelled 'Cut' he sauntered over to where the woman was leaning over the cordon and eagerly asked what she wanted. 'Could you get me Sean Connery's autograph?' came the question.

Once during a break from filming Costner, something of a western buff, started reciting a scene from a favourite movie of his – *Hombre*. 'This bitch gets in front of Paul Newman and she won't move. She ends up getting him killed. Hey, who *was* that actress?'

'That bitch,' Connery interjected, 'was my first wife.'

'That was your wife!' said a genuinely bewildered Costner. 'That's great. Jeez, Sean – you're something.'

Mark Harmon

Police rivals in the movie *The Presidio*, Harmon and Connery indulged in some light-hearted rivalry themselves off-camera. Harmon had just been voted the world's sexiest hunk in a magazine poll and Connery loved ribbing him about it. 'Hello, ducky,' he'd call out on set. 'God, you are sexy! How about dinner tonight?' In his hotel lobby one evening Harmon was delighted when a group of screaming women rushed towards him until, that is, he realized it was Connery standing behind him who was the centre of attention.

Connery later confessed that Harmon had disappointed him as a co-star, that he could have been a little stronger in the action-man stakes. 'You know, like Costner or Don Johnson.' He had a point – Harmon has never really cut the mustard as a movie actor, though had nothing but praise for Connery. 'He's a guy's guy who wants to work, to prepare a scene, to rehearse ahead of time, to do his homework. He works and he listens. It was a real lesson being with him.'

Dustin Hoffman

The film *Family Business* is today chiefly remembered for the meeting of Connery and Hoffman, two great movie leviathans. Beforehand there was some trepidation about method actor Hoffman being able to work harmoniously with the more traditional, no-nonsense Connery. As a rule Sean rejects on-set improvisation, preferring to rehearse intensely and plan things out in advance. He is highly disciplined where Hoffman is more intuitive. 'But they got along so well that Sean tried improvising,' revealed Sidney Lumet. 'And he turned out to be brilliant at it. Sean met Dustin improvisation for improvisation. And a great deal of richness and humour came out of it.'

Halfway through shooting Connery attended a private screening of *Rain Man* and assured a sceptical Hoffman that he'd bag that year's Oscar. Hoffman did eventually go on to win Best Actor. He later recalled:

> I'm there holding the Oscar. And there's this amazing standing ovation. And I'm looking out into this sea of faces and the only person I saw was Sean Connery. I'm not kidding. He's in the fifth row, looking like a leprechaun on steroids with those pointed ears and that sweet smile of his. And I could read his lips: 'I told you!'

Not long after the release of *Family Business* Hoffman admitted a secret desire to play 007. 'I would love to do it, seriously. James Bond is the one part I want.' He did acknowledge, though, that his height, or lack of it, might prove a stumbling block.

Harrison Ford

'Don't call me junior!!'

Despite the fact that Connery was only twelve years his senior, Harrison Ford loved the notion of casting him as his crotchety dad in *Indiana Jones and the Last Crusade*. 'When I first met him I was in awe of him,' Ford confessed. 'He is a towering talent. But within a few hours we were like life-long buddies.' Little rehearsal was required to perfect their comic father/son interplay, which to the delight of the unit usually continued off-camera. 'When Sean and Harrison arrived on set everyone got quiet and respectful,' Speilberg told *Time* magazine. 'The two are like royalty.'

Filming on hot days Ford recalled how Connery, dressed in a three-piece tweed suit, would do the scene minus his trousers in order to keep cool, remaining in that position for his close-ups. 'Harrison didn't quite appreciate it at first,' Connery observed. 'Then when his face was dripping in perspiration, he realized it was quite clever.' On another occasion they were chatting idly by a roadside waiting to be called on set when a woman in a car

pulled up. 'Hey look, there's Sean Connery!' she tells her children, who crane forward pointing excitedly. 'So what am I, chopped liver?' asks Ford. The anecdote perfectly illustrates that while Connery never fails to radiate star power or trigger instant recognition, Ford has managed to remain as understated as the man next door.

At first glance Connery and Ford appear worlds apart, but there are striking similarities between them. Both shun the glitzy side of their profession and protect their personal privacy fiercely. Neither subscribes to any 'heavy' dramatic theory – 'We come from the same school of acting,' as Ford puts it: 'Get there on time, do it and go home. It ain't brain surgery!' Both became famous as fantasy heroes before graduating to a greater diversity of roles that have shaped long and illustrious careers. Each was also his generation's definitive man of action.

Connery and Ford spark off each other wonderfully, and their screen partnership deservedly received the lion's share of the notices. 'There's a warmth and respect that makes this one of the most pleasing screen pairings since Newman and Redford,' wrote *Variety*.

Alec Baldwin

In a role turned down by both Kevin Costner and Harrison Ford, newcomer Alec Baldwin got to play America's answer to James Bond, CIA technocrat Jack Ryan in *The Hunt For Red October*. It was a role that could have brought him superstardom, instead Baldwin remains firmly lodged in the B-list category of leading men. Connery none the less recognized the same star-in-the-making qualities in Baldwin that he had earlier noted in Costner. 'I made no secret about how I felt about Costner and I feel the same with Baldwin,' Connery generously reported. 'They come to work totally prepared and professional and with their strong individual presence.'

Baldwin, however, came on set from a different prospective. He was something of a film novice and admitted to being conscious of sharing the screen with people. 'I thought Sean Connery, well you know he's got no hair and he's kind of old now, maybe I'll have a chance. He showed up the first day with this incredible silver hairpiece and beard and I thought, I'm dead. The man still is the best looking guy you've ever seen in your life. Of course I became just a piece of furniture whenever he was around.'

The two have remained good friends, and in a further connection Baldwin is married to Connery's *Never Say Never Again* co-star Kim Basinger. 'Sean was wonderful to work with in every way,' he told *Interview* in 1989. 'When you're with somebody who has made 50 films, he usually knows more than the combined total of everybody else on the set about making movies.'

It was Harrison Ford and not Baldwin who starred in the next two Jack Ryan movies.

Michelle Pfeiffer

Connery had casting approval on *The Russia House* and selected Pfeiffer as his co-star, an actress who seemed fairly representative of the new breed of American leading lady. 'I think she was terrific,' Connery told the *Daily Mail* in February 1991. 'Her approach was unlike any other actress I've worked with. No messing around in make-up or what have you. She arrived at the set on time, was prepared and raring to go. You can't ask for more than that.'

As for Pfeiffer, she confessed to being intimidated by Connery the moment he walked into the rehearsal room. 'First of all, he's so big – an enormous man. He does have this kind of power. He kind of just takes control of the room and has an incredibly powerful presence.'

Filming in Russia was a real eye-opener for Pfeiffer and not an altogether pleasant one. 'An American in Russia, trying to play a Russian. I thought, why didn't they just use a Russian? Why me? What am I doing here?' Conditions didn't help. One scene on top of a bell tower required extensive rehearsal in temperatures well below freezing. After twenty takes Pfeiffer could no longer get her lines out. Connery noticed something was wrong. 'Your face is blue,' he said. Pfeiffer's face had literally frozen. 'I'm not joking! It really did freeze.' Connery said later. 'Luckily she was smiling at the time.'

The Russia House features a romance – one that strains one's credulity – between Pfeiffer's Russian ice-maiden and Connery's boozy old publisher. 'The amorous sparks they strike together would barely ignite a Guy Fawkes sparkler,' ribbed the *Financial Times*. Only Connery could pull off such a feat without it appearing downright farcical. Pfeiffer, though, had another view. 'When I'm 60 years old are they going to let me do *The Russia House* with a 32-year-old leading man? I don't think so.' Sour grapes or mere brute fact?

Wesley Snipes

It made sound box-office sense to cast up-and-coming action star Snipes as Connery's police sidekick in *Rising Sun*. His performance in recent hit *New Jack City* had certainly left an impression on Connery. 'We needed somebody ready to have a go so it would be like walking with a live hand grenade.' People speculated how far the film's senpai–kohai (mentor–protégé) relationship, with its rough humour and tense mix of racial and intellectual one-upmanship, would colour their off-camera dealings. But from day one they developed a lively camaraderie, sharing jokes as well as advice. 'He's a very serious man,' Snipes told *Premiere* in August 1993. 'He doesn't take a lot of shit. At the same time, he's a relaxed guy; he jokes and he plays.' Snipes often watched Connery at work; for him, the man was a master-class on legs. 'You gotta understand what it's like being a young actor

coming up to get the opportunity to work with a person like Sean Connery. Like, those things don't usually happen.'

Actually Snipes was lucky to be cast in the first place. The character in the novel was white for starters, but director Philip Kaufman thought it would add to the drama of the piece if a black actor were to play the part, rather than first choice Tom Cruise. 'And of course I agreed with him 100 per cent,' said Snipes.

Richard Gere

The talk before the shooting of *First Knight* centred on the potentially explosive pairing of Connery and Gere, whose combined fees were around $14 million. Sean is a man's man, keen on a round of golf and a pint of beer. Richard is more your 'new man': free Tibet, no alcohol, into Buddhism. 'I don't think there is going to be any great collusion of minds on this one,' joked the producer.

In the end there was little friction, both men being consummate professionals, though Connery did once or twice berate Gere for his poor time-keeping: one crew member reported Connery banging on Gere's trailer door urging him to hurry up. But Gere was still magnanimous in his praise. 'Everything that makes him Sean Connery made him perfect to be Arthur. He immediately had the respect and command of everyone.' During filming Gere kept a low profile, not just from fans, but even from his own co-stars. To be fair, his personal life was in turmoil at the time. His marriage to supermodel Cindy Crawford was heading for the divorce courts and photographers were grouped outside Pinewood every day. Gere was often reduced to being driven from the studio with a black bin liner over his head to thwart would-be pursuers.

Amid such pressure there was the occasional light moment. During one take of the scene where Gere races through a crowd to kiss Guinevere, he suddenly veered off in the direction of Connery and planted a kiss on him instead, much to the star's amusement.

Nicolas Cage

There are two films Nicolas Cage clearly remembers going to see as a kid: *Pinocchio* and *Dr No*. Connery's performance as 007 left an indelible mark on him. 'When I saw Sean acting in that it was like every other man wanting to become James Bond. And I remember thinking he looked incredibly like my father.'

Cage admitted it was a dream come true working with Sean in *The Rock*, if a little unnerving to act opposite a childhood hero. Cage can recite at will

whole chunks of dialogue from the early Bond movies. It was also a refreshing change finally to play an action man after so many oddball characters. And the role of Stanley Goodspeed turned out to be a career milestone, leading to more action films like *Con Air* and *Face/Off*.

The Rock benefits enormously from the terrific chemistry between Cage and Connery, the old timer's world-weary charm neatly counterbalanced by Cage's manic energy. 'Sean and I got into a mode that seemed really to click,' Cage told *Time Out* in June 1996. 'We developed a rapport and it just went into a kind of synchronicity where we actually got a kick out of what each of us was doing. I think we figured out how to act without getting too method.'

During filming Cage acknowledged that Connery became something of a mentor for him. He would probe the big man for answers, particularly to the thorny question of whether a movie star should cultivate an image. 'Don't worry about that,' Connery told him. 'Don't concern yourself with image. Just do your work.'

6 The Directors

'Sean Connery can be very mean with directors. He has an enormous presence and if you feel insecure as a director, he can become very ironical. I know how to handle him, you have to humour Sean. If you don't have the weight to withstand him, it can get nasty.'
 —Thomas Schuhly

Connery has worked with some of the all-time great directors, names like Hitchcock, Huston and Spielberg. The one director he laments never having made a film with is Ingmar Bergman. 'The test of a picture for me is if I go into the cinema to see it, and while I'm there I'm completely unaware of time; then it has succeeded for me. And I find that quality more consistently with Ingmar Bergman than with any other director.'

Alfred Hitchcock

Personally chosen by Hitchcock to star in *Marnie*, his forty-ninth picture, Connery unwittingly caused uproar in Hollywood when he demanded the script. 'Not even Cary Grant asks to read a Hitchcock script,' he was told. 'I'm not Cary Grant,' Connery hit back. Accusations of arrogance followed, but Connery felt it was a legitimate request. 'For the first time in my life I can ask to read a script. And if you had been in some of the tripe I have, you'd know why.'

Hitchcock was a touch displeased. Normally, he said, it was sufficient enough for an actor to be asked to appear in one of his movies. 'Well I have to play it so I'd like to read it,' Connery later explained. 'Because I could end up playing Bambi or something.' Hitchcock finally relented, won over by the nerve of the man, and even tried signing him up to a three-picture deal. Ever the trend-spotter, he knew that Bond and therefore Connery were mere months away from stratospheric fame.

For Connery this was his first opportunity to demonstrate the range and quality of his acting and he revelled in the experience of working with a master technician. This was a director who rarely looked through the

viewfinder, because every frame of his picture was already mapped out in his head. On set Hitch followed a strict regime: every afternoon at 3.30 there would be a tea break in which he'd regale the crew with stories, usually revolving around his old movies, or tell jokes. 'His humour was pretty schoolboyish,' recalls Connery.

The two men enjoyed a good relationship, which had the best of starts. On arriving in Hollywood Connery discovered two bottles of a favourite brand of scotch in his motel room, courtesy of his director. 'I never had too many problems discussing anything with Hitchcock; he would just say, "Oh, it's just a movie." ' This attitude extended to learning anything related to the character he was playing, about whom Hitchcock offered no clues or motivation. He reasoned that as he was paying out a fortune, the actor ought to know what he was doing without added help. Connery received only two pearls of wisdom from Hitchcock. First, that he listened to other actors with his mouth open. ('I don't think that the people in the theatre are interested in your dental work,' Hitch one day whispered in his ear.) And secondly, whenever he got excited in a scene Connery had a tendency to speak too fast. 'Just sneak in some dog's feet,' Hitch would say – meaning pauses.

Before leaving to begin work on *Goldfinger* in London, Connery was given a radio alarm clock by Hitchcock. There was a note attached which read: 'Now you'll have to come back.' It wasn't until he got home that the words made sense – the clock would only work properly in a US time zone!

Sidney Lumet

'Most people think of Sean as a legendary star. I don't – but only because we go to the toilet together.'

The acclaimed director of movies such as *Twelve Angry Men*, *The Pawnbroker* and *Serpico*, Lumet worked with Connery for the first time on *The Hill*. Initially the actor didn't believe an American would have a clue about the ins and outs of discipline in a British military establishment. 'I couldn't quite see how he would get such a handle on it. But he did.'

Since *The Hill* they have collaborated a further four times (*The Anderson Tapes*, *The Offence*, *Murder on the Orient Express* and *Family Business*). For Connery each was a renewed pleasure; Lumet encapsulates the kind of director with whom he enjoys working – fast, professional, no-nonsense. *Family Business* was shot in an efficient thirty-one days, for example. 'We get on with it,' says Connery. 'And it's hard work, but rewarding.'

Lumet was among the first to grasp Connery's potential as a serious actor. 'It's only in the last 10 or 15 years that people have started saying. "Oh, he can act!" In the Bond era, the assumption was that Sean was this charming sex hulk. Non-professionals didn't realise what superb high comedy acting that Bond role was.' Hollywood greats like Cary Grant and David Niven

were labelled 'personalities' rather than actors, though both were capable of dramatic performances that passed the critics by. Lumet always felt that that was how Connery was largely perceived. 'God knows, after *The Hill* I felt there was almost no telling where he'd go.'

The formula of Connery's success Lumet simply puts down to his having always striven for the best parts available. 'There's no vanity about him,' he told *American Film* in May 1989. 'He has no worry about playing a hero or a villain, looking ugly or pretty. He's so sure of himself as a man, he goes for the best parts.'

The Lumet/Connery partnership has yielded some marvellous movie moments and arguably the two greatest performances Connery has ever given (in *The Hill* and *The Offence*). Lumet, for one, hopes it's a relationship that will long continue. Each time a script lands on his desk Lumet is inclined to thumb through it first in the hope there might be a part in it for Sean.

John Milius

Nineteen-seventy-five's *The Wind and the Lion* established John Milius as the standard-bearer of the new machismo in Hollywood; he went on to write *Apocalypse Now* and direct *Red Dawn*.

For Connery it was his first experience of working with one of America's new breed of directors, the so-called 'movie brats'. These also included the likes of Coppola, Lucas, Spielberg and De Palma. On the whole he was impressed with what he saw. 'Milius is an exceptional writer,' he told *Time Out* in February 1987, 'especially of heroic stuff. But he is so busy being butch and Hemingway and Samurai and all that, it gets in the way of his direction nowadays. But his invention as a writer is wonderful.' Connery classes Milius as by far a better writer than a director, and later recruited him to beef up the part of Ramius in *The Hunt for Red October*. And while he views *The Wind and the Lion* as a good film he believes it 'would have been a really fantastic movie with a different director'.

As for Milius the impression left by the actor is still strong. 'Sean is a very charismatic figure on screen,' he told the makers of an American television profile on Connery. 'He is a very skilled actor and knows exactly the effect of everything he does. He's probably the best actor I've ever worked with.'

John Huston

During the filming of *The Man Who Would Be King*, Hollywood veteran John Huston acted more like a benign grandfather to Connery and Caine than a director. The first scene in the can involved a group of natives bestowing gifts of arrows on the two conquering heroes. Huston ordered that more

arrows be brought over to give the 'kids' extra confidence. Both stars looked at each other, trying to recall the last time someone had called them that. In a television documentary Huston spoke with sincerity of his admiration for Connery. 'He's a joy to work with, he's a joy to watch work. He has a flow of energy, a kind of aura of power and masculinity and humour.'

Years later when Huston lay gravely ill in a Los Angeles hospital, Connery and Caine were among his first visitors. 'He's going fast, you know,' a nurse told them. Huston opened his eyes when he saw them and mumbled, 'Danny, Peachy' (during filming Huston only ever addressed the actors by their characters' names). Then he started telling tales about his early days as a boxer. Connery and Caine sat listening with tears welling up in their eyes, convinced he was dying. 'I thought that was the end,' remembered Connery, 'curtains.' But Huston's will to live was so strong that within a week he was up and about. Not long after, struggling with emphysema, he came to dinner at Connery's home with his bottles and tubes. 'He was a rogue,' Connery spoke later, 'a rascal.'

Michael Crichton

Connery's relationship with best-selling novelist, film-maker and the man behind *Jurassic Park* Michael Crichton is an interesting one. The main character in *Rising Sun* was written expressly with Connery in mind – hence the name Connor – while in the early eighties Crichton had wanted to direct the film version of his novel *Congo* with Connery in the lead.

But the two first worked together on 1978's *The First Great Train Robbery* and Crichton came away from the experience in awe of his leading man. 'Connery throws himself into his work with abandon. He is one of the most remarkable people I have ever met.' It was during the shooting of one scene in particular that Crichton learned a valuable lesson in how to direct Connery. After the first take, Crichton felt one of Connery's hand gestures was veering towards the effeminate, but didn't know exactly how to break the news to the screen's premier action star. Eventually he plunged in. 'Sean, on the last shot, you had a hand gesture . . .'

'Yes, what about it? I thought it was good.'

'Well, uh, it was a little loose. Limp.'

There was a brief silence. 'What are you trying to say?'

'Well it could be a bit crisper. Stronger, you know.'

'Stronger . . .'

'Yes. Stronger.'

'You're saying I look like a poof,' said Connery, clearly relishing Crichton's discomfort.

'Yes. A little.'

'Well, just say so, ducky! Just say what you want! We haven't got all day!'

The take was completed to Crichton's satisfaction. Afterwards Connery took him to one side. 'Michael, you don't do any favours beating about the bush. Making us try and deduce what you mean. You think you're being polite, but you're actually just difficult. Say what you mean and get on with it.'

Terry Gilliam

Casting the fabled Greek King Agamemnon, Gilliam had only one actor in mind. 'I couldn't think of anybody else who had the qualities Connery has. He had to be a hero, a king, and he also had to be a father figure. We wanted a hero and Connery's a hero.' Gilliam guessed that Connery was drawn to the role of Agamemnon, who in the story becomes surrogate father to a lost boy, because he perhaps felt some guilt for not being as good a dad as he might have been for his own son Jason – a standard hang-up of most actors. Agamemnon became the first of many father/mentor roles Connery would play in the Indian summer of his career.

'Right from the start he knew what we intended the role to be about,' Gilliam said. 'He had just the right twinkle, the right amount of authority.' Connery asked for the inclusion of one new scene, in which he berates the child, to avoid the traditional trap of sentimentalizing such relationships.

Each evening the pair would dine out together, and the topics of conversation were always money and golf. Gilliam's only gripe with the star was his habit of addressing him on set as 'Boy', or even worse, 'Quasimodo'.

In 1988 Gilliam offered Connery the part of the King of the Moon in his Baron Munchausen fable. Producer Thomas Schuhly originally wanted Connery for Munchausen. 'Sean's great, but he's not our Baron,' argued Gilliam. Schuhly then suggested him for the moon king. 'Now you're talking,' said Gilliam. 'Sean would be terrific as the king.'

He was to preside over a moon populated by thousands of minions, but as the budget careered out of control it was cut to just two characters – the king and queen. Gilliam still believed Connery had the 'majestic' presence to carry it off, but the scene no longer resembled what had first interested the actor and so he passed. Robin Williams was an inspirational last-minute replacement.

Peter Hyams

Hyams is one of the few directors to have worked more than once with Connery – in the brutally bleak 1981 film *Outland* and 1989's turgid *The Presidio*. 'When there's a leading role in a film for a man who has to portray a sense of strength as well as a sense of intelligence and vulnerability, Sean is

one of the few people who spring to mind. He is an extraordinary actor and a remarkable craftsman. He raises the level of everyone around him.'

Hyams revealed that during the shooting of *Outland* Connery enjoyed getting involved in every aspect of the production. Busy one day working out a tough shot, Hyams saw Connery come down to watch, even though he wasn't needed on set. Before long he started making suggestions.

'Don't you have a star dressing room to go to?' Hyams asked irritably.

Connery stared back. 'I can't fit in there because of the fan mail.'

What impressed Hyams was the actor's emotional range and technical ability: one never knew quite what was coming next. 'His face has enormous potential, because it's always surprising you,' the director told *Prevue* in 1981. 'He can be very quiet, then jump up and tear a building apart, or make you smile or cry – it's always unexpected and believable. This is the definition of a star.'

Fred Zinnemann

From the moment he saw *High Noon* as a struggling actor Connery wanted to work with the man he dubbed 'a living legend', Zinnemann. It's just a shame that these two great artists collaborated on such weak material. They had been friends for years, after Robert Shaw introduced them on the set of *A Man for All Seasons*. However, Zinnemann never rated Connery as an actor until his performance in *Robin and Marian*, deciding then that he was the one and only choice for his pet project – *Five Days One Summer*.

Zinnemann noted how Connery's physical courage on a hazardous location and his gruff, sarcastic sense of humour made him popular with the international crew. 'He would much rather play golf than muck about in mountains,' said Zinnemann, stating the obvious. 'But he never grumbled and always projected an air of complete authority. One felt he had only one objective – to get on with the picture and do what was best for it.' By the close of filming he was describing his leading player as: 'Utterly professional and utterly straight in his dealings. Not since I directed Gary Cooper had I come across a man like Sean, not only a great natural actor, but a hell of a man.'

Sadly *Five Days One Summer* turned out to be the last film Zinnemann ever made. It was not much of an epitaph, but speaking in 1992 the director said, 'It vanished rapidly from the world's screens, but seems to be emerging again as a minor sort of cult picture.'

Steven Spielberg

As a young film-maker Steven Spielberg had a wish-list, and near the top was a desire to work with Sean Connery and direct a James Bond movie. You

could say he won the jackpot with *Indiana Jones and the Last Crusade*. An admirer of Connery, dating back to the time he saw *The Hill* as a film student, Spielberg rates *The Man Who Would Be King* as probably his finest movie. 'He's done so many incredible parts that you can pretty much cast him in any nationality and people accept Sean.'

One incident stands out for Spielberg, during an intricate dialogue scene between Indiana and his father, as perfectly encapsulating Connery's approach to his craft. The actor had to say the line 'I knew I had to get that book as far away from me as possible' but kept messing it up. Connery insisted on doing it over and over again, about seven times in all. 'He's from the old school of the complete professional. He has to say his lines word perfect.' On set it became something of a running joke, and crew hands came close to getting T-shirts made up with those infamous words printed on them. Doubtless Connery would not have been amused.

'Sean is not like anybody else; he's an original,' Spielberg said in 1989. 'He's never been stronger or more sought-after and he's finally recognised as the movie star he's always been. Hollywood has at last admitted to itself that Sean is one of the great movie stars. He will be remembered throughout recorded film history.'

John McTiernan

One of a rare club of directors to have worked more than once with Connery John McTiernan initially found him an intimidating presence on *The Hunt for Red October*, though he quickly discovered how to coax the best out of the actor. 'Not only could I get away with telling him what I thought, he wanted me to tell him what I thought,' McTiernan told the *Sunday Express* in 1991. 'In fact, the only sure way to get him annoyed is if you *don't* speak your mind.'

McTiernan described Connery as being like 'some extraordinary modelling clay' able to become different people. 'No matter what circumstances you put him in, a rigid and intimidating ship's captain or an old reprobate working in the rain forest in tattered clothes and old sneakers, there's always something riveting about him.'

The two men were reunited on *Medicine Man*, hardly the artistic or personal success *Red October* was. Though full of praise for his star, calling him an 'encyclopedia of film actor's skills', McTiernan this time clashed with Connery off-camera. Connery once cleared the set to make room for a shouting match with McTiernan. He felt that the director was too obsessed with the mechanics of film-making, and distanced himself from the actors by watching things unfold on his video monitor. 'I had bent every actor's dictum and rule to accommodate what he wanted.'

Michael Bay

A former director of commercials and music videos Bay's hyper-kinetic way of working occasionally clashed with Connery's old-school approach. And while Bay conceded to Sean's demand that they rehearse scenes in the morning before shooting, he still managed to ruffle his star's feathers. 'One day I had to get him underwater holding his breath with a fireball coming over him.' Connery was less than delighted at the prospect. 'I think the word "fuckhead" came out in the air.'

Connery had seen Bay's début feature *Bad Boys* and didn't care for it much. So when offered *The Rock* he went back for a second look; this time he came away with a clear sense of a director with an energy and style all his own. At their first meeting a tense Bay fumbled nervously while trying to open a bottle of wine. Connery nonchalantly picked up the bottle and in a few strong movements had the cork out. He looked over at the director, smiled and said, 'Bond. James Bond.' The ice was broken.

7 Relatives and Associations

Diane Cilento

Diane Cilento was born in New Guinea, the 'wild child' daughter of Raphael Cilento, an Australian knighted for his contribution to tropical medicine, and Lady Cilento, an eminent physician. When Raphael was posted to the United Nations in New York the fifteen-year-old Diane studied at one of the city's most exclusive schools, learnt ballet at Carnegie Hall and later enrolled at the American Academy of Dramatic Arts. She moved to London in 1950 and studied at RADA, eking out a meagre living by doing odd jobs. She would rather sell programmes in a circus than accept an allowance from her wealthy parents.

Cilento's excellent stage work at London's Mercury Theatre and the Library Theatre in Manchester, where she scored her first big success as Juliet, earned her the critical acclaim that allowed her to break into films. Despite a less than auspicious début in *The Angel Who Pawned Her Harp* alongside Alfie Bass (who would also star opposite Connery in his first movie), she landed a contract from Sir Alexander Korda. He cast her with Peter Finch in *The Passage Home*, for which she was voted Britain's most promising actress of 1955. With her distinctive husky Aussie drawl, pouting lips and blonde hair Cilento was a screen natural and her 'high IQ sex kitten' press tag was not misplaced.

Cilento continued to excel in the theatre, especially as Helen of Troy opposite Michael Redgrave in Giraudoux's comedy *Tiger at the Gates*. A transfer to Broadway in 1954 ran for seven months and brought her a coveted Tony award nomination. Hollywood scented a hot commodity, but she turned down an offer from Elia Kazan to appear in Tennessee Williams' *Baby Doll*. Her independence was something in which Diane took great pride, smoking cigars and driving round London on a Vespa scooter. Her free spirit made her a model of the liberated sixties woman.

In 1955, after a whirlwind affair, the 22-year-old Cilento married Italian journalist Andre Volpe. 'I must have been mad,' she confessed years later. 'But in those days, it was the thing to do, to get married.' It was never a particularly close union with the couple spending long periods apart. Cracks had begun to appear by the time Cilento embarked on a touring musical in 1957. It was a disaster. Barred from the production, Volpe finally tracked down his wife to a hotel in Oxford, where she'd apparently tried to commit suicide. He found her in a hysterical state with blood pouring from her cut wrists. Cilento was patched up and rushed to a nursing home, and from there she and Volpe later flew to Italy for a period of recuperation. The pressures of the show, which was constantly being rewritten, were blamed for her apparent breakdown. 'I got to the point where I could stick knives in people without a qualm,' she told reporters. 'Back in my hotel I threw a tantrum. I broke a glass and went to the bathroom. I stood there with the glass in my hand – but I don't remember any more.'

It wasn't long after the attempted suicide that Sean Connery entered her life. Both had been cast in a television production of *Anna Christie* and it was Connery's idea that they put in a little after-hours rehearsing. Though there was no ulterior motive involved, at Cilento's flat he'd stretch out on the floor as if to deliberately antagonize her. 'I felt he was trying to see if he could make me angry,' Cilento remembered, 'so I purposely didn't react.' Like former girlfriend Julie Hamilton, Diane's first impression of Connery was far from favourable: it was of an arrogant, rough man with little manners and a terrific chip on his shoulder. Cilento claims it took her a whole year finally to fall in love with him, since 'he was not nearly as attractive in those early days'.

For Connery things were a little different. 'Diane swept me off my feet,' he claimed, describing her as 'the girl who has the most inner sex appeal for me'. Cilento seemed like the ideal match for Connery, a strong woman who spoke her mind. She shared his single-minded determination to succeed and coveted her privacy almost as intensely. Cilento was quite unlike anyone he'd ever met before.

Soon after her encounter with Connery Cilento returned to Australia to give birth to Volpe's daughter, christened Giovanna. By the New Year she was back in her Bayswater flat and had begun to regularly meet with Connery; divorce from Volpe was now a matter of when, not if. During this troublesome time Connery was a stabilizing influence in her life, a shoulder to lean on. When she was struck down by tuberculosis in 1959 and lay gravely ill for weeks Connery refused valuable offers of work to stay close by her.

In November 1960 they appeared together in a production of Pirandello's *Naked* at Oxford, which Cilento had translated from the Italian. But for the most part the couple kept a low profile. Their affair was conducted with utmost discretion, and few outside the business knew how deep their love

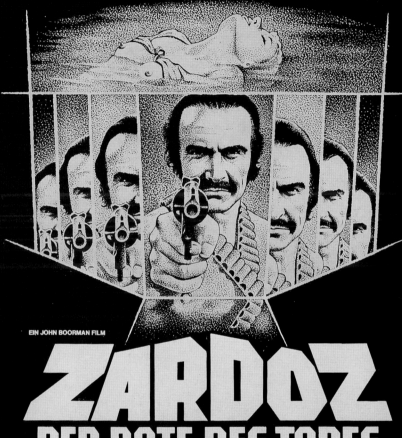

Rare poster art for this the most bizarre of Connery movies, *Zardoz* (1974)

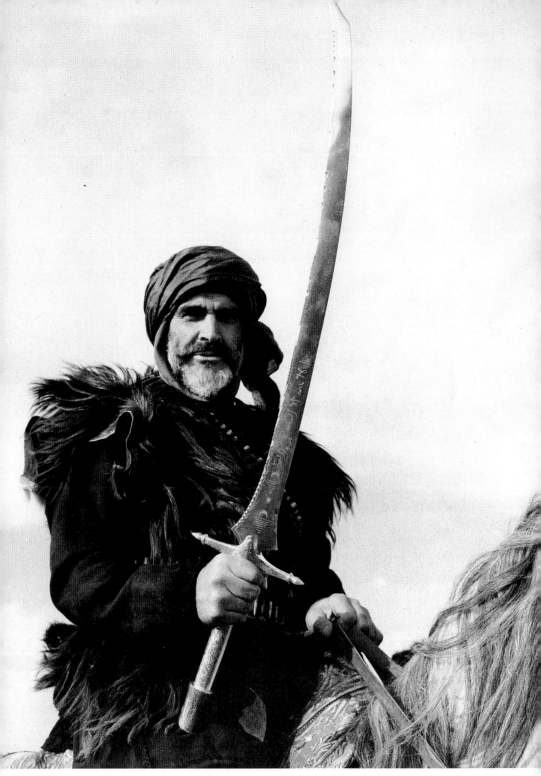

John Milius's *The Wind and the Lion* (1975) presented Connery with one of his most popular roles, Arab pirate El Raisuli

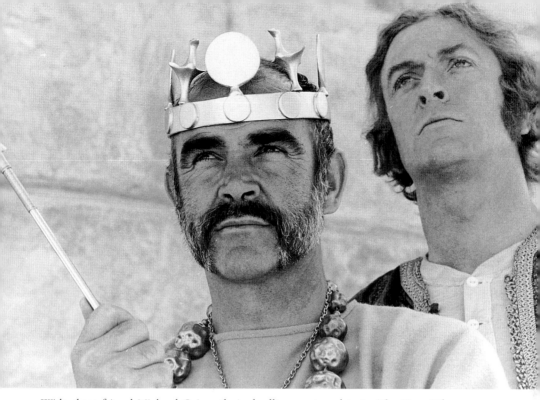

With close friend Michael Caine, their duelling partnership in *The Man Who Would Be King* (1975) makes one mourn the fact they never shared the screen again

Connery's most poetic performance as an innocent thrust into legendhood in Richard Lester's quixotic *Robin and Marian* (1976)

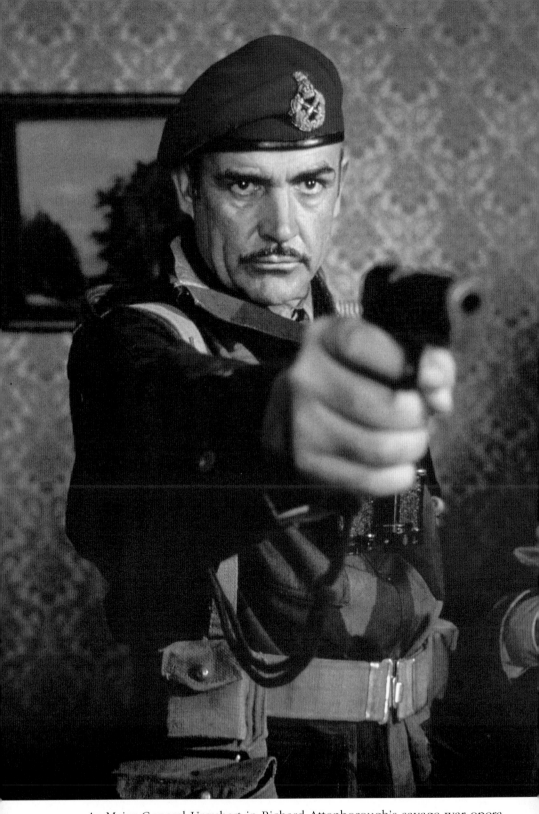

As Major-General Urquhart in Richard Attenborough's savage war opera
A Bridge Too Far (1977)

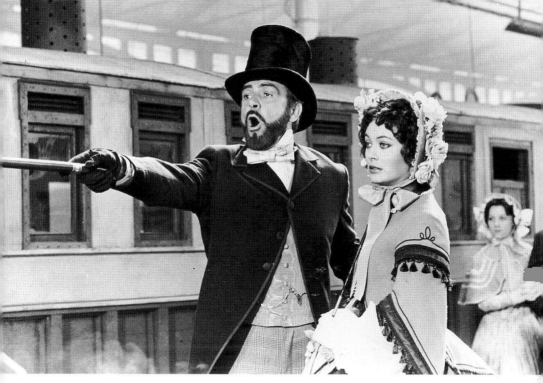

Connery delights as a gentleman crook out to perpetrate *The First Great
Train Robbery* (1978) directed by *Jurassic Park* creator Michael Crichton

As King Agamemnon in Terry Gilliam's fantasy classic *Time Bandits* (1981).
It was to be the first of many father figure/mentor roles

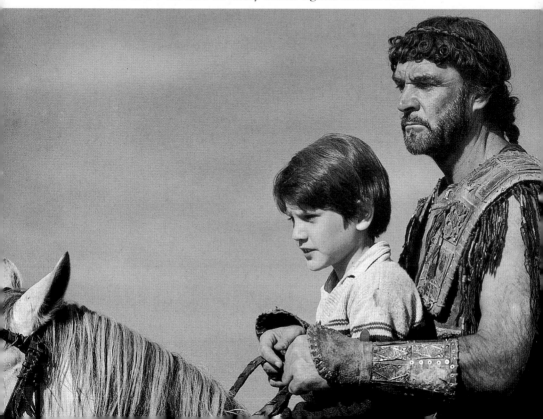

Outland (1981) was Peter Hyams' space reworking of *High Noon* and provided Connery with his best role of the early 1980s

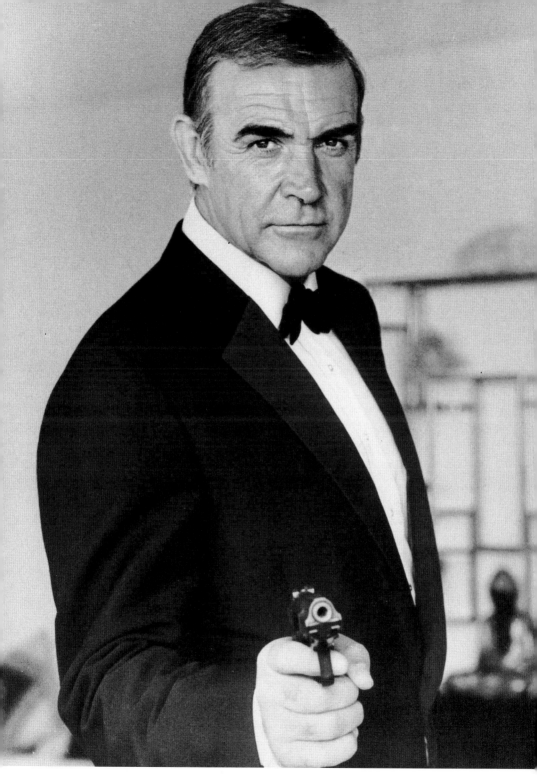

Cinema's most unlikely comeback. As Bond once more in 1983's *Never Say Never Again*

Connery's Bond return in *Never Say Never Again* (1983) was greeted by American critics as the cinematic equivalent of a Beatles reunion

Making sackcloth fashionable. It's Holmes in a habit as sleuthing monk William of Baskerville in the acclaimed *The Name of the Rose* (1986)

ran – a love by turns volatile, unpredictable, thrilling and marked by periods of separation.

When it came time for Diane to meet the folks they struck an immediate rapport, much to Connery's relief. Kicking off her shoes and flopping into an armchair at the Fountainbridge home, Diane fitted in as naturally as the wallpaper. 'I won't marry for looks, Mum,' the teenage Connery once told Effie. 'I'll marry a girl who has a personality.' In Diane Effie was convinced her son had found 'a wee smasher'.

'Were it not for me Sean might never have become James Bond.' So runs a famous Cilento claim. 'When they offered him *Dr No* he asked me what to do. To take or not to take.' Actually it was not unusual for Connery to seek his wife's advice on career matters; her training and experience had been far more extensive. 'I said he should accept. I felt he was right for the part, and the rest is history.' Months after the release of the first Bond Cilento told a theatre colleague, 'Well, Sean is a star. There's no doubt about that. The moment you saw him in that film you thought: Yup, that's someone who has presence and nerve.' Cilento also claims some credit for introducing Bond's trademark humour. 'The man needed a sense of humour, for God's sake. And that's when we started working on Bond's character, giving him all those silly one-liners. But it worked.'

Connery, confident of Bond's success, now turned his thoughts to marriage, even though he had expressed himself eloquently on the benefits of bacherlorhood. 'There's no one to tell you what to do. I can leave my socks on the floor, play poker all night, come and go as I please. I couldn't ask any woman to put up with that.' But Cilento persistently spurned all proposals of marriage, even when she learnt she was carrying his child. Having 'botched' the first attempt she no longer rated what she saw as a stifling institution. However, with her divorce from Volpe finalized it seemed only a matter of time before she would give in to the persuasive Connery. 'He was sure we could make a go of it.'

Cilento would have preferred to leave things as they were. 'I don't like ownership in marriage, I don't like too many promises either. There is no way of being sure you can keep them.' But the traditionalist in Connery balked at the idea of living in sin and having a child out of wedlock. After the huge success of *Dr No*, he had splashed out £9,000 on a home with room for a nursery. He reassured Cilento that he would respect her own career ambitions, and that this would be a partnership based on equality. Finally she caved in.

To avoid the media scrum of a London wedding the couple married in Gibraltar on 29 November 1962. Things went wrong right from the start when Connery was left at the altar anxiously biting his nails, fearful that his bride had had second thoughts. In fact Cilento had been delayed at the Spanish border for several hours. Connery was not amused, but Cilento saw the funny side: 'He was all feet, all thumbs, frustrated.' After the ceremony,

witnessed by two local taxi-drivers roped in at the last minute, the newly-weds decided on a romantic walk up the rock. Inadvertently they stumbled on a military base when making their descent and were detained for an hour. Not in the best of moods, the couple set off for their honeymoon on the Costa del Sol.

At first Cilento enjoyed the role of dutiful wife, helping Connery out with his lines before the next day's shoot. 'I can say I've played just about every part in *Dr No* and *From Russia with Love* and I still remember most of the dialogue.' Whenever they could, each made a point of being where the other was filming. Cilento, with the kids in tow, stayed in Hollywood while Connery was shooting *Marnie*. Her time there was marred, however, by snoopers, who would watch her bathe naked in the swimming pool of their modest Bel Air cabin. One afternoon she noticed a faint stirring in bushes on a nearby hillside. Jumping out of the pool to take a closer look a figure darted off. 'It was a man with a pair of binoculars. There were others there, too.' Later that night she told Sean what happened. 'He simply shook his head and muttered about my being still so naive.' Years later she accompanied Connery on his trip to Japan to make *You Only Live Twice*, even donning a black wig and a bikini one day to play Mie Hama's double.

By the mid sixties, however, things had begun to go awry, partly because of the immense pressures brought on by Connery's fame. A talented performer in her own right, Cilento was all but forgotten in the Bond circus, and she felt degraded when people addressed her as Mrs Connery or, worse, Mrs Bond. Journalists made a habit of asking for interviews just to grill her about Sean, rather than her own now rather stagnated career. She was also bemused that the vehicle of Connery's success – the Bond movies – were in her view beneath her husband. She grew increasingly exasperated with Sean for continuing with the series and couldn't wait for him to quit. In interviews she stressed that Connery was an actor, not a personality, and was delighted when he made *The Hill*. She classed this as his first step towards more 'artistic' horizons. One evening over dinner she said: 'Look, that's an actor,' pointing out guest Victor Spinetti, Connery's old cohort from *South Pacific*. Immediately Spinetti leapt to his friend's defence, arguing that Sean had given more pleasure to more people as Bond than all the world's great stage actors combined.

Jealousy undoubtedly played a part, too. After all, Cilento was an acclaimed actress (nominated for an Oscar for *Tom Jones*), and yet it was Sean who grabbed all the headlines. It only fuelled the element of competitiveness that had always existed between them. Ironically, just as Cilento was irked by Connery's massive stardom, he himself yearned for the respectability and critical *kudos* his wife enjoyed.

A further strain was put on the marriage by press stories speculating whether Sean's bed-hopping antics as 007 continued off-camera. 'I don't

think about the odd flirtation,' countered Cilento. 'I would expect Sean to behave wisely and with discretion. And if there was something serious, well, I would be the first to be told. By Sean.'

To the world at large Sean and Diane were a golden couple, but the tensions in the marriage were kept well hidden – tensions that began almost from day one. In their courting days he'd been, in Cilento's words, 'all sweetness, consideration and strength'. After their honeymoon he turned into the more traditional working man who didn't want his wife going out to work. This, if true, was a strange attitude, since it was acting that had first brought them together. 'If I had known Sean was going to make such a demand,' Cilento confessed to the *Mail on Sunday* in April 1994, 'I would honestly never have married him.' Whenever Cilento defied him and took a job he became difficult to live with and the rows began. In the early days Connery used to enchant Diane with anecdotes and songs from his time as a milkman, but as his Bond fame increased so his sense of fun withered and he became increasingly more serious about himself. Whereas before they'd enjoyed long discussions on a variety of subjects, now there was only silence. 'When discussion stopped, our feelings became bottled up and the inevitable explosion followed,' Cilento revealed.

In March 1965 things reached a head. Connery moved out of the family home and into a suite at the London Hilton. It was called a trial separation. Cilento put on a brave face, maintaining that their careers had caused the rift; in any event he was back within a week. No sooner had things been patched up, when he was off again to the Bahamas for the *Thunderball* shoot. Feeling miserable in London while her husband frolicked in the sun with a bevy of new Bond lovelies, Cilento, along with her son Jason and daughter Giovanna, flew to join him, hiding out in a rented bungalow on the appropriately named Love Beach.

It was here, while Connery was out playing action man, that Diane began work on her first novel, *The Manipulator*, set at an international film festival in Acapulco. Dedicated to Sean, the novel featured abstract art on the cover also designed by him, for which he received £30 payment. Not all her time was spent at the typewriter. Cilento's sudden appearance on location surprised many, who guessed she was there to keep a watchful eye on her husband's new co-star, Claudine Auger, after the inevitable rumours of an affair. As one columnist put it: 'All the girls in Nassau kept begging Sean to play golf – or anything with them. But since Diane arrived with the two kiddies, the girls have gone back into the bushes. Nothing like a wife to snap everybody to.'

By 1965 Cilento was a very different woman: the headstrong artist of a few years before was now reduced to the role of a humble domesticated wife, her ambitious hunger diluted. 'I have my children and my home and I work when it is right. And only then,' she said. Once, while being interviewed at home, Connery barged into the room to ask where his lunch was. Almost

immediately Cilento was on her feet and walking to the kitchen. The wild child had been tamed.

But Diane was still capable of holding her own in some often blistering arguments. 'Can't you see they are very much in love? Otherwise they wouldn't care enough to have fights.' This was *Thunderball* babe Luciana Paluzzi's typical Mediterranean take on matters. The rebellious youth was never too far from Cilento's surface. When Michael Caine visited the couple in the Bahamas he and Connery went out while Diane prepared lunch. Turning up two hours late, Connery said, 'Darling, we're home,' and popped his head round the door – just long enough to see the meal she'd cooked flying through the air towards him. Both stars stood there covered in gravy and green beans.

To escape the stresses and strains of Connery's fame the couple bought a Spanish hillside property near San Pedro de Alcantara, the perfect hideaway to help sort out their life together.

Throughout the sixties various attempts were made to bring together Connery and Cilento on screen. Terence Young wanted them for *The Amorous Adventures of Moll Flanders*, while Twentieth-Century Fox was planning a movie version of the best-selling novel *Call Me When the Cross Turns Over*. Scheduled to shoot in 1965 on location in Australia with Sidney J. Furie, who'd just directed *The Ipcress File*, the story featured Connery as a soft-hearted con man who falls in love with a headstrong girl. Despite excitement over the script, retitled *Big Country, Big Man*, nothing materialized. When finally the couple did collaborate it was more as a last-ditch effort to save their marriage than an artistic venture. In 1969 Connery directed Cilento in the play *I've Seen You Cut Lemons*. It was hoped that by working together they might forge a new and stronger union. But the marriage was now at breaking-point and there was no way back.

It was not an entirely amicable split. At least, given their joint distrust of the media, there were no public recriminations. Indeed Cilento, right to the bitter end, still clung to the vain hope that their marriage might be saved. Not Connery, though; he saw what the rows at home were doing to the lives of their children and wanted out. He'd already bought a large apartment in Chelsea overlooking the Thames. 'This time it is the end,' he conceded. 'One is always reluctant to admit failure, and a marriage that goes wrong is as bad as anything can be.'

Jason and Giovanna were away at boarding school most of the time, so luckily weren't privy to some of the grimmer aspects of their parents' break-up. Jason saw enough, however, to taint him for the rest of his life. 'It took about a year for them to break up and during that time there were many rows. It was terribly upsetting. I realised just how much two people can hurt each other.' Though sleeping in an attic room Jason could hear the arguments going on several floors below. Recalling them years later he would speak of his father's 'powerful voice' and 'presence like a thunderstorm'. In 1997

Jason revealed why he didn't invite either Diane or Sean to his wedding. 'We didn't tell dad and we didn't tell mum, because basically they can't stand each other.'

In 1973 Connery was granted his *decree nisi* from Cilento on the grounds that their marriage had irretrievably broken down. Both had lived separately for the statutory two years. It certainly cost him a small fortune to end the marriage; the exact figure was never disclosed, but it included a full and final settlement payable to Cilento that was reached after months of negotiation. In addition a trust fund was set up for both children, of whom Cilento had been granted custody. The issue of access was amicably resolved.

In reflective mood Cilento admitted the marriage had been the victim of two headstrong career people and that ultimately she had to face up to its dissolution. 'I finally became unable to cope with his legendary meanness with money, his suspicions and oppressions of myself as an actress and the relentless entourage of hangers-on who surround any world star like blowflies around dung.'

Post-Connery, in an effort to bring back some semblance of order into her life, Cilento 'dropped out' and gave community living a try on a Wiltshire farm. Today she lives in North Queensland with playwright Anthony Shaffer, whom she met in 1972 on the set of cult movie *The Wicker Man*. She went on to run a meditation, health and theatre complex near their home, a 200-acre farm that Jason describes as 'the garden of Eden'.

Micheline Roquebrune

'I think I was in love with him from the first look.'

Connery met his second wife on a golf course. It was during a tournament in Casablanca in March 1979; Connery's marriage to Diane Cilento was at rock bottom, while Micheline was also stuck in a marriage going nowhere and with three children. Both picked up individual trophies – he won the men's title; she the women's – and at the prize-giving ball spent most of the evening dancing together. They then spent the next two days in each other's company. Micheline's husband was away playing golf with the king of Morocco. 'The contact between us was immediate and very strong. For me he was the most exotic person I had met in my life.' Not once did Connery speak of marital problems back home and after they parted Micheline never expected to hear from him again.

Born in Nice but raised in North Africa, Micheline Roquebrune's background could not have been more different to Connery's. She grew up surrounded by servants at the family home in Tunis and attended a French Catholic boarding school. What she found so attractive in Sean was his innocence of spirit – and his eyes. 'They have a life of their own, and the smile, so sudden, so boyish.' As for Connery, the fact that Micheline was no star-

struck groupie, who had only ever seen one Bond movie, really appealed. The first time Micheline visited a film set she was genuinely shocked by all the flattery he attracted. 'How they treated him like a king.'

Three months after their first meeting Connery resumed contact. It was what Micheline had been hoping for. He couldn't stop thinking about her, and he revealed that he was in love with her. 'Basically I'm very serious,' he said. 'I don't want to play games with you.' They spent the week together, before parting to begin work on their respective divorces. 'That was really the beginning of what is now our life,' says Micheline.

Soon they were constant companions, and even today Micheline accompanies Connery whenever possible – 'If we are not together, what is the point?' Eventually they married in secret in May 1975 at a registry office in Gibraltar, the same place he'd married Diane Cilento. The news didn't leak out for weeks, as Connery had declined to tell anyone when or where the ceremony would take place. 'If you take my picture, I'll knock your head off!' Connery informed the solitary photographer who turned up.

Standing at least a foot shorter than Connery, with a mass of naturally curly auburn hair that hides a shrewd financial brain, Micheline has an enviable zest for life. More than anyone else in the last twenty-five years it is she who has brought much needed serenity into Connery's life, and continues to be a stabilizing influence. Early on there were problems. 'Everything about Sean was dramatic. My first job was to calm him down. It was like undoing a knot. He was, and still is, a very emotional man.' She also quickly identified those hangers-on who were out only to take what they could from him.

It's a less turbulent relationship than the one with Cilento, mainly because they don't need to contend with the conflicting demands of two acting careers. Micheline is also more of a conventional wife and home-maker. Whereas Cilento was a great career navigator for Connery, Micheline has been an anchor, helping to sort out problems in his private life. Jason credits her for bringing he and his father closer together at a time when things were a little strained and distant. She has helped to create a close-knit family unit, incorporating her own children – sons Stephen and Olivier and daughter Marisha.

Connery often relies on Micheline's judgement and gift for organization – he himself isn't the most organized of men. She'll often join him on set and sometimes make a fuss if she thinks conditions are not what they should be. She never overstays her welcome, though, happy to slip quietly back to Marbella to prepare for his homecoming. 'He is very tired when he returns from making a movie.' Then Connery likes nothing better than to relax, do nothing but recharge his batteries. Sometimes he can be grumpy, and then Micheline will say, in her husky, broken English, 'Listen, be as nice with me as you are with your producer.' She'll also indulge his need for seclusion, which is at its height during the run-up to a movie. At these times he'll shut himself away for a week. Essentially a loner, Connery

believes partners should occasionally seek time away from each other. 'I couldn't ever be with someone night and day,' he admits. For one birthday Micheline designed a self-contained study at the rear of the house, complete with its own bathroom and kitchen-bar, where he could go, lock the door and be alone.

As an accomplished artist in her own right, she liked her own independence too. Exhibitions of her work have appeared in Europe and America, and her subjects have ranged from movie personalities like Michael Caine and John Huston to royalty (the late King Hussein of Jordan). Naturally her favourite subject is Sean, and her studio is littered with painted canvases and sketches of him. Numerous portraits adorn the house, but one features him, rather surreally, possessing four eyes. Another depicts Sean with a small head on top of a gigantic body. 'You know how when he comes into a room he dominates it with his sheer physical presence. I very much wanted to capture that feeling,' Micheline told *Hello* magazine in a 1990 interview.

It was mainly through her own efforts that their home in Marbella became a sanctuary. 'Fights don't bring anything good.' If she's fed up or needs to clear the air she'll make a list of wants, tell Sean to sit down and listen to them, and then make any comments afterwards. Or if she feels he needs to lose a little weight, say, a discreet note will be left in his study – 'And then I get out of the way!'

One regret is that Connery isn't the type of man who tells his wife she's the most beautiful woman in the world. The best Micheline gets is, 'You look very good tonight.' Surprise presents are rare. 'He's a very generous man, but not in that way. Flowers from Sean? It would be like .. my God .. like a miracle.' But at heart he's a romantic, occasionally leaving love notes pinned to Micheline's clothes in her wardrobe, often in badly spelled French. Or when they are away he'll leave with hotel receptionists messages that say, 'You are the best.' 'I always keep these little notes. They are like a treasure. After all our years together, he still has the power to melt my heart.'

But it is Micheline who is the more impulsively romantic of the two. For Connery's sixtieth birthday she organized a surprise bash in Hollywood, despite Connery's dislike of such events. His first instinct was to leave immediately, but the party proved a great success, with a star-studded guest list that included Steven Spielberg, Clint Eastwood, Sylvester Stallone, Liza Minnelli and Harrison Ford. A large banner at the end of the restaurant read: 'The 60th for the sexiest!' And when two Scottish pipers arrived, his emotions sprang to the surface for all to see. 'That moved him so much,' Micheline recalled. 'He began to say something, to thank everyone for coming and to thank me, and then he went to cry in the corner because he couldn't continue.'

As for her husband's movies, among Micheline's favourites is, oddly, *The Offence*. 'But for the way he looks, *The Wind and the Lion*. Oh, he is so romantic in that one.'

Jason Connery

'I often think dad is jealous of my privileged background. But then he gave it to me!'

Jason Connery was born on 11 January 1963 and made one of his first public appearances on the Turkish location of *From Russia with Love*. Sean's fellow cast member Walter Gotell (famous as the KGB chief in the Roger Moore Bonds) was another recent father, and both men indulged in joint bathing sessions with their newborns in between espionage duties.

Something of a tearaway, Jason was four when he decided it would be funny to smash up a greenhouse with an axe. Later, as an encore, he dived off the top of the staircase, having just watched a *Superman* cartoon, and split open his head on a radiator. He still bears the scar today.

At school he was reckless, too, getting into fights with alarming regularity. Being teased by classmates for his pretty-boy looks and nicknamed 003½ served only to fuel his aggression. When his parents split up and moved into separate houses, Jason was left feeling totally disorientated. 'I found it extremely stressful and I became quite aggressive.' At school this culminated in the ten-year-old Jason hiding in a tree to wait for an unsuspecting teacher to pass underneath. He flung himself on to her back. 'They regarded me as a bit of a problem – I was asked to leave.'

Boarding school was seen as the ideal solution to quieten him down, a treatment Jason would never inflict upon his own son. 'I don't think it's right. To be sent away when you're that young, to go at ten is just criminal. I don't know how it's allowed.' Boarding school wasn't the prison sentence it might have been, though. He was seeing little of his father anyway because of his work commitments, and at that stage Jason was probably more in touch with his mother. 'I wasn't living in a normal family set-up,' he told the *Guardian* in May 1993. 'My parents were not your average parents. I don't remember great closeness to my parents or special family outings that we went on. I have never had any problem being alone.'

His main failing in the classroom was a short attention span, which was reflected in his school reports: 'Jason has ability, but doesn't use it.' That incensed his father, someone who had clawed his way up from the slums without an expensive education. There were massive rows, at the end of which promises were always made to try better; but they never lasted long. 'I used to drive Dad mad,' Jason confessed years later. 'I had all these opportunities he was giving me and it looked as if I wasn't using them. Dad would shout with rage and get aggressive. But only because he was worried I had no centre, no purpose. He found it very painful.'

Early on Jason shone at sports, particularly swimming, which he attributes to being hurled, aged just eight months, into a swimming pool by his father. It earned him a swimming scholarship to Millfield, one of the most expensive public schools in Britain, where training was fierce. He had to be

up at five, and then swim till breakfast at eight. He was spending so much time in the water that fungus started growing on his skin and his hair turned green. The real turning-point came when he discovered a fellow pupil had hanged himself using a judo belt. Everyone knew it was the bullying that drove him to it. His parents understood when Jason wanted out.

He was moved to Gordonstoun, a rigorous and spartan institution near Edinburgh renowned for character building. Jason settled in much better here than he had at Millfield, despite the cold showers, early morning runs and regimental atmosphere. Along with fellow classmates, which at the time included a certain Prince Edward, Jason took to wearing his pyjamas under his uniform to keep from freezing. He also discovered acting for the first time, making his stage début in a production of *A Bedroom Farce*.

After failing to get a university place, Jason decided to follow his father into the acting profession. Initially terrified of his response, Jason was surprised when he approved of the idea.

'I thought you wouldn't like it,' Jason heard himself saying in relief.

'Why shouldn't I?' his father replied. 'I think it's terrific.' He told his son that he'd chosen a tough way of earning a living and bestowed upon him two pieces of advice: 'If you have enthusiasm, you will progress.' And 'Look out for sharks.'

One unforeseen benefit of Jason's becoming an actor was the effect it had on his relationship with his father. Having spent so much time apart Jason sensed the beginning of a developing closeness, probably because the old man was proud that his son had at last set his mind on some kind of goal. But Jason still admitted to sharing a far 'less matey' friendship with his dad than the one he enjoyed with his mother. There remained a distance between them, a reluctance on the part of his father to reveal his 'caring' side, combined with a curious lack of emotional openness. To some extent this was fostered by Connery himself, fearful that Jason might become over-dependent, turn into a wasteful rich man's son. As late as 1983 Jason confessed: 'He can shout at me now and I would be reduced to tears.'

A place at RADA seemed the first logical step for Jason, but his father argued against his going to drama school; better to get practical experience in repertory theatre than be stuck in a classroom. So after failing an audition for the Bristol Old Vic, Jason got work at Perth rep in Scotland, appearing in their 1981 Christmas panto *Aladdin* and in a number of plays. Connery declared, 'There's no question that his stint in Perth was helped because of who I am, but once he got there, it was clearly up to him.'

Connery then put Jason in touch with agent Joy Jameson, sometimes ringing her up behind his son's back to check if he was pulling his weight. 'What that boy's got to realize,' he informed Jameson, 'is that life isn't going out to lunch every day, it's having a bowl of minestrone on the back burner.' After securing him a job on *Five Days One Summer* as a 'gofer' – 'running

around helping, to give him the feel of things' – Connery stood back and waited to see if his son could stand on his own two feet.

Jason's film début came along in 1982. *The Lords of Discipline* was a drama set at America's West Point academy, but filmed, incredibly, at Sandhurst in England. Jason's hair was cropped – as were most of his scenes. There followed a long period of unemployment, accompanied by the usual round of soul-crushing auditions. But Jason refused to give up. 'If there's one thing my father's taught me, it's not to be soft. If you want something, go out and get it.'

As a matter of principle Jason refused any parental help, financial or otherwise, and vowed never to touch the trust fund that had been set-up to provide for him. He was determined to succeed as an actor in his own right, rather than ride on his father's coat-tails. This made all the media hullaballoo, the 'son of Sean' stuff, all the more hurtful. When he was starting out in the business people would ask to meet him just to see if he looked like his dad. It was Jason's good fortune that he resembled his mother more – 'Had I looked like my father, I would have changed my name.' But there was one stage role that required him to dye his hair black and he was shocked at how alike he was. 'I'd walk past a mirror and think Dad was in the room.'

Inevitably, though, the media will always link him to his famous father, whatever the story. When Jason married in 1996 one tabloid headline ran: '007's Son Weds.' He has certainly felt the pressure of being the son of a legend; at Perth rep, for example the local paper would send a photographer round if he so much as rehearsed. Connery always strove to protect his son from the glare of the spotlight. It's a testament to him that Jason never grew into the standard film-star brat, rolling in money and fast cars to compensate for an absent father. 'My problem was poverty,' Connery has stated. 'His problem is being the son of a film star. It is something he will have to negotiate and learn to handle.'

Next on the film front was *Dream One*, a turgid French fantasy produced by John Boorman. 'You weren't any great shakes' was Sean's rather blunt assessment of his son's performance, which came as a crushing blow. Connery never spares Jason's feelings when asked for his professional opinion. 'I know he is just being constructive when he criticises me,' says Jason in mitigation. 'Like any son, winning my father's respect means a lot to me.'

Much better was *The Boy Who Had Everything*, an Australian drama which cast Jason alongside his mother Diane Cilento. It turned out to be an exhilarating experience. 'I learned a hell of a lot working with her.' The big test came when Jason invited his dad to watch the film on video at his London flat. As it played, Jason hid in his bedroom watching his father's reactions from the half-open door. Afterwards he nervously awaited the great man's verdict. 'You were very good,' he told his son. 'It was good work and I enjoyed it. And I believed it.'

Following his role as a hurdler in a five-hour mini-series, *The First*

Modern Olympics, and a guest spot on *Doctor Who*, Jason landed that all-important first big break, replacing Michael Praed as television's Robin Hood. He was a big hit, receiving 2,000 fan letters a week, mainly from American teenagers. Midway through the run Jason was involved in a motorbike crash in Sussex, in which he fractured a thumb and some ribs. Most alarmingly he banged his left testicle against the petrol tank. By the time he got to hospital he was suffering internal bleeding and his scrotum was the size of a grapefruit. A specialist suggested minor surgery to drain out the blood, but not before summoning a group of medical students to gaze upon the rare sight of acute testicular haemorrhage. Fortunately the Connery testicle healed of its own accord, but he lost out on a film produced by Michael Douglas because of it.

Jason failed to capitalize on his success as Robin Hood. In 1986 he starred in an obscure Italian movie called *The Venetian Woman* where he engaged in a few bawdy love scenes; on stage he performed in a miserably short run of *The Three Musketeers*. Then came another turning point, an acclaimed West End revival of *Journey's End*, in which he excelled as a young soldier brutalized by war. That first night was an emotional event, particularly as his father was on hand to witness his success.

The two men had by now formed stronger ties, thanks in part to Connery's second wife, Micheline, who saw that father and son needed bringing together. She encouraged more frequent visits. At first it was a little disconcerting for Jason to see his dad with someone other than his real mother, but soon he was enjoying the sense of belonging at last to a close-knit family. 'The only people my father sees are the people he plays golf with. Apart from them, he doesn't have many friends. He doesn't need them. He's got us.' After the troubles of earlier years the bond between father and son is deep and strong. When Connery won his Oscar, the first thing he did was phone his son with the news. The pair have even recently begun to look for projects to do together. One script casts Jason as a younger version of his father's character.

In 1989, on the twenty-fifth anniversary of Ian Fleming's death, two bewilderingly awful TV dramatizations based on his life were broadcast. The first, called *Goldeneye*, starred Charles Dance and was dull as dishwater. *Spymaker: The Secret Life of Ian Fleming* was even worse, but so trashy as to be eminently more watchable than the first. And there was the added bonus of Jason Connery as Fleming. 'Freud would have had a field day,' he explained. 'Fleming created Bond, Dad played Bond, Dad created me, and I'm playing Fleming!'

There was the predictable chorus of: 'I wonder how he got the part!' Surely the American backers were trading on the family's Bond connection – even the British producers balked at what they saw as too obvious a choice. But Jason was adamant that he'd tested best for the role. 'All through my career, I am continuously being compared, but not by my father. My father

is the one person who never makes me feel as though we are in competition.'
When they offered him the part Jason called his father who told him: 'If the
script's good, do it.'

In an interview for the British James Bond fan club, Jason revealed those
aspect of Fleming's life to which he could all too readily relate. 'From the
outside it looked as though he had everything – wealthy parents, good looks,
and he was very good at sport. He seemed to have all the attributes to be a
very happy person – but inside he seemed to be pretty unhappy, basically
striving to prove himself rather than just to be a Fleming.' Or should that
read 'Connery'?

The obvious next question was: Did Jason see himself as a future James
Bond? His name was rumoured, along with others, to be a possible replace-
ment for Timothy Dalton. But he was never officially approached and
doesn't harbour a burning desire to play 007. However, he has been known
to adopt his father's famous motto – never say never.

In the late eighties Connery Snr. discovered he had another son, or some-
body claiming to be his offspring – one Dennis Connery. This bogus son had
been fooling people in both Britain and the United States. Connery realized
that he was unable legally to stop him. 'I mean, apart from physical damage
if I get my hands on him.' The warning apparently sunk in, for Dennis
Connery slunk back into the shadows, never to resurface.

It was his father's good friend Michael Caine who first introduced Jason
to his future wife Mia Sara, the New York-born actress best-known as the
girlfriend in *Ferris Bueller's Day Off* and the princess opposite Tom Cruise
in *Legend*. They were starring together in Caine's feeble resurrection of his
Harry Palmer character, *Midnight in St. Petersburg*. As their trailers were
scarcely habitable Caine, acting as matchmaker, allowed the couple to spend
much of their free time in his imported trailer. 'I bashed Jason over the head
with the concept of "us",' Sara joked, 'and eventually he gave in.'

A mere week after Jason proposed they were man and wife, married on 17
March 1996 at the Candlelight Wedding Chapel in Las Vegas, on the recom-
mendation of Caine. He had married Shakira there and they had been happy
for the past twenty-four years. Jason took that as a good omen. It was a
secret ceremony that surprised everyone, not least his father. 'We decided not
to tell anyone and just do it,' Jason explained to *OK!* magazine in August
1997. 'My parents don't get on at all well and neither do Mia's. If we'd got
them all to come to the ceremony, the occasion would have been all about
keeping everybody apart.'

Though Jason keeps a flat in London, the couple decided to make Los
Angeles their permanent base. Home is a detached, four-bedroom affair,
relatively small-scale by Hollywood standards, a twenty-minute drive from
Beverly Hills. 'It's very low-key with a real sense of community,' says Jason.
'You can walk here without getting stopped as a suspected felon!'

In July 1997 Mia presented Jason with a six-pound baby boy, christened

Dashiell, after the detective novelist Dashiell Hammett. Sean could hardly keep a lid on his emotions when his son called him in Spain. 'That's great, boy, that's great,' he kept repeating. The birth was soon news around the world, with such predictable headlines as: '007 Becomes Grandad.'

The arrival of Dashiell led Jason to re-evaluate his own parent's performance. 'After you have a baby, you're a little less judgemental of your own parents. I realize now that they did what they could under the circumstances.'

Operation Kid Brother

'I'm not James Bond. I'm Brooke Bond.' – Neil Connery

As Connery was scaling the heights of Hollywood, younger brother Neil was working as a plasterer back home in Edinburgh. At the height of the mid-sixties fad for all things Bond two unscrupulous Italian producers persuaded Neil to down tools and jet around Europe as a mini-Bond in quite simply the most bizarre spy movie ever made. *Operation Kid Brother*, whose tagline was 'Too Much For One Mother', featured bikini-clad nymphs by the barrel-load and dart-firing garter belts, plus a host of actors associated with the 007 series – Bernard Lee, Lois Maxwell, Daniela Bianchi and Adolfo Celi. Borrowing one of Sean's shark's-tooth suits Neil flew to Rome for a screen test and signed a £5,000 contract with an option for seven films.

Connery was furious and appealed to the film-makers not to proceed. 'By getting my brother to make this kind of picture,' he told them, 'you are exploiting us both.' When words failed he threatened to do some damage to the producers if their paths ever crossed. They responded by asking Connery to pose with his brother for publicity pictures! 'Sean was only trying to protect me,' Neil told reporters anxious to stir up a family feud. 'As brothers we are close and always will be.'

Though Connery reputedly tried buying up all the prints of *Operation Kid Brother*, he needn't have bothered – it bombed on its release in 1968. 'A grotesque parody of a parody ... bad enough to be hysterically funny,' said *Monthly Film Bulletin*. Turned down by directors for being too much of a clone of his brother, Neil saw his hopes of an acting career fade, and so he had to return to his £20-a-week plastering job, council house and his wife and two daughters. He did appear in one more movie, a dire British sci-fi cheapie called *The Body Stealers*, and later scraped a living as a bit-part player after a plastering accident in 1982 ended that career. But he always refused to ask his brother for a leg-up. 'Sean is a good-hearted chap, but I've made it clear to him that I want to be on my own in my acting ambitions.' Sean once summed up his brother's situation in characteristically blunt fashion: 'Neil should either shit or get off the pot.'

The pair regularly keep in touch (Neil calls Sean 'the brother'), always

meeting up for a round of golf whenever Connery is in Edinburgh. Neil has also helped out with odd chores, like the time he looked after Sean's three-litre turbo diesel Mercedes when the actor was in America. At home Neil's living-room is a virtual shrine to his brother's career, and he has nearly all of his movies on video. 'I asked Sean to put a clause in his contract stating that his brother must be sent a video of the film! I didn't get it.'

Sean excelled as 'big brother', and it's a role he's never quite relinquished. Neil looked up to him in all things, and as a kid he was careful always to follow his example. 'We're two quite different people coming out of the same environment, but going different ways,' Sean once said of his brother. 'Once you make your own momentum, your own direction, you evolve in an entirely different way.'

Julie Hamilton

Connery was still part of the *South Pacific* troupe when he met 21-year-old Julie Hamilton in a London pub. They were introduced by a mutual friend, the actor Ronald Fraser. A freelance photographer, specializing in theatrical subjects, Julie took an instant dislike to Connery. 'My first impression of him was that he was rather large and boring. And those tattoos! They were, to me, the hallmarks of a navvy. I thought: God, what an appalling person!'

As for Sean, he was immediately attracted to the tall, blue-eyed blonde. Over the next few months he bumped into her at various parties, always desperate to impress but according to Julie never without the same soft, slightly dopey grin on his face. The Connery charm appeared to have stalled, until the occasion of Ronald Fraser's wedding. Julie, there as bridesmaid, watched the groom arrive at the Hampstead church in full highland kit, closely followed by a similarly attired Connery. She swooned – never before had she seen such a devastatingly handsome sight.

After the reception Connery walked Julie to her flat at the posh end of Abbey Road, all the time eliciting admiring glances from passers-by. With Julie's parents conveniently away for the weekend the couple spent the remainder of the day and evening together. Julie had at last fallen for Connery, won over by the sheer 'beauty of the man'.

She was the advantaged daughter of writer Jill Craigie and step-daughter of future Labour Party leader Michael Foot. From the start it was obvious that Craigie disapproved of Julie fraternizing with a penniless actor, particularly one with such rough manners. Foot got on rather better with him, usually finding plenty of subjects to talk about, not least politics. The young Connery often sought out his advice, all part of his effort to soak up knowledge wherever possible. This was something Julie found admirable and endearing. He also grew concerned about how much time Craigie spent alone in the house, because of her husband's duties at the House of

Commons. So when a friend's dog had puppies he bought her one; it would make a fine guard dog and companion, and maybe win over Julie's mother. Christened Vanessa, this dog was later immortalized by cartoonists and reporters after accompanying Michael Foot on the first Aldermaston anti-nuclear march.

At the time Connery lived in lodgings in Kilburn, which Julie regularly visited, sometimes bringing food, often staying over. His landlord Llew Gardner was previously a journalist on the Communist paper the *Daily Worker* and owned a thirteen-volume set of Joseph Stalin's writings. When Sean bought a second-hand double bed that boasted three legs the books came in most handy. 'It was Joe's last great humanitarian act,' Gardner had fun recalling, 'that he should supply support for the future James Bond's athletic sex'.

Julie soon emerged as an influential figure in Connery's early London days. Very pretty – one had to be to succeed in the male-dominated world of Fleet Street – and with a biting sense of humour, she was madly in love and a constant source of encouragement. Together they'd go over scripts, and along with Gardner she persuaded him to take proper elocution lessons. 'I don't think for a moment that he ever considered failure,' she later remembers. 'I don't think he dared think of anything other than making it work.'

It wasn't long before Julie was paraded before Effie and Joe, a sure sign that things were turning serious. But the visit was not a success; family and friends failed to take to Julie, while she disapproved of what locals termed the Scottish 'masculine prerogative' – disappearing down the pub. Checking his watch at some point, Connery mimed the downing of a pint to brother Neil and the pair were off. Julie burst in to the local to confront Connery at the bar, fuming: 'I think you might have asked me along for a drink.' An uneasy silence descended, leaving Neil to ponder the life-expectancy of their partnership.

Connery's habit of a night on the tiles with the lads tormented the insecure 21-year-old and fatally damaged their relationship. 'Although I'd no cause to be jealous – Sean was always a one-woman man – I behaved stupidly,' Julie admitted years later. 'He'd go out drinking with the boys and I'd automatically assume women were present. There were quarrels and rows. I was to blame, I was the stupid one.'

Despite such setbacks the subject of marriage was often broached. The biggest stumbling-block remained Julie's parents. 'What would you say,' she tentatively suggested one day to her mother, 'if I said I was thinking, only thinking, of marrying Sean?' Craigie's position hadn't budged: the idea of Connery as a son-in-law did not appeal. Still too young to ignore her parents' wishes, Julie often had to be comforted by Connery after tearful arguments at home.

Acting on Julie's advice Connery used a fee from a BBC play to put a deposit on a home of his own. Having just signed a contract with Twentieth-

Century Fox, he'd never before been so financially secure. A first-floor studio flat in Wavel Mews, St John's Wood, was purchased and furnished with help from Craigie, who wished Connery well – just so long as ideas of marriage remained dormant.

But when a certain Diane Cilento entered his life, Julie was history. At the mews flat one day Connery, wearing a vacant expression on his face, suddenly said, 'She's got the most incredible eyes.'

'Who?' Julie asked.

'Diane,' he replied sincerely, if not tactfully.

Instinctively Julie knew their one-and-a-half years together were over.

'I don't think I love you the same way anymore,' Connery announced.

With tears welling up in her eyes Julie sat and listened as the man she loved described how he'd fallen for Cilento at first sight, just the way it had happened with her.

'I'd better go, then.' She said finally, making for the door.

Revenge came the next day. Returning to pick up some belongings, she took time out to scrawl a choice selection of obscenities on the bedroom mirror with her lipstick. Eventually they were able to meet again as friends, but Julie never lost that pang of sadness. Years elapsed before she could bear to go and see any of his films. She bumped into him after her marriage on an outing with her baby son; it was probably their last meeting. Connery asked for the child's name. 'Jason,' he was told.

'A fine name. If I have a son I'll call him Jason, too.'

Connery was Julie's first real love, someone whom she described as 'a very special person at a point in my life, but I have no regrets.' As for Jill Craigie, her opinions that marriage between them wouldn't have worked never changed, even when Connery became a star. For some mothers, no suitor is ever perfect.

The Stompanato Case

Johnny Stompanato was a charmer with a jealous temper, a small-time hood and preening gigolo employed by gangster Mickey Cohen. He was also Lana Turner's lover. When rumours started flying about her secret fling with Connery on the set of *Another Time, Another Place* most laughed them off as mere gossip. Stompanato, however, took them very seriously. During a fit of pique he stormed into the studio one day waving a gun in Connery's face, warning him to stay clear of Turner. Connery floored the yob with a right hook and Scotland Yard did the rest by ejecting him from the country.

Connery was resident in Hollywood doing his Disney stint when one of the showbiz scandals of the decade hit the front pages. Turner's teenage daughter Cheryl was on trial for stabbing Stompanato to death. Her testimony was full of lurid accounts of violent rows between the two lovers, during which

Stompanato threatened to mutilate Turner. Abuse at his hands was a regular part of their relationship: once he held a razor blade to her face, another time strangled her with such brutality that Turner's vocal cords were bruised.

On the fateful night the threats and beatings reached a peak of brutality. After rushing to the kitchen to grab a butcher's knife Cheryl crouched panic-stricken outside her mother's bedroom door. When Stompanato was heard to scream, 'Cunt, you're dead!' she burst into the room. Somehow the blade ended up in his stomach. Stompanato staggered over to the bed and died before a doctor could be summoned. 'Johnny was going to hurt mother,' Cheryl explained to arriving policemen.

At his hotel one morning Connery received an anonymous phone call warning him to leave town. Mickey Cohen was out for revenge and anyone implicated in the Turner/Stompanato affair was considered fair game. Turner's love letters to Stompanato, which included references to nights out with Connery in London, had been made public at the trial. It all seemed straight out of a western, but a friend advised him not to treat the threat lightly; these boys played for real. 'Apparently Cohen didn't believe that Cheryl had killed Stompanato,' Connery said later. 'He thought the killing had been engineered in some other way.' Deciding on safety, he packed his bags and headed off to the San Fernando valley to lay low. 'Nothing did happen, but it was scary as hell for a while.' As one journalist remarked, it was probably the last time anyone pushed Sean Connery around.

In rather poor taste *Another Time, Another Place* was rush-released in America to capitalize on the scandal. Deservedly, perhaps, the ruse failed and the film flopped. Had the producers jettisoned the plot and merely filmed Turner's private life they might have been on to a blockbuster. As for Cheryl, she received a verdict of justifiable homicide.

Yat Malmgeren

Diane Cilento, noting Connery's 'stodgy movement' during rehearsals for a television production of *Anna Christie* in 1957, introduced Connery to Yat Malmgeren, a former dancer with the Kurt Jooss ballet company who'd opened his own movement school in London. Connery attended several times a week for a period of three years, his first brush with formal dramatic training. 'It was a remarkable period for me,' Connery said, 'proving that with proper exercise you can reshape your physical structure by attacking yourself from within. To awaken yourself physically, completely, so that you become a much better tuned instrument.' For years after he still referred to a tatty copy of Malmgeren's textbook and when son Jason took up acting passed it on to him.

Already naturally athletic, thanks to his weightlifting regime as a young man, Connery's uninhibited physicality in the classroom impressed

Malmgeren. 'When I taught him,' the Swede told *Empire* in August 1994, 'I always said to him. "If Clark Gable could do it, you can do it too." The acting was always more or less the same – he has done many films, but not that many character variations – but what Sean has is that he believes in the situation and everyone seems to love him for that.'

Malmgeren also had a hand in developing the famous Connery 'Bond swagger', described once as 'the threatening grace of a panther on the prowl'. Connery called upon much of what he'd learnt for that first Bond interview. 'I used strong and commanding movements, not with weight, but to show how Bond is always in control of a scene.' Malmgeren's students were taught a technique called 'overpowering', and days before meeting Broccoli and Saltzman Connery spoke to his former tutor. 'I shall establish myself on overpowering and take the interview like that. That would be a good thing, don't you think, sir?' Malmgeren is of the opinion that he probably walked into that audition 'very self-assured, very large, very secure'.

Watching in the wings as Connery hit stardom with Bond, Malmgeren had first-hand experience of the frustrations Connery felt about being type-cast. Employed by the National Theatre at the time, the trainer knew Laurence Olivier and Maggie Smith were discussing casting Connery in a leading role, but they eventually decided that they couldn't have 007 on the stage of the National Theatre. A case of cultural snobbery.

Trivia note: A future pupil of the Swedish drama teacher was a certain Pierce Brosnan.

8 Professional

Acting Methods

'It's not just for money. It's for the fantasy, the way you have to get inside someone else's skin, imagine them, understand them, recreate them.'

As a young actor who read Stanislavsky, the guru of method acting, Connery's early influences were mostly American stars like Marlon Brando. To his eye Brando was a dynamic performer – 'the most watchable of American actors'. He admired the way Brando, Mitchum and others moved, the way they used their bodies with expression and strength. This was something lacking in the more vocally trained British theatre actor. Connery is a firm believer that movement and gesture, that the physicality of actors in a scene, can be just as important as the dialogue. 'I won't even take a role until I work out the body techniques.'

Few actors move with the same carefree, easy grace as Connery. Look at him as Bond entering casinos like a panther on the prowl – or disguised as a mad priest in *The Man Who Would Be King*, dancing like a whirligig. 'He can convey more, walking, in long shot than most actors can, grimacing, in big close-up,' wrote critic Andrew Rissik. *Cuba* co-star Brooke Adams remembers Connery teaching her how to psychologize a character. 'He left the room and walked in like two different men simply by altering his relationship to space; the difference was incredible. Most actors like to keep secret what they do and how they do it. Not Sean.'

What also impressed Connery about American actors was their knack of conveying inner sensitivity, even when playing the most hardened of roles. For this skill he rates Robert Mitchum in particular. 'He can do everything for me. He's got great humour, marvellous timing, can be very menacing, can be very sweet.' Connery worked out that someone who looked muscular and powerful, yet could also be humorous and gentle, had the right ingredients to make a charismatic male lead. The combination is there in practically all his portrayals, notably El Raisuli and Malone. The archetypal Connery hero not only flaunts his machismo, but shows a capacity to cry, to reveal emotion. In its review of Connery in *The Untouchables* the *New York Times* hit the nail on the head. 'Malone gives him ample opportunity to demon-

strate his paradoxical acting abilities, his knack for being simultaneously rugged and gentle, cynical and innocent, hard and soft, tough and almost tender.'

Modern American stars like Hoffman are chameleons who submerge themselves into each character to the point of invisibility, whereas Connery is a master at modifying his personality to suit a particular role. He may always be Sean Connery but we willingly accept him as a Russian submarine commander or an Egyptian nobleman. In this respect he's very much in the mould of an old-time movie star; whatever he plays his own personality shines through. Arguably Connery ranks as the only contemporary actor with the charisma of the romantic Hollywood stars of the past. Director Peter Hyams, observed 'Sean can project tremendous vulnerability, which is very affecting in a man of his size and strength. It's like the image Gary Cooper had.'

But the star to whom Connery has been most likened throughout his career is Clark Gable. In 1961 a writer for *Woman* magazine noted: 'Sean reminds me of Clark Gable. He has the same rare mixture of handsome virility, sweetness and warmth.' While publicizing *The Hill* in 1965, Connery found that continental journalists were picking up on his physical resemblance to the star made famous as Rhett Butler. Even *Time* magazine dubbed Connery 'The screen's new Gable'. But as film writer Kathleen Murphy observed in 1997, there is one major difference between the two: 'Gable had only John Huston's *The Misfits* to crown his later years, while even mediocre movies fail to tarnish Sean Connery's ever increasing majesty.'

An actor is only as good as his script, yet Connery has the ability to invest simple dialogue with a sardonic wit that turns ordinary lines into memorable gems. Down the years Sean's had to spout some unforgivable nonsense. For example, in *The Russia House* he eulogizes Michelle Pfeiffer in her Moscow kitchen: 'All my failings were preparations for meeting you.' The style is stodgy, but Connery's alchemy makes it seem like pure gold.

Everything starts with the script, and for Connery it's the most important element in choosing a project. The writing is what stimulates him the most and he can usually judge the calibre of the writer within the first couple of pages. Only then does he look at the plot itself, and whether it has dramatic potential. But initially it's the words that draw him to any project. 'The toughest thing is to find good dialogue. There are many fine story ideas, but what makes some stand above the others is dialogue and characterisation.'

Connery is an astute script reader; he can glance over a script and establish very quickly if it's right for him. Always he uses the humanity of the character as a base. Take James Bond: however original the gadgets are, it's the man himself with all his strengths and failings who must overcome the obstacles placed before him. Next comes humour. Connery firmly believes that comedy is the key to unlocking a character. The comic aspects of any part are generally more interesting and revealing than all the melodramatic baggage. Most of all, though, he looks for variety in the roles he plays. 'I'd

rather do as many varied things as possible because it's much more stimulating and in the end more rewarding as an actor.'

Not content to rest on his laurels as 007 Connery has continually sought challenges in his career; in triumphantly surmounting them, he has created an extraordinary gallery of compelling characters. Many of them, curiously, have been historical – Alexander the Great, Macbeth, Robin Hood, Richard the Lionheart, King Arthur. He's one of the few stars equally comfortable in period costume or modern dress. But his heroes, however diverse, do share common traits, in particular their penchant for challenging authority (Duke Anderson, Joe Roberts and so on). 'I basically dislike intensely injustice,' Connery has said.

Once committed to a project, Connery meets with both the writer and the director and enters pre-production with them, adding his own ideas, injecting any humour that's missing and sharpening his character's dialogue. When he walks onto a film set he's as prepared as he can be – he knows exactly what his strengths are and how he can use them for the betterment of the project. Connery places great store in rehearsing. According to Michael Crichton he prefers to rehearse alone, playing all the parts himself. 'Sean's a gifted mimic. He did startlingly accurate imitations of everyone in the case of *The First Great Train Robbery*, including Donald and Lesley-Anne, his leading lady.' He likes to come on to a set fully rehearsed and prepared and just do it; he's not one of those actors who build gradually during a scene. 'Sean's a very good actor on take one,' says Richard Lester.

Connery has always said he became an actor because he couldn't do anything else. 'Over the years, I have sometimes thought, what else would I do? I can't come up with any answers.' He abandoned 007 to allow himself the luxury of doing only the work that personally interested him. But he took dangerous gambles, choosing dark, often uncommercial movies that bombed at the box office but were artistically clever. To shift from action man to character actor without losing his appeal or popularity is some achievement.

As for his own favourite actors Connery lists Cary Grant ('the most underrated actor to appear on screen;), Marlon Brando, Ralph Richardson, Laurence Olivier, Robert Mitchum and Spencer Tracy. Of the new brigade he admires Nicolas Cage, Brad Pitt and Johnny Depp ('Off the wall but interesting'). And advice for anyone starting in the business? 'Beware of the sharks. Kill them before they kill you.'

Stardom

'I knew I'd make it sooner or later, one way or another.'

The odds against Connery even reaching the first rung of the fame ladder were vast. A child of poverty with little education, a one-time milkman who

was invalided out of the Navy – this is hardly the CV of a future cinema icon. In truth, he would have been hard-pressed to reach the summit of any meaningful profession. 'If I were to think of how far I've come,' he told *Vanity Fair* in May 1993, 'How much fame one's had, how much money one's made, one would think – well, it wouldn't be physically possible, considering where I've come from.'

Connery's rise coincided with the explosion of 'working-class' British acting talent, men like Richard Harris, Michael Caine, Peter O'Toole and Albert Finney, whose organic acting style resembled the 'method' technique of their American contemporaries. 'We all knew each other and used to go to The White Elephant to eat,' Norman Rossington remembers. 'You could wear casual clothes, so all the actors used to go there after the shows.'

To be a British star prior to 1960 meant having a plummy accent and owning your own tweed jacket. Connery and the rest bulldozed their way through the snobbery, and British acting was never the same again. While never matching Connery's mass fame, Finney, O'Toole and Harris were all judged to be more significant actors, but it was Connery's career which fully developed. He has staying power, too, maintaining his status as a top-dollar, A-list star past pensionable age. And incredibly his reputation as a man of action and sex symbol remains intact. 'He's a leading man in his 60s. How many other actors can say that?' says Lee Rich, producer of *Just Cause*.

Though Connery has never succumbed to the vanity of superstardom he has never underestimated its value. He enjoyed fame when it finally arrived, and was quick to remind people that he'd paid his dues in repertory and on television and accomplished everything 'with my own sweat'. As a struggling actor he always felt within himself that the break would eventually come and that his future would see him become a leading man in film. But there must have been periods of self-doubt, when he wondered if he would ever make it. 'It is a real mystery to me why no film company has built Sean into a great international star,' wrote *Woman* magazine's film critic in 1961. Disney press agent Bill King couldn't interest anyone in interviewing Connery after he had made *Darby O'Gill and the Little People*. 'Who the hell is he anyway?' they'd say. Finally King persuaded a woman journalist to do a piece on him. When Connery had been pointed out to her, she said, 'This handsome guy? Gee, of course I want to talk to him.' Afterwards Sean sent her a thank-you note for what was possibly his first American story. 'He lived very quietly, shunning the Hollywood crowd, then one day he was gone,' recalled King in the mid sixties. 'I said to myself, there goes a nice guy, sorry, nothing will ever become of him. I was sure I'd not hear of Sean Connery again.' When the Bonds arrived he hastily re-evaluated his decision. 'I would have bet 100-1 that Sean would never amount to a sack of beans.'

As it turned out, few stars working today have occupied the high ground for so long. Connery has been a major star for an astonishing four decades and his career shows no signs of flagging. Far from it – he is in constant

demand as one of that tiny band of elite actors whose presence is an asset to any picture, guaranteeing it media interest and, often, commercial success. Connery likes to boast about his worldwide popularity. Whereas stars like Costner are tied primarily to American audiences, he has managed to cultivate a strong international following over the years. 'Outside the United States there isn't an actor who gets better exposure or success ratios in any country than me,' he claimed in 1992.

What, then, is the secret of his enduring appeal? On screen Connery combines sophistication and danger, most notably as James Bond. He appeals to all sexes and ages. Though women naturally find him physically attractive, it is more his integrity, honesty and masculinity, served up with a dash of vulnerability, that wins their vote. Men see him as one of the lads, a tough guy who takes no nonsense, whether in his films or real life. The young, meanwhile, tend to view him as a father figure, someone to look up to. 'A friend of mine who's in his 50s and is eminent in his field says that when he grows up he wants to be Sean Connery ... Connery's physical presence is assured, contained, insolent; that's what makes this burly Scotsman a masculine ideal.' Thus wrote Pauline Kael reviewing *Indiana Jones and the Last Crusade*.

The time of Connery's superstardom was really the mid sixties when his face graced the covers of more magazines than possibly Elvis and Jackie Kennedy. Broadcaster Alan Whicker noted that Bond 'made Connery, an unknown actor, the most famous face in the world'. From 1964 to 1967 he was Britain's biggest box-office draw, while in America he topped the list in 1965, a feat unequalled before or since by any other British actor.

Though still popular in the seventies and early eighties Connery couldn't match the star power of Clint Eastwood and Burt Reynolds, then Sylvester Stallone and Tom Cruise. But after the 1987 Oscar triumph his ranking in Hollywood rose dramatically. Somewhat to his surprise he was elevated into the celestial ranks of the Hollywood greats, becoming a walking, talking legend, the last star in the tradition of John Wayne and Clark Gable. From that point on, Connery started accumulating major lifetime achievement awards and appearing regularly in movie-star polls, notably the August 1993 issue of *Entertainment Weekly*, in which he was included in their list of the thirty greatest movie stars of all time. Such was his fame now that an American autograph company was reported as selling beverage receipts signed by him at the Bel-Air Country Club for $95 each.

What is most staggering about Connery's longevity as a star is the fact that he's appeared in so many oddball movies, misfires and flops, which must call into question his judgement in picking the right scripts. Some of his choices down the years have been ill-conceived or, at best, unworthy of his abilities (*Ransom*, *Presidio* and so on). Some of these failures can be attributed to his desire to escape the Bond image, choosing roles and projects that were so anti-heroic that they alienated mass audiences, such as *The Molly Maguires* and *The Offence*. Of course, Connery has no monopoly on turkeys; all

actors make mistakes. But what is almost unique is his Houdini-like knack of emerging unscathed and professionally intact from even the most turgid mess. Now that's stardom.

Connery: Sex Symbol

Connery was fifty-nine when he was voted the sexiest man alive by *People* magazine. 'It's very flattering,' he said, 'but the sexiest man alive? There are few sexy dead ones.' Back in the mid sixties he spoke of his hope of being remembered as a good actor rather than merely a sex symbol. 'However, the status quo is not bad ... not bad at all.'

Over the years few commentators or co-stars have missed the chance to gush over those famous dark looks, even the men. Alec Baldwin once referred to Connery as 'the most physically beautiful man to stand in front of a camera'.

Actress Zena Marshall, his co-star in *Dr No*, noted how at the London premiere starlet Anita Ekberg scarcely took her eyes off him all evening. 'Whatever effect he'd had on women up till then was doubled. James Bond made him a walking aphrodisiac.' Connery admitted as much to *Playboy* in 1965: women tended to mix up the man with the image. Some of the female fan mail he got was positively bizarre. 'If I actually started to behave to any woman the way Bond does, she'd run like a jack rabbit – or send for the police.'

Here are just a handful of tributes from women who have worked with him or simply watched him work.

Lois Maxwell: 'Sean has this dark, wounded look which simply melts women. It was his Celtic blood or something. Anyway, it worked on me.'

Premiere magazine: 'Sean Connery is way beyond a dream date. It would be like going out with Zeus.'

Barbara Carrera: 'He's one of the few men who've stayed sexy with age. All over the world women ask me about Sean Connery. They stare at me with their mouths open: "What's he like to work with?" '

Jean Rook: 'I've interviewed every great sex symbol from Paul Newman to Guy the Gorilla before he was stuffed. If you laid their libidos end to end they still wouldn't macho up to the sexual impact of Sean Connery. Mr Connery looks like a cross between the Monarch of the Glen and the sharp side of Ben Nevis.'

Lorraine Bracco: 'He has the twinkle in his eye that every woman finds very appealing and I'm no exception. It's no wonder he's been named the sexiest man alive.'

Pauline Kael: 'I don't know any man since Cary Grant that men have wanted to be so much.'

Diana Dors: 'At the height of his Bond fame he could have had any woman in the world. As far as I could see he often did, because the girls flung themselves at him.'

And they still do. 'In the supermarket the women chase him,' despairs Micheline, who must have known what she was getting into when she married him. 'So I wasn't going to be bothered by other women throwing themselves at him. He is such an attractive man, they cannot help themselves.' At times it can be disconcerting, like when she was once brushed aside by another woman aiming to get close to Sean. 'She's not interested in me,' he consoled Micheline later; 'she's only interested in the image.' Apart from his obvious physical qualities, what attracted Micheline to Connery was his lack of affectation. 'Sean is what he is. He's not trying to hide anything. That genuineness by itself is sexy in a man.'

Connery's sexual power has been an essential ingredient in his rise to fame and durability. It was there right at the start. As a muscular sailor in *South Pacific* who had waves of girls swooning at stage doors. His big break into television came about because the director's girlfriend thought female viewers would find him a turn-on. And Cubby Broccoli's wife was keen on him as Bond because of his sex appeal. The directors of his early pictures picked up on this animal magnetism, though few exploited it in the right way.

The sex symbol tag has been great for the ego, though during his Bond reign Connery grew weary of it, mainly because the press portrayed him as behaving like 007 when it came to women. 'Everyone expects Sean to be womanizing like crazy all the time,' Diane Cilento commented at the time. 'Sitting at home with the kids just isn't on.' Years later when *People* magazine voted him sexiest man alive he could afford to be flattered, and modest: 'It'll be all downhill from here!' Asked if sixty-year-old males were more virile, he replied: 'It's years since I went to bed with a sixty-year-old balding guy.' Connery must also be one of the few British actors honoured by Man Watchers Inc., a female organization that compiles annual top ten lists of men they admire. It described Connery as 'Intriguing, smooth, urbane, with savoir-faire and class.' But, says Connery, 'I don't see myself as suave.' This is a man, after all, who succumbs to a less than romantic lip sore each time he starts a new movie. 'It's nerves. It always comes out.'

Perhaps Shelley Winters sums it up best. 'He was sexy at 26 and at 60 even more so. He makes a woman feel sexual chemistry. To be his leading lady I'd lose 50 pounds and get my face lifted. As a matter of fact, I'd get everything lifted!'

Connery as Stuntman

Wherever possible Connery likes to perform his own stunts, everything from hanging off moving trains to the more traditional fist fight. 'His timing is absolutely perfect for film fighting,' according to Irvin Kershner, 'because he has a wonderful sense of rhythm.' Connery is all too aware of the audience's growing sophistication in spotting when a star is sitting out the rough stuff.

Filming the helicopter chase for *From Russia with Love* in the Scottish highlands, the producers discovered too late that the pilot was poorly trained. 'When you see the picture again,' says Connery, 'notice how perilously close the helicopter swoops to me. It was not a camera trick – and it was not planned.'

In another Bond, *Thunderball*, Connery was required to swim in a pool containing a school of Tiger sharks.

'Not bloody likely,' he announced.

'Look, it's perfectly safe,' director Terence Young assured him. 'You're behind plate glass in a little tank of your own. The only way the sharks can get in is if they can jump in the air like a dolphin.'

'Well, how do I know sharks can't?'

'You have my word for it,' replied Young.

What Young had failed to tell his star was that the suppliers hadn't enough Plexiglas to build a corridor the full length of the swimming pool. As a result, there was a four-foot gap. 'The third time we did it something went wrong and two sharks got into the tunnel,' Young related on a Bond television special. 'And believe me the shot we have in the picture, Sean Connery is not acting.'

Connery here takes over the story: 'I was in the wrong side with the sharks. I got out of the water, I think I was dry when I touched the side. I don't know whose fault it was, but it didn't happen again.'

A highlight of *The Molly Maguires* is its faithful recreation of a Gaelic football match, a sort of cross between soccer, rugby and pitched battle. In the interest of realism Connery and co-star Richard Harris heroically forwent the use of doubles and roughed it up with hardened professional players, coming away afterwards with assorted cuts and bruises. Even the referee didn't escape unscathed, getting a kick in the face.

The most dangerous moment occurred in *Indiana Jones and the Last Crusade*, a film which made use of every conceivable mode of period transport – trains, trucks, armoured cars, planes, zeppelins, motorbikes, boats, tanks, horses and camels. Within the relative calm of Elstree studios one stunt backfired. As captives of the Nazis Connery and Harrison Ford are tied up in a blazing room. It quickly became apparent that the inferno was out of control, and technicians struggled frantically to free the heavily insured stars before they sustained serious injury. Connery was livid.

By far the most daring stunt ever attempted by Connery was for *The First Great Train Robbery*. Figuring that the sequence would lack credibility using a double, Connery himself is shown jumping from one carriage to the next on top of a moving train. It's heart-stopping stuff, especially the moment when a bridge hurtles towards him, missing his skull by mere inches. Even the cameraman closed his eyes every time the train sped under it.

An authentic 1863 locomotive was used for these scenes, which the production team had been assured could not exceed 35 m.p.h. Straight away Connery and director Michael Crichton climbed up on the roof for a test ride.

'Within minutes Connery was grinning like a kid on a carnival ride,' revealed Crichton. When a bridge loomed up they threw themselves on the floor. As it roared overhead Connery could be heard yelling, 'Bloody fantastic!'

But the element of danger was never far away. Crichton was on the roof lying next to the cameraman shooting Connery running towards them, when suddenly he felt a sharp pain in his scalp. His hair had caught fire from the cinders spewing out of the locomotive's funnel. While desperately trying to put it out Crichton noticed Connery stumble a bit too convincingly, then wince in genuine pain. Back on *terra firma* he ran over to his star, who was being treated for a badly cut shin. 'Are you all right, Sean?'

Looking up, Connery answered, 'Did you know that your hair was on fire? You ought to be more careful up there.'

As the stunt sequence began to take shape Connery became aware that the train was getting progressively faster. After one particularly hair-raising take he leapt off the roof in a fury. 'It's bloody dangerous up there! This bloody train is not going bloody 35 m.p.h.' The crew radioed the pilot of the camera helicopter to verify the speed of the train, and his answer chilled Connery's blood. '55 m.p.h. We thought Mr Connery was crazy to be up there!'

Crichton and Connery then made their way down the track to the driver's cabin and were staggered to find that it lacked a speedometer. No one had bothered to check.

'How do you know what speed you're doing?' they asked the driver.

'Oh, that's easy,' he replied. 'I count the trees.'

When Micheline found out what her husband had been up to she hit the roof. 'Really, I was mad, because if I had been there he would never have ridden on the train.'

Connery himself had begun to grow weary of the sequence after a few days. At one lunch break he dropped this bombshell to Crichton. 'I'm through on the train. Finished. Going back to Dublin, have a kip.' Crichton reminded him that there were still three more days of filming scheduled. But Connery was adamant and left at the end of the day. After seeing the dailies he was convinced there was enough footage to make the scene work.

Next morning Crichton and a stuntman went through their paces on top of the train. Now Crichton was starting to feel worn out by it all. 'I realize that is what happened to Sean the day before. He'd had enough, and he knew when to stop.' Crichton packed up and joined Connery in Dublin.

As he approached his late sixties, a time when most people are retired and pruning rose bushes, Connery was still playing the action man to tremendous effect in *The Rock*. In a scene filmed in the same studio space where years before he'd braved a mud river in *Meteor*, this time round the danger was no less menacing. Along with co-star Nicholas Cage Connery had to dive underwater and hold his breath as a huge fireball shot overhead. 'If I screw up, my hair is going to burn off, is that right?' Connery asked director Michael Bay, before adding, 'Why don't you try it first.'

The movie's technical adviser Harry Humphries had nothing but praise for the veteran. 'He was 65 years old and he did the job. My only concern was that he would pop up and panic, but he didn't.' Cage was no less impressed. 'Sean's terrifically fit and he does the stunts, he gets in there and does as much of them as he wants.'

Money

'I want all I can get. I think I'm entitled to it. I have no false modesty about it. I don't believe in this stuff about starving in a garret or being satisfied with artistic aspirations alone' – Connery speaking in 1965.

Connery has made fortunes, and lost them too. Yet his motive for work isn't predominantly money – otherwise he would have kept on churning out a Bond film every year or hired a manager to attach his name to brands of golf balls or clothing. 'But I don't want to sell myself like that.' In 1966, however, he did appear in magazine advertisements for Jim Beam, his only product endorsement in America to date; and in recent years he advertised whiskey on Japanese television.

Connery refutes the widely held belief that he's stingy with money – 'just careful'. Once when his prized Mercedes broke down on the way home he refused to pay for a taxi. 'That would be wasted money.' So he insisted that his wife come and pick him up. Another time, when his agent Dennis Selinger was in Lapland with another client, Connery called him up in the early hours of the morning for one of his regular grumbles. Suddenly there was a deathly hush.

'What is it, Sean?'

'Dennis,' Connery answered, almost in shock, 'Dennis, I've just realized *I'm* paying for this call!' and slammed the phone down.

In the mid-sixties Connery once slept on Shelley Winters' sofa prior to flying back to London in order to save paying for another night at the Plaza Hotel in Nerw York.

He is not a great hoarder of money and believes it's for spending: 'Golf, food and drink, that's what I enjoy. And the only point in having money is to indulge them.' But he is frugal with it and doesn't idly throw it around. During the sixties, when film and pop stars changed their sports cars as often as their haircuts, Connery never behaved so extravagantly. 'If I bought a Rolls I'd have to look after it,' he said. 'I don't want that kind of responsibility.' In the eighties he did buy a Mercedes, a rare luxury, but generally surrounds himself with few trappings of the jet set, even though he can easily afford them. In fact he's always on the look-out for bargains, and is obsessed with not being taken for a ride. After filming *Five Days One Summer* in Switzerland he left fuming about how the local hotels and restaurants had charged him at 'star rates'. 'They take you for every penny,' he moaned.

One wonders how much this reputed canniness with money is real and how much he plays up. At home, though, he's known to keep an eye on lights left wastefully turned on. 'I can't bear the thought of all that wasted electricity.' While making *Zardoz*, Connery stayed as a guest at director John Boorman's home. There he often monitored the rooms, switching off lights and turning down the thermostat. He also insisted on paying his way, giving Boorman's wife something towards his rent each week. He also lectured everyone on how best to keep down the budget. Boorman had arranged for cast members to stay at a local hotel on a discount and was amused to learn later that Connery had negotiated the room rates down even further. The drive for cost cutting is the same on most movies he makes. And if he can pull a fast one at the same time, so much the better. One day he approached Boorman on set. 'My contract calls for a car and a chauffeur, right?'

Boorman nodded.

'What's that costing you?'

Boorman told him.

Connery thought about it then said, 'I'll tell you what I'll do. I'll drive myself and split it with you.'

For a man this shrewd with money, he is outstandingly generous. It's an odd paradox. Impulsively magnanimous in big things, he keeps a close eye on small sums. He'll haggle over a taxi fare but think nothing of writing a large cheque for a single charity. 'Blood and tears go into parting with £10 on the golf course. But when something like £40,000 is involved, I am much more objective.' He can be petty too, refusing to go on Michael Parkinson's chat show in the seventies because he alleged that Parky had welched on a £10 bet on a football match.

Above all, for Connery money means power, and power in Hollywood is everything. 'One doesn't do everything for money, of course. But one should be paid what one is worth.' He demands the highest salaries not primarily because he needs the money, but because it brings him status – important for someone who has slogged his way up the top the hard way. 'If you work your arse off the way I have, there has to be some reward.' Cast in *The Hunt for Red October*, Connery got his agent to extract a clause from Paramount that compensated him in the event of the dollar falling against European currencies. 'I don't think the studio had heard that argument before, but funnily enough they came round to my way of thinking.'

Connery's alleged penny-pinching has been attributed to his Scottishness, but it is in fact a product of his upbringing. He has never forgotten what it was like to have little or no money. 'It's difficult to avoid a guilt complex about money when your upbringing was tough. I never get over the fact that sometimes I see more money being paid for a meal than my father earned in a week.' For years Connery was troubled by his new-found wealth. Buying jars of caviare at Harrods he'd be crushed by guilt just going up to the counter. In the late sixties he bought a newfangled shower for his London

home at the cost of a few hundred pounds and agonized over it for days. His dad in Edinburgh could have lived an entire year on that kind of cash. His background has left him with a tremendous respect for the value of money; he knows how hard it is to earn and to keep. That's why when he thinks he is being short-changed he'll fight all the way – usually emerging the winner.

The first of the mega-stars to sign up for *A Bridge Too Far*, Connery agreed a modest appearance fee of $250,000. Then he read in the newspaper that Robert Redford was pocketing $2 million for what amounted to an extended cameo. Connery was livid. 'What is this newspaper crap?' he bellowed down the phone at producer Joe Levine.

'It's not my fault you got a fucking lousy agent!' the mogul answered back.

Along with Anthony Hopkins, Connery had the most substantial role in the film. He resented Redford and the other Hollywood big guns receiving larger pay cheques for doing a lot less. It stank of injustice. After heated debates with Levine Connery's salary was doubled. As usual he got his way where money was concerned and happily bragged about outplaying the money men. 'I showed them back in Hollywood I don't play second string,' he told friends. Levine wasn't obliged to put up his fee and Connery returned the favour by being flexible with his schedule when production hit a snag. In turn Levine offered him a brand-new Rolls-Royce, which was courteously declined.

As if the importance of money in his life needed proving, Connery once bought a bank – well, almost. By the mid seventies he had acquired a number of company directorships, including Dunbar & Co, a merchant bank with impressive premises in Pall Mall. Connery revelled in this image of the shrewd businessman/actor. On the set of *The Man Who Would Be King* actor Saeed Jaffrey was surprised by this side to his character. 'One aspect of Sean I didn't know anything about was how good he was at finances. He used to get the financial papers from America to check what he should invest in.' In 1979 Connery resigned his directorship of Dunbar, though wisely retained a bulk of his shares. When the bank became part of a takeover deal in 1981, he reaped a handsome profit.

In 1973 Connery appointed a business manager, Kenneth Richards, a former army major and film-production accountant. It was Micheline who first sensed something was awry when she looked into the mundane matter of a missing washing-machine. Richards had been in charge of shipping Connery's furniture from his London home to Spain and informed Micheline he had given the washing machine to his son as a wedding present, seeing as it wouldn't function on the Continent. This explanation struck Micheline as rather odd and her feminine intuition took over. Confronting Richards soon after at his home in Switzerland she asked to see the books concerning her husband's income and investments but was told that none was kept.

Eventually it emerged that Richards had, for his own gain, invested over

$3 million of Connery's fortune in shady property deals in France. Micheline described the discovery as the worst moment of her life. Connery claimed he had never authorized such a loan and by the time legal proceedings were initiated to locate the lost funds Richards had made himself scarce. Worse still, Richards actually sued for moneys that he claimed Connery owed him – around £100,000 and a 2 per cent share in the earnings of thirteen movies, including four Bonds. Connery immediately filed a counter-suit alleging negligence in the handling of his financial affairs and breach of duty.

The two men finally confronted each other in open court in 1981. During the hearing Richards promised to 'throw the kitchen sink' at his former employer, alleging that Connery would go to prison if 'certain matters' were revealed to the Inland Revenue. Ultimately it was Richards who caved in under cross-examination and was ordered to pay costs and damages. Connery, comforted by Micheline, was close to tears as he left the High Court in London. 'I'm absolutely delighted,' he told a scrum of reporters. 'I'm thrilled that eventually justice has been done. It was certainly an ordeal I don't want to go through again.'

Seven years of litigation hell was finally over but Connery was left shaken and embittered by the experience. He raged at how easily his whole sense of security had been threatened and at how he had fatally misread a key associate. With the support of his wife 'and about 800 lawyers' Connery found some kind of retribution, but his final victory was fairly hollow and he grew resigned to never tracking down the missing money. 'I'd like to wring his neck,' said Connery. 'It's very nice to be awarded money on paper, but that man should pay in flesh.'

Today Connery oversees most aspects of his business deals personally and trusts no one completely. He has Micheline to thank for that. Always a dab hand at making money, he was never very good at keeping it. 'Not that he is stupid,' says Micheline, 'just too open and honest.' His problem was to have grown up in a world where a handshake was good enough – and forget the lawyers. He would naively enter into ventures thinking that everyone was like himself, principled and straight-dealing, and when he got stung it always amazed him. 'I've been screwed by more people than a hooker.' It took the pragmatic Micheline to open his eyes to the fact that the legion of yes-men he'd collected over the years were only after his money and that he shouldn't be so trusting. 'But Sean has learned now,' she said. 'No one is going to take from him again, that's for sure.' Now he sees lawyers, once so despised, as a necessary evil. 'I think it was Erica Jong,' mused Connery, 'who said that the difference between being rich and making a lot of money is having a good lawyer.'

A Little Litigation

'I think Paramount is the only film company I haven't sued. They all steal.'

Connery's well-publicized partiality for legal action began as far back as 1966 when *A Fine Madness* briefly overran its shooting schedule. Against all advice he sued Jack Warner for overtime payment. Warner was then head of the biggest studio in Hollywood and could easily have blackballed him; instead he paid up. For years Connery delighted in telling anyone who'd listen how he 'screwed' Jack Warner for $50,000.

In 1969 Connery sued the newspaper *France Soir* for suggesting he'd been forced out of the Bond role because of an expanding paunch. Connery testified that his waistline had gone up by just one inch since *Dr No*. The paper apologized and settled out of court.

In 1983 he sued Kenneth Passingham the author of an unofficial biography, because it contained a catalogue of inaccuracies, and won £1,000, which he donated to charity. Virtually all proceeds from cases won go to his charity trust; rarely is the motive money but the upholding of his rights. It's about not being walked over or taken for a ride. 'Nobody can screw Sean Connery,' Terence Young observed. 'I think it's almost a religion. He's been screwed and now he can afford the best lawyers to make sure he isn't ever screwed again.' Connery is a firm believer that law should be taught at school. 'It would cut out a lot of the charlatans who take advantage of poor people who don't understand.'

One of his most famous court actions involved good friend Michael Caine. The two stars were livid when they discovered that Allied Artists, the production company behind *The Man Who Would Be King*, were seriously short-changing them. Having agreed to star for $250,000, plus a 5 per cent profit share, the stars discovered that when the royalties started rolling in the figures looked decidedly lean.

In January 1978 Caine and Connery sued Allied Artists. Predictably the company issued a counter-claim, charging the stars of conspiring to damage their company through false statements. During the ensuing legal battle Connery went vocal in the press about corruption in Hollywood and the growing practice of creative book-keeping in relation to movie profits. The general tenor was uncompromising: 'I've never cheated or stolen from anybody in my life, and I would be quite happy to stick anyone who steals from me in jail.' Within days he was handed a writ from Allied Artists claiming $21 million damages for libel, plus a further $10 million in punitive damages from both actors. Now was the time for lesser mortals to beg for an amicable out-of-court settlement, but not Connery and Caine – despite the fact that if they had lost, both men would have faced financial ruin. Defiantly they pressed on, going further than anyone else in such a dispute. 'Film companies don't spend any sleepless nights,' Connery grumbled. 'It's just another assignment for their battery of lawyers. When you stand alone against those huge legal resources you realize how easily the law can strip you of everything, even when you're totally in the right.'

Friends said they were mad to continue. John Boorman pleaded with

Connery to quit. 'You could do two pictures in the time you're spending on this,' the director said, 'and make more money than you'd get if you won.' But there was no going back; it had become a matter of principle. 'You miss the point, lad,' Connery answered. 'Someone's got to stop them or we're just performing monkeys.'

It was Connery and Caine who won the case, when Allied Artists' suit against them was thrown out of court. Connery acclaimed it as an important victory, saying it proved to Hollywood that actors couldn't be bullied by big studios. It taught him another valuable lesson, too: sign on the dotted line only if the contract is written in easily digestible English. 'If I can't understand it, then something is wrong.' One scribe joked that Connery memorizes his contracts before his lines. But Connery, having conceded a salary cut in return for a piece of the profits, gave notice that he would bring in the auditors and fight court cases when movies proved hits in order to get what was rightfully his.

Today Connery carefully monitors all his movie profits, hiring accountants to review the books, even though the studios now treat him fairly and with respect. 'I think it's much healthier that they know I will go to the end if they inflict any injustice on me,' Connery told the *Daily Telegraph* in October 1996. 'And their having that knowledge stops them from considering the idea so much.'

Connery is aware that such talk makes him sometimes sound more like an accountant than an actor and that it alienates the public. Too often he comes across as paranoid that everyone in the business is out to stitch him up. It became a hobby-horse, particularly complaining about producers, of whom he's naturally suspicious. It's probably why he turned to producing his own movies (starting with *Medicine Man* in 1992), which ensures that he's in a position to check where all the money goes.

At least he's able to laugh about his image as a litigant. At an award ceremony, for example, he couldn't help but have a playful dig at the industry. 'There is always that dilemma crucial to the actor's craft, a problem even Stanislavski had no solution for. How long should one wait before suing the studios.'

Connery and the Press

'You can ask any question you want and I'll decide whether it's your business or not' – Connery, at a press conference.

A state of armed truce best describes Connery's relationship with the press. It is a tough attitude, formed in the early days of his fame. Certain journalists took a rather superior attitude to him when he landed the Bond job, asking questions like, 'Would you call yourself an old Etonian, Mr Connery?' or 'How did your training driving a milk truck prepare you for this picture?' It

is no wonder that Connery came to have so little respect for them.

During *Dr No* Sean didn't take kindly to the rigmarole of selling the picture – the interview treadmill, publicity stunts and so on – but he knuckled down and did it with good grace and humour. As the Bond phenomenon grew, however, the publicity machine began to stick in his throat and by 1964 he'd begun to adopt a stern, reclusive stance towards the media, and referred to press agents as 'manipulative parasites'. Every major newspaper and magazine on earth wanted to interview him, but Connery was fed up being pestered with the same unimaginative questions. 'So one had to say no, or one would have ended up more mentally deranged than one is already.' Plenty of articles purported to make Connery out to be just like Bond in real life, and journalists would ask questions relating to the character, not the man behind the image. 'I am an actor,' he'd rage. 'I'm doing a job of work.' This dislike for journalists grew to such a pitch that he became impatient and ill-tempered in their company. Chatting amicably to someone on the Bond set at Pinewood one day, Connery discovered the man was a reporter and immediately clammed up and walked off. 'Basically I'm a private person and the Bond producers wouldn't let me be that. I'd work six days a week, all day, then have to spend every free moment answering stupid questions like, "Do you like to beat people up?" '

Most of all he disliked talking about personal matters. He didn't see why he should explain himself to the public or allow journalists into his home to scrutinize how he lived. 'Why should I answer questions from a complete stranger?' he reasoned. His attitude drew accusations of arrogance, but Connery has always maintained that people who found him rude and aggressive usually provoked such a response – 'though I do admit that, like most Celts, I'm moody.' In a break from filming *Goldfinger* he was interviewed by a French reporter. She began by asking for the movie's title, then the names of his co-stars. Connery told her that the villain was being played by Gert Frobe. 'Well, I've never heard of her,' answered the woman. Connery exploded and stormed off. 'I suppose I'm considered very rude by that person,' he argued. 'Well, I consider her disrespectful and incompetent, and both are definite sins.'

During the making of *Thunderball*, the Bahamas location was the scene of an international media scrum. A vexed Connery granted just one interview, with *Playboy*. The press pack descended on director Terence Young, complaining that Connery now regarded himself as too important to meet them. 'People said, "Why is he being so unpleasant?" ' Young recalled for 007 fanzine *Bondage* in 1981. 'I said, he's not unpleasant, you were. You started it, after all. Sean's never changed, he's been like this all the time, and you're the people that provoked him. You tried to make a monkey out of him and now he doesn't need you.'

Connery reckons that once work is over on the film set his spare time should remain private and not be taken up with courting publicity. Filming *Cuba*, a torturous production in which everything that could go wrong did,

Connery turned away a party of British journalists who'd been promised an interview. 'Give me a break,' he told them while clambering into his Mercedes, 'I've done my bit.' He then drove home, leaving the producer to shrug his shoulders apologetically.

By the late eighties there was a definite thawing in Connery's relationship with the media. He started making himself available for television chat shows, something he'd rarely done before. In quick succession he was a guest on *The Last Resort*, playing mini golf with host Jonathon Ross, and on *Aspel and Co* with old mate Richard Harris. He was even prepared to send himself up on *The Dame Edna Everage Experience*. In America he guested on both the Johnny Carson and David Letterman shows. He also no longer minded people asking him questions about Bond, so long as it didn't dominate the interview. Most astonishing of all, he allowed a television documentary crew and then *Hello* magazine into the inner sanctum of his Marbella home – just the kind of crass publicity that would have been unthinkable a few years earlier. Despite all this Connery still harbours a healthy scepticism towards the press and grants very few interviews, only talking to the media on his terms. After a 1996 interview with the great man one journalist wrote: 'He was, if not exactly nervous, then very guarded: a man prepared to reply to questions politely and at length without necessarily answering them, not a man about to give anything away.'

Agents

In spring 1957 Connery acquired his first agent, the up-and-coming Richard Hatton; one of his clients was in *South Pacific* and introduced the two men. Hatton was distinctly unimpressed when Connery attended his interview shabbily dressed and minus a tie, but others urged him to take on the young actor. It was a union that lasted throughout the sixties, the years of Bond mega-fame.

When Hatton set his sights on movie production Connery asked Dennis Selinger, whom he'd known since the days of *South Pacific*, to represent him. Now a top agent, representing the likes of Peter Sellers and Michael Caine, Selinger took Connery to one side and proposed a new game plan, the same as he'd given Caine. Don't sit around waiting for offers, get out there and make as many movies as possible; some will stink, but one is sure to hit the bull's-eye. He also advised sticking with commercial projects – recent roles in *The Molly Maguires* and *The Offence* might have been creatively stimulating but they made little impact on the public.

Selinger successfully steered Connery to some mighty post-Bond successes, notably *The Man Who Would Be King*, but by the close of the seventies, the actor's career was in dire need of a life-support machine. Flop followed flop. 'At the time it wasn't that easy to sell me,' Connery said

candidly. 'They weren't breaking the door down for my services.' Parting company with Selinger, Connery decided it was time to be represented by someone in Hollywood.

After auditioning various agents, Connery was drawn to the then relatively unknown Michael Ovitz. He dreamed of creating an agency that comprised the best writers and directors, along with top-drawer acting talent. 'He foresaw the idea of packaging,' Connery said. 'Putting together creative and talented people was very much in his game plan. Nobody talked quite that way to me. They all talked about how good they had done in the past.'

In February 1979 Connery became the first genuine movie star to sign with Ovitz's new company CAA (Creative Artists Agency), a watershed event for both men. With Connery in his client stable Ovitz confidently set about snaring other top names, usually beginning his pitch by saying: 'Hi, my name is Michael Ovitz. I represent Sean Connery!' With his next big catch, Paul Newman, Ovitz was on his way to becoming one of the top power brokers in Hollywood, a position he still holds today.

'Believe me,' Terence Young said in 1992, 'Ovitz is the most important man in Sean's life.' The Bond director reckons that signing up with him was the best decision Connery ever made. After years in box-office wilderness, Connery saw Ovitz turn his career round, slowly but surely building him up into an international superstar again.

Charity Works

In 1970 Connery was the driving force behind the Scottish International Educational Trust (SIET), a charity which aids worthwhile cultural enterprises and backs talented individuals who lack private funds. It is his belief that people with talent should not be held back by social inequalities. Famously he donated his entire fee from *Diamonds Are Forever*, $1.2 million, to kickstart the scheme.

Installing himself as vice-chairman Connery collected successful Scottish trustees who had great personal pride in their country – such men as former racing-driver Jackie Stewart and his old art school colleague Richard DeMarco, now a respected art dealer in Edinburgh. Then there was the Scottish industrialist Sir Iain Stewart, with whom he'd struck up a friendship during the making of his documentary *The Bowler and the Bunnet*. Though heralding from different ends of the social spectrum, both men shared a deep love for golf. Tragically Stewart committed suicide in 1985.

The inspiration behind the idea was the dismay Connery felt at the unemployment and industrial waste he saw all around him on his visits to Scotland. He wanted to do all he could to change it, and by doing so help stem the flow of Scots leaving in search of better opportunities abroad, as he himself had had to do. 'Everywhere I go in the world I keep bumping into

Scotsmen. It seems to me all wrong that so much talent should be leaving the country. Scotland's greatest export isn't our whisky. It's the Scots.' The trust was his way of giving something back to his homeland and offering young people the headstart he never had. His critics, inevitably, didn't see it that way: this was either some elaborate tax dodge or a huge ego trip. 'Publicity!' mocked Connery. 'If they only knew how much time I use dodging it.' Later, when he moved to Spain, similar voices argued how hypocritical it was to encourage others to stay in Scotland while living in exile himself.

Though rarely attending any of the trust meetings Connery has been tireless in raising funds over the years, be it holding Pro-Am golf tournaments or organizing charity premieres of movies. *A Bridge Too Far* opened in Minneapolis with proceeds going to the trust, as did the European premier of *Outland* in Edinburgh. The trust's inaugural charity premiere in October 1971 came close to being a total disaster, however. Connery planned to fly his motley crew of showbiz chums – Stanley Baker, Jimmy Tarbuck, Ronnie Corbett – to Glasgow to see *The Anderson Tapes*. But the party's journey was hampered by a bomb scare and death threats, and their flight from Gatwick was delayed an hour while security checks were made. 'The whole thing is ridiculous,' growled Connery, 'because I am neither political nor religious.'

All monies raised by the trust are used to promote young Scottish talent, whether artistic, academic or sporting. The trust also supports projects that contribute to the cultural, economic or environmental development of Scotland. For example, it established a drama chair at Strathclyde University, while Connery personally recommended a grant be given to a provincial theatre company. The National Youth Orchestra of Scotland, Scottish Opera, various national sports bodies and cancer projects – all have benefited from the trust's benevolence.

Besides SIET Connery has involved himself in other charity work, once flying in from Marbella to take part in a celebrity tennis tournament at the Royal Albert Hall in aid of muscular dystrophy. He had recently become a keen player and featured among pros like John MacEnroe and Jimmy Connors, and stars like Andy Williams and Bruce Forsyth. Arriving on court wearing a bright tartan tam-o'shanter and carrying golf clubs Connery, the showman, elicited cheers and applause from the capacity crowd. He'd risen wonderfully to the spirit of the occasion.

In 1988 Connery came to the rescue of the National Youth Theatre with a gift of £50,000. He'd read in the *Sunday Times* that its future was in doubt after the Arts Council had refused them more cash. Though he had no prior connection with the theatre Connery was only too aware of its significance: Helen Mirren, Ben Kingsley and a certain Timothy Dalton had all risen through its ranks. 'British actors and actresses, writers and directors are among the best in the world,' he said. 'We come second to no one. The NYT is one source of talent, a source that everyone should be proud of. It shouldn't have to go cap in hand for money.' Connery's generosity was

rewarded with a seat on the committee, alongside John Gielgud and Bryan Forbes.

Connery as Director

Unlike a number of his peers, such as Clint Eastwood, Warren Beatty, Robert Redford and Mel Gibson, Connery has yet to turn his hand to film directing. However, it remains a professional ambition. Over the years he's looked at plenty of material, and for a while he worked on a seafaring project developed by Warner Brothers for him to direct. In the end, though, nothing materialized, and that's been the problem – nothing has grabbed him enough to want to take such a creative gamble. 'I would need a good producer, perhaps Michael Caine. I think he only wants to be a producer because when it rains, the producer is the one who goes back to the hotel, and the rest of the cast and crew have to stay in the wet.'

'I think he'd make a damn good director,' was Terry Gilliam's verdict after working with Connery on *Time Bandits*. He was impressed with the star's organizational abilities and his advice on how to make the best use of his limited time on set. In the lead role was a young boy who had never made a movie before; again it was Connery who suggested Gilliam rattle off his few scenes first so that the lion's share of time could be devoted to the child.

Often on the film set it is Connery who takes responsibility for keeping cast and crew in good spirits; as the 'above the title' star he feels it's his duty to make everyone click in order to get the best out of them. It's one of the reasons he prefers filming on location as opposed to studio work – 'because on location you get a sense of camaraderie'. In a BBC interview Connery laid down his working philosophy: 'I adore enthusiasm, in everything; there is nothing better than working with people that are professional, responsible, enthusiastic. There is nothing worse than dealing with people who are incompetent, not interested in what they're doing. It's boring, depleting, suicidal for me.' Though his powerful presence can make everyone around him feel nervous, this can be positive too. 'There's nothing wrong with a little anxiety to keep people on their toes.'

Whereas some stars come in, say their lines and take the money, Connery is constantly discussing changes to improve his character and the film. A contractual precondition that's been in place since the seventies is that he has a right to script revisions. He has an almost intuitive talent for script doctoring. Eric Sykes recalled watching him one afternoon on the set of *Shalako*, tearing out pages from the script until a small pile appeared under his chair. After asking why he was doing it, Sykes was told, 'Because it's unnecessary crap.' Connery was, in essence, editing his own part without consulting director Edward Dymtryk. Sykes was flabbergasted. In the end Dymtryk never challenged Connery about it, because he knew the changes had

improved the story. 'There are a lot of writers who don't have the plot sense that Sean has,' says Arne Glimcher, who directed *Just Cause*. 'He was able to take a script we'd been having problems with and bring a greater subtlety to it.' Most directors would find such intrusion cumbersome, but the difference with Connery is that he's worth listening to. On *Five Days One Summer* Fred Zinneman recalled that Sean had thoughts and concepts 95 per cent of which were 'worthy of assimilation'.

The ambition to direct or to become more involved behind the scenes recently manifested itself in Connery's taking up the role of executive producer on his movies, a combination of his artistry and fascination with finance. It started with the realization in 1989 that he'd effectively been working in the executive producer capacity without recognition or payment for probably the last twenty years. He had always been involved in the nitty-gritty side of film-making, but from his next picture, which turned out to be *Medicine Man*, he wanted to assume a much stronger position – in other words, he wanted the job officially.

In recent years Connery has also made noises about seeking an active role to help the British film industry. In the early eighties he came up with the inspired idea of forming a consortium of top British actors, writers and directors with the clout to take over a top studio like Pinewood. The plan was to get finance from the City and make commercial home-grown movies whose profits would stay in the country and not be absorbed by Hollywood, but the scheme never took off. One of Connery's pet topics is arguing for tax breaks and government finance for British films. He regards as 'disgraceful' the pittance with which the movie business is subsidized, compared to the sums dished out to 'high culture' art forms like opera and ballet. He discussed it with Margaret Thatcher when she was in power, 'and she gave me a look as if I was asking for a job'. Later he raised the issue with Tony Blair at Chequers, with the heavyweight backing of Steven Spielberg. In 1996 Connery got into hot water when he claimed (rightly) that politicians 'don't know the film industry from a hole in the ground,' and had consistently failed to fund or develop home-grown talent. His words led to a rebuke from the then National Heritage secretary Virginia Bottomley, who said, 'Mr Connery would do well to talk the industry up rather than running it down.'

Despite his passionate words and deeds Connery remains pessimistic. For years he has listened to wonderful plans for reforming the British film industry, but he can't see the fat-cat producers ever forgoing their posh suites at luxury hotels, company limousines and extravagant luncheons: '*That's* where the money goes.'

As for his own movies Connery has a personal satisfaction code which is not correlated with success at the box office: an A and B stage. The A stage: he reads a script, likes it and the movie is made to the best possible standard. The B stage: the film is given over to the public, who either turn it into a hit

or make it a flop. 'A film when it is finished is like a young bird leaving the
nest. Once out, it's up to the bird to fly around or to fall on its arse. But if
you believed in it in the first place then it doesn't matter.' Just as well, for
Connery's own back yard is littered with fallen fowl.

Connery: Theatrical Impresario

Connery's various returns to the stage over the years have not been as an
actor but as a theatrical impresario. In 1966 he expressed an interest in direct-
ing Ted Allan Herman's play *The Secret of the World* on Broadway, with
Shelley Winters in the lead. In New York filming *A Fine Madness* at the time,
he'd begun to flirt with the trendy Greenwich Village art scene, seeing plays
and making friends with movers and shakers in the theatre. A meeting with
theatre guru Sir Tyrone Guthrie might have been the biggest influence on the
decision to try his hand at directing, or maybe it was because he'd recently
passed the age of thirty-five. 'I promised myself from now on, and for the
next 35 years, I would do only the things that excited me. That's why I want
to direct my first play in New York.' People said he was crazy: in the last
season thirty-eight out of forty-four new Broadway shows had flopped, so
it was hardly the time for a greenhorn Brit to try his luck. Yet Connery
remained as keen as mustard, though nothing ever materialized.

In January 1967 Connery made his début as a theatrical manager, co-
presenting a production of Ben Jonson's comedy *Volpone* at London's
Garrick Theatre. The play starred Leo McKern and Leonard Rossiter. His
foray into theatre production proved short-lived, however, until its spectac-
ular resurrection three decades later.

When Diane Cilento was cast in Ted Allan Herman's new play *I've Seen
You Cut Lemons* it was her suggestion that Connery be engaged as director.
Robert Hardy, with whom Connery hadn't worked since the BBC's *An Age
of Kings* in 1960, was hired to play opposite Cilento. Rehearsals began in a
church hall close to the Connerys' Putney home. Hardy moved in at the
couple's request. Evenings were spent discussing the metaphysical implica-
tions of the play. What mystified Hardy even more was a 'think tank' that
the Connerys kept upstairs in their study and that both inhabited each morn-
ing. It helped to concentrate his energies, Sean claimed, protecting him from
the distractions of the outside world. Hardy's one and only venture inside
the bizarre contraption left him none the wiser.

I've Seen You Cut Lemons opened in November 1969 in Oxford, and a small
provincial tour to Newcastle and Manchester followed before its West End
début at the Fortune Theatre in December. The play's overblown material – an
intense duel between a brother and his mentally unbalanced sister that spirals
towards incest – drew mostly drab notices. One critic described the play as 'an
emotional dustbin', while *Plays and Players* pondered, 'Goodness knows why

Sean Connery chose this psycho melodrama as his directorial debut. He kept it going with a quiet desperation, but judgement had best be reserved until he shows his colours in a better vehicle.' Critical contempt, allied to poor audiences, precipitated the show's closure after just five days.

Hardy never regretted his involvement in the production, however, having come away from the experience impressed with Connery's directorial talents and the good grace with which he took its failure. Still, it was a sad end to a decade in which Connery had emerged as one of the world's top stars.

He might never have returned to the theatre again if it hadn't been for his wife's enthusiasm for a play about a trio of middle-aged friends called *Art*. Micheline caught the play, written by Yasmina Reza, during its original run in Paris and raved about it to her husband. A shareholder in a company owned by producer David Pugh, Connery brought the play to his attention and together they approached Christopher Hampton to write an English translation. Although his job in Pugh's company amounted to little more than public relations, Connery felt confident enough to plough $65,000 of his own cash into the play. It was a gamble that paid off handsomely. In October 1996, when *Art* opened in the West End, with Albert Finney and Tom Courtney as original cast members, it met with immediate critical and commercial success. Connery revelled in the praise. '*Art* is one of the most brilliantly funny new plays I've ever seen,' its director Matthew Warchus told the *Daily Telegraph*. 'That Connery should have recognised this immediately bodes very well for his taste.'

In his guise as producer of *Art* Connery attended that year's *Evening Standard* drama awards at the Savoy hotel. There he fell victim to a barrage of abuse from young hotshot playwright Martin McDonagh. Obviously well tanked-up, McDonagh's audible rubbishing of the event and its pretensions soon got up the nose of Connery, seated nearby. 'Shut up, sonny, and mind your language,' he snapped, poking the writer in the ribs. McDonagh retaliated with a string of four-letter words. Afterwards he refused to apologize, and boasted that while Connery had only ever made one good film he intended to produce 'seven brilliant plays and at least 20 good films'. Time will tell.

Inevitably there was talk of transferring *Art* to Broadway – 'it's very much a New York piece,' said Connery – and employing a dream American cast rumoured to comprise Robert De Niro, Al Pacino and Kevin Spacey. It may even yet be turned into a film. We hold our breath.

Awards and Honours

1960s

In 1963 Connery was nominated for election to Rector of St Andrews University, along with Dr Julius Nyerere (premier of Tanzania) and actor Peter Ustinov. 'He took it really seriously,' Lois Maxwell told the *Mail on*

Sunday in August 1986. 'He kept saying, "I'm not 007, I'm Sean Connery."
He didn't get it and really resented that. Sean is a deep, dour man.'

In March 1964 Connery received a special award from the Variety Club
of Great Britain for his vivid creation of the role of James Bond.

1980s

In 1981 Heriot-Watt University bestowed on Connery an honorary Doctor
of Letters degree, 'in recognition of the contribution he has made to public
entertainment worldwide and to young enterprises in Scotland'. Connery
arrived at the ceremony, held at the Assembly Hall in Edinburgh, with only
minutes to spare. Touching down late, he was bundled into a police car on
the airport's tarmac and raced through the city with motorcycle outriders
and sirens blaring.

It was an honour Connery set great store by. Having received no proper
state education Connery felt it represented a vindication of his accomplish-
ments as an artist and the intellect he brought to bear upon his craft.

Connery was 1984's Harvard Man of the Year, the first British celebrity to
be so honoured. Over the years recipients have included Robert De Niro,
Warren Beatty and Tom Cruise. Posters advertising the ceremony were plas-
tered across Boston, and the fact that Connery was attending in person
guaranteed a minor press invasion.

Bounding on to the stage to thunderous applause and an out-of-tune
rendition of the James Bond theme, Connery was clearly here to have a good
time and accepted his prizes with good humour. They included a handy
Roger Moore dartboard and a Wonder Woman wig, which Sean insisted on
wearing for the remainder of the celebrations. During the speeches two male
students in drag pecked him on each cheek, but it was Connery who enjoyed
the last laugh, grabbing each firmly on the backside as they left. 'Thank you
very much,' Connery told the packed hall. 'It's the first time I've come to
Boston, and I'm thrilled to be going back with hair.'

Later that year Connery was made a Fellow of the Royal Scottish
Academy of Music and Drama in Glasgow, in recognition of his 'contribu-
tion to the furtherance of education' through his charity trust.

Further honours came in 1988 when St Andrews University awarded him
an honorary doctorate, while overseas he received the Commandeur des Arts
et des Lettres, the highest accolade that can be bestowed on an artist by the
French government. Three years later France saluted him again, this time
with the Légion d'Honneur.

At the 1989 Cannes Film Festival Connery was due to be guest of honour
at a gala dinner, during which he was to collect an award for his outstanding
contribution to the British Film Industry. Forced to cancel at the last minute
– his presence was required on *The Hunt for Red October* set – Connery left
numerous film dignitaries with egg on their irate faces. Roger Moore was

asked whether he would deputize for his friend. 'I've subbed for Sean in seven Bond pictures. Surely that's enough.'

1990s

This was the decade in which Connery was to receive perhaps more lifetime achievement awards than any actor in history. His mantelpiece back home in Marbella was soon groaning under the sheer weight of them all.

In the early 1990s the National Association of Theatre Owners in America created a new prize category – Worldwide Star of the Year – and named Connery as its first winner. While in Rome he was personally accorded the Man of Culture award by the president of Italy.

The evening of 7 October 1990 was one of the proudest of Connery's life. At a ceremony held in the Odeon Leicester Square in front of fans and colleagues he received the British Academy of Film and Television Arts Tribute Award – given to the British actor who has made an outstanding contribution to world cinema. Stars such as Ursula Andress, Kevin Costner, Roger Moore and Michael Caine trotted out on stage to pay homage to their friend. Yet it was Connery's own son Jason who made one of the night's most memorable speeches. 'I'm often asked, do I think my father is a good actor and in all honesty I have to answer – no. I think my father is a great actor. And as for being voted the sexiest man in the world aged sixty – I just hope it runs in the family.'

By far the most striking praise came from Sir Richard Attenborough.

> You're the most professional actor I've ever worked with in my life and it is on behalf of those who are not here this evening that I wish to salute you – the technicians, the plasterers and the sparks and the props. You are king in their eyes, Sean, you are the best. You are as fine a screen actor as this country has ever produced and you now stand as one of the finest in the world.

Striding forward to collect the award, presented by Princess Anne, Connery was visibly overcome by the occasion and struggled to put his feelings into words. What came out was tinged with regret. 'There is one lesson in it all,' he said nervously. 'I've had a thirty-year filmic odyssey and met some marvellous people. But what became apparent watching this evening was I had not seen them as much as I should have.' It was an apology of a kind: he now saw how his driving career ambitions had been largely to the detriment of friendships back home.

Caine marked that BAFTA award ceremony as a watershed in Connery's life; it showed him just what he'd missed by shutting himself away in Marbella. 'A place where he doesn't even speak the language. I think he has suffered. He had been quite isolated in Marbella and he thought nobody cared. When the BAFTA award came, there were all these people who had

come just to honour him. He suddenly realized that all these people really did care about him.' After the bash Connery took his old pal to one side and confessed. 'I don't know why I've locked myself away. It's so much fun with everybody here.'

In July 1992 Connery was honoured by the American Cinemateque at their seventh Moving Picture Ball at the Beverly Hills Hilton. His 'significant contribution to contemporary film' award was presented to him by Audrey Hepburn, six months prior to her death. According to the organization's director Connery was the unanimous choice of the board to be the seventh recipient: 'He is one of the world's most acclaimed and provocative actors.'

In 1994 Connery received a Lifetime Achievement award from the National Board of Review. Joseph Wiseman, his old nemesis from *Dr No*, was one of many colleagues to pay rich tribute. The two men hadn't seen each other since filming that Bond classic in 1962.

Another lifetime achievement honour came Connery's way in January 1996 – this time the coveted Cecil B. DeMille Award, whose past winners had included Clint Eastwood and Laurence Olivier. 'His range is so wide,' said the president of the Hollywood Foreign Press Association. 'He crosses over the ages, both the young and old love him. He crosses the national boundaries. He is loved all over the world.'

Collecting his award at that year's Golden Globes ceremony, Connery was in philosophical mood. 'I've made a lot of films, some of which I've forgotten and some I would like to forget. I've travelled to scores of exotic places, met many interesting people, kissed dozens of beautiful women and actually been very well paid for it. I'm very grateful.'

In May 1997 Connery was honoured by the prestigious Film Society of Lincoln Center at their annual gala in New York. 'Connery is one of the great film stars of any age,' Roy L. Furman, the society's chairman, told *Variety*. 'His commanding presence, sophisticated manner and unflappable humour place him in a class by himself. His enduring popularity harks back to the days of the Hollywood studio star system. In fact, he may well be the last and best of that breed.' Film companies took out advertisements in trade papers to congratulate Connery on this latest accolade. The best came from Warner Brothers. 'Sean, congratulations on being honoured for your incredible body ... of work!'

The ceremony began with two bagpipers marching down the aisles to the stage, followed by assorted film clips and a special Bond montage introduced by singer Diana Ross, herself a fan since the sixties. She described Connery as 'sexy, self-assured, dangerous. I always pictured myself in the arms of 007.' There were live tributes from Ursula Andress, Tippi Hedren, Sidney Lumet and Harrison Ford, plus video greetings from Michael Caine, Steven Spielberg and Nicolas Cage. It was a wonderful evening and by its close Connery was visibly moved. 'There's one constant,' he said. 'It's you, the

audience. If I do my job right, you won't ask for your money back. If you do, I'll just have to go back and sell milk. On behalf of my wife and myself, I thank you, America.'

In April 1998, just a couple of months after being snubbed for a knight-hood Connery was able to take pride in becoming only the seventh actor to receive the British film industry's highest honour – the BAFTA Fellowship. He was following in the illustrious footsteps of screen legends like Charles Chaplin and Alec Guinness. 'When I saw the list of names of the people who have received this great honour, to say that I was impressed is the under-statement of the year.' The show was presented during BAFTA's televised awards ceremony, and Connery was forced to endure much good-natured ribbing from compatriot Billy Connolly, who mentioned how his friend strode like a colossus over Scotland – 'from the Bahamas'. Even Princess Anne, presenting the award, got in on the act. 'She said you didn't see many Scotsmen in kilts with brown legs,' Connery revealed afterwards.

The next month another illustrious accolade was given to Connery – a place at Madame Tussaud's. Remarkably this was the first time a model of him had featured in the famous collection of wax celebrities. Connery was too busy to come in and pose in person, so the museum's craftsmen assem-bled the figure using photographs. The final result, dressed in black slacks, black polo-neck jumper, a dog's-tooth check jacket and holding a tumbler of whiskey in his hand, captures the actor at his rugged best.

In April 1999 Connery's hand and footprints were set in concrete outside the Mann's Chinese Theatre in Hollywood. Watched by thousands of fans, Connery was aided by his wife Micheline and *Entrapment* co-star Catherine Zeta Jones. Only a select number of stars have been asked over the years to make their marks at Mann's. Many more are part of the Hollywood Walk of Fame in the street alongside the cinema. Connery's prints lay immortalized alongside legends like Humphrey Bogart, John Wayne and Bette Davis.

Of all the awards won by Connery, none means as much to him as the Freedom of Edinburgh. He was staggered when news reached him of the intended award, the highest his home town can bestow, and even more nonplussed on reading the illustrious names of past recipients – Sir Walter Scott, Benjamin Disraeli, Lloyd George, Alexander Graham Bell, Charles Dickens, William Gladstone, David Livingstone and Winston Churchill. For the previous two decades the honour had remained unclaimed and there were only five living recipients, including the Queen. 'I think I'm the first from Fountainbridge,' Connery claimed proudly.

The Freedom of Edinburgh was given in celebration of his career and in recognition of charity work. Of course, there were dissenting voices – a few spoilsport councillors who objected to the choice of someone who'd aban-doned his native land for sunnier climes. But the public backed the decision: 90 per cent of callers to a local phone-in were in favour of it.

The ceremony was held on 11 June 1991 at Edinburgh's Usher Hall.

During the day Connery was enthusiastically received across the city, even finding time to visit his old school to engage in a question and answer session with pupils. He also made a point of inviting former neighbours to the ceremony, as well as old school mates, work colleagues and the few remaining elderly folk who'd known his parents. It was a touching gesture. Outside the hall the large crowd that turned out just to cheer his arrival was both heartwarming and unexpected. 'It was really so moving,' commented Micheline. Connery was happy to mingle among them, shaking hands, giving autographs and indulging in idle banter with the odd face from the past. It must have made him stop to think just how far he'd come.

Inside the packed auditorium, organizers revealed how they could have filled the place five times over. The Lord Provost spoke of a man who had walked with kings and millionaires, 'but at all times he is still that boy from Edinburgh'. The evening's compere, actor Tom Conti, said: 'There are good actors who will never be stars. There are some stars who will never be actors. There are very, very few who, like Sean Connery, are both.'

When the time came for his stage entrance the welcome was thunderous. 'Words fail me,' he began his speech, eyes welling up with tears. If only Effie, his mother, could have been there. Then a lone voice from the dark boomed, 'Welcome home, Big Tam.' A broad smile lit up Connery's face as he continued. 'When I was first informed about the possibility of receiving the Freedom of Edinburgh, I knew that I would not be able to express my full thanks adequately in words. I can tell you how I feel. I feel like I've gone fifteen rounds with Mike Tyson – but I won.'

As he left to a standing ovation a jazz band suddenly struck up with a ragtime tune. Ever the showman, Connery turned and danced a wee jig on the stage before finally leaving, both arms raised in appreciation of an adoring public.

Of all the fine words uttered during that memorable day none quite matched those by Sean's old school friend Craigie Veitch. 'Men who make it big often have their name linked to a region. Lawrence of Arabia. Scott of the Antarctic. Clive of India. Tonight, we have Connery of Edinburgh.'

Oscar

It was a long time coming, but in 1988 Connery finally won an Oscar for his performance as a grizzled Chicago beat cop in *The Untouchables*. He was up against stiff opposition in the Best Supporting Actor category – Denzel Washington (*Cry Freedom*), Vincent Gardenia (*Moonstruck*), Morgan Freeman (*Street Smart*) and Albert Brooks (*Broadcast News*). Collecting his Oscar from Cher, Connery joked, 'I first appeared here thirty years ago. Patience truly is a virtue. In winning this award it creates a certain dilemma because I had decided that I would give it to my wife, who deserves it. But I

discovered backstage that they're worth $15,000. Now I'm not so sure.'

Always the bookie's favourite to win, Connery got a hint of what was to come when he drew a long standing ovation earlier in the evening when he presented the Oscar for the Best Visual Effects. But irony hung heavy in the air. What was one of cinema's great leading men doing winning the Best Supporting Actor Oscar? Where had the Academy voters been when Connery played Joe Roberts or Daniel Dravot?

In modest mood at the after-show press conference Connery told reporters that he considered the award to be a recognition for past achievements rather than this one single performance. He felt he'd been overlooked in the past because he had never been an Academy member and was too far removed from the political games of Hollywood – 'And I don't suppose all the lawsuits helped.' Asked which of his previous performances he thought had deserved to win him an Oscar, Connery replied without hesitation: 'Danny, in *The Man Who Would Be King*.'

Michael Caine saw Connery's winning the Oscar as a major turning-point in his life. The Bond tag was now truly banished, and he had been accepted by the industry as a great actor. The tumultuous reception he received that night brought home to Connery the warmth and affection in which he was held by his peers. 'That was a great moment for him,' said Caine. 'You'd never get him to say it, but I'll bet you it was one of the greatest things to happen to him. It shook him to the core. When he came on to get his Oscar, he got a standing ovation from the cream of Hollywood. And this for winning just Supporting Actor. I'll bet you nobody's ever done that.'

A decade later Connery returned to the Oscars, entering the stage to the strains of the James Bond theme, to present *Titanic* with the Best Film award.

Arise, Sir Sean

Few Honours Lists have proved as controversial as 1998's – not because of who had been included, but because of a glaring omission. Sean Connery.

It was the *Mail on Sunday* which first broke the news that the Labour government had intervened to stop Connery receiving a much deserved knighthood. Their opposition was based largely on his support for the Scottish National Party, Labour's main political foe on the thorny issue of devolution. Making Connery a Sir, they feared, would only turn him into an even more potent figurehead and vote-catcher for the SNP. So forty years of sterling service for the British film industry counted for nothing.

Public and political reaction to the snub was swift. Questions were raised in Parliament, and it became a topic for debate in pubs, newspapers and on television. The Conservatives, who had first considered Connery for an honour in the early nineties, denounced the move as 'shameful and hypocritical'. Passed over as a possible Commander of the Order of the British

Empire, Connery was in 1997 put forward again, this time as a knight. The recommendation passed from the National Heritage Department to the Scottish Office, which approved it, paving the way for Connery to be knighted in the 1998 Honours.

When Labour swept into power the whole process had to be repeated. The Heritage Department gave him the thumbs-up, but the new Scottish Secretary, Donald Dewar MP, sought to veto the idea. It was obvious for all to see that the decision was, in Connery's words, 'purely political'. Indeed when criticism began to mount Labour's spin doctors swooped into action, organizing a spiteful smear campaign against the actor. They claimed that the real reason for blocking his knighthood was his status as a tax exile (though this hasn't stopped other Britons living overseas receiving Honours) and that he approved of wife beating. Hoary old quotes from decades ago about slapping women were dusted down and paraded again as if brand new. It was all a very distasteful way for a modern and supposedly civilized government to behave.

Connery wasn't stupid – he recognized a character assassination when he saw one. On first hearing the news that the Labour hierarchy had ostensibly banned him from becoming a knight he spoke of being 'deeply disappointed but strangely not angry or greatly surprised'. And though he spoke of his remorse over past 'stupid' remarks about violence towards women, he showed contempt for the way it had been dragged in to cloud the issue.

When one thinks of some of the people that governments have decreed worthy of knighthoods or OBEs, Connery's continued absence from the Honours List has raised a good many eyebrows. Repeatedly he's asked why his country has never deigned to honour him, as, say, France has. 'I've never been able to answer them, but I knew there must be some hidden reason which has now been revealed.' Connery admitted it would have been a great privilege to kneel before the Queen to receive his knighthood – 'Even now I would accept such an honour.' His sole consolation from the whole sordid ordeal was that by their action Labour had probably pushed political fence-sitters into voting Nationalist.

As for Dr Dewar, as one paper put it, instead of being remembered as the man who gave Scotland back her Parliament, he would now forever be the man who wouldn't knight her hero. During the weeks of the Connery scandal, Dewar's nickname among Civil Service mandarins was, appropriately, Dr No.

9 Personal

Personality

'Sean Connery is the only superstar who never let success go to his head.'
Richard Harris

In an industry which thrives on artificiality Connery has refused to be anything other than what he is; perhaps his greatest achievement is that he hasn't allowed fame to change him. 'It's amazing,' says Sidney Lumet. 'He's close to being a legend, but there's been no change in him. He's the most level-headed person I know. He knows it's all crap. He enjoys life.' There's no phoniness about him, no conceit or personal vanity. 'Sean never was one who had time for the accoutrements of ego. In that sense he was always an actor's actor,' says Michael Caine. Certainly Connery must rank as the most un-star-like star Hollywood's ever known. 'I think Sean is the person who's been least changed by success,' according to Terence Young. 'And when you consider the magnitude of his success it's even more remarkable.'

'Stars can get so submerged by success,' he once said, 'they can't lift a tissue to wipe their nose without someone there to help.' On location for *A Bridge Too Far* Connery astonished everyone by standing in line with the rest of the crew outside the canteen truck. In New York a friend went with him to see John Schlesinger's *Darling* and was amazed when, instead of demanding the best seats from the manager, he gladly joined the end of the queue. In the end he was recognized at the ticket office and let in for free anyway.

Nor is Connery the sort of star to call his agent in a fit of pique because he's unhappy with his dressing-room. 'Sean would just go up to the producer,' mused friend and agent Joy Jameson, 'and say something like: "I'm not going in that shit hole, thank you very much. You get that changed by this afternoon otherwise I'm not coming back." ' If Connery feels something is wrong he'll come right out and say so; if other people don't like it, well, that's their problem. It's a habit that's actually quite refreshing for film crews used to a lot of 'double talk' from fellow professionals. In his early days, though, Connery's straight talking was seen as a handicap. 'We all thought this Connery guy a bit too forthright for his own good,' recalled Disney press agent Bill King, who worked on *Darby O'Gill and the Little People*. 'Too candid. Too honest.' King thought him an odd mixture of diligence, dedication and rebellion.

209

Everything is black and white in Sean's world; there are no grey areas. What you see is what you get. 'He's a very natural, basic man,' Diana Dors, who knew him well during the sixties, once said. 'Sometimes he can be quite blunt and even hurtful in the things he says, but you do know where you stand with him. He is no hypocrite.' Wherever possible, Connery treats people the way he'd wish to be treated himself – honestly, openly and simply. 'But if someone treats me rudely or dishonestly, I repay them an eye for an eye.'

In spite of all he's achieved Connery retains an endearing shyness, something that goes against his macho image. But it is an image Connery maintains was built up by others; he doesn't view himself that way at all. 'People treat him as if he has no sensitivity because of the way he looks,' revealed Michael Caine. 'But there's an extraordinary sensitive man behind that, more sensitive than you could ever imagine.' By nature he is low-key, polite, soft-spoken (a surprisingly nervous public speaker). A gentle man who articulates his thoughts slowly and clearly, he is someone so sure of his own masculinity that he has the confidence to expose what John Boorman calls his 'poetic, feminine side'. Boarding a plane once, Connery was approached by a woman sighing, 'Oh, you're so masculine.' He laughed back: 'But I'm very feminine.' His more gentle side is perhaps best demonstrated by his love of poetry, particularly Dylan Thomas and Seamus Heaney. Often in moments of isolation he writes his own poems, which he never allows anyone to read, nor plans to have published. He started writing poetry in the early days of his acting career, on tour with *South Pacific*. They were mostly just ideas, images and personal feelings and were usually written late at night. 'In the light of day they seemed a bit alarming. I destroyed quite a lot of it. Very few people have read what's left.'

The one thing that crops up most when colleagues talk of Connery is the sheer professionalism of the man. Even by the time of the early Bonds he'd garnered a reputation as a stickler for efficiency – arriving on time, being well prepared and always expecting the same level of dedication from fellow workers. 'He's as professional an actor as I've ever met,' confirmed Richard Lester. Famously Connery doesn't suffer fools gladly, especially on a film set, where he likes things to be as organized as possible. He is wont to lose his temper if things are not done properly. Once he donned a space suit for *Outland* and suspended himself from a harness only for the camera to fail to roll on cue. Connery was not amused, angrily shouting at those responsible: 'Get everything set to shoot before you put that harness round my balls again!' While he's prepared to bawl at people sloppy in their work, he's forgiving if mistakes are the outcome of genuine enthusiasm – 'which is the most important quality of all in my book'. What he can't abide is plain inefficiency or negativity, people unprepared to take risks. 'I think I'm only difficult with real idiots.'

Connery is a man perfectly at ease with himself. 'I like to eat with my fingers,' he informed Michael Crichton one evening at dinner in a fancy restaurant. He proceeded to do so, not giving a damn what other people

thought. When a few diners came over for autographs he glowered at them and said: 'I'm eating. Come back later.' When they returned he politely signed their menus. He is also a loyal friend to those few lucky enough to gain his trust. With Sean it all comes down to trust. Once a friend you tend to be a friend for life, though opportunities to gather and meet have sometimes taken second place to his work commitments. 'I'd like to think that there are a few of us who have stayed ordinary,' says Millicent Martin. 'Sean and Michael Caine are both like that. You can meet them again after fifteen years and there are no walls between you.'

Once asked to list his virtues Connery mentioned his sense of morality and truth, and an awareness of the value of money. He is also a firm believer in discipline, though he admits that when Jason was growing up he might have seemed a bit harsh and Victorian at times. 'But it worked. I'm autocratic rather than democratic.' As for faults he counted his temper and egotism, though this trait afflicts most actors. A less-talked-about hang-up relates to footwear. 'He always kicks off his shoes when he comes home,' Diane Cilento once said. 'He remains barefooted for the rest of the evening. He doesn't like shoes. He may spend the whole weekend around the house without putting on his shoes once.' Actor Saeed Jaffrey once told me an amusing story. During the shooting of *The Man Who Would Be King* he overheard Micheline mutter. 'When I met Sean Connery I was told he was James Bond, that he was very tall and in his movies very strong. But he has got sensitive feet, he is always complaining about his shoes being too tight. His feet are not James Bond's, his feet are Sean's.'

Connery likes to cook, though it is a 'skill' few others seem to appreciate. 'There are some things in the house that Sean thinks he can do,' Micheline revealed, 'but he obviously can't. He thinks, for example, that he can cook. Every time he goes into the kitchen, he just has to be gently led out of it!'

Most odd of all is that in spite of his huge wealth Connery doesn't set much store by personal possessions, and never has. For example, he doesn't keep any mementoes from his movies – 'not a single photo'. Novelist Jackie Collins once asked him where the scripts to his old movies had gone. 'I told her I didn't know where they were. I've never kept a script in my life. It never occurred to me to keep them.' It's Micheline who is the home-maker, who collects the souvenirs of their shared life. When they first met she couldn't understand why he'd never kept anything himself. 'Which is still true,' he said in 1996. 'I don't even have a birth certificate.'

Anger

'When he's angry you can see death in his eyes. Only the law holds him back.'
 Thomas Schuhly
One evening Connery and Michael Winner had planned to meet for dinner at a fancy New York eatery. Minus a jacket Connery would never be allowed

in, so Winner offered to lend him one of his. Walking down the corridor to his hotel suite, Winner suddenly realized he'd left his keys behind. Connery stood at the door and kicked it in with one foot, then calmly strode inside to claim the jacket.

When his blood is up, Connery is an awesome sight: his whole being, flesh, bone and sinew, can explode with fearsome power. Luckily for those who live and work around him he rarely loses his temper seriously. He memorably hit the roof filming the final sequence for *Zardoz*, in which he and co-star Charlotte Rampling age from adulthood to death in about ten seconds. The make-up took hours to apply, only for John Boorman to demand a full re-take; he wasn't happy with it. Nor was Connery, about having to do the scene all over again, but he persevered dutifully. The next take was perfection, but then a young studio worker accidentally exposed the film. When told, Connery literally exploded. 'Where is he?' he bellowed. 'If I get my hands on him I'll break his fucking neck!' Boorman watched all this with a degree of amusement. 'Sean's reaction was hilariously frightening.' As for the poor worker, he kept a very low profile for the remainder of the shoot.

Mostly Connery's temper and ill-patience manifests itself in moods and plain old grouchiness. 'If I have to deal with idiots, I can get cantankerous.' One night in May 1966 Connery attended the Cassius Clay v. Henry Cooper fight in London. He was among a host of celebrities accosted by autograph seekers before the bell. Half-way through the opening round, a woman burst out from nowhere and shoved a book under his nose, obscuring his view of the action. 'Get out of my bloody way, woman,' he snapped. 'Do you think I've paid £50 a seat to sit here and look at you?'

The burden of being Bond assuredly made Connery more irritable, as Diane Cilento confirmed in an interview with Alan Whicker in 1967. 'He's not changed much because of Bond, though perhaps nowadays he's quicker-tempered because of all the pressures. He's tired beyond normal limits, because everywhere you go there's always someone coming out from behind a tree.' To escape his Bond fame Connery and Cilento bought a hideaway Spanish villa, but they weren't safe even there. One afternoon hundreds of fans turned up, having been sold fake tickets that promised: 'Meet James Bond – food and drink included.' Connery went ballistic. 'We were still chasing people away at 4 a.m.', remembers Cilento.

In California Connery and Michael Caine paid a visit to the famous Comedy Store on Sunset Boulevard. A young comedian there was being heckled by a clutch of British tourists. Connery handled the situation in his own inimitable style. 'One more word out of you lot and I'll smack you through that fucking wall. Now give the kid a chance.'

Once driving home to Marbella with Micheline beside him, and Jason and his two grandchildren in the back, Connery was cut up by another car. 'I caught up with this idiot at the lights and gave him one. I didn't knock him out, I just gave him a real thump on the jaw.'

Most memorable of all was his near-nuclear encounter with that other great screen macho-man, Lee Marvin. At the time Marvin was in London shooting *The Dirty Dozen* and both stars had been invited to a showbiz party. When Connery arrived Marvin was already out for the count, but he spied a quaint old lady sitting on her own. Getting up, he staggered across the room and propositioned her in the most vulgar manner possible. So slurred was his speech that the dear old lady had trouble understanding, so she innocently asked him to repeat it. Marvin obliged. It was then that some-one whispered to him that the old lady in question was Connery's aunt and that the man himself had got the gist of what was happening. Indeed, he was on his way over. Kenneth Hyman, who made *The Hill* with Connery and was producing *The Dirty Dozen*, saw the danger and desperately leapt into the breach.

'Hit him in the body, please,' begged Hyman. 'Please, don't hit him in the face, Sean ... SEAN!! He's got close-ups tomorrow.'

Just in time Connery saw the funny side of it. 'You fucking producers,' he said, a broad smile breaking out on his face.

Sense of Humour

'He is a very good comedian, with a quick wit, not with schoolboy humour.'
Terence Young

Although an attractive self-deprecating humour is one of the hallmarks of a Connery performance, he has had few opportunities to play comedy on screen. It is obviously his more familiar tough-guy image that has ingrained itself on the public consciousness. But as early as 1974 he expressed a desire to make comedies, 'preferably a very well constructed farce'. His sometimes growly countenance and dour demeanour belie a keen sense of fun; this is a man who has a way with throwaway lines and banter. Once during a photo shoot he was asked who his favourite designer was. After a pause Connery replied: 'Woolworth's.' He's a born storyteller too, and his anecdotes are laced with humour. Many of the jokes in the Bond movies were invented by him; Ralph Fiennes noticed this skill during the making of *The Avengers*. 'He's got a great sense of humour which he brought to the script – great jokes and one-liners. He's brilliant at that.' Connery values the use of comedy above most things in his acting, he is always looking for traces of humour in the characters he plays, in order to humanize them. 'The dramatics take care of themselves. The humour you have to find.'

He has also earned a reputation for fooling about on set, of playing the odd practical joke; it's a tradition that goes back to the early Bond days. A few light moments in the right place, he feels, create a jovial and harmonious working atmosphere. Designer Ken Adam, famous for his hugely extravagant sets, was

often teased by Connery, who would say things like, 'I don't think the camera caught that corner over there.' On *Thunderball*, while kissing actress Mitsouko, he stuck a pin into her bottom. 'His wife told me he played this kissing trick on all of his co-stars,' she revealed. On *You Only Live Twice* Mie Hama also struggled to keep a straight face during a love scene. 'Sean was tickling my stomach. It was difficult to keep from laughing until the scene was finished.'

Pinching bottoms appears to be a habit for Connery. Filming *Just Cause* in Florida Connery was in a car parked near a news reporter in the middle of a broadcast. The actor noticed she was heavily pregnant but couldn't resist pinching her delicate behind as he drove by. Infuriated the woman gave chase in her car, eventually catching him up. Connery turned on the charm and the reporter promised to forgive and forget – in exchange for an autograph.

Filming *First Knight* Connery knew that co-star Julia Ormond's next big film was opposite Harrison Ford in *Sabrina*. So he decided to give her a little bit of advice. 'You have to tell him a joke; he likes jokes. Send him a big Swiss kiss from me.'

'What's a Swiss kiss?' Ormond enquired.

'It's the same as a French kiss, only you yodel.'

On the first day of shooting Ormond gave Ford the message, who frowned upon hearing it, then smiled, realizing that Sean had meant it as an icebreaker.

This sense of mischief would reach its peak whenever he hosted a dinner party. Connery always made sure of inviting at least one couple who were likely not to get on with the other guests. He would then sit back and wait for the sparks to fly. But he was often on the receiving end too. While filming *The Man Who Would Be King* in Morocco, Connery was told as guest of honour at a special feast that it would cause great offence if he refused to eat the local speciality of sheep's eyes. Reluctantly he agreed. While he was chewing on the second eyeball his host, a 'sheikh', whisked off his robes to reveal himself as friend Eric Sykes.

Connery's often blunt humour has landed him in hot water more than once. At some highbrow function he was introduced to Sarah Ferguson, who was shortly to be married to Prince Andrew. It was a hot day so Fergie put both hands in her pockets and waved her skirt round to create a breeze. 'If I did that in these trousers, I'd be arrested for indecency,' Connery whispered to her. Fergie fixed him with an icy stare before walking off in a royal huff. On another occasion he attended a private showing of the film *One Day in the Life of Ivan Denisovich*, directed by Caspar Wrede, then making *Ransom* with Connery. Unbeknown to everyone the great novelist Alexander Solzhenitsyn was in the audience. When the lights came on and he stood up, everybody cheered him spontaneously. Connery watched as the familiar figure passed with bearded face and high domed forehead, and then said: 'He's got his fucking head on upside down.' Fortunately Solzhenitsyn didn't hear. 'The Scot's drawl probably saved him,' said Wrede.

As for his own choice of humour, Connery's particular favourite is Billy Connolly; he finds a lot of truth in his countryman's comedy, a shared reality. Connery finds himself naturally drawn to Scottish comedians, old-timers like Jimmy Logan and Chic Murray. 'Now there's a great comedian,' he once reminisced. 'The way he can play with words so surrealistically. "I saw my auntie and said, Hello dear! I always call her dear because she's got antlers." ' He enjoyed Morecambe and Wise too, and recalls watching the pair get a frosty reception from a Glasgow Empire audience when he was still in the Navy. Connery also never missed any of the Carry On movies. 'And John Cleese makes me laugh,' he revealed in 1995. 'I adored *Fawlty Towers* and *A Fish Called Wanda* is one of my favourite films.'

Privacy

'I honestly believe there's a public life and a private life. I'm secretive by nature.'

One of the cherishable scraps of advice Connery remembers his father giving him was: 'There is always a price to be paid for success.' Coming from a man who achieved so little in his own life, it struck Sean as an odd thing to say. Only after years of being in the spotlight did those words hit home.

In the early Bond days, though he never got a kick out of signing autographs, he responded graciously because he thought it came with the territory. But before long any interruption of his private life was considered fair game and he resented that above everything else. Of course one doesn't go into showbusiness if one's an introvert; but common decency, Connery believes, should entitle him to be left alone in a private place. In the public domain it's fair enough; there he expects some degree of intrusion.

He's also tried not to let fame infringe on the things he did before, like going to football matches (he proudly joined the Tartan army in Paris for Scotland's games in the 1998 World Cup). He enjoys the freedom of travelling under his own steam; no private Lear jets for him, unlike some pampered stars. He even prefers driving himself to and from film sets, and golf courses.

Connery is fortunate to be rarely troubled by people, mainly because he doesn't travel around with an entourage or create false dramas by arriving at places in a hail of popping flashbulbs. 'That's not for me. Anyway it is far more attention-grabbing than walking into a place as you are.' If hassled, he'll always have the guts to tell his persecutor where to go. Walking with a journalist around Edinburgh Zoo, Connery was approached by a woman who asked him, 'Excuse me, are you who I think you are?' Connery stared impassively back at her before replying, 'No!'

Whatever he commits to celluloid Connery classes as being in the public domain, because he chose to put it there. Everything else, especially his

family life, he keeps private and well away from the spotlight, much to the chagrin of the press pack. Refusing to play the star game Connery has never had time for the publicity machine or the superficial trappings of his job. He's never even employed a press agent, never having seen the need of presenting a manufactured image of himself to the public. He lets his acting do the talking.

After his divorce from Diane Cilento in 1973 Connery stood outside the London High Court and told reporters he intended never more to comment upon his private life. And he's been pretty true to his word. By nature he is a secretive man, intensely private and, despite his self-confidence, shy, the complete opposite of best mate Michael Caine. At parties, unless he is truly relaxed with the company, he remains on the fringes, unresponsive, content to leave the jokes and stories to other people. 'I've never been particularly social,' he once said. To draw him out one must usually resort to bringing up the subjects of either golf, money or Scotland.

Tax Exile

The Taxation policy of the 1974-79 Labour government led to a flood of Britain's top stars leaving the country. It was Chancellor of the Exchequer Denis Healey's threat to make the rich squeal that started the exodus. 'But he forgot that we all had money for the plane fare,' Michael Caine hit back. 'So now we're all squealing from the South of France and Beverley Hills.'

Connery soon started to make ugly noises about the amount of income tax he was having to fork out. 'I was paying 98 per cent tax. I was one of the most successful actors around and I didn't have a pot to piss in.' Realizing that he wasn't as financially well-off as he had supposed or newspapers estimated, Connery began to take steps to ensure the taxman would no longer cream off the bulk of his earnings. 'People said you should have two cars and three secretaries because they're deductible. But they're not constructive.'

Still domiciled in Britain but spending more and more time abroad, Connery acquired a property in Monaco and registered himself as a resident there purely for tax purposes. Within a year all business links with Britain were severed, largely after discovering that he'd been building up a mini-empire that now threatened to engulf him in endless meetings and correspondence. All outside interests then, save for his charity trust, were dropped, including a sports and country club he'd established in Essex with the late football hero Bobby Moore. By 1974 he was out, joining a lengthening list of celebrities, including Richard Burton, Julie Andrews and Roger Moore, who'd also quit Britain to escape Labour's taxman.

Friends such as the fiercely nationalistic Stanley Baker, who believed the onus was on the privileged few to pay these higher taxes, were appalled and disappointed at Connery's becoming a tax exile. But it wasn't solely money

that precipitated the move from Britain to Spain; he was now starting a new life with wife Micheline after the traumas of his divorce from Diane Cilento. Of Mediterranean descent, Micheline would have been unlikely to fancy settling down in soggy Blighty.

Connery has never apologized for deserting his country. 'At least I'm working for myself now,' he once said, 'not the British government.' He does, however, feel aggrieved about being limited by tax law to spending only ninety days per year in Britain. This has led to ludicrous situations, such as the time he was filming *Outland* and had to fly abroad every weekend to conserve his precious allowance. He didn't hide his fury at having brought a $14 million Hollywood movie to a London studio, thereby creating employment, and then being personally penalized for it. Discouraging stars of his calibre from working here hardly boded well for an already beleaguered British film industry. He has since argued for a change in the tax law, so that working days can be separated from private visits. More recently he was at loggerheads with the Inland Revenue over his appearance in *The Avengers*, which was shot in London, and *Entrapment*, a film he'd spent years persuading the Americans to bring over to Britain. 'It is not a question of not wanting to pay tax – it is a question of fairness and what is right.' Connery even used a 1997 meeting with Prime Minister Tony Blair, whose election he had welcomed, to press him for this change in the tax laws.

But what has riled Connery most over the years are his critics in the media and certain politicians who carp about his predilection for avoiding taxes. More than once during an interview he has felt the need to hammer home the message that he is not a tax dodger. 'I pay full tax in Britain and America, wherever I work, without the benefits of living in the country.'

Homes

During his Bond heyday Connery lived with Diane Cilento, son Jason and stepdaughter Giovanna in a deconsecrated twelve-room convent in West London. Formerly home to twenty-five nuns and set in its own grounds, Acacia House was the only dwelling in a cul-de-sac off Acton High Street. Connery bought it for £9,000. Moving in soon after *Dr No*'s release Connery spent thousands more on renovation, for example converting the long chapel into an L-shaped living room. He was quite prepared to haggle with the contractors. Having worked on a few building sites himself he knew their tricks and the corners that could be cut. 'I supervised them like a foreman to see that they got it done.'

The house was furnished throughout in vivid colours, because 'it was gloomy where I grew up.' One room, which remained locked, became his den. There was also a bar, a billiard room and piped-in stereo sound. They employed some servants and a regular stream of nannies, who usually

developed raging crushes on their employer. 'I don't think I figured much in the whole set-up,' remembers Jason. 'They were usually too much in love with Dad.' Connery would tell reporters how he tried to live as normal a life as possible there. 'On Sundays I walk across the green to the local pub, and on the way back chat with the neighbourhood children.'

But such was the fame of the occupants that the Acton house became a mecca for burglars. With Connery away on a business trip soon after moving in, a group of kids broke in and stole two cameras, an alarm clock, an electric razor and some records. 'Boys Rob James Bond' ran one newspaper headline. After that the burglaries increased; once Connery's 12-bore shotgun and Cilento's wedding ring were taken. Later it was discovered that the robbers had rented out the flat opposite and raided the house when the couple were out. For Cilento the final straw came when someone tried to steal her prized Mini Cooper. The two were in bed early one morning when they heard the engine start up. Connery was naked, but grabbed a sweater and ran outside. Diane got there just in time to see his bare backside scurrying down the road. The thief must have been so surprised to have James Bond chasing him as he crashed and ran off.

Burglars weren't the only problem. Fans would scale the walls to catch a glimpse of their idol, and women waited outside for him to emerge in the mornings. 'People knew the house and would come and sit and stare at Diane and me in the main room,' Connery grumbled. 'If it had gone on I'd have been found guilty of assault.' Sick of the break-ins and the sightseers, the couple decided to move. Prior to *You Only Live Twice* going before the cameras Acacia House was placed on the market for £18,000 under the heading: 'Sean Connery, the motion picture actor, offers for sale ...' A Victorian mansion on Putney Heath was bought. 'A monster of a house' as Jason remembers it, it had a closed-off garden that afforded the family greater privacy. The Connerys purchased a holiday home in Spain too, adjacent to a golf course, naturally.

When Connery separated from Cilento he moved to an apartment on Chelsea embankment in the same block where Ribbentrop, Hitler's Foreign Minister, had lived before the war. This was Connery's last residence in Britain before he went to live in Spain, a move partly precipitated by London's pollution. Having recently spent time in Spain and in Ireland filming, London looked unpalatably grubby by comparison – 'all those car exhausts spewing out muck'. The Chelsea flat was sold for £60,000. Five years later he bemoaned the fact that it was now worth in the region of £300,000.

Soon after remarrying in 1975 Connery moved to Spain, setting up home near Marbella, a haunt of the rich and famous. Connery's Spanish villa, located at San Pedro del Alcantara, a former fishing village, is a sprawling and comfortable oasis that reeks of affluence and idle contentment. It started life as a shabby collection of derelict bungalows on the sea's edge, from which on

a clear day you can see Gibraltar, but grew over the years into a splendid walled enclave of trees, lush green inner courtyards, the obligatory swimming pool and a cluster of castellated white houses. The interior is exquisitely furnished with antiques chosen by Micheline. 'Everything that you see in the house, the concept and everything, is entirely Micheline's,' Connery confessed. 'I got the easy part, I just had to pay for it.' Pride of place in the marble-floored lounge is a full-length portrait of Connery with his son Jason, then a boy. Elsewhere there are tiled murals hand-painted by Jean Cocteau. The one real whiff of movie-star luxury is Connery's wardrobe, a whole room in the house devoted to his hundreds of suits. He also has his own self-contained building that he uses as a study, the doorstop of which is a golf trophy. 'When I get a script that I like I take it down there and that's when I start to take it apart and work it through.' They even have their own well. 'I have to drink a lot of water here,' he admitted, 'otherwise I just dehydrate.'

Only the privileged few are allowed within a hundred yards of the villa. This is a place that Connery has called his 'sanatorium', where he feels more at peace than anywhere else he's ever lived. 'I try to make the house around Sean,' said Micheline. 'I try to make it very serene.' Returning at the end of a shoot, having lived out of a suitcase or in rented property, Connery puts his feet up, repairs and recharges himself. His perfect day during these precious weeks consists of, say, a leisurely spot of morning tennis or perhaps sorting out his mail, which is prodigious, and dictating letters to his secretary. A nap in his hammock after a light lunch is followed by a trip to the local golf course, five minutes from his doorstep. The couple are generally homebodies, staying away from the local nightlife. If they do venture out for the evening, it's usually to a local restaurant where people tend not to bother them.

In going to live out in Spain, was Connery choosing to shut himself off? Connery has a reputation, one he denies, of being a virtual recluse when he's not filming. He readily acknowledged the drawbacks of living in Spain – its remoteness from the film community for a start. That's why he has always enjoyed working in London or Los Angeles, for it provides a chance to meet up with old friends. 'Since I moved to Spain that's something I've missed, conversations and stimulus.' Plenty of friends have come over to visit, but it took his BAFTA tribute award in 1990 for it finally to dawn on him just how isolated he'd become from friends and colleagues.

Besides the Marbella villa there are other Connery residences scattered around the globe: an apartment in west Los Angeles, a home in the south of France and a £2 million ocean-front villa on Lyford Cay, an exclusive gated community for the world's super-rich on New Providence island, west of Nassau. In February 1998 it was reported that Connery had put on the market both his Marbella home and his mansion near Nice – for £10 million and £5 million respectively. He and Micheline had now decided to move permanently to their more peaceful home in the Bahamas. The reason? Over

recent years this once-secluded Marbella beach area had fallen prey to developers, and tacky bars and discos were springing up too close by. 'They don't need all the hassle,' a friend was quoted as saying.

Golf Mad

'I couldn't just play golf. My god, I'd kill someone.'

The golf duel between Bond and Goldfinger remains an all-time favourite with fans. Filmed at Stoke Poges, an exclusive course in Buckinghamshire, the sequence is said to mark the beginning of Connery's love for golf. It's Terence Young, however, who lays claim to first introducing Connery to the ancient game during the filming of *Dr No* in Jamaica. 'He'd never played before and he didn't like the game, he just went round with me a couple of times,' Young told 007 fanzine *Bondage* in 1981. 'Then when he was doing *Goldfinger* he had to learn to play properly, and he became an absolute golf nut. He's probably the craziest golf enthusiast I've ever met. Sean will play 36 holes of golf any day if he can get somebody to play with him.' Years later Connery and Young took a short break in the Bahamas. Their plane touched down at 7 a.m. and the two men headed straight for the nearest golf course. They didn't have any golf shoes, so played barefoot, and just managed to get in a round before the clubhouse opened.

In an eighties television interview for the BBC Connery revealed that he was first introduced to golf by, of all people, his dentist, who at the time was hoping to become England's amateur champion. He was instrumental in making Connery a member of Sunningdale. Sean regretted that he hadn't started the game at an earlier age. 'Then I could have lost all of my hair by the time I was twenty-eight.'

Shooting *Marnie* in 1964, Connery enjoyed testing out the local courses around Hollywood. He was proficient enough even then to be elected an honorary member of the exclusive Bel-Air Country Club. 'In his free time he always had his golf shoes and clubs out,' co-star Tippi Hedren later recalled. 'I guess if I hadn't been interested in somebody else at the time, I probably would have played golf.' Connery even turned down an offer to attend the opening of the new MCA administration building in Beverly Hills, a publicity coup for any foreign star, preferring instead to knock balls into little holes.

Arriving in the Netherlands to begin work on *A Bridge Too Far*, the first thing Connery did was to take Anthony Hopkins out to dinner. He proceeded to grill the actor on how things were progressing, and whether everyone on the crew was pulling their weight. He was worried that the whole enterprise might go wildly over schedule and interfere with his plans to get home quickly and back to the golf swing.

By this time he was almost inseparable from his clubs. Asked whether he would rather win an Oscar or triumph at the Open, he unhesitatingly nominated the latter. One of Connery's great joys is travelling round the world playing in celebrity golf matches, and his unfulfilled ambition is one day to make a film about golf – 'something like the Jack Nicklaus Story'. Soon it wasn't enough just to hit a ball around; now he played to win and played for money. But above all to win – he has never been a good loser at anything.

Connery sees golf as the archetypal loner's game. 'I like the isolation of golf. I do a lot of thinking when I'm playing.' He also firmly believes that golf should be mandatory in every school, because it's the only sport that teaches you when you cheat, you're cheating yourself. It's a social activity too. Many of the friends he's collected over the years started as golfing partners. 'It's a game which is very revealing. You can get a quicker measure of anybody playing golf with them than you can at anything else.' By the same token golfing chums like Jimmy Tarbuck, Bruce Forsyth, Ronnie Corbett, Jackie Stewart and Eric Sykes could tell a tale or two about how Connery has lost his temper over a missed putt or a poor drive. Playing a round with Tarbuck once Connery missed a short putt. In a fit of anger he tried to bend the putter over his knee, but succeeded only in giving himself a muscle spasm. Sympathy came there none from Tarby or the other players, who were all too busy laughing. A Spanish magazine once printed a series of photographs showing how a not-entirely-happy Connery looks on a golfing green. First he's seen seething with rage over a fluffed shot; then hurling the offending club into the air; then shaking a tree into which it has landed; then collapsing in laughter at his own ludicrous behaviour. Connery later owned up. 'This photographer was there and he photographed me throwing other clubs at the club trying to get it down off the tree. I wouldn't have believed it until I saw the pictures.'

One great story involves a Variety Club golf trip up to Glasgow. Connery, along with a gang of showbiz golfers – Jimmy Hill, Henry Cooper, Dickie Henderson, Graham Hill and others – were marooned at London Airport, which was at a standstill thanks to a baggage handlers' strike. The poor man organizing the event crumbled under the pressure and started scurrying around asking who hadn't turned up yet. Connery, with his customary Gaelic charm, replied, 'Well, if they are not here how could they tell you, you idiot!'

Finally Graham Hill came to the rescue. His light aircraft was stationed at nearby Elstree and he could take six people. They drew lots. Once airborne Hill hardly boosted anyone's confidence by asking on which side of Scotland Glasgow was. In the end he told his passengers everything was fixed: he was going to follow the crease in the atlas.

Golf was to have the most profound effect on Connery's personal life. He met his second wife, Micheline, at a golf tournament, so she understands and tolerates this obsession. 'My interest in golf was made clear to her from the beginning.' Though they rarely play together – indeed, Connery rarely plays

with any woman for that matter – it's something Micheline is only too happy to accept. 'She reckons if I'm out on the course all day with other men, there's not very much I can get up to or down to, unless we're all queer, of course.' What is annoying is her husband's penchant for talking endlessly about each individual game – the shots he missed and the shots he made. 'He goes over and over it. If I did not play golf myself, I would go crazy.'

For Connery golf is his one male-only pursuit, something he cherishes and won't give up. 'I like playing with men,' he confessed to *Vanith Fair* in 1993.

> At the club where I play there's a men's bar and there's a mixed bar. Women don't go into the men's bar. I think that's perfectly normal. I like a men's bar where I can sit and talk only with men. It's harmless, really. It's just cama-raderie. It's like male bonding. Where they go into the woods and dance and hug. But I can't see myself dancing with some hairy-arsed guy with a beard in the woods.

Today Connery is an intensely competitive low-handicap golfer and proudly boasts membership of two of the world's most prestigious golf clubs. One is the Lake Sherwood Club in Los Angeles, whose membership fee is thought to be in the region of £150,000, and where Connery's locker number is ... 007. The other is the Royal and Ancient Golf Club at St Andrews, where he rarely misses their spring and autumn foursomes.

Football

'We spent all our energy on football. I was football mad.'

As a youngster Connery lived for football and he was very good at it. His pitch was usually the streets, where he and his mates would have rowdy kick-abouts, and not always with a proper ball. When one wasn't available they would make do with rolled-up newspaper tied up with strint. In the summer they would play all day in the park, run home for a bite to eat, then race back out to finish the game. At school he began life as a half-back, but ended up as centre-forward, because, despite his size, he was fast. After play-ing for a local boys' club, and helping them to win a cup competition along the way, he moved on to amateur teams. This experience led to a stint as a semi-professional for Bonnyrigg Rose, one of Scotland's premier junior-league sides. There he was spotted by scouts from East Fife, then in Scotland's First Division. But to everyone's disbelief he turned down the £25 signing-on fee. Maybe the prospect of leaving family and home wasn't appealing – then. Celtic also gave him a trial.

On tour with *South Pacific* Connery regularly played in a scratch team

made up of cast members. Arriving in Manchester for the Christmas season, they were offered the chance to play against a professional local side. Connery's aggressive style and pace was spotted by a scout from Manchester United, who offered him a trial with the club. For someone who'd loved the game since childhood this was the chance of a lifetime, but incredibly Connery walked away from it. He'd already decided to persevere as an actor. 'I know Matt Busby very well,' Connery told *Empire* in June 1992. 'Because he was a hero of mine when I was very young, because he used to play half-back for Hibs.' In 1997 it was reported that Connery had turned down an offer to play Sir Matt in a film dramatization of the 1958 Munich air disaster. While he was growing up most of Connery's heroes were sportsmen, either footballers or boxers. 'They still are. I never see anything in the theatre or on film that can match sport for sheer drama.' Something that always tugs at the heart strings is the opening ceremony of the Olympics. 'That is the most emotional thing ever.'

Even as an actor Connery was never far away from a football. In the late fifties he played centre-forward for a showbusiness eleven in a series of charity matches. The highlight of a promotional tour to Italy for *Dr No* was watching AC Milan play Inter Milan in the comfort of the directors' box. While in Japan shooting *You Only Live Twice* he was eager to play against a local team in a football match that the crew had organized. Broccoli wasn't so keen. 'He can't play, he's not insured for this sort of thing.' 'It's just a friendly game,' argued Lewis Gilbert. 'What can happen to Sean?' Sure enough, ten minutes into the game Connery twisted his ankle and it swelled up like a tennis ball. Broccoli was not amused.

As he approached pensionable age Connery started to rue his soccer-playing days. 'I have terrible knees from all the soccer I played as a kid.' But his love for the game hasn't diminished. During Scotland's qualifying campaign for the 1998 World Cup he would phone manager Craig Brown after every game. Brown said the level of support received from the likes of Connery and also Rod Stewart (another football-crazy Scot) had helped to create the right patriotic mood among the players. Back in 1970 Connery even tried to raise cash to aid the renovation of Hampden Park, Scotland's national stadium, then in a state of sorry disrepair. His idea was to organize a football match between a Rangers-Celtic 'all star' team and world champions Brazil. What a game that would have been; but the plan got tangled up in red tape and never happened.

Gambling

In January 1963 Connery was in Italy on a publicity tour for *Dr No* when he made a highly publicized visit to a casino, immaculately dressed *à la* Bond. He ended up almost breaking the bank playing roulette. The story made

headlines across Europe. Connery maintained that he'd used the same system Fleming's Bond employed in the novels. But the whole thing was an elaborate hoax dreamt up by the publicity department. Once the paparazzi had finished snapping Connery holding his winnings and gone home, the money was discreetly returned to the casino's vaults.

Chemin de fer and roulette weren't really Connery's games. His weakness was poker, and especially during his days on tour with *South Pacific*, he never travelled without a pack of cards. Canny and competitive, Connery always set out to win. It's the same in every sport he indulges in – this passion to succeed. If he's playing tennis every game is like the Wimbledon final. 'There's no such thing as a good loser.' This could be Connery's motto. Or alternatively: 'Show me a good loser and I'll show you a loser.'

Musical Leanings

When he was sixteen years old Connery's Post Office savings account held the sum of £75, a small fortune in those days, and he thought now was as good a time as any to spend it. He wanted a motorbike more than anything. 'You're not getting a bike – you're too young,' bellowed his dad. If Tommy managed to slice open his head falling off his sled, just think of the damage he might cause himself on a motorbike.

Instead he bought a piano. It was as if he wanted something solid to show for all his years of hard work. The piano cost £56, plus a pound for delivery, and took up valuable space in the already cramped family home. No one had a clue how to play it. Connery sometimes experimented with one finger, but refused to take lessons that his mum had offered to pay for. It made his father livid. For a man who'd scrimped and saved all his life such wastefulness and irresponsibility were beyond reason.

In other areas Tommy was more musically inclined – namely dancing. Many of his Saturday nights were spent at the local Palais de Danse, the largest dance venue in Scotland, which had its own revolving stage and two resident bands. It was always packed and not just with the young; mothers often came and sat up in the balcony to spy on their daughters' dancing partners.

Normally a bit of a scruff in green tweed jacket and brown slacks, the young Connery always made an effort for his nights out at the Palais, donning his one and only evening suit. He was a keen dancer, the quick-step being a favourite, and fearless in asking girls to dance. Few refused. 'And often, Tommy asked the plain girls to dance,' Effie remembered; 'he didn't always pick the pretty ones.' Chiefly, though, his taste ran to blondes, and he was never less than a gentleman, walking his catches home – or at least to the nearest bus stop.

This love of dancing has persisted throughout his life. Posted to Portsmouth while in the Navy, Connery used to attend local dancehalls, and

The Untouchables (1987) celebrate a shortlived victory in their war against Al Capone. Connery won an Oscar for his performance as an honest beat cop

As the Russian Navy's only commander with a Scottish accent in blockbuster *The Hunt for Red October* (1990)

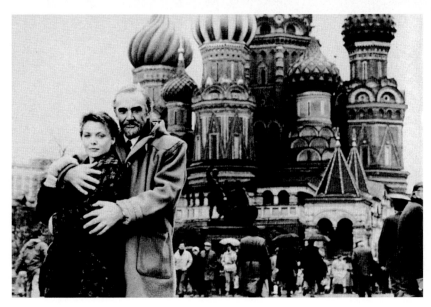

Bond finally makes it to Russia. As reluctant spy in John Le Carré's post-Glasnost thriller *The Russia House* (1990), opposite Michelle Pfeiffer

Connery in wax at London's Madame Tussauds

One of showbusiness's strongest unions; with Micheline Roquebrune, his wife
since 1975

Ramirez resurrected in this disappointing sequel, *Highlander 2* (1991)

With Wesley Snipes in the racially controversial *Rising Sun* (1993)

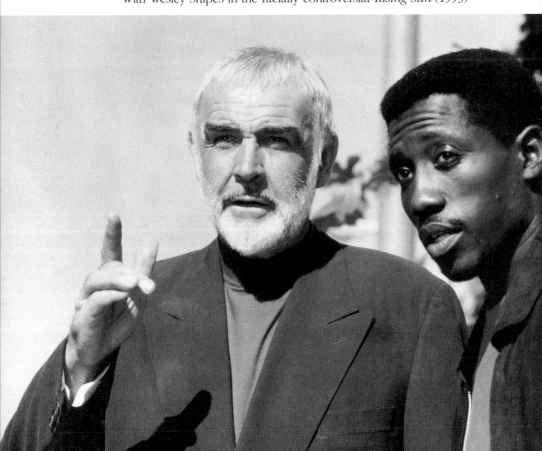

Connery's knack of escaping unscathed from turkeys was put to its severest test in the comedy flop *A Good Man in Africa* (1994)

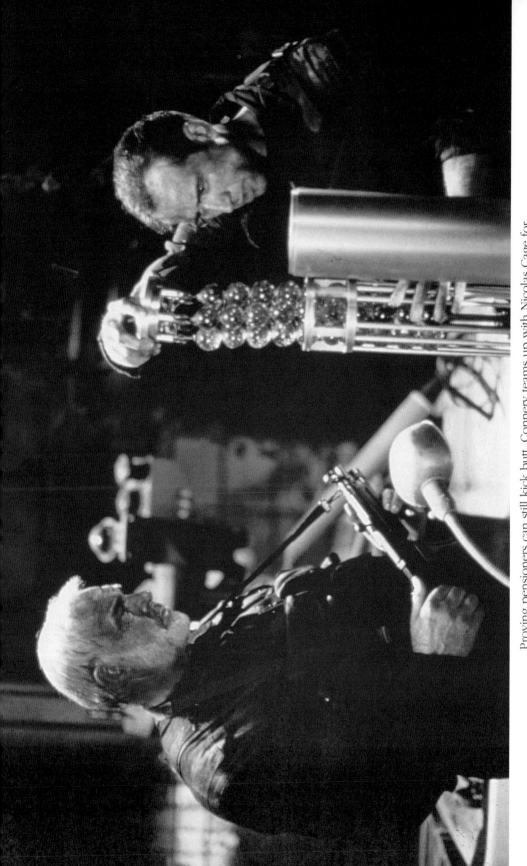

Proving pensioners can still kick butt. Connery teams up with Nicolas Cage for action hit *The Rock* (1996).

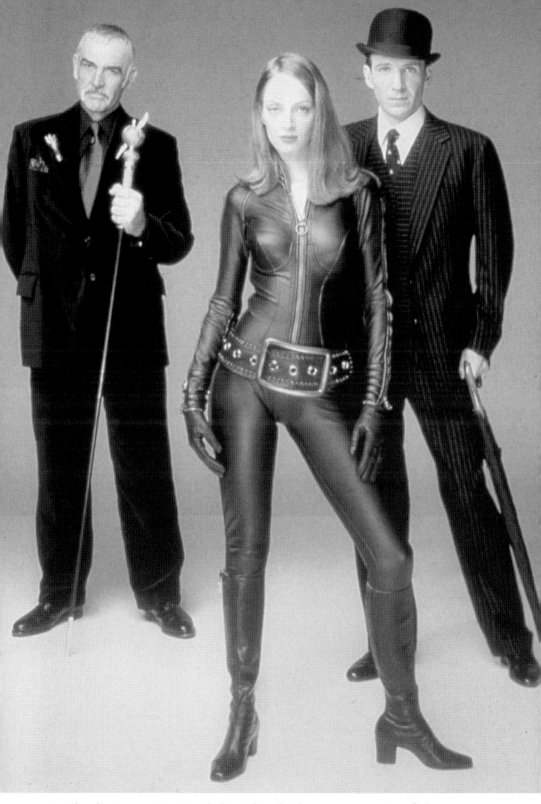

Not the disaster critics carped about, but this big-screen version of classic
1960s' show *The Avengers* (1998) was all style and no substance

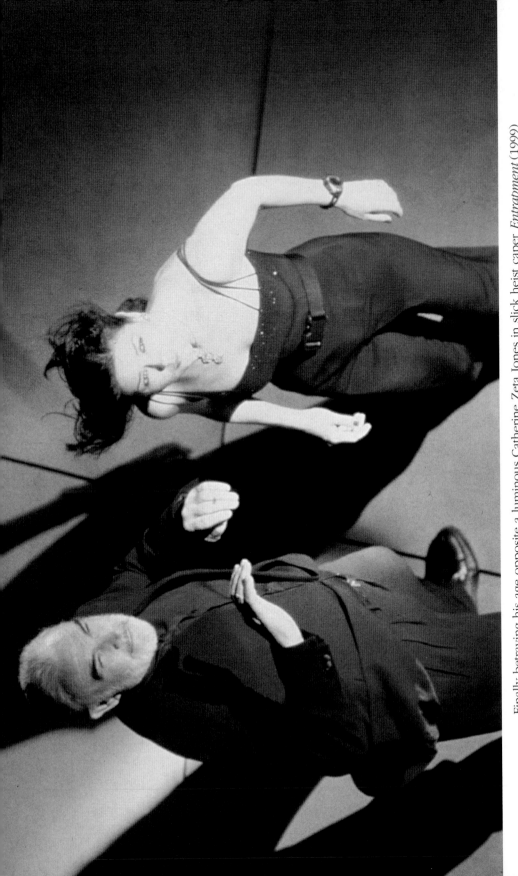

Finally betraying his age opposite a luminous Catherine Zeta Jones in slick heist caper *Entrapment* (1999)

some weekends he would catch the train up to London with mates for a night at the Hammersmith Palais. In his Bond comeback *Never Say Never Again* Connery dances a full-blooded tango with Kim Basinger. Herself a trained dancer, Basinger was impressed with the old man's nifty footwork. 'He never missed a step.' Connery had been taking lessons from *Come Dancing* specialist Peggy Spencer.

Though Connery can live without the tango, he is passionate about flamenco. When at home in Marbella he often invited famed dancer Solera de Jerez, who holds the Guinness Book of Records entry as the fastest flamenco dancer in the world, to his home to perform for party guests. 'Sean shows great artistry in the dance,' Solera revealed to *Hello* magazine. 'He is also charming and passionate. He has a good ear for music. He is a natural dancer and he loves flamenco and particularly the rumba.'

The Accent

'Sean does everything from Arab sheikhs to dragons with a Scot's accent. As an actor, he honours his homeland every time he opens his mouth.'

Harrison Ford

No actor in the world owns so distinctive a voice as Sean Connery. That burr in his voice is the voice of Scotland to the world. 'I think my sex appeal lies in my voice,' he once said. 'Lots of women have told me they think the Scottish burr is very sexy and that's why I never want to lose it.'

As a struggling actor in the fifties Connery had so strong a brogue that it was doing him no favours. For years it was a struggle getting work on account of his accent, then people started accepting it as being part of the man. What was first singled out as a handicap eventually became his trademark. Connery arrived in films at a lucky time. Class barriers were crumbling and regional accents coming more into vogue. A decade earlier, when 'English' actors all spoke as if their uncle was the Duke of Marlborough, he'd have stood no chance. In the sixties the likes of Connery and Albert Finney were manna from heaven; their voices alone had a vigour, an earthy passion lacking in the pinched vowels of RADA-trained actors.

When Connery was still learning his craft, the English prose of someone like Shakespeare was always a stumbling block. Then he heard Richard Burton, an actor he greatly admired. 'He always sounded Welsh to me, however he spoke, and I could understand what he said very clearly.' That greatly influenced Connery's decision to resist refining his accent out of existence. Of course he underwent speech training to soften it a little, but never truly lost that authentic Celtic burr.

On those odd visits home Connery is said to lay on the native brogue with a trowel, as if to let everyone know he still sees himself as one of them and

never intends abandoning his identity. John Boorman once asked Connery why he'd never made any attempt to eradicate the accent completely. 'Because I wouldn't know who the fuck I was,' came the reply. Connery firmly believes his strength as an actor lies in the fact that he's stayed close to the core of himself.

Yet if you compare his earliest pictures with those directly after his big break as James Bond one notices that the voice undergoes a compelling metamorphosis. In their review of *A Fine Madness*, *Films and Filming* picked up on this.

> Connery's accent becomes more and more engaging with every film. When you hear him you can trace the story of his life, the glottal stop of metropolitan Scotland, the showbiz drawl of London, the transatlantic snarl of New York. Without losing any of its origins, the accent gets richer and more delightful in every new venture.

Even earlier the *New York World Telegram* in its review of *Dr No* noted that Connery spoke with: 'a suave mid-Atlantic accent'. Then as his fame increased the Scots accent returned, its thickness depending on the role. Listen to him in *The Hill*, for example, in which he speaks as if he were back on home turf. 'Connery has given up pretending to speak English,' the *Scotsman* later acknowledged in its review of *The Presidio*. 'That Edinburgh burr is back on the front desk, without apology.'

He might try to disguise, modify or lessen his accent in movies, but traces of it emerge in every role he's ever played. As most of these haven't been Scottish, some screenwriters have taken to concocting sometimes bizarre excuses as to why their lead character is speaking broad Scots. Paramount executives were perturbed when John McTiernan suggested Connery for the lead role in *The Hunt for Red October*. 'What! Are you out of your mind?' they cried. 'How are we going to have a Russian sub captain with a Scottish accent?'

Sometimes the accent can be explained away more easily. In *Shalako* Connery avoided the stock mistake of imitating a cowboy drawl; there had been plenty of Scottish immigrants out west, so his slightly modified native voice seemed appealingly at home in a western environment. However, when he played a Saudi-Arabian diplomat in *The Next Man*, the script's explanation that he'd been to university in Scotland just didn't wash. Having lately played mostly American roles, the accent started appearing as part of the plot, in that his characters were fleshed out as emigrés to the United States.

But does all this matter? Audiences don't seem to mind, and for years they've instinctively accepted him in any guise. John Milius, who cast Connery as an Arab Berber in *The Wind and the Lion*, agrees. At first Milius insisted Connery take speech lessons in an effort to alter the accent, but everything came out Scots no matter what. 'So we figured he was an Arab

who'd been educated by a Scotsman.' The *New York Times* thought El Raisuli sounded like 'he'd taken a degree in fortune cookie philosophy at the University of Edinburgh'. Milius again: 'But I think no matter what Sean does, he's such a good actor. He has a Scots accent in *The Hunt for Red October*, but he has a manner of a Tzarist.'

Toupee or Not Toupee

Baldness appears to run in the Connery family. As a child he used to tease his grandfather, whose nickname was 'baldy'. Sean's own father also suffered from premature hair loss, as did his brother Neil. Connery was still a teenager when he first became aware of his shortcomings in the hair department. What he was especially concerned about was girls not fancying him anymore if he began losing that lustrous black mop. No amount of money Connery personally frittered away on so-called special treatments could prolong the inevitable, and Connery had to wear a small hairpiece as early as his first Bond movie. 'It was a nightmare,' he said of his oncoming baldness. 'I thought: "How can I live like this?" ' What galled him most was that his baldness was a weakness open for all to see.

The process no longer held any terrors for him, once reconciled to the fact that he was growing bald, and he began refusing to wear a toupee at home or in public – only for his work, and then only when the part called for one. 'Sean totally lacked vanity,' Lois Maxwell explained to the *Mail on Sunday* in August 1986. 'Everyone knew he wore a toupee, and at the end of every scene he would throw it off. I remember once Sean got upset and said, "Look at me. The more hair I lose on top, the more I grow on my eyebrows." He had to shave his eyebrows.'

In one of the vainest of all professions, Connery is its least vain component. At a Hollywood party once, Connery joined in a conversation, and it was five minutes before he understood what the others were talking about. One man asked: 'You work without one, don't you?' Baffled, Sean suddenly realized they were talking about hairpieces. 'Everyone is so obsessed with looks in that town,' he moaned.

Shortly after being voted sexiest man alive at the age of sixty Connery was in a restaurant when three bald, bearded men stood up and applauded him as he left. 'They told me I had done wonders for their morale!' Like the accent Connery's baldness has become one of the actor's trademarks; one scribe called him 'an ambiguous figure for bald activists'. However, he won't allow the fact that he's short on top to be exploited by others. That's why in July 1996 he filed a writ for damages against *Hair International*, calling the magazine's claim that he'd endorsed a hair restorative product a "malicious falsehood".

Wherever possible Connery likes to go *au naturel* in movies, only wearing a hairpiece if the part demands one or if he's after a certain look. For

example he didn't wear a rug in *Just Cause* because it proved too hot in the Florida Everglades. 'So I threw the blasted thing in the waste can.' Connery believes his metamorphosis in film from action hero to elder statesman was actually made easier because of his premature baldness, in that he was forced to play his age, or sometimes even older characters, long before most of his contemporaries.

Cancer Scare

It was during the making of *Family Business* that Connery began experiencing discomfort in his throat. At first he thought it was laryngitis and consulted a specialist in Los Angeles. A probe was stuck in his throat and three tiny dots were discovered on his larynx, which doctors felt might be malignant. Connery was given the stark choice of laser surgery or not speaking for a month in the hope nature might take its course. After taking three other opinions he chose the latter option.

This enforced period of silence was interesting to say the least. Connery took to wearing a pen round his neck and scribbling messages on the back of old scripts; he ended up using hundreds of pages. He also had cards printed that explained: 'I'm sorry, I cannot speak. I have a problem with my throat. Thank you.' People tended to look at the card, then ask, 'Why, what's the matter?' After writing down his answer Connery found that almost half of them took the pen and wrote their replies back. 'You realise very quickly that the world is full of idiots.' There was humour, too, in the way his not talking affected his golf game. 'I couldn't express myself on the course,' he told one journalist.

'You mean you couldn't swear!' interjected Micheline. 'You should hear his language.'

He can perhaps afford to laugh at such things now, but at the time it was a terrifying ordeal. The pain was sometimes unbearable, leaving him sick and exhausted. Waiting for the doctor's verdict Connery saw his weight drop rapidly as he feared the worst. In the end the silence gambit hadn't paid off and surgery was now required. Connery was terrified at the prospect: anything medical, especially involving needles, filled him with dread. When he and his son Jason went to have a full medical check-up for insurance purposes and the doctor produced a needle to take a blood sample Sean almost passed out. 'He gets a bit queasy when he thinks about that kind of stuff,' reveals Jason. This aversion to needles probably dates back to when he was twelve and knelt on a carpet at home – a darning needle went in just below the kneecap.

On another occasion Connery was having pin-hole surgery on his knee and the doctor invited him to watch the procedure on a monitor.

'I'll have the full anaesthetic, please,' Connery told the surgeon.

'But that's not necessary.'

'It is for me. I don't want to see a thing.'

Connery is also something of a hypochondriac. Make the mistake of asking him how he is and he'll tell you, 'I've got this pain in my foot, I must see the doctor tomorrow. I've just got rid of this cold and I've sprained my finger just here, I can't play golf.' Friend Michael Caine is used to it. 'For all his tough guy image, Sean's a terrible hypochondriac. He always seems to have something wrong with him. It's all imaginary.'

When news of Connery's throat operation leaked, the tabloids had a field day speculating whether cancerous tissue had been removed and the actor might never speak again, except through an electronic voice simulator. Of all ailments to strike Connery it was one which could eradicate his trademark voice. It must have given him pause, having worked with Jack Hawkins on *Shalako*. He had to have his larynx removed because of cancer, and all his subsequent film roles needed to be dubbed by another actor. But Jason, then appearing on the London stage, was quick to scotch all rumours. 'If my father had cancer I wouldn't be in Britain,' he told reporters. 'I'd be by his side.'

It wasn't cancer; during the biopsy three benign polyps were successfully removed. It is a common ailment that singers can be affected by and had occurred in Connery as a possible result of vocal stress while acting. Nevertheless the incident proved the esteem in which Connery is held; truly he had become a national institution. The *Sun* newspaper, for example, made front-page headlines out of the cancer rumours, with more pages inside devoted to his career.

After the operation Connery underwent voice therapy sessions at a Beverly Hills clinic. Sean's doctor just happened to be a former Miss Miami beauty queen. These sessions were to enable his muscles and vocal cords to return to normal and to teach him how to use them without a recurrence of similar problems.

Within weeks Connery was preparing to host a Royal television gala in aid of the Prince's Trust. It was a star-studded evening held at the London Palladium in the presence of Prince Charles and Princess Diana. By agreeing to appear, Connery was defying doctor's orders to rest his voice; indeed he only got the medical all-clear hours before curtain-up. He never spoke during rehearsals and was gargling medication constantly. What nobody knew, however, was that during a routine check-up in London the three white dots were found to have returned, and further surgery was required. After another minor laser operation, Connery was given a clean bill of health, with the proviso that he should have regular check-ups every six months. By now the fear of surgery had largely gone. 'My attitude is entirely different now,' he said. 'I know the problem and it can be treated. I have no worries.'

That was until 1993, when the problem resurfaced yet again while he was filming *Rising Sun*. 'I couldn't get the timbre of my voice right,' he explained to *Time Out* in April 1995. 'I couldn't get the variation and enunciation as

comfortable as I wanted. So I went back to the doctor and he suggested radiation. I went for six weeks and didn't have any side effects or problems.' He was treated at the Royal Marsden Hospital in Chelsea. Against the advice of publicists, he decided to come clean about undergoing radiotherapy, usually given to cure malignant tumours. His motive was partly that he'd become heartily fed up of being photographed every time he visited the hospital. This would precipitate 'Connery has Cancer' scare stories in the press. 'And I thought, if you do radiation and it's a success, why not speak about it?'

Connery on Women

'I like women. I don't understand them, but I like women.'

Connery has made some downright sexist comments in his time, particularly during the Bondmania of the sixties, when perhaps his 007 action-man image coloured some of his views. Was it Connery talking or Bond?

Connery on why women find James Bond attractive: 'By their nature women aren't decisive; "shall I wear this? Shall I wear that?" – so a man like Bond who is absolutely sure of everything comes as a godsend.' And again: 'Bond is never in love with the girl, and that helps. He always does what he wants. Women like that. It explains why so many women are crazy about men who just don't give a rap for them.'

His attitude to marriage was also well in keeping with sixties attitudes. He believed that couples could never truly enjoy full equality in wedlock – either the husband wore the trousers or he was henpecked. No one doubted where Connery stood in his own household. He also declared little patience for women who 'whine or go into hysterics'. As for those who were unpunctual. 'If a woman's late, she won't find me there.'

Connery's perfect woman? 'I don't like one special type – blonde hair, big bust, or tall, dark with long legs,' he confided to *Woman's Own* in 1982. 'No, that doesn't work for me. It's simply chemistry. You're either drawn to someone or you're not.' When pushed, however, Connery does confess to finding foreign women more attractive, more exotic, than their British or American counterparts – and 'However old I get, I don't think I'll ever reach the stage where I won't turn to look at a see-through blouse.'

Finally there's the most infamous quote of all, the thorn that has pricked him periodically for decades. It was first uttered during an interview for the *Sunday Express* shortly before he started filming *Dr No*. Connery was answering a question about the cruel and sadistic side to Bond's character. 'I don't think there's anything very wrong about hitting a woman. I don't, though, recommend hitting a woman the way you hit a man.' At this point in the interview Connery rose to his feet to demonstrate what he meant, much to the consternation of the lady journalist. 'A right to the solar plexus!

A left to the jaw that sends her halfway across the room! No, I wouldn't recommend doing that to a woman. But an open-handed slap is justifiable. Or putting your hand over her mouth. But I wouldn't think I was sadistic.'

In a 1965 *Playboy* interview, conducted during the making of *Thunderball*, Connery repeated the 'slap' comment, even elaborating on it, remarking that a slap was justified only 'if all other alternatives fail and there has been plenty of warning. If a woman is a bitch, or hysterical, or bloody-minded continually, then I'd do it.' These words he would later come deeply to regret. Sure, it was a stupid and offensive thing to say, even in the mid sixties when the line between Connery the man and Bond the role was blurred. Still, this quote has been endlessly regurgitated by the press, usually out of context, and always as if Connery had uttered it just that afternoon.

Eighties American chat show queen Barbara Walters once even challenged Connery about the by now two-decade's old quote on national television. Barely suppressing his anger, Connery tried explaining the context in which he'd originally made the remark and that he didn't advocate knocking women about. Then Walters came right out with it. 'You are a male chauvinist, aren't you?' It's a charge more than one female journalist has levelled at him.

'Am I?' Connery replied, turning the tables. 'What is a male chauvinist?'

Quickly changing the subject, Walters invited Connery to complete the sentence 'Sean Connery is ...'

'... Almost a male chauvinist pig!' he answered, smiling. The next morning, driving in Los Angeles, Connery was amused by the public's reaction: men would give him the right-on sign, while at traffic lights some women gave him the finger.

A fresh storm arose over comments Connery made in a 1993 *Vanity Fair* interview. 'Sometimes there are women who take it to the wire. That's what they're looking for, the ultimate confrontation – they want a smack.' Just the sort of nonchalant statement one has grown accustomed to Connery making. His doggedly unreconstructed attitude towards women has been part and parcel of his timeless appeal – a persona uncorrupted by political correctness. But even Connery was taken aback by the extraordinary backlash his comments inspired. Forty-two MPs, including former actress Glenda Jackson, tabled an Early Day Motion in the House of Commons expressing 'profound disgust' at his remarks, while feminists and newspaper columnists predictably derided Connery's old-fashioned attitudes. Remarkably, Connery escaped general condemnation, even from women. Louisa Moore, ex-wife of former 007 Roger, sprung to Sean's defence. 'I don't think Sean is so violent. He looks it, but he isn't.' And Sheila Johnstone, writing for the *Guardian*, suggested that 'remaining a fan has become, for women, a deliciously guilty pleasure'.

But Connery was not amused, especially when ex-wife Diane Cilento put in her penny's worth, alleging physical mistreatment during their marriage.

Connery decided to put the record straight in an interview with *Paris-Match*. 'I'm fed up with reading these horror stories about me everywhere. They're all total fabrications. Enough is enough. I may not be perfect, but I am an honourable and honest man.' Wife Micheline backed him up. 'If he hit me, I'd kill him. He is very impatient and he sometimes gets very angry over the smallest things, but it only lasts 20 seconds and it's over. Sean is the most sensitive and emotional man I know. If he were the way they describe him, I'd have left him long ago. I'm no martyr.'

Brief Liaisons

'I remember spending most of my adolescence chasing women. I don't think I was successful with women at all. I was shy in those days.'

Connery once claimed to have been eight when he had his first sexual experience with an obliging local girl vastly more mature in years. Today the memory of it is blurred. Exactly what happened and where he can't or won't recall.

His first full-blown sexual encounter was with a uniformed ATS (Auxiliary Territorial Service) girl who followed him home one night. She suggested they might retire to the nearest air-raid shelter and the young Connery didn't feel like arguing. It was waterlogged inside but that didn't dampen their ardour. Of all the emotions buzzing round his head, severe gratitude outweighed all the others. 'I couldn't believe my good fortune.' As for the young lady, he never saw her again.

Fairly shy in his teens, despite an air of devil-may-care confidence, Connery was no more insecure than the average adolescent. What reticence there was Connery partly blames on never being taught the facts of life properly at school. 'I was stuck with all that doctors and nurses stuff.' Still, he courted much female attention. Girls would turn up at football matches where they knew Tommy was playing or at the local dance halls, where he was rarely without a partner. Like most boys he was coy talking about girls in front of his parents and rarely brought any home. When two lasses turned up at his doorstep to ask if he was free for the evening Joe unthinkingly told them that his mum was giving him his bath. Poor Tommy heard the sound of the girls' mocking laughter as they scurried away down the street. 'Fancy telling them a thing like that, Dad. Whatever will they think of me.' From then on he kept his courting activities a secret from his family, though you didn't have to be Einstein to work out where he was going on a Saturday night all suited up. Neil loved ribbing his brother next morning at the breakfast table, interrogating him about the previous evening's success rate. 'Shut your mouth' was the usual response, accompanied by a knowing grin.

After his stint in the Navy Connery grew more confident with the opposite sex and enjoyed an active social life. Blessed with dark good looks, he

never had a problem getting dates. Neil often caught sight of his brother roaring past on his motorbike with a girl on the back. They would be heading into town or out to spend a day at a nearby resort, picnicking and canoodling. Not many long-lasting relationships were formed, but on the rare occasions when he did invite a girl home it was a sure sign that something serious was afoot. One such girl was Isa Farmer, whose parents lived just off the Grass Market area behind Edinburgh castle. They dated regularly for several months, but just when an engagement announcement seemed likely, broke up.

Another serious affair developed during the run of *South Pacific*. Connery had become infatuated with the actress Carol Sopel, despite the fact that she was dating someone else at the time, a young agent named Dennis Selinger. That all changed once Connery made his intentions known. Soon they were inseparable, and the talk backstage was of impending marriage. Not, however, if Sopel's Orthodox Jewish parents had anything to do with it. No way was their daughter going to marry outside the faith – and certainly not to someone from a chorus line. Connery was broken-hearted, and it took him a long time to get over their split. Effie was disappointed, too. She'd taken a shine to Carol and regarded the couple as a perfect match.

For such a legendary sex symbol Connery has never indulged in the debauched lifestyle of a movie star, nor felt the urge to trumpet his conquests from the highest turret. Rumours of the odd affair have surfaced over the years, but remarkably few.

Prior to the opening of *Dr No* Connery enjoyed a brief liaison with actress Sue Lloyd, famous for her role in *Crossroads* and as Harry Palmer's love interest in *The Ipcress File*. They met at an actors' club and again a month later at a party attended by Michael Caine, Terence Stamp – all the up-and-coming sixties faces. Lloyd was aware of Diane Cilento, but also knew that Sean dated other women during the occasional fallow periods in their relationship. After the party she invited him back to her West End flat and they spent the night together innocently curled up in bed. 'He was very sweet and very lovable.'

When they bumped into each other again in 1965, during the height of Bondmania, Lloyd was pleasantly surprised to find no discernible change in the man. At the time he and Diane were in the middle of a trial separation, and this time the evening they spent together was more physically serious. 'It was a very close, friendly experience,' Lloyd revealed years later, 'and I've adored Sean ever since.'

During the filming of *Diamonds Are Forever* Connery indulged in a passionate fling with Lana Wood (Natalie's sister), who played Plenty O'Toole. According to the actress's 1984 autobiography her first meeting with Connery was a shock, to say the least. Wood arrived in his hotel suite unannounced and caught sight of him stark naked. 'Well, hello there' were Connery's first words.

'Sean is the most masculine of men, extremely confident, and when he wants, very charming and attentive,' wrote Wood. On set they had fun together and dined out each evening, always careful to find a place where they wouldn't be seen. It was only a matter of time before the relationship turned physical. 'He was an assured lover,' she wrote, 'given to bursts of spontaneity.' The affair was little more than a fling, probably for both of them, and it soon petered out.

In the nineties two alleged affairs in which Connery was 'supposedly' embroiled made front-page headlines. First there was Lynsey de Paul, the singer and songwriter, and then Helle Byrn, a 44-year-old Danish journalist, but Connery again strenuously denied any wrongdoing. In a statement he said: 'I have been the victim of a vicious set-up. I adore Micheline. She is the love of my life.'

Unlikely Pensioner

'A lot of actors go to great lengths to hide the fact they are getting old. Not Sean. His approach is: "I'm old and I'm bald; if you don't like it you can go to hell." '
Bryan Forbes

In the sixties Connery told a journalist he'd like to be an old man with a good face. He had in mind someone like Hitchcock or Picasso, men who'd worked hard all their lives and never wasted a day worrying about petty things. 'They know that life isn't just a bloody popularity contest.'

Connery has made growing old a fine art, as William McIlvanney wrote in the *Sunday Times* in 1996: 'He has somehow contrived to make ageing look like cosmetic surgery. He doesn't look any younger than he should, he just continues to look better than someone of his age has any right to do.' Blessed with a rare male beauty, it's easy to be blasé about the onset of wrinkles and attempts of others to combat the process. He finds Hollywood's quest for eternal youth ridiculous. 'The fascination for looking young is the joke of all time. As much as one would like to postpone death, it's inevitable – the only sure thing in life.' What he does fear is the possibility of one day becoming an invalid. 'I don't want that. No way. I would rather take a pill.'

In the seventies as Connery matured his film choices reflected that process. He never shirked from playing his true age, sometimes older. Yet in real life middle age did come as a bit of a shock. Turning forty-five and about to embark on a new film, Connery was asked by the production company to undergo a full medical check-up. After all the tests were carried out Connery asked the doctor for the verdict.

'You're in good shape, for a middle-aged man.'

Connery was somewhat taken aback. 'Middle-aged! I'm not middle-aged.'

The doctor looked at his patient intently before asking, 'How long do you think you're going to live?'

'Till I'm ninety,' Connery replied.

'Right,' the doctor said, 'You're halfway there. You're middle-aged.'

Everything was still in a decent working order. He continued to play sport in order to keep fit, 'though I'm pretty crook at the end of a strenuous game of tennis. I think it has a lot to do with all the delivering of milk I did as a child, in the rain and going straight to school in wet clothes. I don't think the whisky helps either.' Connery also meditated on what he wanted from the future. 'A little living, a little work, support my children and die quickly and without pain.'

Far from offers of work drying up, as Connery passed fifty the roles he was being asked to play became more varied and interesting. 'As Sean's gotten older, he's become much more subtle,' believes director Arne Glimcher. 'He can say more with a raised eyebrow than most actors can with a whole paragraph of dialogue.'

Increasingly he was playing more character roles, happy to accept the mantle of older, wiser statesman. 'For me there is nothing more beautiful than to watch Bogart at 48 or Connery today,' Christopher Lambert remarked in 1994. 'They've got something in their face that is interesting and charming.' But Connery knows what his audience loves him for best and refused to give up the action roles entirely. Most actors the wrong side of sixty are no longer convincing as heroic leads. Wayne and Eastwood just about managed it. But it was Connery who turned that notion on its head in films like *The Rock* and *The Avengers*, proving that in his late sixties he could outdo Stallone and Schwarzeneggar in the action-man stakes.

Upon reaching pensionable age, Connery joked that he was looking forward to claiming his bus pass and getting into the cinema for half price. 'I'm discussing with my lawyers whether it will affect my earnings. I pay through the nose in taxes so I hope it's deductible.' The inevitable question arose of a possible relaxation of movie commitments. Did he still have the appetite? His answer was firm. 'At the moment I don't feel I'm in the market for retiring.'

The publicity surrounding Connery's sixty-fifth birthday was enormous. SB Holdings, a bus company in Scotland, even wrote to the star offering him free travel for the rest of his life. Quick as a flash Connery responded by letter. 'Many thanks for my bus pass. I don't know how many times I shall get the opportunity to use it, but I shall have it clutched to my bosom and I won't venture over the border without it.'

Sure, Connery was getting old, but not old enough to warrant rumours of his demise, which first started in 1995. 'It's happened twice now,' Connery told reporters, after he was found to be alive and well. 'Again, I was the last to know, of course.' He could only guess that when close friend and ex-racing driver James Hunt died in the same week as former Texas governor

John Connelly, the overseas wire services must have got the two names mixed up. Confused? Connery certainly was. Numerous friends were understandably afraid to call his wife. Eventually one of them did. 'We hear that Sean died.' Micheline was perplexed. 'I don't think so,' she replied' 'he's out playing golf.' Later he was able to see the funny side of the mix-up. 'My death came as a bit of a shock. I wondered if anyone was celebrating.'

Scotland Forever

'As long as actors are going into politics, I wish for Christ's sake that Sean Connery would become King of Scotland.'

John Huston

Not for nothing does Sean Connery have the legend 'Scotland Forever' tattooed on his arm. He is a living, breathing commercial for the place and one of her greatest sons – the only person, according to the Scottish Tourist Board, whom foreigners unhesitatingly identify as a Scot. He has made it on the world stage without once compromising his Scottishness or apologizing for it. As Billy Connolly once put it: 'When you consider that Bonnie Prince Charlie was Italian and Mary Queen of Scots was French, Sean's the first Scotsman who's actually Scottish to have achieved anything.' He returns 'home' at least twice a year and it's always an emotional experience, though there's little from his own childhood to draw him back. His old haunts are now ghosts in the air, and his house in Fountainbridge is so much dust. 'The whole thing is gone,' he said soon after the street was demolished. 'It's like a whole slice of one's life has disappeared.' He is even partisan when it comes to golf, claiming Scottish courses to be the best in the world. Saying all that, it's curious that the country he so desperately wanted to escape from in his youth should now hold so dear a place in his heart.

This love of Scotland is most visible in his support for an independent state and his affiliation with the Scottish National Party. Connery was first asked to stand for Parliament as a Scottish National candidate as far back as the late sixties. 'I'd probably win on my name and Bond's. You could go into Parliament as an idealist, but pretty soon you'd discover where and how you had to toe the line.' In 1968 Connery admitted to never having voted in his life; no politician had ever excited him enough to make him want to vote for them. But the invitation to stand as a candidate if he ever chose to return to live in Scotland remained. Instead Connery promised to help in other ways, financial mostly. In June 1998 it was revealed that Connery paid £4,800 a month to the SNP, the party's single biggest individual donor, though amazingly it wasn't until 1992 that he became a card-carrying member. For years he'd been no more fiercely patriotic than any other ex-pat Scot, until he made his 1967 television documentary about the Upper Clyde shipyards.

'Then I began to see what could and should be done.'

Connery has never made any secret of his support for the nationalist cause. He would be glad to see his homeland pull away from the influence of Westminster and play its own part in Europe. He attached himself specifically to the SNP because it is the only party that actively seeks independence. 'The rest are all playing silly buggers.' In 1991 Connery participated in a television broadcast extolling the virtues of Scotland becoming a republic. It was his most public statement so far of support for the party and membership swelled as a direct result. SNP leader Alex Salmond claimed that his political enemies had been left 'shaken, stirred and panicked' and that Connery had delivered a 'rocket boost' for the fortunes of his party, which shot up seven percentage points in the polls.

But the repercussions were enormous. Politicians of every colour condemned the star's involvement in the devolution debate; of course, as a public figure Connery was an easy target. Labour MP Alistair Darling said, 'I think Scotland's future should be decided by people who live in Scotland, pay taxes in Scotland and have a personal stake in the nation's future. As far as I am aware, Mr Connery has made his future in a villa in Spain.' Glasgow's Labour MP George Galloway commented: 'As a tax exile living in Marbella who spends most of his time on the rolling golf courses of the Iberian peninsula, he ought perhaps to think twice about lecturing the rest of us unlucky enough to have lived through these last 12 years of Tory government.' And this from the *Sunday Times* political commentator: 'Sceptics will find Connery's attachment to the cause of an independent Scotland unconvincing until he announces his intention to reside here, and to pay the taxes an independent Scotland would require.' Harsh words; but the very virulence of these attacks was testimony to Connery's potency as a nationalist symbol. Still, he hit back, amazed at the reaction. 'I am entitled to be interested and involved. I have a birthright in Scotland.' Alex Salmond defended him too in a speech at an SNP rally. 'As for Sean Connery, he's done much more for Scotland in financial and in many, many other ways than every single Tory, Labour MP in Scotland put together and multiplied by ten.'

The star supplied more ammunition to the anti-Connery brigade when he appeared in a television commercial flogging Japanese whisky. Many saw this move, coming so soon after allying himself with the SNP, as the action of an unpatriotic hypocrite. A spokesman for the Scottish Whisky Association didn't mince his words. 'It certainly shows where his loyalties lie. Considering his strong pro-Scottish stance, he might have had second thoughts and put patriotism before greed.' Again Alex Salmond put the case for the defence, claiming that what Connery chose to do as an actor should be divorced from his political activities, adding, as a slight on the whisky brewers, 'They should have got off their backsides and signed up Mr Connery themselves.'

In November 1996 Connery made another television appeal on behalf of

the SNP, and again membership swelled as a result. In his broadcast he welcomed the recent return to Scotland of the Stone of Destiny, which had been taken to England in 1296 by Edward I where it lay under a throne in Westminster Abbey. Today it sits in Edinburgh Castle. But Connery declared: 'We need the substance, not just the symbols. We need more.'

That 'more' edged ever closer in September 1997, when Connery lent his considerable clout to the campaign for a Scottish Assembly. 'He urged Scots to back the Yes Yes vote, at times standing shoulder to shoulder with Scottish Secretary Donald Dewar, the man who only months later blocked the star's knighthood. 'We are pushing for nothing less than equality with England,' he said. Attending a pro-devolution rally Connery quoted from the declaration of Arbroath, written 677 years ago. 'It is not for glory, it is not for riches, neither is it for honour, but it is for liberty alone that we fight.'

When the results came in, Connery couldn't hide his glee. 'Fantastic. I feel really great that there will now be a Scottish Parliament in my lifetime.' At a meeting with Tony Blair just prior to his becoming Prime Minister Connery said how 'amazed' he was that Labour had pledged itself to a Scottish Parliament. For him that was the first step towards independence.

'I believe in the United Kingdom,' Blair answered.

'But once Scotland gets the smell of democracy we are on the road to independence,' Connery continued, informing Blair of his desire to carry out some non-political role in Scotland's future. 'I made it quite clear that if we really got our film industry together I would invest heavily in it – and not just be a figurehead.' Connery spoke of establishing a Scottish film foundation with the aim of turning Scotland into 'the Hollywood of Europe.'

Yet Connery's film-making activities in Scotland over the years leave much to be desired. The boat and helicopter chases in *From Russia with Love* were shot in the Highlands; some of *Five Days One Summer* was filmed in Glasgow; some scenes in *Entrapment* were set in Scotland; and there's *Highlander* of course: but that's about it. He has contributed in other ways, though. In the early eighties he backed a drive by the Scottish Office for kidney donors, inviting the public to become a 'special agent for life'. A few years later he joined a television campaign to help prevent a blood-supply crisis in Scotland. In 1988 Connery accepted membership of the Edinburgh Festival council and later became a patron of the neighbouring film festival. The committee got Connery to open their headquarters and someone asked, 'Have you ever been in this building before?' And Connery replied. 'I used to deliver milk here.' It was said perfectly seriously, not as a joke. 'And that's the side of him that I absolutely love,' says Billy Connolly. 'He doesn't differentiate between the milkman and the star.'

However, in November 1998 it was revealed that Connery had been holding secret talks with a group of businessmen and the Hollywood studio Sony in the hope of establishing a major studio on the outskirts of Edinburgh. The deal was reported as being worth in the region of £60m. One of the instiga-

tors behind the scheme, John Archer, told newspapers. 'Certainly for Sean there is a big element of patriotism. He sees this as putting something back and ever since the devolution vote he has been keen to back Scottish film-making.' It was hoped the facility might be up and running by 2001 and making 20 films in its first five years. 'I see it as a studio attracting major films.' Connery said on a visit to Scotland in March 1999. 'But with a training agenda involving all the main universities. It will be community-based and industry will grow around it.'

Most significantly of all in March 1997 he lent his voice to an anti-gun campaign. The controversial cinema advertisement was the highlight of an intense drive to pressurize the government to ban the use of handguns in Britain in the wake of the Dunblane tragedy. 'It is said that a total ban on handguns would take away innocent pleasure from thousands of people,' ran his voiceover. 'Is that more or less pleasure than watching your child grow up?' The choice of Connery, an actor not averse to appearing in films featuring guns and violence, was criticized in some quarters. But the campaigners were unapologetic. 'We don't regard this as hypocritical and we were delighted that Sean agreed to get involved. His voice is known all over the world and he has said he would only take part in future films involving guns where there was a moral image shown.'

In 1991, during one of his infrequent trips to Edinburgh, Connery insisted on visiting Scotland's only AIDS hospice to meet with each of the twenty patients in turn. One young man who'd contracted the disease from an infected needle desperately clung to life in order to meet his hero, but died just days before. 'Sean put his arms around me,' the boy's widow told reporters. 'He held me very tight. He kissed my cheeks and my hands, stroking them and soothing me. I could hardly speak I was so choked with emotion. He was so big, he was like a bear, yet so gentle. He jokingly whispered to me: "Will you be my knockabout?" I was crying, but I said, "Of course I will." ' Then a nurse came in cradling a child barely a year old. Connery asked to hold her, and as he rocked the baby girl softly in his arms he was told she had barely days to live.

Sally White, aged twenty-three, who'd got AIDS from her boyfriend, said, 'I know I'm dying, but Sean gave me hope. He held me in his arms and kissed me. You can't know what that means to someone in my condition, when a man of his magnitude will do that. He's a giant.' Two months after the visit, Sally died. 'It seems ironic he made *The Untouchables*, offered another of the patients. 'To many people *we* are the untouchables – but certainly not to Sean. He made us feel like human beings.'

10 Classic Connery Characters

Mark Rutland (*Marnie*)

'I've caught something really wild this time, haven't I. I've tracked you, and caught you and by God I'm going to keep you.'

One of the test titles for *Marnie* was *I Married a Frigid Female Thief*, which though it makes it sound like a dreadful drive-in cheapie pretty much sums up what the movie's all about. The coldly calculating Mark is actually just as warped as kleptomaniac Marnie, and Hitchcock is questioning not simply why she is a thief, but why Mark wants to marry one.

Radiating animal magnetism and warped masculinity, Connery channels the suave savagery of his Bond persona into a magnetically misogynistic performance that ranks among his finest work. Critic Dilys Powell was spot-on when she wrote: 'And there is Connery, trailing Bondish clouds of sexual arrogance.' Despite rating him as one of his most satisfactory leading men, Hitchcock admitted he was never convinced of Connery as an American businessman. Perhaps the part called for the kind of patrician charm and refined sex appeal of a James Stewart. Connery was just too masculine. How could Marnie, in spite of being unhinged, fail to be interested in sex with this man? 'Sean is very, very attractive,' Tippi Hedren said in 1983. 'And here I was playing the part of a woman who screamed every time he came near her.'

Joe Roberts (*The Hill*)

'I'm a regular soldier because I couldn't get a bloody job in civvie street.'

This was Connery's first true 'breakaway' role from Bond and a career milestone. Whereas in his previous two post-007 movies, *Woman of Straw* and *Marnie*, he wore nifty suits and tuxedos that drew inevitable parallels with his super-spy image, Connery played Roberts *sans* toupee, with a moustache and dressed in a dull khaki army uniform.

Court-martialled for striking an officer and alleged cowardice under fire, Roberts's will must be broken before he can be rebuilt into a model soldier. But after the death of a fellow prisoner he begins to question the methods and morality of army discipline. He is the classic case of the single man at odds with the establishment, championing the rights of the individual under a prison regime, and *The Hill* is a film that is as much an allegory about free will and human dignity as it is a study of military corruption.

The themes broached in the movie come to an explosive head in the parade-ground shouting-match between Roberts and Harry Andrews' sergeant-major (a role Connery initially wanted to play). Incredibly the scene was not in the original script, but came about midway through filming when director Sidney Lumet felt these two big lead characters needed a direct confrontation of some kind. It turned out to be arguably the single most impressive piece of acting Connery has ever done.

Samson Shillitoe (*A Fine Madness*)

'Why did I have to be a poet, Rhoda? Why a poet, why not a saint?'

The role of Samson Shillitoe was another departure for Connery and a performance of some virtuosity – all fists and mouth from start to finish.

Samson is the quintessential rebel-artist, a Dylan Thomas figure, drunken, violent, womanizing and stubborn with a bullish attitude to life. Shillitoe's struggle against society was seen by *Life* magazine as a metaphor for Connery's own battle to escape from the Bond straitjacket. Miraculously Connery makes this rogue a comic creation, almost charming, in spite of the fact that he's a virtual wife beater.

The highlights are a poetry recital at a prim women's guild, where, drunk on champagne, he causes a riot. The ensuing carefree romp along Brooklyn bridge is a great moment that wouldn't look out of place in any compilation of classic Connery clips.

Jack Kehoe (*The Molly Maguires*)

'There's them on top and them below, push up or push down, who's got more push, that's all that counts.'

Jack Kehoe was one of the toughest, most uncompromising characters Connery has ever played, and because of his own background someone he didn't have too much trouble relating to: 'Unless you give a man something aside from malnutrition you're going to get retaliation, terrorism.'

On set there were battles over how the part should be played. Connery

sensed that director Martin Ritt was disinclined to empathize with Kehoe, a downtrodden miner who advocates violence in the cause of social change, because of what would be construed as his Un-American stance. It's perhaps why in the final cut we never get to learn anything about Kehoe's background: he remains unyielding and closed off, attributes amply conveyed by Connery's brooding, sullen intensity.

Audiences were confused as to where their allegiances should lie. Were they supposed to cheer for Kehoe the terrorist or Richard Harris's ambivalent detective. Ritt later stated that he always saw Kehoe as the film's hero. But on screen it's not always that obvious.

El Raisuli (*The Wind and the Lion*)

'I pray to Mecca five times a day. If I miss the morning prayer, I pray twice in the afternoon. Allah is very understanding.'

One of Connery's larger-than-life characters and his most poetic performance, El Raisuli, Lord of the Riff and last of the Barbary pirates, is a gallant desert warrior ripped from the pages of a child's storybook. Charismatic and contradictory, Raisuli can be full of childlike wonder and joy one minute, while the next brutally decapitating those who have offended him.

Taking on the role Connery admitted to being fairly ignorant of Islam, but learnt much during the making of the movie. 'He's been written as a well-rounded, full-fledged man who lived by the Islamic code – and I find that stimulating.'

Playing Raisuli was a landmark in Connery's career: not since Bond had he been presented with a role so deserving of his imposing cinematic stature. The success of *The Wind and the Lion* revived his slipping popularity, returning him once again to the entertainment mainstream after the mediocre public response to his post-007 repertoire. It also helped change audiences' perception of him as a tuxedo-dressed, sophisticate to an old-fashioned epic hero. In despair at the approaching modern world, with its high-tech weaponry and declining moral codes, Raisuli is a hero in a world too late for heroes, and this is a common thread running through many of the characters Connery has since chosen to play.

Daniel Dravot (*The Man Who Would Be King*)

'Peachy, I'm heartily ashamed for getting you killed instead of going home rich like you deserve to on account of me being so bleeding high and bloody mighty.'

John Huston's film centres on the relationship between two likeable rogues who are loyal to each other and their ideals. 'Sean and I were sort of born to play these two fellas,' Caine has said. Both symbolize the immorality of the British Raj, the inbred belief in an Englishman's supremacy over the rest of the world. Arrogantly they march into a foreign land to claim it for themselves.

Where Peachy is the brains of the outfit, Danny is the muscle; he's also a dreamer, and power goes to his head with tragic results. When Danny starts believing his own legend, that he truly is the heir to Alexander the Great, their plan crumbles around their ears. A simple, flawed man, but still heroic, Danny is also a tragic clown, butchered because he aspires to be more than he is.

Robin Hood (*Robin and Marian*)

'I've never kissed a member of the clergy. Would it be a sin?'

Connery's Robin Hood is a tired and tragic figure. Like El Raisuli he's out of kilter with a changing world, and both *The Wind and the Lion* and *Robin and Marian* are in a way elegies for the passing of a chivalric age. Returning disillusioned from the Crusades, Robin struggles to recapture the daredevil exploits of his youth. 'Robin's trying to be a young revolutionary at the age of 50 and it doesn't work,' said Connery. It's a path which brings about a touching reunion with Maid Marian and rivalry with his old nemesis the Sheriff of Nottingham.

In a performance one never grows tired of watching, Connery plays Robin with an engaging honesty and a wry line in self-mockery. There's a marvellous moment in the forest camp when Robin wakes up. He is about to relieve himself in the bushes when he notices Marian stirring nearby and stops just in time.

Lester's film is about the fading of a man's dreams for adventure and the waning of youth. Like *The Man Who Would Be King*'s Daniel Dravot, Robin's stubborn belief in his own mythical status ultimately leads to his downfall. 'He's not a very intelligent guy, who's at heart a boy, and that's how I played it.' He's also naïve in the extreme; both Marian and the sheriff are vastly more clued-up about what's going on in the real world than Robin. Robin has never grown up and is struggling to come to terms with a legend he doesn't understand. In one of the most touching moments in seventies cinema Marian ensures that the legend will never decay by bestowing on Robin the death that passed him by on the battlefield.

Once asked which of the characters he'd played most resembled the real Sean Connery, the actor revealingly chose Dravot and Robin Hood.

Robert Dapes (*Cuba*)

'South American squares are full of statues to soldiers of fortune, mostly British.'

While the film *Cuba* itself may have been critically dismissed, mercenary Robert Dapes is a good example of the roles Connery was playing in his post-007 career – characters who rarely got the girl, often fought for a lost cause and were rigid moralists rather than Bond's slick cynic.

Like El Raisuli and Robin Hood, Dapes is another man out of his time. Hired by the Cuban government to quell a revolution that is already lost, Dapes struggles to make sense of a world in which his traditional soldier's code seems anachronistic. 'Soldiering has changed,' he laments in one scene. 'It's not as clean as it was.' Dapes wanders in and out of the frame looking increasingly lost as reality dawns on him that his paymasters are corrupt and the system he's been sent in to save stinks.

In the midst of revolutionary chaos Dapes renews relations with Alexandra (Brooke Adams), whom he'd fallen in love with years before. *Cuba* now turns into a *Casablanca* pastiche, as Dapes attempts to ferry Alexandra to safety on the last plane out of the country. Will she or won't she join him? Several finales were filmed and the one director Richard Lester chose certainly didn't impress the critic of the *New Yorker*: 'Any woman who would pass up Sean Connery in order to keep her white Cadillac convertible deserves whatever fate the insurgents plan for her.'

O'Neil (*Outland*)

'They send me here to this pile of shit because they think I belong here. I want to find out if they're right.'

Connery's choice of material sometimes reflects his own personal philosophy, and he certainly felt an affinity with O'Neil's battle against interstellar drug dealers. 'Because I'm in favour of law and order. I loathe the high security factors we live with now, the senseless slayings, cruelty, mugging and god knows what else. It's everywhere, and I think a lot of it is drug-orientated.' Playing O'Neil, Connery gave voice to his fears as a human being and father about the dangers of drugs.

O'Neil is the quintessential Sean Connery hero, a common man who overcomes great odds through guts and dogged integrity. 'O'Neil is a stubborn man, a decent man – a man with strength as well as intelligence and vulnerability.' *Outland*'s director Peter Hyams could almost be referring to Connery himself.

Having been shuttled from one no-hope outpost to the next, O'Neil finally decides to stand up for the principles he believes in. He embarks upon a personal odyssey against the system, represented by his drug-pushing boss. It's very much a fight to redeem himself and restore some lost honour. His is a strong, credible and sincere performance in an otherwise bleak film.

As critic Neil Sinyard wrote in 1981, 'The roles Connery plays are those which celebrate acts of personal courage, and they still have some power to move.'

Douglas Meredith (*Five Days One Summer*)

'I can't help you, because I'll never let you go.'

The role of Douglas went very much against the grain of Connery's usual macho screen image. It's possibly his most vulnerable performance, in which he subtly conveys the guilt gnawing at the core of this sad and pathetic man. He likened Douglas to an Ibsen character, a pillar of the community ultimately undone by his emotions. He played the part with just the right mixture of paternal concern and sexual longing.

Significantly Fred Zinnemann's picture was the first in which a visibly older Connery enjoys a sexual relationship with a much younger actress. It's a trend that has continued to this day with stars like Kim Basinger, Michelle Pfeiffer, Julia Ormond, Kate Capshaw, Tia Carrere, Uma Thurman and Catherine Zeta Jones – this despite the fact Connery is now approaching his seventies. But the man's charisma and sheer sex appeal stops these pairings from seeming ridiculous. Few other actors could get away with it.

Ramirez (*Highlander*)

'In the end, there can be only one.'

This 2,437-year-old Egyptian nobleman is one of Connery's more flamboyant creations. Resplendent in colourful garb, ponytail and grandee's pearl earring, Connery makes a dashing and witty hero, a return to the old El Raisuli days. 'Connery is terrific and made me wonder why his long career has included little or no swashbuckling, because here he manages a mature Errol Flynn to great effect,' commented the *Glasgow Herald*.

For Connery the challenge in playing Ramirez was to imbue him with a flavour of all the different cultures to which he would have been exposed down the centuries. This search for credibility was, however, hampered by the wacky script and occasionally crass dialogue.

Audiences worldwide warmed to Ramirez in a way they hadn't to any

other Connery role since possibly James Bond. The part was the first in a long line of father/mentor roles that Connery was saddled with for the remainder of the eighties. In this sense Ramirez practically defined his screen image for the next half-decade.

William of Baskerville (*The Name of the Rose*)

'How peaceful life would be without love, Adso. How safe, how tranquil. And how dull.'

Perhaps Connery's greatest challenge, the role of this super-sleuthing four-teenth-century monk certainly caught his eye. 'It's such a pleasure to play somebody who's reasonably intelligent and witty. Most movies are bereft of that. It got me excited, which rarely happens.'

Part of his research included a visit to a monastery outside Madrid. Not a great fan of organized religion, Connery did find himself intrigued by the firm commitment to God made by the monks. To play the part Connery deliberately scaled down much of the body movement he usually employs in his acting. William moves slowly and deliberately, avoiding close contact with other people in accordance with medieval religious custom. The overall effect is a delight. Connery turns his Franciscan monk into an unlikely hero, the upholder of reason and justice in a world ruled by ignorance and super-stition. It's possibly his finest performance. 'Connery radiates presence, even in grey sackcloth,' wrote the *Daily Mail*.

After *Highlander*, *The Name of the Rose* confirmed the arrival of a new dimension in Connery's work: the role of teacher. Connery is a master at conveying paternal tenderness, and his relationship with Christian Slater's character is at the core of this movie. 'Adso is the student and Sean is the teacher,' Slater told *Rolling Stone*. 'It's pretty much what's going on here in real life.' At times the two come across as a medieval Holmes and Watson, and Connery even quotes the great sleuth's immortal "elementary" line. And the comparisons don't stop there: that surname certainly sounds familiar. With all that sleuthing, however, one wonders how much room there is in William's life for his faith.

Jim Malone (*The Untouchables*)

'You want to get Capone, here's how you get him. He pulls a knife, you pull a gun. He sends one of yours to the hospital, you send one of his to the fucking morgue.'

The stereotypical honest cop in a dirty town, still walking the beat in his old age, Connery as Malone again extends his role as tutor. He teaches a green-

horn Eliot Ness (Kevin Costner) about the harsh realities of Chicago and how to fight dirty, turning him into an unlikely man of action ready to manipulate the laws he once held dear. 'Malone is a guy who is worldly-wise,' said Connery, 'knows the score with the crooks, is frightened for his life, and had just planned on staying alive until he met Ness.'

Burned out and fed up with the injustice all around him, Malone finally takes a stand alongside Ness and becomes boyishly enthused about going after Capone. 'It's one of those classic relationships,' said Costner. 'I think we all would like to go through life with a figure that's standing over us, keeping us from mistakes and Sean represents that with all the charm that Sean brings to bear in a movie.' The *Evening Standard* described Connery's performance as 'a gale force of moral integrity'; certainly, Malone is the film's heart, its soul. Always philosophizing and exuding a grandfatherly glow, Malone finally meets death at the hands of a Capone thug in perhaps the most melodramatic since John Wayne's departure as Davy Crocket in *The Alamo*.

In playing Malone Connery first emphasized the character's harsh side in that memorable scene where he berates Ness for throwing litter. Then he reveals a gentle and vulnerable man behind the gruff exterior, a man capable of emotion and forming close bonds. Connery based the character in part on a local policeman in his old Edinburgh neighbourhood. 'We would watch him coming down the street. If he was walking at his usual measured pace all was well. But if not, if he was really moving, then someone was in for it.'

Henry Jones (*Indiana Jones and the Last Crusade*)

'The diary tells me that goose-stepping morons like yourself should try read-ing books instead of burning them.'

Connery achieved an impossible feat with this role, managing to portray a cantankerous, absent-minded old scholar without blunting his forcefulness and without sacrificing his sexual charisma. Connery was behind the sugges-tion that Jones Senior should bed the leading lady before the hero does. It was the film's funniest revelation, something Messrs Spielberg and Lucas initially flinched at, a puritanical response which surprised Connery. As conceived by screenwriter Jeffrey Boam, would the Henry Jones character have bedded this blonde bombshell? 'No way,' said Boam, 'but Sean Connery would.'

Connery took exception to the way Henry Jones appeared in the script – 'There wasn't any jazz in the part' – so he roped in playwright Tom Stoppard to beef it up. Though uncredited, Stoppard was responsible for the touching scene in which Indy taxes his father with having been an absent parent. Father and son haven't spoken for years. With the two now reunited, Indiana Jones is reduced to the status of snot-nosed child; his father still refers to him

as 'junior' and slaps him for blaspheming. But their mutual antagonism eventually thaws, and during the course of searching for the Holy Grail father and son discover an intimacy after a lifetime of estrangement.

John Mason (*The Rock*)

'Losers always whine about their best. Winners go home and fuck the prom queen.'

Connery here played a former SAS officer, privy to enough conspiracies and government secrets to keep the X-Files team happily going for a whole season. John Mason, who has been held in an American prison 'longer than Mandela,' represents yet another Connery teacher role; his protégé this time is a nerdy FBI chemical expert with no field experience.

Arguably the meanest, toughest son-of-a-bitch Connery has ever played, Mason may be over pensionable age but succeeds in duffing up muscular marines half his age. With the exception of Clint Eastwood any other actor would have looked stupid and strained audience credibility to breaking-point. But at sixty-six Connery proved he could still handle the action stuff with customary panache.

Sir August de Wynter (*The Avengers*)

'Now is the winter of your discontent.'

If for no other reason, *The Avengers* ranks as a unique film in the Connery canon, because for the first time since 1964's *Woman of Straw* he plays an out-and-out villain, a crazy 007-style baddie intent on taking over the world by controlling the weather. 'It's James Bond on acid,' said co-star Ralph Fiennes. 'I think Sean wanted to play de Wynter as a larger than life villain.'

Connery's de Wynter is an operatic eccentric crook, but it doesn't really work; in fact it's probably one of the worst outings of his career. 'Connery's bored performance suggests that his mind was on breaking 80 at some adjacent golf course,' wrote *USA Today*. His presence remains as magnetic as ever, but the problem is that Connery just can't play villains, unlike the Hackmans and Nicholsons of this world. He can do the roguish crooks of, say, *The Anderson Tapes* or *Family Business*, in which there's always that charming twinkle in his eye. Stripped of his trademark charisma Connery, as de Wynter, comes over like a one-dimensional irascible pensioner.

11 Allsorts

Miscellaneous Projects

In 1966 Connery narrated the classic story of *Peter and the Wolf* for a Decca album release, for once exploiting his Bond fame in a positive way by helping to introduce young people to classical music.

The next year he provided the voice-over for a twenty-minute documentary entitled *The Castles of Scotland*, before embarking on the most personal project of his life. *The Bowler and the Bunnet* centred on the plight of Fairfields shipyard on Clydeside and the rift between workers and bosses. The division is highlighted in the title: while the bowler is obviously the institutionalized headgear of the businessman, the bunnet is Scotland's equivalent of the flat cap.

The film came about after Connery was introduced to Sir Iain Stewart at a golfing dinner in London. He felt drawn to the Scottish industrialist's revolutionary proposals to revitalize the ailing Clydeside shipyard by eradicating the 'them and us' barrier between workers and management. It was a noble experiment, one which received the backing of Harold Wilson's Labour government, and Connery wanted to be part of it. 'I don't want to sound like a communist on Clydeside,' he said soon after, 'but I think if they can solve their problems there, then they have the solution to all the labour-management problems in Britain.'

Connery went up to have a look for himself, talk to the workforce and find out whether the scheme stood any kind of a chance. He came away so impressed that he decided to make a documentary about what Stewart was trying to achieve. Scottish television lent him one of their camera teams and during a few weeks at the end of 1967, Connery wrote, directed and presented the documentary. Not surprisingly, he found himself siding with the workers, angry at how shabbily they'd been treated by bosses. These hard-grafting men were mildly taken aback by Connery's humility and lack of showbiz trappings. After the initial novelty of having a film star in their midst wore off, they grew to accept him as an ordinary Scot. For a brief time he almost became one of them, and in the evenings would prefer to mix with the trade-union mob than management.

Though *The Bowler and the Bunnet* was shown in Scotland, both the

BBC and ITV refused to give it an airing, even when it was offered free of charge. This decision was hard to fathom considering that Connery was then one of the most famous people on earth. Or did politics get in the way? Connery was heartened to learn later that his work was highly regarded in Russia, securing an honoured place in Moscow's film archives. It was also valuable on a more personal level, waking him up to the fact that part of his soul still belonged to that kind of background. 'I just couldn't turn my back on it completely.' After years of fame and wealth the time had come to give something back. This realization ultimately led to his creation of the charity trust and a renewed belief in nationalist politics.

What became of Sir Iain Stewart's bold initiative? In 1968 Fairfields was subject to a company merger and the methods that had hitherto proved so successful were abandoned. Sir Iain resigned in protest and within fifteen months the shipyard was declared bankrupt.

It wasn't until 1982 that Connery returned to the medium of documentary. After providing the narration for *Gole*, a colourful record of the 1982 World Cup, he was asked by the Lord Provost to help with a film that aimed to promote tourism in Edinburgh. Just a voice-over would do, they said, but Connery became so enthusiastic that he ended up presenting the piece and giving his services for free. The end result was a mildly diverting travelogue about the sights and sounds of his birthplace. The film was well received when shown at the Edinburgh Film Festival and was released on video.

Fans had to wait until August 1986 for Connery's radio drama début in Peter Barnes's *After the Fire*, a black comedy about three pimps lamenting the death of a famed prostitute. Though star-heavy (with Donald Pleasance and John Hurt joining Connery), the BBC's budget was paltry, and Connery ended up donating his small fee to charity. He even had to pay his own plane fare from Spain. The BBC didn't even lay on a car. When recording finished at the corporation's Maida Vale studio, the three stars were forced to hail cabs. Connery snaffled the first and headed straight for Heathrow, leaving Hurt and Pleasance hanging around for another. When one arrived the driver instantly recognized the pair. 'Cor, wait till I tell my missus.' To which Hurt replied, 'You should have been here five minutes ago.'

In March 1998 Connery lent his voice to another project. Fabled producer and 'fifth Beatle' George Martin asked him to give a spoken rendition of the John Lennon classic 'In My Life' for his farewell album, which included covers of other Beatles hits by the likes of Goldie Hawn, Jim Carrey and Robin Williams.

In the film *The Man with the Deadly Lens*, Connery, playing television reporter Patrick Hale, is asked: 'What's the best thing you've done?' To which he replies, 'Not written my autobiography.' Yet it's one of the key 'solo' projects for which Connery fans have been waiting. Since the early eighties he's been hounded by top publishers offering millions for his memoirs. While Michael Caine has done it, very successfully, Connery has

always refused. 'I could certainly write some strong stuff but I don't think afterwards I would feel too comfortable in my own skin. You can't write those private things without other people getting hurt.' It's a fair reason, and so typical of the man.

Connery on Russia

As Bond he was the scourge of the KGB, but it wasn't until 1969 that Connery paid his first visit to Russia, shooting *The Red Tent* on location in Moscow and Leningrad. With 007 movies banned from public exhibition in Russia, Connery could walk about totally unpestered. Copies on 16 mm film were, however, secretly shown behind closed doors at all the embassies. 'So I was very big on the embassy circuit, but no one in the street knew me from a bag of beans.' Connery revelled in the anonymity. There were drawbacks, however, such as the time he was invited to the British Embassy club in Moscow for some home brew only to be turned away at the door when a Foreign Office policeman failed to recognize him.

At first the authorities were a touch apprehensive about James Bond working on Soviet soil. When they realized that Connery had directed a documentary about trade unionism, *The Bowler and The Bunnet*, they eased up on the bureaucracy. 'They asked for a print of it and it's now in the Mosfilm archives,' Connery proudly claimed. 'Once they'd seen it and found out about my tenement background they had no trouble accepting me.'

Communism left an indelible mark on Connery. He witnessed first hand a political system that spread fear and paranoia throughout its population. 'You got the impression that everything was like some rather sinister, well-oiled machine.' Every day the chauffeur was changed, doubtless so that Sean's decadent Western ways would not corrupt him. 'You didn't know who your driver was. But he knew you,' Connery remembered. 'You used to come out of the door and wait, and the driver picked you up like you were laundry.'

The mountainous piles of red tape irritated him no end: to get into the film studio each morning he'd have to endure endless identity checks, usually carried out by KGB staff. His interpreters also turned out to be KGB. Connery was under no illusions that he was in a police state. 'You couldn't even talk on the telephone. It was like a B-movie, but it was for real.'

The Russian film industry also got a big thumbs-down. The Mosfilm studios were monolithic ('bigger than all the American studios put together') but there was little organization or sense of schedule: scenes took an eon to light and shoot. 'There was no urgency about anything in filming the production.' Worst of all the decision-making was usually wrenched from the artist's hands. On set a KGB officer would hover behind the director on every shot, and his decision was final. 'There were no negotiations, no disputes. It was total totalitarianism.'

Twenty years later Connery returned, during the height of *glasnost*, to film *The Russia House* in Moscow. On this visit he took time out to inaugurate the city's first ever golf course. Though much had changed in the interim, a lot had stayed the same; local people still failed to recognize him or his new co-star, Michelle Pfeiffer. 'Fayfer?' inquired one puzzled Moscovite. 'I don't know her.' The name James Bond did ring a bell. 'Ah yes, 007, the American spy. *He* is here?' Since his departure the Bond movies had acquired a cult following in Russia and were hugely in demand on the black market.

The authorities were certainly more co-operative this time. Whatever the production team wanted they usually got, be it help from the police or permission to shoot in Red Square. Kremlin officials could oversee proceedings from their offices. Connery was also relieved to see how much younger the interpreters were; there were no KGB this time, and most turned out to be women. 'They are very much more overt, much more argumentative, much more human.' More so than before, Connery was able to get closer to ordinary Russians and talk to them. During the late sixties every other person looked like KGB, 'and you couldn't question anything'.

Inevitably Connery was asked about Gorbachev. 'An extraordinary combination of intelligence, serenity and baldness' was his opinion, though the state of the country still left him despairing. 'You can see that it's rotten,' he told *Premiere* in April 1990. 'The general level of health is pretty pathetic. Teeth bad. Skin not great. Soap rubbish. It's like wartime Britain. Long queues. And they are outspoken to an extreme in criticizing Gorbachev; they don't seem to be conscious of how big a leap they've taken compared to when I was there before.'

Macbeth

The spectre of Macbeth, arguably the most famous (or infamous) play ever written, has loomed large across the Connery career.

In 1959 Connery's acting caught the attention of Joan Littlewood, who offered him a place in her Macbeth Theatre Workshop tour of Russia and Eastern Europe. To his friends' surprise Connery declined, giving no reason. Perhaps by this time his goal was film, theatre no longer holding the allure it once did. One aspiring actor who jumped at the chance was Richard Harris.

In the autumn of 1961 Connery – egged on by Diane Cilento – accepted an offer to appear in a Canadian television production of *Macbeth*. It was Friday morning and he was at home in bed with the flu when the call came through. He'd been chatting away for about twenty minutes before he realized that the call was coming through from Toronto. His first thought was: 'My god, I hope he hasn't reversed the charges!' The producer was desperate to snare Connery's services. 'We're doing Macbeth on Monday. Would you like to play it?'

'What *this* Monday?'

'Yes, get a plane and come over. It's a special cultural thing on TV and there's not a lot of money in it.' (Connery got around $500.)

Anyway he said yes and jumped out of bed. Then it hit him: 'Christ, what do I do first?' Grabbing a copy of the text, he read it straight away and suddenly realized what he'd got himself into. 'It was monumental. I re-read it over and over all the way to Canada and somehow I was ready to go on Monday morning.'

In the late sixties Connery toyed with directing his own film version of Shakespeare's tragedy, 'to be made in Scotland with Scottish actors,' and based on a script he'd written himself. The long-cherished project was ultimately scuppered when he learned that Roman Polanski was planning his own production. Speaking in 1982 after reading his old *Macbeth* script, Connery revealed some of it to be 'quite good. Apart from the fact it was a terrific author that started it.'

In another weird twist son Jason played the role, complete with beard and heavy-metal hair cut, in a 1997 low-budget film that was shot in just twenty-eight days in Scotland. Jason hoped the role might finally establish him as a major acting talent in his own right. Alas, a very limited cinema run ensured that practically no one saw it.

Trainspotting

Trainspotting was a movie Connery announced should be seen by everyone, especially those living in Edinburgh. 'It blows away a side of what's going on in Edinburgh and it's very healthy to expose what it's all about.' He was also delighted that one of the movie's characters sporadically adopts a Bond impersonation and fantasizes about being 007. 'It's very flattering that the guy Sick Boy has this obsession about me and James Bond.'

The *Trainspotting* team of Danny Boyle and John Hodge wanted Connery to play a walk-on role as God in their 1997 movie *A Life Less Ordinary*. Connery turned it down, being too involved with the practicalities of forming his own production company Fountainbridge Films. The only solution was to write the Almighty out of the script. Barring Charlton Heston, is there any other actor alive with the clout to play God?

Tributes

'He's a huge personality and he plays himself to the hilt' – John Huston

'He is undoubtedly the world's number one bullshit detector. He is also the funniest man alive' – Michael Caine

'I fantasize about riding bareback with him, on an Arab horse along a sandy beach. We fall naked on the ground and make passionate love in the moonlight. It always leaves me hot and bothered. I just love the man!' – Kim Basinger

'He's enjoying a career where he's at the top of his form at his age which is remarkable. I mean, who gets to act that long and still be the event with every movie?' – Nicolas Cage

'Sean's a great big pussy cat, a rare animal. He talks to you like a person. He doesn't put on airs' – James B. Sikking

'He's an interesting handknitted commodity in an industry of synthetic fibres' – William McIlvanney

'He's what I call a really good man. He leads his life and conducts himself in a way that I would seriously aspire to' – James Hunt

'Sean Connery is probably the biggest star in the world' – Kevin Costner

'He's a straightforward guy. He could have made millions sticking to Bond, but he didn't want to be typed. In two seconds I'd let him play in anything I've got' – Joseph E. Levine

'Connery is a generous actor, which is to say that he just goes to work with no bullshit' – Harrison Ford

'Once Sean is convinced everyone is professional, Sean does what he likes to do most, which is be creative, and act' – Philip Kaufman

'Sean brings his own particular energy and presence to the set, which is unlike anything I've encountered before. It is something unique about him' – Ralph Fiennes

'Apart from being a damn fine actor he has a natural chemistry that works on the screen and that is something you are born with' – Sir John Mills

'Most actors, if they are lucky, stay as good as they are. Sean is one of the rare ones who got better' – Sidney Lumet

'Look how long Sean has sustained, and it's what he brings, a tremendous power that he has, tremendous artistic integrity that he brings into a project' – Martin Bregman (producer)

'He truly has qualities that I wish that I had' – Kevin Costner

'Sean is the consummate professional – which is the highest compliment that I can pay him. While I'm inclined to wing it, I've always had the feeling that Sean's known his lines for weeks. He comes to the set so well rehearsed, it's as if he's spent hours in his bedroom going through all his moves' – Michael Caine

'There are seven genuine movie stars in the world today and Sean is one of them' – Steven Spielberg

'He's a very straight man, without guile. If he makes a mistake, he's the first to say "I screwed up." He respects his craft and his responsibility. He will not tolerate ego from others, because he does not display it himself' – Peter Hyams

'He's a marvellous person. He's fundamentally honest, a little too honest. I like him inordinately as a man; as a man he's even more impressive than he is as a public figure' – Terence Young

'With the glorious exceptions of Marlon Brando and Laurence Olivier, there's no screen actor I'd rather watch than Sean Connery. His vitality may make him the most richly masculine of all English speaking actors' – Pauline Kael

Filmography

NO ROAD BACK (GB/RKO 1956)
Director: Montgomery Tully
Producer: Steve Pallos
Screenplay: Charles A. Leeds and Montgomery Tully
Cast: Skip Homeier, Paul Carpenter, Margaret Rawlings, Eleanor Summerfield, Alfie Bass, Sean Connery
UK Release Date: February 1957

HELL DRIVERS (GB/Rank 1957)
Director: Cy Endfield
Producer: S. Benjamin Fisz
Screenplay: John Kruse and Cy Endfield
Cast: Stanley Baker, Herbert Lom, Peggy Cummins, Patrick McGoohan, William Hartnell, Wilfred Lawson, Sidney James, Jill Ireland, Alfie Bass, Gordon Jackson, David McCallum, Sean Connery
UK Release Date: August 1957
US Release Date: May 1958

TIME LOCK (GB/British Lion 1957)
Director: Gerald Thomas
Producer/Screenplay: Peter Rogers
Cast: Robert Beatty, Betty McDowell, Vincent Winter, Lee Paterson, Sean Connery
UK Release Date: August 1957

ACTION OF THE TIGER (GB/MGM 1957)
Director: Terence Young
Producer: Kenneth Harper
Screenplay: Robert Carson
Cast: Van Johnson, Martine Carol, Herbert Lom, Gustavo Rocco, Anthony Dawson, Sean Connery
UK Release Date: August 1957
US Release Date: August 1957

ANOTHER TIME, ANOTHER PLACE (GB/Paramount 1958)
Director: Lewis Allen
Producers: Lewis Allen and Smedley Aston
Screenplay: Stanley Mann
Cast: Lana Turner, Barry Sullivan, Glynis Johns, Sean Connery, Sidney James, Terence Longdon, Doris Hare
UK Release Date: May 1958
US Release Date: April 1958

DARBY O'GILL AND THE LITTLE PEOPLE (US/Walt Disney 1959)
Director: Robert Stevenson
Producer: Walt Disney
Screenplay: Lawrence Edward Watkin
Cast: Albert Sharpe, Janet Munro, Sean Connery, Jimmy O'Dea, Kieron Moore, Estelle Winwood
UK Release Date: July 1959
US Release Date: June 1959

TARZAN'S GREATEST ADVENTURE (GB/Paramount 1959)
Director: John Guillermin
Producer: Sy Weintraub
Screenplay: Berne Giler and John Guillermin
Cast: Gordon Scott, Anthony Quayle, Sara Shane, Scilla Gabel, Sean Connery, Niall MacGinnis
UK Release Date: June 1959
US Release Date: July 1959

THE FRIGHTENED CITY (GB/Anglo Amalgamated 1961)
Director: John Lemont
Producers: John Lemont and Leigh Vance
Screenplay: Leigh Vance
Cast: Herbert Lom, John Gregson, Sean Connery, Alfred Marks, Yvonne Romain, George Pastell, Kenneth Griffiths
UK Release Date: September 1961

ON THE FIDDLE (GB/Anglo Amalgamated 1961)
Director: Cyril Frankel
Producer: S. Benjamin Fisz
Screenplay: Harold Buchman
Cast: Sean Connery, Alfred Lynch, Cecil Parker, Wilfred Hyde White, Stanley Holloway, Eleanor Summerfield, Alan King, John Le Mesurier, Barbara Windsor
UK Release Date: October 1961

THE LONGEST DAY (US/20th Century Fox 1962)
Directors: Ken Annakin, Andrew Marton, Bernhard Wicki, Darryl F. Zanuck
Producer: Darryl F. Zanuck
Screenplay: Cornelius Ryan
Cast: John Wayne, Robert Mitchum, Henry Fonda, Richard Burton, Rod Steiger, Richard Todd, Kenneth More, Robert Ryan, Robert Wagner, Peter Lawford, Jeffrey Hunter, Stuart Whitman, Eddie Albert, Edmond O'Brien, Roddy McDowall, George Segal, Sean Connery, Curt Jurgens, Gert Frobe, Mel Ferrer, Frank Finlay
UK Release Date: October 1962
US Release Date: October 1962

DR. NO (GB/United Artists 1962)
Director: Terence Young
Producers: Albert R. Broccoli and Harry Saltzman
Screenplay: Richard Maibaum, Johanna Harwood and Berkely Mather
Cast: Sean Connery, Ursula Andress, Joseph Wiseman, Jack Lord, Bernard Lee, Anthony Dawson, John Kitzmiller, Zena Marshall, Eunice Gayson
UK Release Date: October 1962
US Release Date: May 1963

FROM RUSSIA WITH LOVE (GB/United Artists 1963)
Director: Terence Young
Producers: Albert R. Broccoli and Harry Saltzman
Screenplay: Richard Maibaum
Cast: Sean Connery, Daniela Bianchi, Pedro Armendariz, Lotte Lenya, Robert Shaw, Bernard Lee, Lois Maxwell, Desmond Llewelyn, Eunice Gayson, Vladek Sheybal, Martine Beswick, Walter Gotell
UK Release Date: October 1963
US Release Date: April 1964

WOMAN OF STRAW (GB/United Artists 1964)
Director: Basil Dearden
Producer: Michael Relph
Screenplay: Robert Muller and Stanley Mann
Cast: Gina Lollobrigida, Sean Connery, Ralph Richardson, Johnny Sekka, Alexander Knox, Andre Morell
UK Release Date: April 1964
US Release Date: October 1964

MARNIE (US/Universal 1964)
Director/Producer: Alfred Hitchcock
Screenplay: Jay Presson Allen

Cast: Sean Connery, 'Tippi' Hedren, Diane Baker, Martin Gabel, Louise Latham, Alan Napier, Bruce Dern
UK Release Date: July 1964
US Release Date: June 1964

GOLDFINGER (GB/United Artists 1964)
Director: Guy Hamilton
Producers: Albert R. Broccoli and Harry Saltzman
Screenplay: Richard Maibaum and Paul Dehn
Cast: Sean Connery, Honor Blackman, Gert Frobe, Shirley Eaton, Tania Mallet, Harold Sakata, Burt Kwouk
UK Release Date: September 1964
US Release Date: December 1964

THE HILL (GB/MGM 1965)
Director: Sidney Lumet
Producer: Kenneth Hyman
Screenplay: Ray Rigby
Cast: Sean Connery, Harry Andrews, Ian Hendry, Michael Redgrave, Ian Bannen, Alfred Lynch, Ossie Davis, Roy Kinnear, Jack Watson
US Release Date: June 1965
US Release Date: October 1965

THUNDERBALL (GB/United Artists 1965)
Director: Terence Young
Producer: Kevin McClory
Executive Producers: Albert R. Broccoli and Harry Saltzman
Screenplay: Richard Maibaum and John Hopkins
Cast: Sean Connery, Claudine Auger, Adolfo Celi, Luciana Paluzzi, Rik Van Nutter, Martine Beswick, Guy Doleman, Molly Peters
UK Release Date: December 1965
US Release Date: December 1965

A FINE MADNESS (US/Warner Bros. 1966)
Director: Irvin Kershner
Producer: Jerome Hellman
Screenplay: Elliott Baker
Cast: Sean Connery, Joanne Woodward, Jean Seberg, Patrick O'Neal, Colleen Dewhurst, Clive Revill
UK Release Date: July 1966
US Release Date: May 1966

YOU ONLY LIVE TWICE (GB/United Artists 1967)
Director: Lewis Gilbert

Producers: Albert R. Broccoli and Harry Saltzman
Screenplay: Roald Dahl
Cast: Sean Connery, Akiko Wakabayashi, Tetsuro Tamba, Mie Hama, Karin Dor, Donald Pleasance, Charles Gray, Burt Kwouk
UK Release Date: June 1967
US Release Date: June 1967

SHALAKO (GB/Warner Bros. 1968)
Director: Edward Dmytryk
Producer: Euan Lloyd
Screenplay: J.J. Griffith, Hal Hopper and Scot Finch
Cast: Sean Connery, Brigitte Bardot, Stephen Boyd, Jack Hawkins, Peter Van Eyck, Honor Blackman, Woody Strode, Eric Sykes
UK Release Date: December 1968
US Release Date: October 1968

THE MOLLY MAGUIRES (US/Paramount 1969)
Director: Martin Ritt
Producers: Martin Ritt and Walter Bernstein
Screenplay: Walter Bernstein
Cast: Richard Harris, Sean Connery, Samantha Eggar, Frank Finlay, Anthony Zerbe
UK Release Date: May 1970
US Release Date: February 1970

THE RED TENT (Italy/USSR/Paramount 1969)
Director: Mikhail K. Kalatozov
Producer: Franco Cristaldi
Screenplay: Ennio de Concini and Richard Adams
Cast: Peter Finch, Sean Connery, Claudia Cardinale, Hardy Kruger, Mario Adorf, Massimo Girotti
UK Release Date: June 1972
US Release Date: August 1971

THE ANDERSON TAPES (US/Columbia 1971)
Director: Sidney Lumet
Producer: Robert M. Weitman
Screenplay: Frank R. Pierson
Cast: Sean Connery, Dyan Cannon, Martin Balsam, Ralph Meeker, Alan King, Christopher Walken
UK Release Date: December 1971
US Release Date: June 1971

DIAMONDS ARE FOREVER (GB/United Artists 1971)
Director: Guy Hamilton
Producers: Albert R. Broccoli and Harry Saltzman
Screenplay: Richard Maibaum and Tom Mankiewicz
Cast: Sean Connery, Jill St. John, Charles Gray, Lana Wood, Jimmy Dean, Bruce Cabot, Putter Smith, Bruce Glover
UK Release Date: December 1971
US Release Date: December 1971

THE OFFENCE (GB/United Artists 1972)
Director: Sidney Lumet
Producer: Denis O'Dell
Screenplay: John Hopkins
Cast: Sean Connery, Ian Bannen, Trevor Howard, Vivien Merchant, Peter Bowles
UK Release Date: January 1973

ZARDOZ (GB/20th Century Fox 1974)
Director/Producer/Screenplay: John Boorman
Cast: Sean Connery, Charlotte Rampling, Sara Kestleman, Sally Anne Newton, John Alderton
UK Release Date: March 1974
UK Release Date: January 1974

RANSOM (GB/British Lion 1974)
Director: Casper Wrede
Producer: Peter Rawley
Screenplay: Paul Wheeler
Cast: Sean Connery, Ian McShane, Norman Bristow, Isabel Dean
UK Release Date: February 1975
US Release Date: April 1975 (US Title: **The Terrorists**)

MURDER ON THE ORIENT EXPRESS (GB/EMI 1974)
Director: Sidney Lumet
Producers: John Brabourne and Richard Goodwin
Screenplay: Paul Dehn
Cast: Albert Finney, Lauren Bacall, Martin Balsam, Ingrid Bergman, Jacqueline Bisset, Jean-Pierre Cassel, Sean Connery, John Gielgud, Wendy Hiller, Anthony Perkins, Vanessa Redgrave, Rachel Roberts, Richard Widmark, Michael York
UK Release Date: November 1974
US Release Date: December 1974

THE WIND AND THE LION (US/Columbia 1975)
Director: John Milius

Producer: Herb Jaffe
Screenplay: John Milius
Cast: Sean Connery, Candice Bergen, Brian Keith, John Huston, Geoffrey Lewis, Vladek Sheybal
UK Release Date: June 1975
US Release Date: May 1975

THE MAN WHO WOULD BE KING (US/Columbia 1975)
Director: John Huston
Producer: John Foreman
Screenplay: John Huston and Gladys Hill
Cast: Sean Connery, Michael Caine, Christopher Plummer, Saeed Jaffrey
UK Release Date: December 1975
US Release Date: December 1975

ROBIN AND MARIAN (US/Columbia 1976)
Director: Richard Lester
Producer: Denis O'Dell
Screenplay: James Goldman
Cast: Sean Connery, Audrey Hepburn, Robert Shaw, Richard Harris, Nicol Williamson, Denholm Elliott, Kenneth Haigh, Ronnie Barker, Ian Holm
UK Release Date: March 1976
UK Release Date: March 1976

THE NEXT MAN (US/Allied Artists 1976)
Director: Richard C. Sarafian
Producer: Martin Bregman
Screenplay: Mort Fine, Alan R. Trustman, David M. Wolf and Richard C. Sarafian
Cast: Sean Connery, Cornelia Sharpe, Albert Paulsen, Adolfo Celi, Bob Simmons
UK Release Date: Not theatrically released in the UK
US Release Date: November 1976

A BRIDGE TOO FAR (US/United Artists 1977)
Director: Richard Attenborough
Producer: Joseph E. Levine
Screenplay: William Goldman
Cast: Dirk Bogarde, James Caan, Michael Caine, Sean Connery, Edward Fox, Elliott Gould, Gene Hackman, Anthony Hopkins, Hardy Kruger, Laurence Olivier, Ryan O'Neal, Robert Redford, Maximilian Schell, Liv Ullmann, Denholm Elliott, Ben Cross
UK Release Date: June 1977
US Release Date: June 1977

THE FIRST GREAT TRAIN ROBBERY (GB/United Artists 1978)
Director: Michael Crichton
Producer: John Foreman
Screenplay: Michael Crichton
Cast: Sean Connery, Donald Sutherland, Lesley-Anne Down, Alan Webb, Wayne Sleep, Michael Elpick, Pamela Salem
UK Release Date: December 1978
US Release Date: January 1979

METEOR (US/American International 1979)
Director: Ronald Neame
Producers: Arnold Orgolini and Theodore Parvi
Screenplay: Stanley Mann and Edmund H. North
Cast: Sean Connery, Natalie Wood, Karl Malden, Brian Keith, Martin Landau, Trevor Howard, Henry Fonda
UK Release Date: December 1979
US Release Date: October 1979

CUBA (US/United Artists 1979)
Director: Richard Lester
Producers: Arlene Sellers and Alex Winitsky
Screenplay: Charles Wood
Cast: Sean Connery, Brooke Adams, Jack Weston, Martin Balsam, Denholm Elliott, Hector Elizondo, Chris Sarandon, Walter Gotell
UK Release Date: February 1980
US Release Date: December 1979

TIME BANDITS: (GB/HandMade Films 1981)
Director/Producer: Terry Gilliam
Screenplay: Michael Palin and Terry Gilliam
Cast: John Cleese, Sean Connery, Shelley Duvall, Katherine Helmond, Ian Holm, Michael Palin, Ralph Richardson, David Warner
UK Release Date: July 1981
US Release Date: November 1981

OUTLAND (US/Warner Bros. 1981)
Director: Peter Hyams
Producer: Richard A. Roth
Screenplay: Peter Hyams
Cast: Sean Connery, Peter Boyle, Frances Sternhagen, James B. Sikking, Kika Markham, Steven Berkoff, Clarke Peters
UK Release Date: August 1981
US Release Date: May 1981

THE MAN WITH THE DEADLY LENS (US/Columbia 1982)
Director/Producer/Screenplay: Richard Brooks
Cast: Sean Connery, George Grizzard, Robert Conrad, Katherine Ross, G.D. Spradlin, John Saxon, Henry Silva, Leslie Nielsen, Robert Webber, Hardy Kruger, Dean Stockwell, Ron Moody
UK Release Date: November 1982
US Release Date: April 1982 (*US Title: Wrong Is Right*)

FIVE DAYS ONE SUMMER (US/Warner Bros. 1982)
Director/Producer: Fred Zinnemann
Screenplay: Michael Austin
Cast: Sean Connery, Betsy Brantley, Lambert Wilson, Anna Massey, Isabel Dean
UK Release Date: October 1982
US Release Date: October 1982

SWORD OF THE VALIANT (GB/Cannon 1983)
Director: Stephen Weeks
Producers: Menahem Golan and Yoram Globus
Screenplay: Stephen Weeks, Philip M. Breen and Howard C. Pen
Cast: Miles O'Keefe, Sean Connery, Cyrielle Claire, Leigh Lawson, Trevor Howard, Peter Cushing, Ronald Lacey, John Rhys-Davies
UK Release Date: Not theatrically released in the UK
US Release Date: December 1984

NEVER SAY NEVER AGAIN (US/Warner Bros. 1983)
Director: Irvin Kershner
Producer: Jack Schwartzman
Screenplay: Lorenzo Semple Jnr
Cast: Sean Connery, Klaus Maria Brandauer, Max Von Sydow, Barbara Carrera, Kim Basinger, Bernie Casey, Alec McCowan, Edward Fox, Pamela Salem, Rowan Atkinson
UK Release Date: December 1983
US Release Date: October 1983

HIGHLANDER (US/20th Century Fox 1986)
Director: Russell Mulcahy
Producers: Peter S. Davis and William N. Panzer
Screenplay: Gregory Widen, Peter Bellwood and Larry Ferguson
Cast: Christopher Lambert, Sean Connery, Roxanne Hart, Clancy Brown, Alan North
UK Release Date: August 1986
US Release Date: March 1986

THE NAME OF THE ROSE (Italy/Germany/France/20th Century Fox 1986)
Director: Jean-Jacques Annaud
Producer: Bernd Eichinger
Screenplay: Andrew Birkin, Gerard Brach, Howard Franklin and Alain Godard
Cast: Sean Connery, F. Murray Abraham, Christian Slater, Michael Lonsdale
UK Release Date: January 1987
US Release Date: September 1986

THE UNTOUCHABLES (US/Paramount 1987)
Director: Brian De Palma
Producer: Art Linson
Screenplay: David Mamet
Cast: Kevin Costner, Robert De Niro, Sean Connery, Charles Martin Smith, Andy Garcia, Richard Bradford, Jack Kehoe
UK Release Date: September 1987
US Release Date: June 1987

THE PRESIDIO (US/Paramount 1988)
Director: Peter Hyams
Producer: D. Constantine Conte
Screenplay: Larry Ferguson
Cast: Sean Connery, Mark Harmon, Meg Ryan, Jack Warden, Mark Blum
UK Release Date: January 1989
US Release Date: June 1988

MEMORIES OF ME (US/MGM 1989)
Director: Henry Winkler
Producers: Billy Crystal, Alan King and Michael Hertzberg
Screenplay: Eric Roth and Billy Crystal
Cast: Billy Crystal, Alan King, JoBeth Williams, Sean Connery (cameo as himself)

INDIANA JONES AND THE LAST CRUSADE (US/Paramount 1989)
Director: Steven Spielberg
Producer: Robert Watts
Screenplay: Jeffrey Boam
Cast: Harrison Ford, Sean Connery, Denholm Elliott, Alison Doody, John Rhys-Davies, Julian Glover, River Phoenix, Alexi Sayle
UK Release Date: June 1989
US Release Date: May 1989

FAMILY BUSINESS (US/Tri-Star Pictures 1989)
Director: Sidney Lumet
Producer: Lawrence Gordon

Screenplay: Vincent Patrick
Cast: Sean Connery, Dustin Hoffman, Matthew Broderick
UK Release Date: February 1990
US Release Date: December 1989

THE HUNT FOR RED OCTOBER (US/Paramount 1990)
Director: John McTiernan
Producer: Mace Neufeld
Screenplay: Larry Ferguson and Donald Stewart
Cast: Sean Connery, Alec Baldwin, Scott Glenn, Sam Neill, James Earl Jones, Tim Curry, Richard Jordan, Peter Firth, Joss Ackland
UK Release Date: April 1990
US Release Date: March 1990

THE RUSSIA HOUSE (US/MGM 1990)
Director: Fred Schepisi
Producer: Paul Maslansky and Fred Schepisi
Screenplay: Tom Stoppard
Cast: Sean Connery, Michelle Pfeiffer, Roy Scheider, James Fox, John Mahoney, Klaus Maria Brandauer, Michael Kitchen, Ken Russell
UK Release Date: February 1991
US Release Date: December 1990

HIGHLANDER II – THE QUICKENING (US/Interstar Releasing 1991)
Director: Russell Mulcahy
Producers: Peter Davis and William Panzer
Screenplay: Peter Belwood
Cast: Christopher Lambert, Sean Connery, Michael Ironside, Virginia Madsen
UK Release Date: April 1991
US Release Date: February 1991

ROBIN HOOD – PRINCE OF THIEVES (US/Warner Bros. 1991)
Director: Kevin Reynolds
Producers: John Watson, Pen Densham and Richard B. Lewis
Screenplay: Pen Densham and John Watson
Cast: Kevin Costner, Morgan Freeman, Mary Elizabeth Mastrantonio, Christian Slater, Alan Rickman, Geraldine McEwan, Brian Blessed, Nick Brimble, Sean Connery
UK Release Date: July 1991
US Release Date: June 1991

MEDICINE MAN (US/Hollywood Pictures 1992)
Director: John McTiernan
Producers: Andrew G. Vajna and Donna Dubrow

Screenplay: Tom Schulman and Sally Robinson
Cast: Sean Connery, Lorraine Bracco, Jose Wilker
UK Release Date: May 1992
US Release Date: February 1992

RISING SUN: (US/20th Century Fox 1993)
Director: Philip Kaufman
Producer: Peter Kaufman
Screenplay: Philip Kaufman, Michael Crichton and Michael Backes
Cast: Sean Connery, Wesley Snipes, Harvey Keitel, Cary-Hiroyuki Tagawa, Tia Carrere, Kevin Anderson, Mako, Ray Wise
UK Release Date: October 1993
US Release Date: July 1993

A GOOD MAN IN AFRICA (US/UIP 1994)
Director: Bruce Beresford
Producers: John Fiedler and Mark Tarlov
Screenplay: William Boyd
Cast: Colin Friels, Sean Connery, John Lithgow, Diana Rigg, Louis Gossett Jnr, Joanne Whalley-Kilmer
UK Release Date: November 1994
US Release Date: September 1994

JUST CAUSE (US/Warner Bros. 1995)
Director: Arne Glimcher
Producers: Lee Rich, Arne Glimcher and Steve Perry
Screenplay: Jeb Stuart and Peter Stone
Cast: Sean Connery, Laurence Fishburne, Kate Capshaw, Blair Underwood, Ed Harris, Daniel J. Travanti, Ned Beatty
UK Release Date: March 1995
US Release Date: February 1995

FIRST KNIGHT (US/Columbia 1995)
Director: Jery Zucker
Producers: Jerry Zucker and Hunt Lowry
Screenplay: William Nicholson
Cast: Sean Connery, Richard Gere, Julia Ormond, Ben Cross, Liam Cunningham, Christopher Villiers, John Gielgud
UK Release Date: July 1995
US Release Date: July 1995

DRAGONHEART: (US/Universal 1996)
Director: Rob Cohen
Producer: Rafaella De Laurentiis

Screenplay: Charles Edward Pogue
Cast: Dennis Quaid, David Thewlis, Pete Postlethwaite, Dina Meyer, Julie Christie, Sean Connery (voice only)
UK Release Date: October 1996
US Release Date: May 1996

THE ROCK (US/Hollywood Pictures 1996)
Director: Michael Bay
Producers: Don Simpson and Jerry Bruckheimer
Screenplay: David Weisberg, Douglas Cook and Mark Rosner
Cast: Sean Connery, Nicolas Cage, Ed Harris, John Spencer, David Morse, Michael Biehn
UK Release Date: June 1996
US Release Date: June 1996

THE AVENGERS (US/Warner Bros. 1998)
Director: Jeremiah S. Chechik
Producer: Jerry Weintraub
Screenplay: Don MacPherson
Cast: Ralph Fiennes, Uma Thurman, Sean Connery, Jim Broadbent, Eddie Izzard, Fiona Shaw, Eileen Atkins, John Wood, Shaun Ryder, Patrick Macnee (voice only)
UK Release Date: August 1998
US Release Date: August 1998

PLAYING BY HEART (US/Miramax 1998)
Director: Willard Carroll
Producers: Willard Carroll, Meg Liberman and Tom Wilhite
Screenplay: Willard Carroll
Cast: Gillian Anderson, Ellen Burstyn, Sean Connery, Anthony Edwards, Jay Mohr, Dennis Quaid, Gena Rowlands, Madeleine Stowe, Nastassja Kinski
UK Release Date: Summer 1999
US Release Date: December 1998

ENTRAPMENT: (US/20th Century Fox 1999)
Director: Jon Amiel
Producers: Sean Connery, Michael Hertzberg and Rhonda Tollefson
Screenplay: Ron Bass and William Broyles
Cast: Sean Connery, Catherine Zeta-Jones, Will Patton, Ving Rhames, Maury Chaykin, Kevin McNally
UK Release Date: July 1999
US Release Date: April 1999

Index